ALL-STARS & MOVIE STARS

FILM & HISTORY

The Film & History series is devoted to creative scholarly works that focus on how feature films and documentaries represent and interpret history. Books in the series explore the significant impact of motion pictures on our society and analyze films from a historical perspective. One goal of the series is to demonstrate how historical inquiry has been reinvigorated by the increased scholarly interest in the intersection of film and history. The Film & History series includes both established and emerging scholars and covers a diverse array of films.

Series Editors
Peter C. Rollins and John E. O'Connor

ALL-STARS & MOVIE STARS

Sports in Film & History

Edited by Ron Briley,
Michael K. Schoenecke, and
Deborah A. Carmichael

THE UNIVERSITY PRESS OF KENTUCKY

Scholarly publisher for the Commonwealth,
serving Bellarmine University, Berea College, Centre
College of Kentucky, Eastern Kentucky University,
The Filson Historical Society, Georgetown College,
Kentucky Historical Society, Kentucky State University,
Morehead State University, Murray State University,
Northern Kentucky University, Transylvania University,
University of Kentucky, University of Louisville,
and Western Kentucky University.
All rights reserved.

Editorial and Sales Offices: The University Press of Kentucky
663 South Limestone Street, Lexington, Kentucky 40508-4008
www.kentuckypress.com

12 11 10 09 08 5 4 3 2 1

Library of Congress Cataloging-in-Publication Data

All-stars and movie stars : sports in film and history / edited by Ron
Briley, Michael K. Schoenecke, and Deborah A. Carmichael.
 p. cm.
 Includes bibliographical references and index.
 ISBN 978-0-8131-2448-3 (hardcover : alk. paper)
 1. Sports in motion pictures. 2. Sports. I. Briley, Ron, 1949–
II. Schoenecke, Michael K. (Michael Keith), 1949– III. Carmichael,
Deborah A., 1947–
PN1995.9.S67A45 2008
791.43'657—dc22
 2008006084

This book is printed on acid-free recycled paper meeting
the requirements of the American National Standard
for Permanence in Paper for Printed Library Materials.

Manufactured in the United States of America.

 Member of the Association of
American University Presses

Contents

Part Three: National Identity and Political Confrontation in
Sports Competition

Foreword

FILM AND SPORT WERE quickly connected in the late 1890s as Thomas Edison introduced one-reelers that capitalized on growing popular interest in baseball. In 1908 the Essanay Company released a one-reeler of World Series highlights, and in 1913 another film production company, Selig Polyscope, distributed four reels of World Series footage. From 1908 to 1920 fans packed movie houses for showings of the visual highlights and plays they had read about or seen in newspaper photographs or illustrations. In 1924, at the same time that baseball films (dramatic and documentary) were becoming popular, the National College Athletics Association declared the use of movies in scouting college football opponents "unfair" and "unethical." Even before this, the value of slow-motion film analysis had been established in baseball and golf, and it was extended to football by Walter Camp.

Early interest in seeing the visual and dramatic elements of sports contests, sports personalities and stars, and the places where these contests were held (e.g., ballparks, stadiums, and boxing rings) was satisfied by the documentary qualities of these films. Feature films tended to be comedies, melodramas, or action adventure—that is, other forms grafted onto sports.

When the talking, full-length feature film became the standard product of Hollywood studios, studio heads and producers deemed sports films "box-office poison." Sports films were not commercially viable and not suitable to multiple variations of the same story format or to the "star" system. However, over time this negative assessment lessened, as producers learned that sports and sports heroes offered compelling stories that could be put into formulas: the underdog or unlikely winner; the big comeback after failure, decline, or adversity; the relationships of coaches and play-

ers or teams; the phenom or fast-rising star or sensation; the athlete's experience with women and romance; the inside story of how a sport is run by those who control it and make it profitable, with the athlete as the pawn in this larger game. These films were, of course, stories of white male athletes, coaches, and teams, and with the exceptions of certain films about boxing and football, they reinforced and inscribed the hegemonic order and its values about competition and its attendant rewards. These values include fame, fortune or wealth, social visibility, admiration and emulation, and immortality.

The contributors to this volume focus substantially on story elements that have been necessarily omitted, silenced, changed, marginalized, or minimized in sports films—specifically, race, class, and gender. Standard commercial products like feature films cannot usually accommodate the complexities of culture and identity because box office appeal involves leveling out race, class, and gender so as not to create issues or resolve issues easily. A number of the contributors to this volume have read against the grain of the films' explicit themes to uncover substrata of meaning and implications or to find salient connections to the times in which the films were released.

Another major contribution of this volume is the extension of its focus beyond and outside the Hollywood film genre to documentaries, international cinema, and television coverage of sports. As the volume's editors note in their introduction, one of the central developments in sports has been the dramatic expansion of individual sports such as running, triathlons, snowboarding, cycling, biking, golfing, surfing, fishing, and conditioning. The multidirectional nature of individual sports means that mass media products such as feature films about certain sports have less of a hold on those pursuing individual sports. Their interests run along the lines of specialized feature or instructional videos, cable television channels, publications, or websites. More important than the narrative or dramatic representation of it is the actual experience of the sport and the culture in its venue. It is little wonder that a number of these sports have been brought into Olympic competitions and have developed into organized, sanctioned sports with international competitions or championships. Consumerist forces co-opt and market what is profitable, and it is profitable because it is popular. Nations hold on to sports because athletes and competitions continue to provide a means of promoting national

mythologies and ideologies and keeping athletic prowess and excellence before the nation as an achievable ideal.

The feature film plays an increasingly diminished role in the cultural diffusion of sports, which makes the excellent sports film seem even more remarkable when it comes along. When ideals or success formulas have been tarnished or compromised by athletes or those involved in sports, it is more difficult for sports films to uphold or reify these. Amateurism or non-performance-enhanced athletes seem, at times, anachronistic, even when we know that virtues and values still exist in sports because competitors put them there and share them. We find in our sports ourselves and our worlds—small and contained, large and expansive. Each of the essays in this book is part of that process.

DOUGLAS NOVERR
SENIOR ASSOCIATE DEAN OF ARTS & LETTERS
PROFESSOR OF WRITING, RHETORIC & AMERICAN CULTURE
MICHIGAN STATE UNIVERSITY

Acknowledgments

THIS WORK IS DEDICATED to Peter C. Rollins, Regents Professor of English and American/Film Studies at Oklahoma State University, for his important contributions to the study of film, history, and popular culture, and for his mentorship and friendship graciously given to each of the editors of this anthology for many years. The editors express their gratitude to all the authors represented in this volume for their cooperation and outstanding contributions.

Ron Briley, Michael K. Schoenecke, and Deborah A. Carmichael

Introduction

Sports in Film: Cultural and Historical Representations of Athletic Competition on the Screen

Traditionalists often perceive the athletic playing field as a meritocracy in which issues of race, gender, class, and nationality play no role. Films such as *Miracle* (2004), which focuses on the upset victory of the U.S. hockey team over the Soviet Union in the 1980 Olympic Games, and Ron Howard's *Cinderella Man* (2005), which chronicles the rags to riches story of heavyweight fighter James Braddock during the 1930s, perpetuate the idea that the athletic world provides a vehicle for social mobility in which hard work will prevail in the best tradition of Benjamin Franklin and Horatio Alger.

The authors represented in this volume, however, question this assumption, arguing that nationalism, race, class, and gender are major components of sports and their representation through cinema. Athletes are often burned out at a young age and fail to acquire the education and skills necessary to succeed in life. Sports as an avenue for social mobility often proves illusive, as the documentary film *Hoop Dreams* (1994) well illustrates. And notions of fair play in the increasingly big money world of sports are challenged by the emergence of performance-enhancing drugs. Yet we are still drawn to the struggle in which underdogs do achieve that impossible victory, encouraging us all to believe that equality and justice might truly reign on and off the field of play.

The bottom line is that, for better or worse, sports are big business, with sporting spectacles in baseball, football, basketball, hockey, boxing, horse racing, race car driving, and soccer reflecting the mass culture of the twentieth century. Increased leisure time for the middle class has led

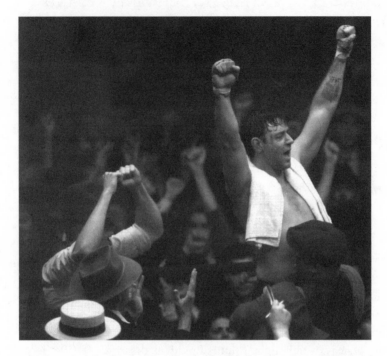

Based on the life of James Braddock, *Cinderella Man* (2005) is but one example of the athlete hero triumphing over adversity. Courtesy of Oklahoma State University Special Collections.

to the growing popularity of individual sports such as running, bicycling, skiing, bowling, golf, skating, tennis, surfing, and swimming. These sports are an integral part of the culture and cannot simply be dismissed as bread and circuses for the masses. In *America's Obsession: Sports and Society Since 1945*, Richard O. Davies concludes that American sports are "unquestionably big business in terms of dollars generated . . . [and] also of major importance in a social sense. For many Americans, 'winning is the only thing,' as football coach Vince Lombardi once promised, for them sports has become an obsession of dubious worth. For the great majority, however, sports provide a wholesome and positive means of enriching their lives."[1]

Although Michael Jordan and Muhammad Ali are two of the most recognizable faces on the planet, modern sport is not all about American hegemony. The power of sports on the international stage was certainly evident in the 2006 World Cup, the world's premiere sporting event. Although

soccer increasingly is played in both male and female youth leagues, the sport has failed to register as a mass spectator sport in the United States, and as usual, the U.S. team fared poorly in the tournament. Nevertheless, U.S. television ratings for the World Cup were at record levels. Who could not be fascinated by the drama of the championship game between France and Italy? In overtime, the French star and captain Zinedine Zidane was ejected from the game for head-butting Italian defender Marco Materazzi. With Zidane absent, the Italians were able to prevail in a shoot-out, and delirious celebrations erupted in Rome. The postgame analysis focused on what Materazzi said to provoke Zidane, who had already announced that he would retire following the 2006 championship game. Both players were disciplined by the Fédération Internationale de Football Association (FIFA), the international soccer federation, after speculation that Materazzi had insulted Zidane's mother or called the Algerian-born Zidane a terrorist. This is the type of drama that makes sport such a ripe arena for cinema.

Thus, it is not surprising that Hollywood is drawn to the sports genre film. As Aaron Baker suggests in *Contesting Identities: Sports in American Film*, sports are of interest to filmmakers because they are hardly apolitical and they serve as an arena in which the "contested process of defining social identities" regarding race, class, gender, and sexuality takes place.[2] One of the leading box office successes of 2004, *Friday Night Lights*, which was adapted from the 1990 bestseller by H. G. Bissinger, makes this process evident. *Friday Night Lights* chronicles the 1988 high school season of Odessa Permian in football-crazy West Texas. It captures Americans' obsession with sports in the words of an Odessa, Texas, businessman, who proclaims, "Life really wouldn't be worth livin' if you didn't have a high school football team to support."[3]

In the 1920s Hollywood began to recognize the importance of sports heroes such as Babe Ruth, Lou Gehrig, Red Grange, and Jack Dempsey, incorporating these figures into small-budget pictures that drew on the celebrity status of the athletes. During the Depression, football was often the subject of Hollywood's attention, with films such as *Saturday's Heroes* (1937), *Hero for a Day* (1939), and *Yesterday's Heroes* (1940) raising serious reservations about the hypocrisy of college sports. Pugilist films such as *Golden Boy* (1939), in which a promising young violinist sacrifices his musical career to become a prizefighter, also questioned the greed of capitalism. A more positive representation of sports in the post–World War II era was developed in the popular film biographies *Knute Rockne—*

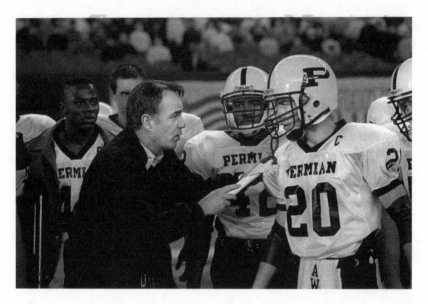

"Life really wouldn't be worth livin' if you didn't have a high school football team to support." *Friday Night Lights* (2004). Courtesy of Oklahoma State University Special Collections.

All-American (1940), starring Pat O'Brien in the title role and Ronald Reagan as George Gipp, and *The Pride of the Yankees* (1942), which starred Gary Cooper as Lou Gehrig. Two popular archetypes were created in these films: in *Rockne*, the coach who is tough on his players because he cares for them; and in *The Pride of the Yankees*, the athlete who perseveres against tremendous obstacles.

The latter archetype was used in a series of biographical baseball films in the post–World War II era in which male athletes had to overcome difficulties, usually with the encouragement of their adoring spouses. In *The Stratton Story* (1949), James Stewart stars as Chicago White Sox pitcher Monty Stratton, who must learn to cope with losing his leg in a hunting accident. *The Pride of St. Louis* (1952) features Dan Dailey as St. Louis Cardinals pitcher Dizzy Dean, who must deal with his lack of education. And in *The Winning Team* (1952), Ronald Reagan as Grover Cleveland Alexander copes with alcoholism. Baseball was also the subject of *Strategic Air Command* (1955), in which a fictional Dutch Holland, portrayed by James Stewart, leaves a lucrative baseball career to serve his country in the

air force. In a Knute Rockne–like role, Frank Lovejoy plays commanding officer General Hawks, who is supposed to personify the cigar-chomping General Curtis Lemay.

Despite the burgeoning post–World War II civil rights movement, sports films in the 1950s continued to focus on a white male America. Two exceptions to this were *The Jackie Robinson Story* (1950) and *Jim Thorpe: All American* (1951). Robinson portrays himself in the film biography, which concludes with the baseball star testifying before the House Committee on Un-American Activities (HUAC), refuting Paul Robeson's statement that black Americans would not defend the country during the Cold War. Robinson later regretted his decision to provide this testimony. The movie becomes another American epic of success as he surmounts the problems of racial discrimination. In *Jim Thorpe: All American*, Burt Lancaster portrays Jim Thorpe, the famous Olympic athlete and professional football and baseball player. Thorpe's problems derived from what the film depicts as his oversensitivity to possible racial discrimination (Thorpe was of mixed white and Native American ancestry), which culminated in the drinking problems that destroyed his marriage. While these two films broadened the sports film genre to include African Americans and Native Americans, they placed their protagonists within the traditional success ethic of hard work and democracy. Only postwar boxing films such as *Body and Soul* (1947) and *Champion* (1949) seemed to challenge the American consensus, offering a more critical analysis of American society and capitalism as being based on greed and exploitation. Similarly ambiguous elements are apparent in Elia Kazan's *On the Waterfront* (1954), the story of prizefighter Terry Malloy (Marlon Brando), a film that usually is used in defense of the decision by director Kazan and scriptwriter Budd Schulberg to cooperate with HUAC.

With the civil rights and women's movements taking center stage during the 1960s and 1970s, sports films began to broaden their focus in the last decades of the twentieth century. Women increasingly participated in athletics following the implementation of Title IX in 1972. The legislation denied federal funding to any educational institution that failed to maintain equity in its men's and women's athletic programs. Although discrepancies persist, more young women participate in athletics today than ever before. However, based upon Hollywood's depiction of women in sports, one would not necessarily gather this fact. Films such as *A League of Their*

Own (1992), *Personal Best* (1982), and *Bend It Like Beckham* (2002), although they tend to perpetuate gender stereotypes, suggest the potential in making women the protagonists of sports films.

The sports film genre, like sports in general, has made few inroads into exploring issues of sexual preference. In the macho and male-dominated world of professional athletics, it is difficult for gay athletes to openly discuss their sexuality. Male athletes who publicly identify themselves as gay—for example, Billy Bean and Glenn Burke in baseball and David Kopay and Esena Tuaoio in football—usually do so only after their playing days are over. One of the few sports films to tackle the subject is *Personal Best*, which deals with lesbianism in a fashion that some critics consider to be exploitive.

Filmmakers are more comfortable addressing the intersection between race and class, and in films such as *Brian's Song* (1971), *Remember the Titans* (2000), and *Glory Road* (2006), sports are portrayed as the means through which racial barriers and discrimination can be broken down.

The pursuit of the American dream is embraced by *Rocky* (1976) and its many successors. Nostalgia for an idyllic America is also apparent in the baseball films *Field of Dreams* (1989) and *The Natural* (1984), and sports films that contest the American success ethic include *Cobb* (1994), *That Championship Season* (1982), *Eight Men Out* (1988), and Martin Scorsese's masterpiece of the fight genre, *Raging Bull* (1980).

The increasing popularity of sports in American society is evident in the number of films dealing with athletic endeavors beyond mass spectator sports. Many of these films also address social and class issues, but they are generally notable for their emphasis on white America. The widening lens of the sports genre film has covered sports such as bicycling in *Breaking Away* (1979), pool in *The Color of Money* (1986), skiing in *Downhill Racer* (1969), skating in *Ice Castles* (1979), track and field in *Prefontaine* (1997), golf in *Tin Cup* (1996), tennis in *Players* (1979), and surfing in *Endless Summer* (1964).

This brief survey indicates that the sports film genre offers a rich resource for scholars of film and sports. One of the major strengths of this collection of essays, however, is that the treatment of the topic extends beyond Hollywood to include television sports coverage, documentaries, and international cinema. We have divided the anthology into three sections: sports as cultural production and representation; masculinity, misogyny,

and race in sports; and national identity and political confrontation in sports competition.

Sports as Cultural Production and Representation

The section on cultural production and representation begins with an essay by Joan Ormrod on the classic surfing film *Endless Summer* (1964). Ormrod investigates the cultural fascination with surfing during the 1960s, a phenomenon that extended from the coasts to the landlocked Midwest. Ormrod maintains that the search for the "perfect wave," as exemplified in *Endless Summer*, represents the consumerism of the 1960s, a time when the United States attempted to impose American cultural values in the international sphere, culminating in the Vietnam War.

In the next essay, "'I'm Against It!': The Marx Brothers' *Horse Feathers* as Cultural Critique, or, Why Big-Time Football Gives Me a Haddock," Daniel A. Nathan examines the Marx Brothers' film *Horse Feathers* (1932) as a critique of college athletics. Nathan is confident that the Marx Brothers never read the Carnegie Foundation's report *American College Athletics* (1929), which criticized colleges and universities for putting a greater priority on sports than education; however, the comedians always had an excellent eye for hypocrisy among pompous individuals such as university presidents. Unfortunately, many of the points made in this film still ring true today.

The essay by Michael Schoenecke explores the relationship between celebrated athletes and the movies, focusing on one sportsman who preferred not to "go Hollywood." Unlike his 1920s contemporaries such as Babe Ruth, Lou Gehrig, Jack Dempsey, and Red Grange, golfer Bobby Jones chose to participate in instructional films rather than feature films. As Schoenecke reveals, however, humorous scenes were included in the films in order to respond to audience expectations, reflecting cultural assumptions about both sports figures and sports films. We have yet to see Tiger Woods in a feature film, but his commercials are a staple of contemporary television.

The more frequent depiction of golf in cinema today, with features such as *The Legend of Bagger Vance* (2000), is a product of the growing popularity of professional golf on television. Although the uninitiated might think of golf as incredibly uncinematic and about as exciting as

watching corn grow, it is a lucrative part of contemporary sports television, as is evident in the creation of the Golf Channel. In "Televised Golf and the Creation of Narrative," Harper Cossar investigates this phenomenon, concentrating on television coverage of the 2003 Funai Classic as an example of how the networks have made golf a staple of weekend coverage. Cossar's essay suggests the necessity for further investigation into the relationship between sports and television. The profit margin for many professional sports franchises comes not from ticket sales but from lucrative television contracts. The question that scholars of television and sports need to examine is the influence that television networks now have on how games are played.

Sports also are gaining a spot in the nation's classrooms, with sports history classes attaining high enrollments in many universities. In "What's *Natural* About It?: A Baseball Movie as Introduction to Key Concepts in Cultural Studies," Latham Hunter discusses her experience teaching *The Natural* (1984) to community college students. In her predominantly male classes, many students are taking a cultural studies course only because it is a requirement; however, Hunter finds that teaching an accessible film such as *The Natural* allows her to critically engage students in a dialogue regarding ideas of gender, heroism, and nation. Her experience suggests sports film can be used successfully as a pedagogical tool.

Masculinity, Misogyny, and Race in Sport

The second section of the anthology examines the roles of masculinity, misogyny, and race in sports as revealed through film. Focusing on both male and female athletes, in movies such as *Rocky* (1976), *Slap Shot* (1977), *Raging Bull* (1980), *A League of Their Own* (1992), and *Pat and Mike* (1952), Dayna B. Daniels argues that cinematic depictions of the athletic world as a male domain have perpetuated sexism and misogyny in American culture. Daniels observes that coaches in the locker rooms of the nation, and in the films that depict them, use language that vilifies women to motivate male athletes. In the vocabulary of misogyny, the only thing worse than being called a girl is to have one's heterosexuality questioned. Perhaps the only way to rectify the situation described by Daniels is to have more gays, lesbians, and women involved not only on the athletic field but also in sports films.

In "As American As . . . : Filling in the Gaps and Recovering the Narratives of America's Forgotten Heroes," Pellom McDaniels III observes that, with the exception of *Bingo Long's Traveling All-Stars & Motor Kings* (1976), Hollywood baseball films have ignored the accomplishments of the Negro Leagues. According to Hollywood, black baseball began with Jackie Robinson and integration. Filmmakers have overlooked the fact that integration destroyed the black institution of baseball, although McDaniels acknowledges that documentaries such as *There Was Always Sun Shining Someplace* (1984), *Kings on the Hill: Baseball's Forgotten Men* (1993), and *The Journey of the African-American Athlete* (1996) document the contributions of the Negro League players, fans, and entrepreneurs. The essay underscores the importance of consulting sports documentaries in research and teaching.

Some of the points raised by McDaniels are echoed in Ron Briley's essay on the popular basketball film *Hoosiers* (1986). Briley attempts to place *Hoosiers* within the historical and cultural context of Ronald Reagan's America of the 1980s. The "Milan Miracle" of 1954, in which an all-white team from a farming community defeated a black urban high school team for the state basketball championship, is interpreted as a longing for a mythical white middle-class America of the 1950s, a time before the challenges posed by feminists, civil rights reformers, antiwar protesters, and advocates for greater economic equality. *Hoosiers* thus represents nostalgia for the simpler (white as opposed to multicultural) America found in *Field of Dreams* (1989), the rhetoric of President Reagan, and Disney theme park recreations of Main Street at the turn of the century.

Boxing films have often challenged this simplistic and nostalgic perception of America. The boxing film genre in the United States is noted for such acclaimed movies as *Golden Boy* (1939), *Body and Soul* (1947), *Champion* (1949), *Raging Bull* (1980), and *Hurricane* (2001), but perhaps the most beloved Hollywood fight film is *Rocky* (1976). Rocky and its sequels are extolled by many filmgoers and critics as the embodiment of the American dream of success through hard work and determination. The essays by Victoria Elmwood and Clay Motley challenge this simplistic reading of the film and the character.

In her reading of *Rocky*, Elmwood interprets the film as a reflection of male insecurity during the troubled economic and political period of the 1970s. Reacting to the growth of feminism and the blurring of traditional

gender boundaries, Elmwood argues, *Rocky* enlists the support of black men into the consensus in order to roll back the gains of feminism. Motley also perceives the film as reflecting male insecurity during the 1970s, comparing the crisis in American manhood in the 1970s to a similar crisis during the 1890s. During the earlier period, men like Theodore Roosevelt were threatened by modernism and questioned their masculinity. They sought "manly" experience in conflicts such as the Spanish-American War of 1898. Motley asserts that a similar identity crisis was present during the 1970s, as the economy tumbled and Americans suffered from the aftermath of the Vietnam War and the Watergate scandal.

National Identity and Political Confrontation in Sports Competition

The final section of the anthology examines national identity and political confrontation in sports. In his essay "Do You Believe in Miracles? Whiteness, Hollywood and a 'Post-9/11' Sports Imagination," David J. Leonard supports many of the points made in the preceding essays. Focusing on the Hollywood feature *Miracle* (2004) and its documentary companion *Do You Believe in Miracles? The Story of the 1980 U.S. Hockey Team* (2001), Leonard argues that the victory of the U.S. hockey team in the 1980 Olympics should be read through the lens of whiteness. Sports films often celebrate the victory of David over Goliath, and in this case the Americans were the underdogs against the favored Soviets. In a postmodern analysis, Leonard insists that the 1980 U.S. hockey team overcame their lack of athletic ability and their poor facilities through their white working-class work ethic and their masculinity. Leonard concludes that in a "post-9/11" world, this cinematic trope resonates with Americans who perceive themselves as underdogs in the war on terror, fighting an enemy that does not play by the rules. Accordingly, Leonard concludes that America's greatest sports heroes demonstrate the power and possibility of a collective white masculinity.

As Leonard's essay suggests, the Olympic Games provide a venue for political statement as well as athletic excellence. The 1936 Berlin Games were employed by Nazi Germany to assert Aryan superiority, but this notion was shattered by the accomplishments of Jesse Owens. The Mexico City Olympics of 1968 witnessed the brutal suppression of student dissent by the Mexican government, as well as the symbolic black power salutes

of sprinters Tommy Smith and John Carlos. While political boycotts in response to the Cold War and racial apartheid were significant factors in several of the post–World War II Olympics, perhaps the most infamous example of politics intruding into the games is the 1972 terrorist attack that resulted in the slaying of Israeli athletes. David Diffrient offers an interesting commentary on the official documentary of the 1972 games, *Visions of Eight* (1973), in which a deliberate effort was made not to focus on the violence of the summer games in Munich. Produced by David L. Wolper and Stan Margulies, *Visions of Eight* consists of eight short films directed by such outstanding international filmmakers as Arthur Penn, Milos Foreman, and John Schlesinger. Diffrient argues that, by concentrating on the tension between cooperation and competition, these films exemplify the Olympic spirit and experience.

The essay by John Hughson provides an international perspective on class and sports, addressing issues of social class in director Tony Richardson's *The Loneliness of the Long Distance Runner* (1962). Hughson places this well-known sports film within the context of the "angry young man" genre, which is represented most notably by the work of playwright John Osborne.

Christoph Laucht and Tobias Hochscherf contributed the final essay in the collection. They examine the 2003 German feature film *The Miracle of Bern*, which narrates Germany's soccer victory in the 1954 World Cup. Laucht and Hochscherf assert that *The Miracle of Bern*, which was produced a decade after the fall of the Berlin Wall and the ensuing unification of East and West Germany, uses Hollywood emotional techniques to foster a German foundational myth. They examine the important link between the Hollywood sports film genre and one of Germany's most beloved sports features, demonstrating the capability of sports and film research to reach across international boundaries.

Considerable work remains to be done to fully explore sports documentaries, the connection between sports and television, and the relationship between international sports cinema and the Hollywood sports film genre. The pieces contained in this anthology only begin to suggest the wide range of research and writing that is needed in the field, thus pointing the way for additional study in this important arena of life in the twenty-first century. We trust that the collection will inspire and foster further work on sports and film.

Filmography

Bend It Like Beckham. Directed by Gurinder Chadha. Kintop Pictures, 2002.

Bingo Long Traveling All-Stars & Motor Kings. Directed by John Badham. Motown Productions, 1976.

Body and Soul. Directed by Robert Rossen. Enterprise Studios, 1947.

Breaking Away. Directed by Peter Yates. Twentieth Century Fox Film Corporation, 1979.

Brian's Song. Directed by Buzz Kulik. Screen Gems Television, 1971.

Champion. Directed by Mark Robson. Stanley Kramer Productions, 1949.

Cinderella Man. Directed by Ron Howard. Universal Pictures, 2005.

Cobb. Directed by Ron Shelton. Alcor Films, 1994.

The Color of Money. Directed by Martin Scorsese. Silver Screen Partners, 1986.

Do You Believe in Miracles? The Story of the 1980 U.S. Hockey Team. Directed by Bernard Goldberg. Home Box Office, 2001.

Downhill Racer. Directed by Michael Ritchie. Wildwood, 1969.

Eight Men Out. Directed by John Sayles. Orion Pictures, 1988.

Endless Summer, The. Directed by Bruce Brown. Bruce Brown Films, 1966.

Field of Dreams. Directed by Phil Alden Robinson. Gordon Company, 1989.

Friday Night Lights. Directed by Peter Berg. Universal Pictures, 2004.

Glory Road. Directed by James Gartner. Walt Disney Pictures, 2006.

Golden Boy. Directed by Ruben Mamoulian. Columbia Pictures, 1939.

Hero for a Day. Directed by Harold Young. Universal Pictures, 1939.

Hoop Dreams. Directed by Steve James. KTCA Minneapolis, 1994.

Hoosiers. Directed by David Anspaugh. Orion Pictures, 1986.

Horse Feathers. Directed by Norman S. Macleod. Paramount Pictures, 1932.

Ice Castles. Directed by Donald Wrye. Columbia Pictures, 1978.

The Jackie Robinson Story. Directed by Alfred E. Green. Legend Films, 1950.

Jim Thorpe: All American. Directed by Michael Curtiz. Warner Brothers, 1951.

The Journey of the African-American Athlete. Directed by Leslie D. Farrell and William C. Rhoden. Home Box Office, 1996.

Knute Rockne—All-American. Directed by Lloyd Bacon. Warner Brothers, 1940.

A League of Their Own. Directed by Penny Marshall. Columbia Pictures, 1992.

The Legend of Bagger Vance. Directed by Robert Redford. Allied Filmmakers, 2000.

The Loneliness of the Long Distance Runner. Directed by Tony Richardson. Woodfall Film Productions, 1962.

Miracle. Directed by Gavin O'Connor. Walt Disney Pictures, 2004.

The Miracle of Bern. Directed by Sönke Wortmann. Little Shark Entertainment, 2003.

The Natural. Directed by Barry Levinson. TriStar Pictures, 1984.

On the Waterfront. Directed by Elia Kazan. Columbia Pictures, 1954.

Pat and Mike. Directed by George Cukor. Metro-Goldwyn-Mayer (MGM), 1952.

Personal Best. Directed by Robert Towne. Geffen Pictures, 1982.

Players. Directed by Anthony Harvey. Paramount Pictures, 1979.

Prefontaine. Directed by Steve James. Hollywood Pictures, 1997.

The Pride of St. Louis. Directed by Harmon Jones. Twentieth Century Fox Film Corporation, 1952.

Pride of the Yankees, The. Directed by Sam Wood. Samuel Goldwyn Company, 1942.

Raging Bull. Directed by Martin Scorsese. Raging Bull, 1980.

Remember the Titans. Directed by Boaz Yakin. Walt Disney Pictures, 2000.

Rocky. Directed by John G. Avildsen. United Artists, 1976.

Saturday's Heroes. Directed by Edward Killy. RKO Radio Pictures, 1937.

Slap Shot. Directed by George Roy Hill. Universal Pictures, 1977.

Strategic Air Command. Directed by Anthony Mann. Paramount Pictures, 1955.

The Stratton Story. Directed by Sam Wood. Metro-Goldwyn-Mayer (MGM), 1949.

Tin Cup. Directed by Ron Shelton. Warner Brothers, 1996.

That Championship Season. Directed by Jason Miller. Cannon Film, 1982.

Visions of Eight. Directed by Milos Forman, Kon Ichikawa, Claude Lelouch, Yuir Ozeroy, Arthur Penn, Michael Pfleghar, John Schlesinger, and Mai Zetterling. Wolper Productions, 1973.

The Winning Team. Directed by Lewis Seiler. Warner Brothers, 1952.

Yesterday's Heroes. Directed by Herbert I. Lees. Twentieth Century Fox Film Corporation, 1940.

Notes

1. Richard O. Davies, *America's Obsession: Sports and Society Since 1945* (Fort Worth, TX: Harcourt Brace & Company, 1994), x.

2. Aaron Baker, *Contesting Identities: Sports in American Film* (Urbana: University of Illinois Press, 2003), 1–2.

3. H. G. Bissinger, *Friday Night Lights: A Town, a Team, and a Dream* (Reading, MS: Addison-Wesley Publishing Company, 1990), 20.

Sport as Cultural Production and Representation

JOAN ORMROD

Endless Summer

Consuming Waves and Surfing the Frontier

> *The Endless Summer* defined our sport. For the first time
> the rest of the world would have a clear look at the surfing
> lifestyle.
>
> —Matt Warshaw, *Surfer's Journal History of Surfing Films*

> Brown cobbled together $50,000 and set out with two
> California surfers, Mike Hynson and Robert August, to
> produce a true documentary on real surfers. Not beach
> bums or playboys who sang to their girlfriends, surfers
> were athletes who enjoyed the adventure of scanning the
> globe in search of the perfect wave.
>
> —Ben Marcus, "The Sick Six: Six of the Most Important Surf
> Movies Ever Made, from the Fifties to Now"

AFTER WORLD WAR II, America and the West experienced a consumer
boom as a result of greater disposable incomes, advances in technology,
and an increase in commodity production. The consumer culture focused
in part on the pleasure derived from acquiring goods, and goods came to
symbolize lifestyles and identities.[1] The baby boom generation, which was
born following the war and became teenaged in the 1950s, was an integral
part of the consumer culture. American teenagers numbered ten to fifteen
million in the 1950s and had a potential spending power of nine billion
dollars.[2] It is therefore not surprising that this market became the target of
advertising and mass media exploitation and that it has been shamelessly
exploited since the 1950s.[3] By the early 1960s youth culture was the locus
for innovation in fashion, music, and style, and this innovation crossed
over into adult lifestyles as well, bringing about, for example, dance crazes
such as the Twist in the early 1960s.[4]

Among young people the growth in consumerism included leisure activities such as going to the movies, driving, and sports. Surfing in particular was regarded as a hot new sport with a youthful focus, which appealed to middle class, white youth and epitomized the ideal California lifestyle. "Surfsploitation," as the surf craze became known, emerged in the United States as a cross-media drive to attract youth audiences through the glamour and freedom supposedly offered by the surfing lifestyle. Surfsploitation included the surf music represented by groups such as the Beach Boys, the Ventures, and Jan and Dean. The Beach Boys were marketed as all-American high school boys who surfed, were clean cut, and cared only for cars, girls, and fun, fun, fun. Hollywood produced about seventy surf-related exploitation films purporting to lift the lid on just what happened on the beach when adults were not around to regulate undesirable behavior. Out of this heady, consumerist mix of mass media exploitation emerged what many surfers regard as the definitive "pure" surf movie, Bruce Brown's *The Endless Summer* (originally released in 1964).

The Endless Summer has a simple premise—the quest for the perfect wave, which is one of the defining myths of surf culture and its representation outside the subculture. Director and surfer Bruce Brown followed two surfers, Robert August and Mike Hynson, around the globe to experience an endless summer and catch the perfect wave. The two friends traveled to little-known destinations such as Australia, Ghana, New Zealand, South Africa, and Tahiti, in addition to more familiar locales such as Malibu and Hawaii. Brown explained, "Originally we were just going to South Africa and then come back . . . but it turned out to be $50 cheaper to go all the way round the world, so we did that."[5]

The Endless Summer belongs to a subgenre of surf films that Douglas Booth describes as "pure."[6] These are surf films that were made by surfers for a surfing audience and typically were exhibited at surf clubs. Brown's credentials as a surfer and surf filmmaker, and his association with significant surfboard shapers such as Dale Velzy, ensured the authenticity of his representation of surf culture. "Pure" surf films relied on the film producer to distribute and exhibit them at independent cinemas and other small venues. Brown exhibited the film along with a running commentary to enthusiastic surfer audiences at high school halls and clubhouses.[7] Brown developed a script from which he distilled the best of the jokes and script elements before recording a permanent soundtrack. In an effort to

gain Hollywood studio distribution, Brown, aided by Paul Allen, toured around the United States, stopping in cities such as Wichita, Kansas—a venue hardly famed for its waves—where the film ran for two weeks to full houses. However, something unexpected happened with *The Endless Summer*: it crossed over from niche to mainstream audiences when the distribution was taken up by Columbia Pictures Corporation. Indeed, the film was so popular that *Newsweek* dubbed *The Endless Summer* one of the best ten films of 1966, after it was re-released by Columbia.

So why was *The Endless Summer* so popular? Robert August, one of the film's stars, believes that the distribution of the film to mainstream audiences in 1966 was a reminder of a more innocent time, providing Americans with time out from the Vietnam War and the chance to have fun for a while. "It was the right time for it," August said.[8] Bruce Brown is not sure: "I don't know . . . I've run into so many people who saw *The Endless Summer*, particularly back east, and said it had some effect on them. But a lot of 'em, they didn't surf, and they never did surf. It's always been a mystery to me."[9] A generation of surfers later, Albie Thoms wrote of *The Endless Summer*, "What everyone picked up on was the beauty of surfing, the harmonious union of man and nature, the adventure implicit in riding waves no-one surfed before, and the sense of freedom to be found away from civilisation's complexity."[10]

Thoms, however, ignored the consumer aspect of *The Endless Summer*, conferring upon it an Edenic innocence with which it has been associated ever since. However, this essay argues that it is impossible to wrest the film from its consumer roots. The reason for the popularity of *The Endless Summer* was that it perfectly expressed the dreams of American culture in a hedonist search for freedom from the restrictions of conformity. Further, the main premise of the film, the surfers' quest for the perfect wave, was attractive to American culture in the early to mid-1960s, articulating a reenactment of the conquering of the American frontier and, as August suggests, reminding Americans of a simpler, more innocent time before the Vietnam War.

Surf Exploitation and the Teenage Consumer

In the early to mid-1950s, teenagers were represented as transgressive, and the perceived threat of juvenile delinquency to the American way of life was, according to J. Edgar Hoover, second only to communism.[11]

However, the late 1950s and early 1960s saw the emergence of the "clean teen"—the fun-loving teen who conformed to the strictures of society. The clean teen phenomenon was "a quite literal product of the parent culture, fabricated from above, peddled down below."[12] Rebellious teen pop icons of the 1950s, including Elvis Presley, Jerry Lee Lewis, and Chuck Berry, were replaced by squeaky-clean stars such as Pat Boone, Frankie Avalon, and Annette Funicello. Clean teen stars were promoted in film, pop music, and television. For instance, Frankie Avalon had a big hit with "Venus in Blue Jeans," and Annette Funicello starred as a Mouseketeer in the *Mickey Mouse Club* and also had a hit record with "Tall Paul." Just as pop music was tamed, so Hollywood quickly changed its representation of teenagers in the early 1960s, depicting them as fun loving, clean living, and most of all, good consumers.

Surfing, which previously was regarded as transgressive, became part of the clean teen phenomenon when it was identified as a sport enjoyed by teenagers—more importantly, by white, middle class teenagers from families with good incomes. The surf boom was fueled by the release of the 1959 film *Gidget*, starring teen star Sandra Dee as the "girl midget." *Gidget* was adapted from Fred Kohner's book about his daughter Kathy's experiences with a bunch of surfers at The Point in Malibu. Sandra Dee's costar was heartthrob James Darren, who played a surf bum wannabe, Moondoggie.

Gidget was a typical white, middle-class teenager who either had enough disposable income to buy a surfboard or was able to cajole her doting parents into buying it for her. The story is about her romance with Moondoggie and the romantic, dropout lifestyle of the surf bums, led by Kahuna. By the end of the film, Gidget gets her man and converts Kahuna, previously a confirmed bachelor and layabout, into a productive member of society. Following on the success of *Gidget*, American Independent Pictures released a series of six exploitation films with a surfing background. The first of the series, *Beach Party* (1963), set the paradigm for the other films: *Muscle Beach Party* (1964), *Bikini Beach* (1964), *Beach Blanket Bingo* (1965), *How to Stuff a Wild Bikini* (1965), and *The Ghost in the Invisible Bikini* (1966).

Most of American Independent Pictures' beach films starred Frankie Avalon, Annette Funicello, and a regular gang of surfers, such as Joel McCrae as Deadhead.[13] There was also a regular supporting cast, which included Harvey Lembeck as Eric von Zipper, a middle-aged "wild one,"

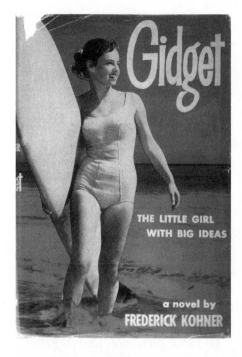

Gidget book cover, 1957. Courtesy of Shiffer Publishing.

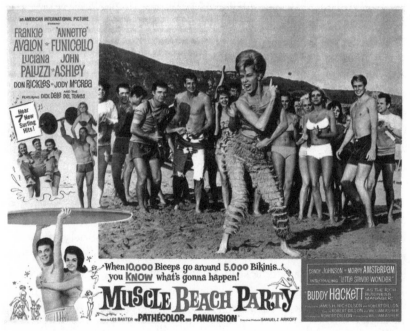

Poster for *Muscle Beach Party* (1964), featuring Candy Johnson (Miss Perpetual Motion). Frankie Avalon and Annette Funicello are pictured bottom left. Courtesy of Evergreen.

and Don Rickles in a variety of guises, from Jack Fanny in *Muscle Beach Party* to Big Drop in *Beach Blanket Bingo*. The liminal nature of the beach, coupled with scanty beachwear and the lack of adult supervision, offered the opportunity for frolics and sexual innuendo in the sand dunes, as well as pop songs and slapstick comedy. However, this shameless exploitation of their culture caused such fury in the Californian surf community that Mickey Dora, the most famous surfer in California and a vociferous opponent of surf commercialism, released a jar of moths onto the screen at *Beach Party*'s first screening. Paradoxically, Dora was not above taking money for stunt work in the film. He also provided stunt footage for several other Hollywood films of the time, including *Ride the Wild Surf* (1964) and *Gidget* (1959).

Coincidentally, surfboard technology was also undergoing a revolution at this time. Previously, surfboards had been made from the increasingly rare and expensive balsa wood, and the boards were too expensive for the average teenager to buy. The weight of the surfboards also made them more difficult to carry and maneuver in the water. Surfboards also were scarce. A surfboard might take up to three weeks to craft. However, when Hobie Alter and Dale Velzy began to use foam to make surfboards, they could produce up to 160 boards per week at a cost of seventy to eighty dollars.[14] Indeed, Alter noted that, "If that movie'd [*Gidget*] come out in the balsa era . . . no one could have supplied 'em."[15] The production of cheaper and lighter boards enabled a whole generation of teenagers to take to the waves. Coupled with the growing affluence in California, an affluence that was especially experienced by teenagers, the production of cheaper surfboards soon made Malibu and other Californian surf spots very popular and very crowded.

The exploitation of the sport dismayed many of the bona fide surfers. It was in an effort to depict the authentic surf lifestyle that Bruce Brown claims he produced *The Endless Summer*. The sobriety of the film is apparent from the press pack, which is restrained, consisting of a brief history of surfing and some stills from the film with reviews from *Time*, *The New Yorker*, and *Playboy*. When compared with the flashy, hyperbolic poster for *Muscle Beach Party*, the simplicity of the poster for *The Endless Summer* promises a mythic and idealized portrayal of surfing and surf culture, as Robert August and Mike Hynson "follow this everlasting summer around the world."

Columbia Pictures, which took over the release of the film in 1966,

The poster image for *The Endless Summer* (1964) was taken from a photograph of Mike Hynson, Robert August, and Bruce Brown. Courtesy of Columbia Pictures.

deliberately placed a good deal of clear blue water between *The Endless Summer* and its exploitative cousins. Poster and advertising copy for *The Endless Summer* is predicated on youth and tourism. The notion of summer connotes the optimism of vacations and youth, and adding "endless" to this idea holds out the promise that youth and vacationing may go on forever. The poster copy begins as follows: "On any day of the year it's summer somewhere in the world." It goes on to describe the quest for the perfect wave and concludes with this offer to audiences: "Share their [Mike Hynson and Robert August's] experiences as they search the world for that perfect wave that might be forming just over the horizon." The wave forming "just over the horizon" promises the fulfilment of the quest, but it also suggests pushing back a frontier or exploring a new and undiscovered country.

The frontier myth has been a part of American culture since its origins.[16] Surfers' quest for the perfect wave expresses an underpinning American value, an aim to explore the wilderness and thereby extend the frontiers of civilization.[17] It also intersects with the aim of the tourist to discover new locations in which "authentic" life may be scrutinized. The

surfer as constructed through tourist discourse is a phenomenon that originates from the dissemination of surfing from the Pacific Islands to the United States at the beginning of the twentieth century.

Surfing was part of the ancient *kapua* caste system of Hawaii for at least one thousand years. When Captain Cook's ship *The Resolution* anchored at Kealano Bay, the *kapua* system was already in decline.[18] The arrival of European missionaries and disease hastened that decline, and surfing too virtually disappeared until the mid- to late nineteenth century.

Surfing reemerged as a result of consumerist discourse and modernity in the late nineteenth century. In an effort to overthrow plantation culture, Hawaii developed its tourist potential using myths of paradise on earth and unspoiled beauty to attract mainly American tourists.[19] The Waikiki Hotel in particular attracted tourists with its outrigger club and the Waikiki Beach Boys, native Hawaiians who gave surfing demonstrations to tourists. Before *The Endless Summer*, surfers regularly made pilgrimages to "the Islands." Beginning in the 1920s, surfers migrated to Hawaii to experience surfing's spiritual home. The Hawaiian Islands were associated with an exotic mystique that conferred subcultural capital on the émigrés.[20] Indeed, in the 1930s, one of the first surfing colonies in California, at San Onofre, celebrated the Hawaiian lifestyle in a hedonistic and bohemian way of life. Reverence for Hawaii was translated into popular notions of surfing through the character of Kahuna in *Gidget*. In the movie, Kahuna, who was named after a Hawaiian priest, is regarded as the head of the surfing colony at Malibu both because of his lifestyle as a dropout and because he has surfed the Islands.[21] In *The Endless Summer* Bruce Brown took the mystique of surfing the exotic and primitive "other" and developed it into a global quest for the perfect wave.[22] However, despite the movie's simple premise, the construct of the perfect wave and the representations of surfers and other places in the film could only be expressed as such because of American culture at that specific historic and societal moment. Indeed, the consumerism that underpinned exploitation films in that era was more crucial to the production of *The Endless Summer* than either Columbia or Bruce Brown would care to admit.

The Development and Commodification of Californian Surfing

Several issues are important to the discussion of *The Endless Summer*. First, the importance of California cannot be overemphasized. Beginning in the

late 1950s, California, home of the typical American surfer, was regarded as a state filled with golden people who were all young, tan, and affluent.[23] Second, America was "discovered" in 1492 as a result of European exploration and expansion.[24] However, before Columbus, America was imagined on maps as "terra incognita," and Europeans made assumptions about the inhabitants of such a land. Once Europeans began to colonize the United States, European clerics and academics began to position the indigenous population as children. The continent was described as "the New World," as opposed to Europe, the Old World. These associations have informed representations of the United States ever since the sixteenth century, and they continue to influence contemporary notions of the United States as a youthful society. These notions also have influenced America's ideas about its own culture and are particularly apparent in the worship of youth and youthfulness.[25]

Herbert Gans suggests that much of American ideology revolves around the idea of personal liberty and freedom of choice.[26] Within American capitalism there is the notion that an individual can make money by striving harder than anyone else. Competitiveness is a major component of the American Dream, suggesting that it is every person's duty to strive and ultimately to win. These ideas are enshrined in what Slotkin describes as America's frontier myth, in which early settlers conquered the land, pushing back the frontier and civilizing the wilderness. By the early 1960s the only frontiers left to conquer were space and the ocean. Surfers seemed to represent frontiersmen conquering the final American frontier. Indeed, in 1958 the *Saturday Evening Post* noted that surfers represented "the last frontier. Civilization drops behind them when they leave the shore and the beauty and challenge of the great oceans is all around them."[27] Surfers seemed to symbolize the Californian spirit. They were golden people who represented infinite possibility and youthfulness to American mainstream culture. Travel and surfing were inexorably linked, and they coalesced in the notion of the surfing safari (the "surfari").

Malibu, California, was crucial to the growth and development of surfing. Foam technology from the aircraft industry made possible the wider availability of affordable surfboards. Hobie Alter is credited with first using foam technology in surfboard production. His aim was to shape a board that could substitute for rare and expensive balsa wood. Alter's main rival, Dale Velzy at Venice Beach, quickly adopted the foam technology and was so successful that he was able to buy himself a Mercedes.

His altruism was legendary amongst Californian surfers. He would give good surfers free surfboards and send surfers to international contests in Australia. He gave Bruce Brown his first camera and enough money to shoot his first film, *Slippery When Wet* (1958). However, films were not the only advances in the surf culture. In the early 1960s the first major surfing magazine, *Surfer*, appeared, and it solidified the international surfing community and promoted Californian surf culture.

Surfer started in 1961 as a newsletter with a circulation of ten thousand, promoting filmmaker John Severson's latest film, *Surf Fever*. The first newsletter sold five thousand copies in Southern California, which inspired Severson to produce the newsletter as a quarterly magazine. Within three months *Surfer* sold five thousand copies and became a vital part of surf culture. The magazine was issued bimonthly starting in 1962 and monthly starting in 1976. Initially it promoted the Californian fantasy of the surfing lifestyle, featuring articles about surfing and travel and high-quality surfing photography. In 1965, for instance, Fred Wardy claimed that "surfing is a release from exploding tensions of twentieth-century living, escape from the hustling, bustling city world of steel and concrete, a return to nature's reality."[28] Wardy's comment articulates the romance of the leisure surfer's escape to the natural, which was to become fully developed with the emergence of the soul surfer of the 1970s. Wardy also expressed the surfer's "endless search for the windless day, an uncrowded beach, the perfect wave." *Surfer*, which became known as "the surfer's bible," presented surfers with images of perfect waves six times a year in the early 1960s. In an early editorial, "Surfing Is . . . ," Severson described *Surfer* as "a dream magazine. I saw that right away. The perfect surf, the faraway places . . . we all dream about the same things."[29] This notion of the daydream is worth discussing here as it is central to consumer and tourist discourse and, in surfing, to the perfect wave. Indeed, *The Endless Summer* could be described as a cinematic realization of *Surfer* magazine in its evocation of the quest for the perfect wave, a quest that was not predicated on "discovery" so much as "rediscovery."

By the early 1960s, Malibu's waves had become too crowded. Indeed, whenever a hot new surf spot was discovered, word quickly traveled and it became a nightmare to surf. Matt Warshaw notes that in the 1950s and early 1960s, surf magazines and films were quite transparent about the best locations for waves. However:

Discovery . . . invited ruin. In the late 1950s, when the "perfect wave" designation floated above Malibu like a neon sign, surfers were banging off one another in the line-up like heated molecules. To varying degrees, the same would eventually hold true for the Pipeline, Kirra, Jeffreys, Grajagan, and any other spot renowned and cursed as "perfect." For many surfers . . . the real search for the perfect wave has been less to do with adventure, romance, and the pursuit of new experiences and more with just getting the hell away from what . . . Mickey Dora called "all the surf dopes, ego heroes, rah-rah boys, concessionaires, lifeguards, fags, and finks." Surfers on the road didn't look for anything particularly different. They wanted Malibu (or Kirra, or Grajagan, etc.) without the crowds.[30]

Indeed, so intense was the pressure on popular surf spots that in the mid-1960s *Surfer* stopped identifying locations. Starting in the late 1950s, Californian surfers began to travel farther afield on the "surfari" to find the perfect wave. However, as Warshaw notes, the aim of the surfari was not to discover new waves but to rediscover waves that surfers already knew. Thus, according to Warshaw, films such as *The Endless Summer* and magazines such as *Surfer* promoted travel to distant beaches as a dream, a fantasy, a "reality heightened by imagination."[31]

Surfing is a leisure activity predicated on consumerism. It is the romantic aspect of consumerism that is crucial here, for as Colin Campbell argues, consumerism is based on desire and the possibility of achieving the perfect life through buying and consuming objects or experiences.[32] This separates the physical from the imaginary world for the consumer, who "learns to substitute imaginary for real stimuli and by self-consciously creating and manipulating illusions or imaginary experiences or emotions in daydreams and fantasies constructs his or her own pleasurable environment."[33] Images are an important part in the daydream of the perfect life. However, images can never live up to the dream. The idea of vacationing also conjures up an image of the perfect experience, whether in reality or in the images constantly broadcast on television, displayed on the Internet, or printed in newspapers, magazines, and travel brochures. Alluring images also encourage the potential tourist's daydream: "Names like Waikiki, Nice, Majorca, Acapulco, Bali and Marrakech roll across the page evoking images of sun, pleasure and escape. In a world dominated by bureaucracies and machines, we are offered these destinations as retreats

to a childlike world in which the sun always shines, and we can gratify all our desires."[34] This quotation neatly summarizes many of the notions associated with vacationing. There is the idea that a vacation is a retreat or escape from the routine of everyday life. And there is the notion of a return to childishness and the implicit notion of a return to an Edenic state of innocence, in which tourists can satisfy their whims. These ideas, at their root, coalesce around notions of time and the ways in which time is segmented in modern Western cultures, but the cultural appropriation of space is also significant. As Turner and Ash argue, tourism is implicated geographically in the "pleasure periphery," in which certain geographical locations are designated tourist areas by virtue of their proximity to urban centers. Tourist destinations tend to be two to four hours away from big cities in northern or industrialized nations. Turner and Ash identify the United States' pleasure periphery as the Caribbean, Latin America (Mexico, Tijuana, Acapulco), and the Pacific Islands. Hawaii became a popular destination for rich American tourists beginning in the mid-nineteenth century. It appealed to the desire for the exotic—for paradise and the simple life. Although Turner and Ash wrote in the mid-1970s, their arguments concerning vacationing remain valid today and are peculiarly appropriate to our discussion of surfing and leisure.

A further reason for the desire to retreat to an idealized lifestyle is urbanization. Urry notes that, beginning in the late eighteenth century, the growth of urbanization, with its attendant overcrowding and the squalor of city life, induced in city dwellers a wish for escape to a rural idyll.[35] Along with romantic sensibilities, increasing urbanization caused city dwellers to desire to return to a rural or idyllic space, a space that might be likened to Eden or Arcadia—in short, a paradise on earth. To this end, tourists might anticipate the vacation, or a daydream about it, using tourist literature to spur their imagination. The imagining of future pleasures is a symptom of modern hedonism: "Pleasure is sought via emotional and not merely sensory stimulation, whilst . . . the images which fulfil this function are either imaginatively created or modified by the individual for self-consumption, there being little reliance upon the presence of 'real' stimuli. These two facets mean that modern hedonism tends to be covert and self-illusory; that is to say, individuals employ their imagination and creative powers to construct mental images which they consume for the intrinsic pleasure they provide, a practice best described as day-dreaming or fantasizing."[36] Daydreaming, an integral part of the

sojourn or tourist experience, depends on the visual and may be induced by vacation brochures, television programs, or other mass media texts.[37] Rosengren takes the importance of the visual further in his discussion of the sojourn: "to dwell in a place temporarily or as a stranger, the implication being that once returned to the point of departure the sojourn is of no further consequence." The "surfari" is a type of sojourn; it is an activity that is based on sensation but that contains many elements of tourism, such as the daydream (which Rosengren describes as the "self-departure"). The experience of sojourning is fueled by the rhetoric and images in surf magazines and films, which hold out the promise of escape from everyday routine. A "surfari" is a daydream based on consumerism and articulated through media representations. Issues surrounding the romance and daydream implicit in tourism and the appropriation of space recur continuously in *The Endless Summer*.

The Endless Summer: Constructing the Known/Unknown

The press book for *The Endless Summer* includes several reviews that praise the film. *Playboy*, for instance, notes: "*The Endless Summer* is one of the most pleasant and least self-conscious travelogs and sports commentaries to come along in years, a delightful sojourn into surfdom."[38] The opening credits pick up the theme of the title in gold-drenched images of surfboards packed into a car driving toward the sun. Travel is highlighted in the opening credits—a yacht bobs on sun-flecked water, and an airplane flies toward the sun. As the film begins in California, Brown contextualizes surf culture, describing the favored type of surf: "Most surfers like to ride a regular board and perform on a medium sized wave." When Brown suggests the surfer "performs," he refers to the popularity of the hotdogging style of surfing. Hotdogging was a performance style of surfing in which the surfer performed maneuvers on the board. The ideal hotdogger wave was the small to medium Malibu wave. Matt Warshaw reinforces the argument that surfers enact both a spectacular and performative identity when he describes hotdogging as "trick riding . . . often on beaches full of onlookers."[39] Brown lists hot surfers of the early 1960s, including Mickey Dora, who at the time was the star of the Malibu medium wave; Phil Edwards, the first to surf the Pipeline, Hawaii, whom Brown had starred in his previous film, *Surfing Hollow Days* (1961); and Australian Nat Young, who had just won the World Surfing Championship in San Diego.[40] There is

the archetypal wipeout and footage of surfing in Hawaii, with a list of the most famous waves: the Garbage Hole, Waikiki, and Number 3.[41] Brown says that the object of surfing is "to remain in the curl, stay as close to the wave without getting caught by it. All the movements in surfing, stalling, turning, riding the nose are directed towards the ultimate aim of riding the curl." There is some slapstick footage of surfers carrying their surfboards and attempting to cross the busy highway, a sequence that demonstrates the overcrowding of the Californian surf.

Another negative aspect of Californian surfing, according to Brown, is the winter: "The ultimate thing for all of us would be to have an endless summer; the warm water and waves without the summer crowds of California. The only way to do this is to follow the summer season as it moves around the world." Robert August and Mike Hynson sit in front of a fire one evening planning and daydreaming about such a trip. They consult travel magazines such as *National Geographic*, read a malaria manual, and browse a book on how to repel shark attacks. The following ninety minutes shows the pair visiting Senegal, Ghana, South Africa, Australia, Tahiti, and Hawaii. Each location is stereotyped in a particular way. Brown notes that in Senegal they stamp "sucker" on your forehead, because August and Hynson are forced to stay in a government hotel costing them $30 per day and $1 for coffee. Brown estimates that each wave costs $9.95. However, they convert several "natives" (a term used incessantly by Brown) to surfing.

In Accra they stay in a small fishing village, the first white men ever seen by some of the villagers. Brown stresses the unchanging way of life for thousands of years. Here villagers make canoes from a tree trunk, money is rarely used, and when Hynson and August surf the children quickly make paddleboards for themselves and begin surfing. The surf is compared favorably with that at Malibu. The lack of surfers is stressed in the visit to South Africa, where there are only one hundred surfers around the Cape. However, the brotherhood of surfing is stressed when all one hundred arrive on the beach to welcome Robert and Mike. Despite the lack of surfers, when Mike and Robert hitchhike outside Durban ("you can wait three days for a car"), they manage to hitch a lift with two passing surfers. In South Africa, defying narrative conventions, Robert and Mike discover the perfect wave just off Cape St. Francis. Brown describes it in typical hyperbole: "so perfect it could be made by a machine . . . so long I couldn't get most of them [the waves] on one piece of film." The local

fishermen note that the waves in this area are funny-looking things—"like pipes"—and, as Brown asserts, they are like this three hundred days a year. The water temperature here is also perfect—seventy degrees, with a prevailing offshore wind. The wave is so long and perfect that the surfers get cramps in their legs from squatting down in the curl. Brown concludes, "I couldn't help but think of the hundreds of years these waves must've been breaking here but until this day no one had ever ridden one. Thousands of waves must've gone to waste right now on Cape St. Francis."

Hyperbole continues in the Australian segment, when Brown, August, and Hynson cannot find any waves and are constantly told that they "should have been here last winter." However, the perfection of New Zealand waves echoes that of South Africa, and on Christmas Day August and Hynson surf in a cove by themselves. Brown says, "I can't even show you a full ride; it would take the whole second half of the film."

The final leg of the journey marries the weird with the familiar. In Tahiti, where reputedly there are no waves, the surfers discover well-formed waves. In Papeete waves can be ridden in and out. The film climaxes in Hawaii ("good old Hawaii"), the surfers' spiritual home. Brown demonstrates the art of the filmmaker when he straps the camera to the front of the board to show the waves from a surfer's point of view. There are shots of the Pipeline, which is described as "a Roman gladiator's pit" because of the razor-sharp coral underneath the shallow wave. The spikes can wound or kill. "Any wipeout at the Pipeline in Hawaii is a bad one." As if to underline this point, a surfer named Bob Pike takes a wipeout and Brown reports that he sustains a broken collarbone and three broken ribs. The board of another surfer, Butch van Arsdale, is broken in two—and, as Brown informs the audience, surfboards are so tough they cannot be broken even if you drive a car over them.[42] The films ends with Brown's admonition: "With enough time and money you could spend the rest of your life following the summer around the world." This describes the wish of many surfers, to have enough free time and money to surf without the routine of work and everyday living. The film gives surfers a taste of what such a life might be like.

The Endless Summer: Surfing the Frontier, Selling the Wave

The Endless Summer is a documentary, but it is not a documentary in the traditional sense of the genre. It is not a sober and objective narrative. Rather, like all "pure" surf films in the early 1960s, it was meant to be

exhibited by its director in front of an enthusiastic surf audience. Brown, like other "four-wall"' producers, produced, distributed, and presented the film, and he would play music from a tape recorder while narrating from his written script. The film was meant to "stoke" the audience. It was imperative that something was happening throughout the film; there could be no quiet passages. Therefore, Brown disrupted the narrative in reel and real time. So, for instance, while Mike and Robert flew from Africa to Australia, Brown injected interest by showing footage of Hawaii: "While Mike and Robert are on their way to Australia, let's look at waves in Hawaii." When they arrived in Australia, he directed the audience to rejoin Robert and Mike. This was obviously a narrative device to prevent boredom in the audience, but it also used up Brown's excess footage of Hawaii. These flashbacks also served the purpose of reminding surfers of the familiar compared with the unfamiliar, reinforcing the recognition and rediscovery of their own waves through the unfamiliar wave. Pleasure in the past was reflected upon and compared with the imperfection of the present. Therefore, when Hynson and August attempted to hitch a lift in Durban, rather than showing several minutes of the isolated African road, Brown took the audience to Newport Beach, California, to "the dirty old Wedge." He stressed the crowded beach and waves and compared them with the isolation and strangeness of the African road. Similarly, when there was a lull in the waves at Bell's Beach in Perth, Australia, Rod Sumpter described a surfing session he enjoyed with Nat Young in the winter. In Sydney, August and Hynson reflected upon the monster waves in Waimea, which had to be ridden on "big gun" surfboards. These three flashbacks contain the juxtaposition of the familiar and the unfamiliar and also an engagement in daydreaming and imagination, an integral part of modern hedonism. In all of three cases, pleasure and the perfection of the imagination, the daydream, is compared with the imperfection of reality.

The Endless Summer, however, did not always represent a true picture of what happened on the surfers' quest for the perfect wave. It glossed over some of the more tedious aspects of production. Each location was represented as containing certain elements. Robert August admitted, "We went to a lot of places [where] there was just nothing."[43] Nevertheless, this aspect of production is not apparent in the film's narrative. For instance, Brown describes how the perfect wave was discovered after a trek across three miles of sand dunes at Cape St. Francis in South Africa. Narrative

tension is built up when Brown comments that the odds of finding a perfect wave were ten million to one. The film shows the surfers on top of a sand dune looking down on the ocean, and Brown says, "They finally got their first look at St. Francis, South Africa." The camera then shows the perfect wave. Brown built up tension and the "stoke" in the audience by selling them the wave in South Africa—a wave so perfect it looked like it was made by a machine, so long it could not be contained on one film. "I timed them in the curl for forty-five seconds." Brown exhorts surfers to visit South Africa by reminding them of the wasted opportunities to ride this perfect wave: "Out of a whole day's surfing . . . each wave was perfect." Indeed, he compares this wave with Malibu and Rincorn, concluding, "And it's better every day." Selling the wave to American surfers through the pure surf film commodified it just as much as the exploitation films commodified surfing. Indeed, *The Endless Summer* shared many of its values with the image of "clean teens." The two stars of the film, Robert August and Mike Hynson, were typical middle-class, clean-cut youth. At the airport they dressed in suits, their hair was neatly cut, and they were respectful to their elders. In a scene in Africa, they call the village chief "sir." They were, at the same time, ambassadors of American youth and frontiersmen venturing into the wilderness and colonizing waves in undiscovered territories.[44] Further, their exploration of the unknown wave was only made possible by increasingly cheap airfares in the early sixties.

The Endless Summer articulates issues surrounding the American frontier myth that is encapsulated in consumerism and tourism discourses. These issues recur throughout the film in binaries such as the known/unknown, named/unnamed, exotic/familiar, and crowds/isolation. Brown begins the film with an account of the crowds on the beaches of Malibu and Hawaii. The theme of the crowd was juxtaposed with that of isolation and the notion of the idyllic ride in locations around the world. For instance, on Christmas Day, when August and Hynson surfed by themselves in New Zealand on what is an extremely long wave, Brown notes that eventually the ride became so long that August and Hynson resorted to chatting with each other as a means of diverting boredom. Obviously this was an exaggeration aimed at selling the unknown and, more importantly, the uncrowded wave so desired by frustrated American surfers. As if to emphasize the point, Brown juxtaposed footage of crowds on the beach at "the dirty old Wedge" in California with an empty highway in Durban,

South Africa ("one of the few places in the world you can be alone on a main highway"). Of the beaches in South Africa, Brown states, "Most beaches haven't been set foot on for ten years."

The crowds/isolation theme was intimately linked with that of the exotic (elsewhere) and the familiar (the United States). Throughout the film, California and Hawaii are continuously contrasted with unknown and exotic locations through flashbacks. California is positioned as the physical home of surfing, Hawaii (described as "good old Hawaii" by Brown) as the spiritual home of surfing. August and Hynson traveled to Hawaii on the last leg of their journey, in effect, travelling from the familiar to the familiar, from home to "paradise on earth." Brown concludes, "Hawaii is truly a land of an endless summer."

Throughout the film Brown refers back to California in terms of time or distance. For instance, in Dakata, Senegal, Brown states, "Here they were only four hours off an airplane from the United States and already into better surf than the day they left California." Time and space is conflated through the act of riding the wave: "They rode those waves knowing they were the first to ever do it and also knowing the closest surfer to them was four thousand miles away." August and Hynson are portrayed in this segment of the film as civilizing influences, akin to the civilizing influence of Europe on the United States after Columbus. They descended like gods into a primitive village in Ghana—so primitive that money was unknown and goods were obtained by barter or exchange. They were the first white men ever seen by many of the villagers. As missionaries in Hawaii, they set about spreading the good word—in this case, the good word was explicitly about surfing and implicitly about capitalism. They established a surf school to teach children how to surf. The children quickly took to this new pastime, making paddleboards so they could surf the waves.[45] Adults enjoyed surfing too, and one attempted to surf in his outrigger canoe in a style similar to that of early surfing in the Pacific Islands.

The wilderness, uncultivated and unshaped, is evoked in descriptions of the unknown surf spot. A wave with ideal conditions in Durban, South Africa, "doesn't even have a name." In Dakata, Senegal, Brown describes "surf that no one had ever ridden before, and as far as we know, surf that no one ever knew before."

Brown gives these unnamed surf spots names, names that in some cases remain to this day. In Tahiti, for instance, a wave was named "The Other Spot," a title designed to be as obscure as the location. It is worth

noting that the names Brown gave to a particular spot might overlay names given to these places by local people. The renaming is reminiscent of Columbus's claiming and naming islands for the Spanish throne.[46] In claiming symbolic ownership of the wilderness for surfing and America, Brown's naming of the waves echoes a colonial enterprise.

Another aspect of the known/unknown binary relates to the representation of the surfers whom August and Hynson encountered. When the duo visited South Africa, all one hundred local surfers, some from as far as four hundred miles away, descended on the beach and surfed with them. Brown suggests that surfers are part of a global tribe, sharing the waves and a special brotherhood. However, the difference between different surf cultures is also noted. South African surfers tended to be older than Californian surfers. Australian surfers were of similar age but were very competitive with the "Yanks"—a phenomenon that became significant with the advent of the shortboard revolution within two years of the making of *The Endless Summer*.[47]

The quest for the perfect wave did not aim to discover the unknown; rather, it aimed to recreate the known. The constant comparison between waves in Lagos, Senegal, and Cape St. Francis and waves in California and Hawaii reflects the search for a new Waimea or Malibu. Just as surfers the world over were similar to but different than Californian surfers, so the waves were also continuously compared to already known waves in California and Hawaii. In Sydney the lack of waves and flat conditions were juxtaposed with the mountainous waves of Waimea in Hawaii, which were first ridden in 1958 after surfers spent ten years looking at them. In an analogy to hunting, Brown notes that these waves needed special surfboards—"big guns"—and were surfed by "only a handful of surfers . . . sportsmen and nuts." In these dangerous waves the flailing surfboard could cut you in half. For this reason surfers dove away from their boards in a wipeout. The water temperature was also compared with "home"—in South Africa it was fifty-four degrees, while Lagos's ninety-one degrees was so warm that "it melted the wax right off the surfboards." What is of note here, however, is that until 1958 this wave had not been ridden or given a name. When it was named and tamed, surfers, usually American surfers, claimed it as theirs.

Unknown waves could be dangerous, and Brown constantly stresses the importance of surfing with a friend in strange waters. It was not only the waves that were dangerous but also what lurked beneath them. In

Australia and South Africa beaches are cordoned off from shark attack. In Australia, sharks are known as "the men in grey." In South Africa, when the sinister grey fins are seen cutting the surface of the water where Hynson and August are surfing, Brown warns that despite netting, there is a fifty/fifty chance you would be killed by a shark. However, the danger is mitigated later, when the sharks are identified as porpoises. Brown turns this into a political statement, noting that porpoises and sharks do not swim in the same waters. "They have yet to integrate." In addition to sharks in Lagos, there was the hazard of the stonefish: "If you step on a stone fish, you die in about fifteen minutes."

In the global quest for the perfect wave, Brown, August, and Hynson made known the unknown and incorporated locations and waves into American culture. It was a culture based on consumerism. A quest for the perfect wave could not have been made by a subcultural surfing group from any society other than the United States—and specifically, California—at the time. All the conditions for such a journey were in place within this specific sociohistorical moment. In addition to being a journey of exploration and adventure, it was a journey of colonization and incorporation of other surfers and waves into American surf culture. It affirmed U.S. dominance of global surfing at the time and was a crucial component in the popularity of the film with surfing and non-surfing audiences.

Notes

1. Mike Featherstone, *Consumer Culture and Postmodernism* (London: Sage Publications, 1998).

2. Eugene Gilbert, *Advertising and Marketing to Young People* (Pleasantville, NY: Printer's Ink Books, 1957), 21.

3. Bill Osgerby, *Playboys in Paradise: Masculinity, Youth and Leisure-style in Modern America* (Oxford: Berg/New York University Press, 2001).

4. Thomas Frank, *The Conquest of Cool: Business, Culture, Counterculture and the Rise of Hip Consumerism* (Chicago: University of Chicago Press, 1997).

5. Ben Marcus, "The Sick Six: Six of the Most Important Surf Movies Ever Made, from the Fifties to Now," Yerba Buena Center for the Arts, San Francisco.

6. Douglas Booth, "Surfing Films and Videos: Adolescent Fun, Alternative Lifestyle, Adventure Industry," *Journal of Sport History* 23, no. 3 (1996): 309–27.

7. Keith Beattie, "Sick, Filthy, and Delirious: Surf Film and Video and

the Documentary Mode," *Continuum: Journal of Media & Cultural Studies* 15, no. 3 (2001): 333–48.

8. Bruce Brown, Greg MacGillivray, and George Greenough, *The Surfer's Journal 50 Years of Surfing on Film*. VHS. (San Clemente, CA: The Surfer's Journal, 1996).

9. Bruce Brown, quoted in Drew Kampion, *Stoked: The History of Surf Culture* (Köln, Germany: Evergreen, 1998), 109.

10. Albie Thoms, "Morning of the Earth," in *Polemics for a New Cinema* (Sydney, Australia: Wild and Woolley, 1978), 125.

11. Thomas Doherty, *Teenagers and Teenpics: The Juvenilization of American Movies in the 1950s* (London: Unwin Hyman, 1988).

12. Ibid.

13. *The Ghost in the Invisible Bikini* starred Nancy Sinatra. In some movies, such as *How to Stuff a Wild Bikini* and the spin-off, *Ski Party*, Funicello and Avalon made guest appearances, usually providing a punch line for the plot.

14. Nat Young, Craig McGregor, and Rod Holmes, *The History of Surfing* (Angourie, Australia: Palm Beach Press, 1994), 77.

15. Kampion, *Stoked*, 69.

16. Richard Slotkin, *The Fatal Environment: The Myth of the Frontier in the Age of Industrialization, 1800–1890* (Middletown, CT: Wesleyan University Press, 1986).

17. Joan Ormrod, "'Just the lemon next to the pie' . . . Apocalypse, History and the Limits of Myth in *Big Wednesday* (1978)," *Scope: An Online Journal of Film Studies* (February 2005).

18. Reet A. Howell and Maxwell L. Howell assert that the view that missionaries hastened the decline of the *kapua* caste system is ill founded. Rather, ancient Hawaiian sports such as *Holua* (sled sliding), *maika* (bowling), and *heenalu* (surfing) declined as a result of the destruction of the *kapua* system by King Liholiho in 1819. See Reet A. Howell and Maxwell L. Howell, "Holua: Myth or Reality?," *North American Society for Sport History, Proceedings and Newsletter* (1989): 44.

19. Bryan H. Farrell, *Hawaii: The Legend that Sells* (Honolulu: The University Press of Hawaii, 1982), 15.

20. Sarah Thornton, *Club Cultures: Music, Media and Subcultural Capital* (Middletown, CT: Wesleyan University Press, 1996).

21. The ad was published in *The Saturday Evening Post* in 1922, and the copy describes Kahanamoku as a "famous athlete, expert on the surf-board and champion 100-metre swimmer." Kahanamoku is reported as commenting, "No matter how long the board is used in the water, the Valspar is not affected." Nancy Schiffer, *Surfing* (Atglen, PA: Schiffer, 1998), 122.

22. R. L. Rutsky, "Surfing the Other: Ideology on the Beach," *Film Quarterly* 52, no. 4 (1999): 12–23.

23. Kirse Granat May, "Suburban Eden: Californian Youth Images in Popular Culture 1955–1966" (PhD diss., University of Utah, 1999).

24. I place "discovered" in quotation marks because at the time of Columbus's arrival in the islands off the American coast, there were an estimated six million people living on the continent.

25. Hayden White, *Tropics of Discourse: Essays in Cultural Criticism* (Baltimore: Johns Hopkins University Press, 1978); and Stephen Greenblatt, *Marvelous Possessions: The Wonder of the New World* (Oxford: Clarendon, 1991).

26. Herbert J. Gans, *Middle American Individualism: The Future of Liberal Democracy* (New York: Free Press, 1988).

27. May, "Suburban Eden," 137.

28. Fred Wardy, cited in Sam George, *The Perfect Day: 40 Years of Surfer Magazine* (San Francisco: Chronicle Books, 2001), 15.

29. Matt Warshaw, *Surfriders: In Search of the Perfect Wave* (Del Mar, CA: Tehabi Books, 1997), 38.

30. Ibid., 38.

31. Ibid., 43.

32. Colin Campbell, *The Romantic Ethic and the Spirit of Modern Consumerism* (Oxford: Basil Blackwell, 1987).

33. Celia Lury, *Consumer Culture* (Oxford: Polity, 1996), 73.

34. Louis Turner and John Ash, *The Golden Hordes: International Tourism and the Pleasure Periphery* (London: Constable, 1975), 11.

35. John Urry, *The Tourist Gaze: Leisure and Travel in Contemporary Societies* (London: Sage, 1990).

36. Campbell, *The Romantic Ethic*, 77.

37. William R. Rosengren, "The Rhetoric of Sojourning," *Journal of Popular Culture* 5, no. 2 (1971): 298–314.

38. *Playboy* review of *The Endless Summer*, cited in the press book for *The Endless Summer*.

39. Brown, MacGillivray, and Greenough, *The Surfer's Journal*.

40. The Pipeline is a legendary break in Hawaii that surfers watched but did not surf. However, within two hours of Edwards's first ride, fifteen surfers were riding the wave. Bruce Brown commented, "In one day it went from nobody surfed there to a 'spot.'"

41. A surfer experiences wipeout when they fall off their board and are engulfed by the wave. The wipeout was a typical narrative device in "pure" surf films and originated in early films made by surfers such as Bud Browne.

42. Hyperbolic elements in oral storytelling, such as the Roman gladiator's pit, are an integral part of John Milius's *Big Wednesday* (1978), which contains many elements found in *The Endless Summer* (perhaps one of the reasons it is held in such high esteem by surfers). See Ormrod, "'Just the lemon next to the pie.'"

43. Brown, MacGillivray, and Greenough, *The Surfer's Journal*.

44. Slotkin, *The Fatal Environment*.

45. Indeed, these paddleboards bear a strong resemblance to those made and surfed by Tahitians and recorded in German anthropological films from the early twentieth century. One wonders how the children picked up the notion of a curved board tip: were they told by August, Brown, and Hynson, or did they have previous knowledge of this component of the paddleboard?

46. Greenblatt, *Marvelous Possessions*.

47. The shortboard revolution occurred in the mid 1960s, when surfing values changed from medium waves to tubes. Australian and American surfers enacted a war on the waves through the surf press in which, most infamously, Australian John Witzig infuriated American surfers by suggesting, "We're tops now." John Witzig, quoted in George, *The Perfect Day*, 24.

Daniel A. Nathan

"I'm Against It!"

The Marx Brothers' Horse Feathers as Cultural Critique; or, Why Big-Time College Football Gives Me a Haddock

FAST-PACED AND WITTY, antiauthoritarian and anarchic, the Marx Brothers' *Horse Feathers* (1932) is a seriously funny film. More than seventy years after it was released, it continues to evoke laughter—not just because it is a timeless "classic" but also because it is still timely. Its objects of ridicule are still with us—academic pretentiousness and inanity, and the hypocrisy and foolishness of institutions of higher education chasing gridiron glory. In other words, *Horse Feathers* was and is more than "the mere antics of funny men" and "pure clowning," as one reviewer noted when the film was in theaters.[1] On the contrary, its "peculiar brand of lunacy" had some well-recognized and well-deserved targets.[2] As critic Richard Rowland remarked in 1947 when praising the Marx Brothers, "the finest comedian in the world cannot be funny without something to be funny about."[3] College life in the early 1930s, especially big-time college football, provided the Marx Brothers and their writers with rich material, an opportunity to have a good time and to produce a commercially successful product but also to do widely accessible cultural criticism, albeit via a mélange that was "part vaudeville, part theater of the absurd, part surrealistic satire," rather than a cogent, carefully documented critique.[4]

This essay aspires to the latter, and I can hear some people now: Do we really need or want to think critically about something that's as much fun as *Horse Feathers*? Obviously critiquing a text does not diminish it or the pleasure it gives us, but isn't it a mistake to take something like a Marx Brothers film seriously? Apparently at least one of the Marx Brothers thought so, for historian Lawrence W. Levine notes that "Groucho Marx

was amused at the professors who professed to see significance in the routines he did with his brothers, when in fact they were just improvising without any grand purpose, just trying to make people laugh."[5] Laughter can be its own reward, and there is some truth to Groucho's claim. After all, the Marx Brothers were first and foremost trying to be amusing, and they were not cultural critics in the same way that a contemporary like Reinhold Niebuhr was. Moreover, one needs to be mindful that the last thing most comedians want is to be taken seriously. They usually want to be taken humorously, which is fine and does not preclude the fact that comedy, like other forms of popular culture, is a practice or discourse that can also be a trenchant form of cultural criticism, a way of promoting critical thought about myriad subjects. It may come as a surprise to some, but *Horse Feathers* (a phrase that means nonsense or foolishness) did and does just that, even though the social world the film creates is bizarre and, thankfully, far from realistic.[6]

The movie's plot, as with most Marx Brothers films, is uncomplicated and not particularly noteworthy per se.[7] The following synopsis elides most of the events that do not have much bearing on the film's portrayal of college life and football, like the famous and still wonderfully funny "swordfish" speakeasy scene.[8]

The film begins in an auditorium where Professor Quincy Adams Wagstaff (Groucho Marx) is introduced as Huxley College's new president. (Why Huxley would hire the roguish Wagstaff is hard to imagine, but it is a Marx Brothers film so viewers know they must suspend their disbelief.) Wagstaff's inaugural speech is impertinent and snappily delivered, riddled with non sequiturs and ridicule for the trustees, administrators, students, and faculty. Early in his speech, Wagstaff explains that he has come to Huxley to save his son Frank (Zeppo Marx), a student who has been at the school for twelve years, partly because he has been fooling around with Connie Bailey (Thelma Todd), the "college widow" (a non-college woman "who makes a habit of going with students").[9] Soon thereafter, Wagstaff bursts into song, which is as anti-intellectual and nihilistic as it is funny, and includes the lyrics:

I don't know what they have to say
It makes no difference anyway
Whatever it is, I'm against it.
No matter what it is or who commenced it, I'm against it![10]

Film critic Allen Eyles asserts that this song "sums up the Marx Brothers' attitude toward life—irreverent, comic and fearless."[11] The next scene features Wagstaff and his wayward son, who explains that Huxley has had a new president every year since 1888, the same year the school's football team last won a game. Despite his knee-jerk opposition to new ideas, Wagstaff is convinced (why is a mystery) that it is important for Huxley to field a football team that can beat rival school Darwin. So, on Frank's advice, Wagstaff recruits two "ringers" who hang out at a speakeasy. Unfortunately, the real football players, Mullen and McCarthy, a couple of thugs, have already been hired to play for Darwin, and thus Wagstaff mistakenly retains and enrolls misfits Baravelli (Chico Marx), an iceman and bootlegger, and his sidekick Pinky (Harpo Marx), a mute dogcatcher. By any measure, they are an athletically and intellectually challenged duo. Meanwhile, Connie Bailey, the flirtatious college widow, who is in cahoots with the unethical Darwin flunky (is he a school official? a booster?) who hired the ringers, tries to get the Huxley football signals from Wagstaff, but to no avail. Once Wagstaff finds out that Darwin has beaten him to the real players, he enlists Baravelli and Pinky to kidnap them. No more adept as kidnappers than as college students or football players, Baravelli and Pinky are held captive by Mullen and McCarthy, who lock the inept pair in their apartment before they leave to play in the Huxley-Darwin game. In spite of themselves, Baravelli and Pinky manage to escape and make it to the game, which is in progress. Huxley comes from behind and wins the game, thanks to a series of chaotic on-field events, including the use of a huge rubber band attached to the end of a football, several dozen banana peels, and a horse-drawn garbage wagon/chariot. In the film's final scene, Wagstaff, Baravelli, and Pinky simultaneously marry (and then maul) Connie, apparently as a reward for Huxley's gridiron victory.[12]

Horse Feathers was a critical and commercial success, but before discussing those subjects I want to make an obvious though important point: the film did not make itself. This is worth mentioning because, as historian George Lipsitz puts it, sometimes people seem to underestimate or forget "the origins and intentions of the messages we encounter through the mass media; sometimes we forget that artists have origins or intentions at all, so pervasive are the stimuli around us."[13] So besides the Marx Brothers, who made *Horse Feathers*? What is its production history?

The children of German-Jewish immigrants, the Marx Brothers did

not go to college. Thanks in part to an aggressive mother, they learned their craft on vaudeville stages, graduated to musical comedy, and made their first film, *The Cocoanuts*, in 1929. They made two more movies, *Animal Crackers* (1930) and *Monkey Business* (1931), before *Horse Feathers*. Years earlier, the Marx Brothers did a vaudeville act called *Fun in Hi Skule*, "which cast Groucho as the professor and Harpo as the teacher's pet peeve."[14] Indeed, writer Charlotte Church quips, "*Horse Feathers* is *Fun in Hi Skule* graduated to college and Hollywood."[15] Nonetheless, the idea for *Horse Feathers* has been attributed to Bert Granet, then an assistant director, who did not have a hand in the film's actual production, and its title was derived from a 1928 Barney Google cartoon.[16]

Although he is not credited, Herman Mankiewicz produced *Horse Feathers*; Bert Kalmar, Harry Ruby, Will B. Johnstone, and S. J. Perelman wrote its screenplay and music; and Norman McLeod directed it. Of these men, two in particular need to be mentioned here. Mankiewicz, who graduated from Columbia University in 1916 and is sometimes described as "mercurial" and "abrasive," was one of the busiest and most influential screenwriters in Hollywood during the late 1920s and early 1930s, and he later shared the screenwriting credit for *Citizen Kane* (1941) and *The Pride of the Yankees* (1942).[17] Like the Marx Brothers, Mankiewicz was a Jewish New Yorker who helped bring a "wisecracking, fast-talking" Broadway sensibility to Hollywood.[18] S. J. Perelman, who has been described as "a slapstick James Joyce," was the film's only screenwriter who attended college (Brown University), where it seems he spent most of his time writing humor pieces for literary magazines and "diatribes against university policies."[19] According to his biographer, Dorothy Herrmann, "The spirit of *Horse Feathers* is pure S. J. Perelman. Only a man who was forced to endure four years in a place where he didn't fit in and that refused to graduate him could have made such devastating fun of it."[20] Despite their difficulties working together, the Marxes, Mankiewicz, and Perelman (among others) instilled *Horse Feathers* with an anarchic frenzy that may have had its roots in the sense of alienation that many Jewish Americans experienced as members of a beleaguered outgroup.[21]

Typically, directors—more so than producers or writers—are credited with being a film's driving force. It is hard to see how that was the case with *Horse Feathers*, however. Norman McLeod, who made *Monkey Business* the year before *Horse Feathers*, was given "the job of directing the

directionless," as Marx Brothers historian Joe Adamson puts it, becoming the first filmmaker to work with the unruly comedy team twice.[22] A college graduate and former World War I fighter pilot who apprenticed as a writer and animator in the 1920s, McLeod had his hands full with the Marx Brothers.[23] He filmed most of *Horse Feathers* in the early spring of 1932, although its production was delayed because Chico Marx got into a serious car accident, shattering a kneecap and breaking several ribs. It was several months before filming could resume.[24] (If you watch closely, you can see that in the football scenes, which were filmed at Occidental College in Los Angeles, either Chico is limping or a double is used.[25])

Paramount released *Horse Feathers* in mid-August 1932, the same month the studio premiered forgettable films like *Guilty as Hell* and *Love Me Tonight*.[26] Film critics were enthusiastic and mostly positive about the Marx Brothers' fourth film; presumably the same was true of audiences, as *Horse Feathers* ended up being "Paramount's most profitable" film that year.[27] (*Dr. Jekyll and Mr. Hyde* was its most critically successful film and was the studio's only movie ranked among *The Film Daily*'s "Ten Best Pictures of 1932."[28]) Describing the movie as a "bundle of mirth," Mordaunt Hall of the *New York Times* reported that "Groucho's characteristic corkscrew humor, Chico's distortions of English and Harpo's pantomime aroused riotous laughter from those who packed the theatre for this first performance. Some of the fun is even more reprehensible than the doings of these clowns in previous films, but there is no denying that their antics and their patter are helped along by originality and ready wit."[29]

Several weeks later, Hall reviewed the film again, noting, "Whatever may be said against the low order of comedy in some of the sequences in 'Horse Feathers,' the new Marx Brothers picture which is now at the Rialto, this broad humor is spiced invariably with shrewdly twisted wit and originality."[30] The reviewer for *Variety* was similarly impressed, remarking that the film "promises much and delivers more."[31] *Variety* added, "Like the other Marx pictures, the stuff is so fast and there's so much of it, this one is sure of a second helping from the Marxian addicts."[32] That same week, *Time* featured the Marx Brothers on its cover, thus suggesting something about their cultural resonance, which the magazine seemed at a loss to explain, simply saying that *Horse Feathers*, like previous Marx Brothers films, "is distinguished by its irrationality."[33] Philip K. Scheuer of the *Los Angeles Times* was much more impressed, declaring, "The cur-

Time covers the Marx Brothers, August 15, 1932. Courtesy of Time, Inc.

rent Marx comedy is the funniest talkie since the last Marx comedy, and the record it establishes is not likely to be disturbed until the next Marx comedy comes along."[34]

European critical responses to the film were mixed if impassioned. Francis Birrell of *The New Statesman and Nation* argued that *Horse Feathers* "is the best thing they [the Marx Brothers] have done, and leads one to hope that one day they will produce a really good film, instead of only a really good entertainment."[35] The *London Times* was less evenhanded. Its reviewer sneered that it was "quite impossible to mistake the Marx Brothers for human beings. They are half human and half wild creatures, not unlike ourselves in their desires, but with few of the repressions which hold society together."[36] Philippe Soupault of *L'Europe Nouvelle* likewise understood that the Marx Brothers were uninhibited, but he was less dismissive and more appreciative of their work: "The comedy of the Marx Brothers lifts us out of reality by exaggerating our peculiarities and aggravating our habits. We are neither shocked nor vexed by this caricature, but astonished to recognize ourselves. All our usual gestures become

mechanical and we laugh, we laugh at ourselves. But the real quality of the Marx Brothers and of their extravagant, excessive comedy remains human. They are exactly like ordinary people and act just as we should act if social regulations did not prevent us from behaving in that way."[37] One hopes not, but his point is understandable. In general, the collective critical response to *Horse Feathers* was favorable; critics and apparently moviegoers found the movie energetic and engaging, a frantically funny parody, witty if raw.[38]

Whatever its cinematic merits, *Horse Feathers* was certainly iconoclastic; few Hollywood films have ever been as critical of college football.[39] Perhaps the movie's most scathing scene features Wagstaff and two regalia-clad faculty yes-men:

> WAGSTAFF: And I say to you gentlemen, that this college is a failure. The trouble is we're neglecting football for education.
>
> PROFESSORS (in unison): Exactly, the professor is right.
>
> WAGSTAFF: Oh, I'm right, am I? Well, I'm not right. I'm wrong. I just said that to test you. Now I know where I'm at. I'm dealing with a couple of snakes. What I meant to say was that there's too much football and not enough education.
>
> PROFESSORS (in unison): That's what I think.
>
> WAGSTAFF: Oh, you do, do you? Well, you're wrong again. If there was a snake here, I'd apologize. Where would this college be without football? Have we got a stadium?
>
> PROFESSORS (in unison): Yes.
>
> WAGSTAFF: Have we got a college?
>
> PROFESSORS (in unison): Yes.
>
> WAGSTAFF: Well, we can't support both. Tomorrow we start tearing down the college.

More than a cheap laugh, Groucho's punch line encapsulates academe's overemphasis on football at the expense of education. The entire scene accentuates the misplaced values then afflicting many institutions of higher education and part of the reason for them: misguided leadership and a lack of integrity. Furthermore, the scene nicely anticipates the comment made by a real-life former University of Oklahoma president, George L.

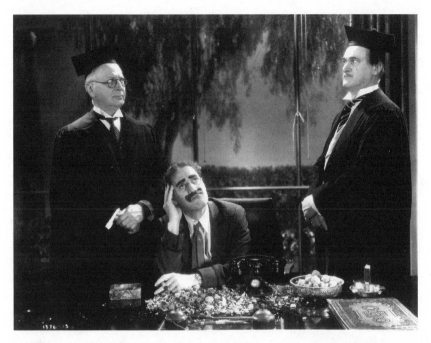

Wagstaff (Groucho Marx) befuddles the Huxley faculty. Courtesy of PhotoFest.

Cross, who said, "We're trying to build a university our football team can be proud of."[40]

Wiley L. Umphlett's *The Movies Go to College: Hollywood and the World of the College-Life Film* (1984) makes it plain that *Horse Feathers* was far from the first Hollywood film about college life. By the early 1930s dozens of them had been produced, perhaps most famously *The Freshman* (1925), starring Harold Lloyd, who plays a bespectacled water boy turned football hero. Indeed, football films were so successful that Hollywood had made more than fifty of them to this point, eight in 1932 alone.[41] "The 1920s has been known virtually since the decade ended as the Golden Age of Sports," historian Michael Oriard explains, "but the 1930s was more truly the Golden Age of Football. College football had been a phenomenon in the 1920s; in the 1930s, it was utterly familiar."[42] Perhaps that familiarity bred the filmmakers' contempt, for *Horse Feathers* offers a remarkably derisive appraisal of college football's so-called integrity and value to institutions of higher education. Coming on the heels of the Carnegie Foundation's *American College Athletics* (1929), an exhaustive

study critical of schools' misplaced emphasis on winning athletic contests and the methods used to do so, *Horse Feathers* tapped into and expressed something important, a sense that big-time college football was corrupt, corrupting, and out of control, if not absurd.[43]

The Carnegie report, a copiously detailed tome that one historian describes as an "indictment of big-time college athletics and especially the crafty and deceitful practices of college football programs," is but one source on college football's contours and cultural standing when *Horse Feathers* was produced.[44] Yet compared to other sources at the time, the Carnegie report was quite discreet. Take, for example, Reed Harris's *King Football: The Vulgarization of the American College* (1932), which was published approximately a month before *Horse Feathers* was released. Harris, who had recently been the editor of the undergraduate newspaper at Columbia University, declared that college football at many if not most universities and colleges was "a racket."[45] A former football player himself, Harris opined, "Watching college football from inside and out has convinced me that the 'grand old game' has become a Frankenstein, threatening to throttle what is left of American higher education."[46] Harris argued that to field "winning football teams, alumni, faculty, and trustees of the colleges will lie, cheat, and steal, unofficially. Officially, they know nothing of the sordid business behind the gigantic spectacles which are college football games."[47] Much like other critics of the sport, Harris was disturbed that "coaches are hired at outrageous salaries, players are bought and paid for, elaborate training staffs are maintained to keep the gridiron warriors in the peak of condition, special quarters are constructed to house these privileged mugs, and money is beautifully wasted here, there and everywhere."[48] All of this led Harris to ask an obvious question: "What, in heaven's name, has the possession of a winning football team to do with the main business of a college or a university?"[49] It was (and remains) a good, tough question, one that Huxley's president Wagstaff would surely deflect with contemptuous bravado and mock intelligibility.

Clearly, *Horse Feathers* is not a coherent, well-reasoned critique, and I am confident that Groucho never read the Carnegie report. Still, the film's "nonstop mockery of higher education, athlete-heroes, and the pieties of intercollegiate athletics" is almost as culturally valuable as it is amusing.[50] Like a funhouse mirror, the film contorts if not inverts football's alleged social value. Film critic Aaron Baker argues that *Horse Feathers* ridicules "college football's claim to develop an ideal masculinity of strength, disci-

pline, and self-determination, instead pursuing alcohol, sex and laughter at every opportunity. What matters for Groucho, Chico, and especially Harpo is not how college and football offer the chance to acquire the values and social contacts for future success, but the opportunities for the immediate physical pleasures of drinking, humor, and sexual contact."[51] The point to be emphasized is that *Horse Feathers* is everything that a still popular film like *Knute Rockne—All-American* (1940), with its inane "win one for the Gipper" sentimentality, is not.[52] *Horse Feathers* is sublimely ridiculous, not romantic; it is satirical, not sappy.[53]

Did the Marx Brothers consciously parody college life for some reason other than to make people laugh and to make money? In a word, no. There is no smoking gun suggesting that the makers of *Horse Feathers* explicitly set out to critique academe and college football, at least not in the way that the Carnegie Foundation did. Moreover, biographer Simon Louvish is correct that "the last thing on the Marx Brothers' minds was any notion of changing society. They liked it just as it was—a sitting target."[54] In particular, college football was a target worthy of their wrath and mockery because, then as now, it was partly characterized by unethical recruiting, academic abuses, commercialization, exploited athletes, rabid boosterism, and an overemphasis on winning.[55] And this explains much of the film's continued resonance. *Horse Feathers*, film critics Paul Zimmerman and Burt Goldblatt contend, "will lose its punch the day colleges stop cutting corners, compromising standards and cheating to lure athletic talent—or, as it appears now, roughly when the sun burns out."[56]

When put in historical context and thought of as carnivalesque, *Horse Feathers* can and should be taken seriously—although not too seriously, since the film obviously is a comedy. Joe Adamson puts it well: "In a dishonest world, honesty is amusing; in an indirect, discreet world, directness and indiscretion are a riot; in a world full of compromises, going to extremes is hilarious."[57] If nothing else, *Horse Feathers* goes to extremes. Its representation of academe and college football is beyond caricature, closer to lunacy. At the same time, like the best parodies, it lampoons and skewers hypocrisy and false values, without subtlety.

"The Marx Brothers," explains Lawrence Levine, "gave their audiences not truths but situations in which they could *perceive* truths about their society and their lives."[58] The college football "situations" and perhaps "truths" that *Horse Feathers* provided in 1932 apparently did not unsettle most Americans; they were so commonplace, so familiar

that they were laughable rather than contemptible. Of course, it is easy to dismiss Marx Brothers films as pabulum for the masses, the kind of movies that help us get in touch with our inner moron—merely "manic, antisocial, and ridiculous."[59] Yet with regard to *Horse Feathers*, this is a mistaken assessment, for idiocy sometimes has its uses, to say nothing of its pleasures.[60]

Notes

I would like to acknowledge and thank Ron Briley, Greg Pfitzer, Jeff Segrave, David Zang, and Joanna Zangrando for their constructive criticism and support. I am also grateful to Skidmore College for its assistance in procuring the images used here.

1. "Madness from Hollywood," *The Nation*, August 31, 1932, 198.

2. Ibid., 198.

3. Richard Rowland, "American Classic," *Hollywood Quarterly* 2. no. 3 (April 1947): 265.

4. Michiko Kakutani, "He Came to Say He Must Be Going," *New York Times*, June 6, 2000, E7.

5. Lawrence W. Levine, *The Unpredictable Past: Explorations in American Cultural History* (New York: Oxford University Press, 1993), 294.

6. *American Heritage Dictionary of the English Language*, 4th ed. (Boston: Houghton Mifflin Company, 2000), 848.

7. Film critic and historian Alan Dale argues that in Marx Brothers films the plots barely hold "the pictures together and are so riddled that it's not unusual for people to be confused about which movie a famous routine is in." Alan Dale, *Comedy Is a Man in Trouble: Slapstick in American Movies* (Minneapolis: University of Minnesota Press, 2000), 136.

8. Groucho is trying to enter a speakeasy but doesn't know the password. Chico is watching the door and reveals that the password is a kind of fish. "I got it," exclaims Groucho. "Haddock." Chico: "That's-a funny. I gotta haddock, too." Groucho: "What do you take for a haddock?" Chico: "Well-a, sometimes I take-a aspirin . . ."

9. Lester V. Berry and Melvin van den Bark, *The American Thesaurus of Slang: A Complete Reference Book of Colloquial Speech* (New York: Thomas Y. Crowell Company, 1942), 774.

10. *Horse Feathers*, produced by Herman Mankiewicz, directed by Norman McLeod (Paramount, 1932; DVD, Universal, 2003).

11. Allen Eyles, *The Marx Brothers: Their World of Comedy* (New York: Paperback Library, 1971), 1.

12. Evidently the film's original script called for a bonfire to celebrate Huxley's win, with the Marx Brothers playing cards "as the college burns

down around them." Glenn Mitchell, *The Marx Brothers Encyclopedia*, rev. and expanded ed. (London: Reynolds & Hearn Ltd, 2003), 144.

13. George Lipsitz, *Time Passages: Collective Memory and American Popular Culture* (Minneapolis: University of Minnesota Press, 1991), 5.

14. Paul Zimmerman and Burt Goldblatt, *The Marx Brothers at the Movies* (New York: G. P. Putnam's Sons, 1968), 65.

15. Church continues: "The school act was the most appropriate vehicle for the Marx Brothers' first comedy routines. What better place for disrupting vested authority than in school? From *Fun in Hi Skule* to *Horse Feathers* and in virtually everything they did afterward, the Marx Brothers displayed the frenetic energy of boys from an apartment on East Ninety-third Street in the artificially restrained atmosphere of a classroom." Charlotte Church, *Hello, I Must Be Going: Groucho and His Friends* (Garden City, NY: Doubleday & Company, Inc., 1978), 145, 560.

16. Hector Arce, *Groucho* (New York: G. P. Putnam's Sons, 1980), 184; Dorothy Herrmann, *S. J. Perelman: A Life* (New York: G. P. Putnam's Sons, 1986), 84.

17. Simon Louvish, *Monkey Business: The Lives and Legends of The Marx Brothers: Groucho, Chico, Harpo, Zeppo, with added Gummo* (New York: Thomas Dunne Books, 2000), 203; Arce, *Groucho*, 188; Richard Meryman, *Mank: The Wit, World, and Life of Herman Mankiewicz* (New York: Morrow, 1978).

18. Pauline Kael, *The Citizen Kane Book* (Boston: Little, Brown, 1971), 18.

19. Rowland, "American Classic," 265; Herrmann, *S. J. Perelman*, 84.

20. Herrmann, *S. J. Perelman*, 85.

21. Lawrence J. Epstein argues that the Marx Brothers "were outsiders who didn't feel comfortable or fit into the wider society or, more commonly in Jewish history, weren't let into the society. Their assault on the kinds of political and social institutions that had been historically hostile to Jews was so fervent because the desire to attack them had been repressed for so long." Lawrence J. Epstein, *The Haunted Smile: The Story of Jewish Comedians in America* (New York: PublicAffairs, 2001), 89.

22. Joe Adamson, *Groucho, Harpo, Chico, and Sometimes Zeppo: A History of the Marx Brothers and a Satire on the Rest of the World* (New York: Simon and Schuster, 1973), 182.

23. "Norman M'Leod, 68, Screen Director," *New York Times*, January 28, 1964, 31; David Thomson, *A Biographical Dictionary of Film*, 3d ed. (New York: Alfred Knopf, 1996), 503.

24. Stefan Kanfer, *Groucho: The Life and Times of Julius Henry Marx* (New York: Alfred A. Knopf, 2000), 161.

25. Mitchell, *The Marx Brothers Encyclopedia*, 144.

26. Ibid., 141.

27. Ibid., 148.

28. Jack Alicoate, ed., *The 1933 Film Daily Year Book* (New York: The Film Daily, 1933).

29. Mordaunt Hall, "Groucho Marx and His Brothers in a New Film Filled with Their Characteristic Clowning," *New York Times*, August 11, 1932, 12.

30. Mordaunt Hall, "Those Boisterous Marx Brothers," *New York Times*, August 21, 1932, X3.

31. Review of *Horse Feathers*, *Variety*, August 16, 1932, 15.

32. Ibid.

33. "Horse Feathers," *Time*, August 15, 1932, 24.

34. Philip K. Scheuer, quoted in Zimmerman and Goldblatt, *The Marx Brothers at the Movies*, 81.

35. Francis Birrell, "The Marx Brothers," *The New Statesman and Nation*, October 1, 1932, 374.

36. *London Times* review, quoted in Mitchell, *The Marx Brothers Encyclopedia*, 145.

37. Philippe Soupault, quoted in "The Marx Brothers Abroad," *The Living Age*, December 1932, 372.

38. For more reviews, see *Motion Picture Herald*, August 6, 1932, 35; *The Film Daily*, August 11, 1932, 1; *The Film Daily*, August 12, 1932, 3; Richard Watts, Jr., "On The Screen," *New York Herald Tribune*, August 11, 1932, 10; *New Outlook*, October 1932, 38.

39. Wiley L. Umphlett asserts that the "iconoclastic bite of *Horse Feathers* went largely unappreciated in the 1930s in favor of this film's periodic flights of fancy, which moviegoers of that troubled era must have found more attractive than any kind of social criticism." Wiley L. Umphlett, *The Movies Go to College: Hollywood and the World of the College-Life Film* (Rutherford, NJ: Associated University Presses, 1984), 52.

40. George L. Cross, quoted in Lee Green, ed., *Sportswit* (New York: Random House, [1984] 1991), 1.

41. Michael Oriard, *King Football: Sport and Spectacle in the Golden Age of Radio and Newsreels, Movies and Magazines, the Weekly and the Daily Press* (Chapel Hill: University of North Carolina Press, 2001), 370–71. The other football films released in 1932 were Russell Mack's *The All-American*, Dudley Murphy's *The Sport Parade*, Ralph Murphy's *70,000 Witnesses*, Roy William Neill's *That's My Boy*, Norman Taurog's *Hold 'Em Jail*, Alfred Werker's *Rackety Rax*, and Sam Wood's *Huddle*.

42. Oriard, *King Football*, 11.

43. The Carnegie report was, among many things, an "attack on the pervasive 'professionalism' in the so-called amateur sport. Commissioned by the NCAA in January 1926, following [Red] Grange's defection to the NFL, the Carnegie Report was wide-ranging in its criticism (including a chapter on the excesses of the press that was ignored by sportswriters). The AP account that was read in most of the country, however, focused on what Howard J.

Savage, the report's principal author, called 'the deepest shadow that darkens American colleges and school athletics—the widespread practice of recruiting and subsidizing athletes.' Of 112 institutions that cooperated with the foundation, only twenty-eight were found guiltless." Ibid., 105–6.

44. John Sayle Watterson, *College Football: History, Spectacle, Controversy* (Baltimore: Johns Hopkins University Press, 2000), 165.

45. Reed Harris, *King Football: The Vulgarization of the American College* (New York: Vanguard Press, 1932), 8. For earlier critical appraisals of college football, see Raymond L. Summers, "The Football Business," *The New Republic*, November 6, 1929, 319–22; C. W. Savage, "The Football Frankenstein," *The North American Review*, December 1929, 649–52; and John R. Tunis, "Dying for Dear Old Mazuma," *The New Republic*, June 18, 1930, 120–22. Also see John R. Thelin, *Games Colleges Play: Scandal and Reform in Intercollegiate Athletics* (Baltimore: Johns Hopkins University Press, 1994).

46. Harris, *King Football*, 8.

47. Ibid., 16–17.

48. Ibid., 29–30.

49. Ibid., 30. For more on Harris, see "College Football Viewed as 'Racket,'" *New York Times*, November 11, 1931, 25, and "Football Men Threaten Columbia Editor; His 'Racket' Charge Upsets Alumni, Too," *New York Times*, November 12, 1931, 1.

50. Murray Sperber, *Onward to Victory: The Crises That Shaped College Sports* (New York: Henry Holt and Company, 1998), 3.

51. Aaron Baker, *Contesting Identities: Sports in American Film* (Urbana: University of Illinois Press, 2003), 59.

52. Murray Sperber argues that "the social criticism of *Horse Feathers* was not unique in this period of Hollywood history; the studios produced a surprising number of movies critical of college sports both before and after the Marx Brothers trashed the academy and its athlete-heroes." Sperber, *Onward to Victory*, 33.

53. What constitutes satire is debatable. Alan Dale argues, "Satire is purposeful and usually compares its object of ridicule to a norm of better behavior. It hopes to ameliorate." With this definition in mind, Dale declares that the "Marx Brothers' movies lack satire's concentrated, utilitarian purpose." Dale, *Comedy Is a Man in Trouble*, 132.

54. Louvish, *Monkey Business*, 240.

55. Sperber, *Onward to Victory*, xxiii–xxiv; Watterson, *College Football*, 158–82.

56. Zimmerman and Goldblatt, *The Marx Brothers at the Movies*, 74.

57. Adamson, *Groucho, Harpo, Chico, and Sometimes Zeppo*, 15.

58. Levine, *The Unpredictable Past*, 317.

59. Thomson, *A Biographical Dictionary of Film*, 488.

60. According to Steven Watts, "Idiocy is a complex word, as demon-

strated by Karl Marx's famous description of the rising bourgeoisie as rescuing 'a considerable part of the population from the idiocy of rural life.' In small part, Marx drew upon the generic meaning of idiot as an untutored person in the lower registers of mental deficiency. He used this to chastise the bull-headed backwardness and determined provincialism of the rural peasantry. But idiot also has a much older meaning stemming from its original Greek root meaning private person, a peculiar and self-possessed individual, the opposite of a public-minded citizen of the republic." Steven Watts, "The Idiocy of American Studies: Poststructuralism, Language, and Politics in the Age of Self-Fulfillment," *American Quarterly* 43, no. 4 (December 1991): 632.

MICHAEL K. SCHOENECKE

Bobby Jones, Golf, and His Instructional Reels

THE 1920S HAS BEEN CALLED the Golden Age of American Sport; the decade produced some of the most respected, honored, and cherished sports heroes that Americans have ever seen. As veteran sports reporters Allison Danzig and Peter Brandwein noted in 1948, "Never before, nor since, have so many transcendent performers arisen contemporaneously in almost every field of competitive athletics as graced the 1920s" (xi). The major sports heroes of the 1920s became athletic fountainheads: George Herman "Babe" Ruth in baseball, William "Jack" Dempsey in boxing, Harold "Red" Grange in football, William T. "Big Bill" Tilden in tennis, and Robert T. "Bobby" Jones in golf.

Like today, the 1920s public celebrated and revered their athletic heroes because of their performances on the field of play. Babe Ruth's brute power that produced towering home runs and extraordinary records established him as baseball's greatest player. Red Grange's athleticism—quickness and ability to change directions—created dramatic touchdowns that made the "Galloping Ghost of the Gridiron" one of football's most dangerous players. By defeating Jess Willard, the "Pottowatomie Giant," in three rounds in 1919, Jack Dempsey captured the public's imagination; mauling characterized Dempsey's fighting style. These sports heroes achieved instant success and adulation from the American public; as a result, the public enthusiastically identified with and embraced the sports heroes. Having been "expelled from their Horatio Alger dream," Americans preferred that their heroes be average. Leo Lowenthal noted that the average American liked to "see his heroes as a lot of guys who like or dislike highballs, cigarettes, tomato juice, golf, and social gatherings—just like himself" (Lowenthal 3).

Knowing that the athletes' popularity would make them attractive to moviegoers, Hollywood created cinematic and financial opportunities for

the heroes. Jack Dempsey earned fifty thousand dollars plus 50 percent gross for his fifteen-part serial entitled *Daredevil Jack* (1920). The Manassa Mauler's fists, whose brutality was popularized in the boxing ring, were employed to rescue the heroine and her property in every episode. In 1920 Babe Ruth appeared in *Headin' Home*, the story of a likeable iceman who, in his spare time, uses a hatchet to create a baseball bat from a sizeable piece of wood. Of course, the Babe's character is attracted to a blonde, wins the World Series with his homemade bat, and returns home to his mother and his sister. Since *Headin' Home* was a silent film, Ruth did not need to memorize lines, and even though the film was a box-office bomb, Ruth earned fifty thousand dollars. Like his fellow athletes, Red Grange's cinematic debut in *One Minute to Play* (1926) did not demand acting skill. As the title suggests, Grange, drawing on his athleticism on the gridiron, portrays a halfback who scores the winning touchdown in the last few seconds of a football game.

Although Bobby Jones enjoyed success on his field of play and remains one of golf's most celebrated athletes, he did not perform in Hollywood features. Instead, based on careful consideration of what he knew best and what he really cared about, he agreed to appear in golf instructional reels. Jones recognized that film's unique properties would benefit his talents and his cinematic goals: "The talking picture, with its combination of visual presentation and demonstration, with the possibility of detailed explanation, appeals to me as the ideal vehicle for an undertaking of this nature" (Jones 173).

Robert Tyre "Bobby" Jones, Jr., the second son of Robert P. "Big Bob" and Clara Merrick Jones, was born on March 17, 1902. Bobby's older brother William died of digestive problems at the age of three months, and Bobby suffered from the same disorder. His parents decided to have no more children and to focus their love on Bobby. Legend has it that Big Bob carried his son around on a pillow to protect him.

From birth, Bobby was imbued with a desire to please others, particularly his father. Bobby was not a junior; however, beginning at age eleven, his signature, created to honor his father, always included "Jr." or "Jun." Rather than rely on physical power or swiftness—like Grange, Dempsey, and Ruth—to overwhelm others or to plow through life, Jones used his education to help him communicate his thoughts and goals. He earned a degree in mechanical engineering from the Georgia School of Technology, a

second undergraduate degree in English literature from Harvard University, and a law degree from Emory University. His education benefited him later when he began writing and designing clubs. He authored several books, including *Down the Fairway* (1927) with O. B. Keeler, *Golf Is My Game* (1959), and *Bobby Jones on The Basic Golf Swing* (1969).

Jones exemplified golf and honesty. At the 1925 U.S. Open in Worchester, Massachusetts, he was battling the course and Willie McFarlane, the eventual winner. During the first round, Jones hit his second shot to the eleventh green onto the steep bank; when he addressed the ball, it moved in the long grass. Although the USGA officials did not see the ball move and objected, Jones correctly called a penalty stroke on himself. When he was praised for his honesty, Jones responded, "You just as well praise me for not breaking into banks. There is only one way to play this game." For Jones, most golfers, and the public, his respect for the game is more important than his score and/or his victory; Jones made the honorable decision.

Although initially Jones was attracted to baseball because the other boys played it, he enjoyed golf because he could hit the ball. In *Down the Fairway*, Jones playfully notes his attraction to golf: "Golf was still incidental; I played at it as I played at anything else that came along and seemed attractive; if I have any genius at all, it must be a genius for play! I love to play and at times I love golf, when I get the shots going somewhere near right. It seems I love almost any pursuit except work" (Jones and Keeler 28). Jones obviously got the shots "going somewhere near right," because he established himself as a genius with his hickory sticks.

Jones did not practice at the range as much as other golfers for several reasons. He understood that golf was a mental game. In addition, during his childhood years he honed a repeatable rhythmic swing that made him the envy of almost every golfer during and after his legendary play. In *Golf Is My Game*, Jones describes the "important thing" about tournament golf:

> The one most important thing for the tournament golfer to learn is that golf championships are not won merely by having greater mechanical skill than the other players. It is not rewarding, of course, to harbor a real weakness on the mechanical side. But in most tournaments including players of first rank, there is little difference in shot-making ability among the top echelon. Some

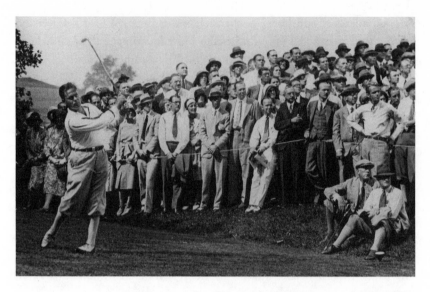

Bobby Jones pictured in action, circa 1930. Courtesy of U.S. Golf Association Archives.

may be able to keep it up longer than others, but in the main, the decisive factor will be found in the relative abilities of the various players to perform under the strain which all must feel. (Jones 165)

And a paragraph later he notes: "You learn very soon, I think, in tournament golf, that your most formidable adversary is yourself. You win or lose according to your own ability to withstand the pressure" (Jones 165).

As a nineteen-year-old, Jones yielded to the pressure in the third round of the 1921 British Open at St. Andrews by snatching his ball off the eleventh green and disqualifying himself; but thereafter he changed as a person and as a golfer. Gaining self-control helped him achieve his unparalleled golfing accomplishments. From 1923 through 1930 Bobby Jones won thirteen national championships, winning at least one each year during that period. In 1930 he won the Grand Slam: the British Amateur, the British Open, the U.S. Open, and the U.S. Amateur. Historian Alistair Cooke, writing about the golfing and personal accomplishments he had gleaned of Bobby Jones over the years, captures Jones's essence in one sentence: "What we have left with in the end is a forever young, good-looking Southerner, an impeccably courteous and decent man with a

private ironical view of life who, to the great good fortune of people who saw him, happened to play the great game with more magic and more grace than anyone before or since" (Cooke 19). When golfers refer to "the genius of Bobby Jones," the reference is to his integrity for the game of golf as well as in his life.

New York City twice held ticker-tape parades to honor and celebrate Jones and his records: in 1926, when he became the first American amateur to win the British Open; and in 1930, when he won the British Amateur and the British Open in one year. Jones is the only person who has ever received two ticker-tape parades on Broadway. Jones's hometown of Atlanta would not be outdone: little girls lined the streets and waved tiny golf clubs with ribbons; men donned lapel buttons with Jones's picture. In New York, Pathé News filmed the parade for screening in theaters across the United States and around the world; in Atlanta, Pathé News and Paramount filmed the events.

Golfing success brought national and international attention. With his place in history secured, Jones retired from amateur golf. Winning the Grand Slam in one year is a great way to conclude an amateur golfing career. He was tired, and he probably knew that he needed to finalize his family's financial future while he could. In other words, Hollywood came calling. Before 1930, Jones had refused staggering offers because the money would primarily benefit the movie moguls. In *Golf Is My Game*, Jones describes his retirement from amateur golf and his reasons for signing with Warner Brothers:

> Fourteen years of intensive tournament play in this country and abroad had given me about all I wanted in the way of hard work in the game. I had reached a point where I felt that my profession required more of my time and effort, leaving golf in its proper place, a means of obtaining recreation and enjoyment.
>
> On November 13, 1930, I signed a contract with Warner Bros. Pictures to make a series of twelve one-reel motion pictures, devoted entirely to exhibiting and explaining the methods which I employ in playing the shots ordinarily required in playing a round of golf. These pictures are to be purely educational in character, and it is the ardent hope of both parties that they will be of some value, first by improving the play and thereby increasing the enjoyment of the vast number of people already interested in the game, and, second, by creating an interest where none exists now

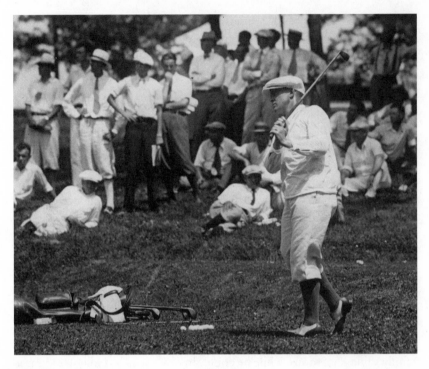

Bobby Jones on the golf course, circa 1930. Courtesy of U.S. Golf Association Archives.

among the many who may find enjoyment and beneficial exercise on the golf course. (Jones 172–73)

Although Jones claimed that he did not believe that making the reels broke amateur rules, he retired from competition so that he would not embarrass himself and the U.S. Golf Association.

Accompanied by Y. Frank Freeman, a close family friend who was employed by S. A. Lynch Enterprises, Jones met with Harry Warner in New York. The men agreed in general to the deal, but Warner assigned the contract's final details to Dan Michalove, a young Warner executive from Atlanta who was a good friend to Jones. Warner Bros. and Jones contracted for twelve reels entitled *How I Play Golf* and included an option, which was later exercised, for six additional reels entitled *How To Break 90*. Each reel is ten minutes long. Jones earned $250,000 from Warner Brothers. He put $120,000 into a trust fund for his children, but

the Internal Revenue Service, which refused to consider the trust fund as a deduction, taxed the $250,000 as income.

Filming began in March 1931, and some of Hollywood's notables volunteered to appear in the reels: W. C. Fields, Loretta Young, Harold Lloyd, Joe E. Brown, Walter Huston, Richard Barthelmess, Leon Ear, and Guy Kibee. Jack Warner assigned George Marshall to direct the instructional reels, and Jones and O. B. Keeler, Jones's journalist sidekick, often wrote much of the dialogue on the set. A significant amount of dialogue was ad-libbed. Each reel contains a storyline with an instructive golf theme woven into each reel. Warner Bros. deemed the storylines necessary, but present audiences find them "corny," to use Jones's word, because no clear format was established.

Jones's overview was to begin with an instructive lesson on putting and progress through the rest of the clubs. In later reels, he discusses golf theory and mechanics. According to Jones, the series was designed to be instructional, but once production began, Jones and the crew realized that it was impossible to fill so much time with instructional material. Therefore, O. B. Keeler's storylines were designed to enhance audience appeal by being humorous and simple as well as to introduce the lesson. For example, the putting storyline begins when Joe E. Brown makes Frank Craven attempt a short putt of about three feet:

FRANK: Now, wait a minute. Going to give me this, are you?

JOE: Give it to you?

FRANK: Sure. This little one.

JOE: You mean concede it?

FRANK: Yeah.

JOE: I made mine, didn't I? Shoot.

FRANK: Alright; alright; if that's the way you feel about it.

(FRANK misses the putt.)

JOE: Nice putt, Frank. Don't forget the balls.

DICK: Oh, Frank. Come here a minute. I want you to know Bobby Jones.

FRANK: How do you do, Mr. Jones.

Bobby: Glad to meet you, Mr. Craven.

Frank: I'm glad to know you, sir. Did you see what happened over there?

Bobby: I certainly did; it was hard luck.

Frank: Um—just that long. The big buzzard wouldn't give it to me.

Bobby: Well, you know the object of the game is to get the ball into the hole. These little short putts count as much as a longer one.

Frank: Do you miss many like that?

Bobby: Well, a good many, but I practice hard on them.

Frank: "The little ones, too? Do you want to do me a favor?

Bobby: Come on over here.

Frank: Show me how you do those things, will you? (Matthew 206)

At this point in each reel, Jones would demonstrate and describe the methods he employed to overcome the golfing affliction. (It is interesting to note that Jones's head moves while he demonstrates the proper putting procedure, but he is noted for keeping his head still while he putted in tournaments.)

O. B. Keeler's voiceovers reinforced Jones's lesson in each reel; the reels contain very little editing. Cinematically, the reels are weak because neither Jones nor Marshall understood how to create an instructional golf film. However, Jones did have a sense of humor that accompanied his skill as a golfer. When Jones demonstrates the three-iron, he hits two shots directly over the camera and cameraman, who is about fifteen feet in front of Jones. His third shot hits the camera lens, and off-screen laughter and a comment about Jones's accuracy are heard while the viewer sees only the cracked lens.

Without a doubt, Jones's swing in the reels is rhythmic, graceful, and athletic, and the reels visually convey the effortless beauty and fluidity that characterized his approach to golf and life. However, the instructional value of the reels is questionable today because Jones has a narrow stance and "overswings," which visually enhances the beauty of his swing but generally produces inconsistent ball striking and a loss of power and

control. His swing was crafted to accommodate hickory shafts, not the steel or graphite shafts that golfers use today. In addition, it appears that on his downswing, Jones regrips the club. Today's golf instructors encourage golfers to adopt a rear-end-out posture, whereas Jones's butt-tucked upright stance would help produce consistently weak slices.

Jones's instructional reels were successful. First, they reached millions in theaters and presented the game "in an attractive manner" (Jones 172). Second, they have provided viewers and golf aficionados with visual testimony to Jones's musical swing. Third, the swing, according to golf lore, reveals the inner person. In *Golf Is My Game*, Jones wrote, "There is a school of Oriental philosophy, I am told, which holds that the aim of life should be the perfection of personality and character, and that sufferings, joys, and achievements mean nothing except as they influence the development of this personality or character" (Jones 166). Bobby Jones's swing and his life, like the fiery Phoenix, reveal his love for golf, competition, and life.

Works Cited

Cooke, Alistair. "What Have We Left for Bobby Jones?" In *The Greatest of Them All: The Legend of Bobby Jones*, ed. Martin Davis. Greenwich, CT: The American Golfer, 1996.

Danzig, Allison, and Peter Brandwein, eds. *Sports Golden Age: A Close-up of the Fabulous Twenties*. New York: Harper & Bros., 1948.

Jones, Robert Tyre, Jr. *Golf Is My Game*. New York: Doubleday & Co., 1959.

Jones, Robert Tyre, Jr., and O. B. Keeler. *Down the Fairway*. New York: Minton, Balch & Co., 1927.

Lowenthal, Leo. *Literature, Popular Culture and Society*. Englewood Cliffs, NJ: Prentice-Hall, 1961.

Matthew, Sidney. *Life and Times of Bobby Jones: Portrait of a Gentleman*. Chelsea, MI: Sleeping Bear Press, 1995.

Harper Cossar

Televised Golf and the Creation of Narrative

Basically in football, if you follow the ball, or in baseball
if you follow the runner and the ball, or in basketball if
you follow the ball, you're not going to get into trouble. In
golf, you have up to twenty balls in play at one time, all of
which have to be covered well.

—Sean McManus, president of CBS Sports

TELEVISED GOLF IS AMONG the more dynamic sporting events on television. Compared with arena sports such as football, baseball, hockey, and basketball, golf is difficult to broadcast due to its natural unsuitability to a typical television sports production. Arena sports possess natural boundaries, and the ball cannot stray too far from the field of play. In golf, however, the whereabouts of the ball often is unknown, making the focus of play unpredictable and difficult to produce. Even the best golfers in the world often produce shots that flummox not only the players but also the television production crew.

Perhaps more importantly, televised golf involves a fractured narrative. While a televised football game follows the more or less linear narrative of two opposing teams playing four quarters for roughly three hours, resulting in a winner, golf challenges producers to depict one hundred or more individual narratives, each composed of fractured segments (individual shots) that are assembled in highlight fashion from action occurring over a period of four days. Commentators, graphics, framing schemata, and editing are among the conventions deployed by television producers of golf.

This essay illuminates the unique concerns of televised golf production and discusses how golf's mode of production might influence its reception by viewers. Scholars and critics alike have considered the aesthetics of televised sports, but they very seldom focus specifically on golf. Given this gap in the literature, this essay offers a critique of televised golf's visual

style, using the 2003 Funai Classic tournament as an example, and how producers attempt to construct narrative from a series of disjointed and fragmented segments. The 2003 Funai Classic tournament at Walt Disney World is of particular interest because it is played on two courses simultaneously and has the added ratings benefit of Tiger Woods as a participant. The coverage analyzed is from a two-hour segment of the opening round, which aired on ESPN on October 23, 2003. The tournament is played at Walt Disney World, and the 2003 tournament was covered jointly by ESPN (Thursday and Friday) and ABC (Saturday and Sunday), both of which are owned by Disney.

History

The earliest sports deemed worthy of television coverage—boxing and wrestling—accommodated the production style and technology of the 1940s (see Owen). Both sports occur indoors, where lighting conditions could be controlled easily. Both boxing and wrestling are held in a ring, and because the athletes do not (for the most part) leave the ring's confines, camera movement is limited. Limiting camera movement was especially important because during television's infancy, cameras were very large. However, producers realized that televising any event that had a built-in audience would be profitable.

The logistical difficulties associated with televising in a large outdoor area such as a golf course were prohibitive in the early days of coverage of sporting events. The broadcasting of golf actually began via television's mass media template—radio. CBS produced the first radio broadcast of the Masters golf tournament in 1934, and CBS eventually became the first network to televise the tournament. The 1947 U.S. Open at the St. Louis Country Club was the first golf tournament to be televised, but the broadcast covered only the final hole of the tournament because of production constraints. The first live nationwide telecast took place in 1954, again at the U.S. Open, when NBC broadcast the final two holes.

The alliance between the Masters and CBS is a historically significant one for televised golf. Clifford Roberts, longtime president of the Augusta National Golf Club, the site of the Masters, recognized early on that there was great potential in broadcasting the golf tournament. CBS and Augusta agreed to a television contract in 1956, which provided for only two and a half hours of coverage over three days and was limited almost exclu-

sively to coverage of the eighteenth hole (Owen 144). Over many years, Roberts and other members of Augusta National critiqued CBS's coverage and submitted their critiques in long memos. Augusta National's tightly controlled (and private) contract with CBS is influential even to this day with regard to the network's coverage of the Masters tournament.

Augusta National's control of the tournament broadcast has a financial foundation. The earliest sponsors of the Masters—American Express, Travelers, Cluett, Peabody, General Motors, and Young & Rubicam, the advertising agency that represented the early sponsors—were all run by members of Augusta National. The financial capital with which Augusta National was endowed was (and continues to be) the source of its great power over its televisual image.

The memos that Roberts wrote to CBS's producers yielded changes in CBS's coverage and ultimately generated the modern conventions in televised golf. For example, Roberts fought to add more holes to CBS's coverage of the tournament. The change happened gradually, as Roberts encouraged CBS to add more and more cameras to its production, and only in 2000 did CBS begin airing all eighteen holes of the Masters. The contract that Roberts negotiated with CBS is among the more interesting ones in broadcasting history because of the unusual power it grants to Augusta National. For example, the Masters coverage is closer to commercial-free broadcasting than any other broadcast on the networks. Until 2002, CBS showed only four minutes of commercials per hour. A very public battle concerning the exclusion of women from the membership of Augusta National prompted the club to cancel its lucrative contracts with Coca-Cola, IBM, and others in order to air the tournament commercial-free. The club has stated that it is prepared—ideologically and financially—to continue indefinitely with the commercial-free tournament coverage.

Roberts also was very sensitive to the language used to describe the golf course at Augusta National. Understanding television's great ideological power, Roberts recognized that image control would result in a certain type of broadcast. Therefore, commentators were advised that Augusta National does not have "mobs" or "fans"; it has "spectators." The course does not have "sand traps," but rather "bunkers." Many announcers have been removed from the broadcast based on the club's wishes. In 1995 Gary McCord, one of golf's most well-known and popular announcers, referred to Augusta National's greens as being so fast that they appeared to have been "bikini waxed." McCord was removed from the broadcast

and has since switched to ABC. Augusta National's close criticism of the broadcasts of the Masters is analogous to the role of the Production Code Administration, which produced the 1930 Motion Picture Code (Hays Code) that governed motion picture content from 1934 to the 1960s. Like the making of movies under the Hays Code, coverage of the Masters was governed by a list of dos and don'ts for golf coverage that "bordered on breaking the First Amendment" (Eubanks 210). Further, commentators were coerced into using subjective language in the telecast. Commentator John Derr recalls, "We could not utter the vaguest reference to how much money [a player] had won. . . . We were discouraged from applying an actual number to the size of the gallery, because they [Augusta officials] felt that would be a guess, and a guess . . . isn't accurate. And we were not to dwell on a player's bad shot. Augusta felt that [the players] were invited guests and we were there to show the public what they were doing—we were not in a position to criticize" (Eubanks 210).

Perhaps Cliff Roberts's most significant contributions to televised golf are the changes he made to the construction of narrative and drama. Unlike arena sports, golf does not have teams in uniforms battling each other for turf, nor does it have the distinct directionality of a field, in the way football, baseball, basketball, hockey, and soccer do. Rather, golf is by nature a meandering and leisurely sport. Roberts recognized that one of golf's few dramatic elements was the flight of the golf ball itself. In 1964 Roberts "suggested that CBS attempt to shoot pictures of airborne golf balls from the golfer's perspective, by placing a camera at the back of one of the tees. . . . Roberts' idea was that a ball would be easier to track from behind, and that a camera placed in back of a tee would clearly show whether a shot was hooking, slicing, or flying straight—information that Roberts felt 'would be very meaningful to golfers'" (Owen 192). This notion of perspective and an understanding of the drama of the flight of the golf ball would prove significant in later broadcasts.

Roberts also suggested to CBS that a scoreboard representing golfers' status in the competition as either over or under par would facilitate viewers' understanding of who was winning and by how much. This creation of a narrative via a scoreboard showing winners and losers added a new dimension to golf. Very often golf is said to be a sport played not against opponents but against oneself and the course, so the notion of competition among players was not as obvious as it might first appear.

Finally, Roberts told CBS what to do in the event that the tournament

became a runaway for one golfer. Blowouts in any sport diminish viewers' interest in who will win. Roberts advised CBS that the company and its announcers should consider "making a contest between the leader and the record book if and when one player should dominate the tournament" (Owen 192). Margaret Morse calls this process sports' "perfect approximation of an ideal performance embodied by statistics and records," and Roberts pioneered it in golf (Morse 47). By creating a narrative out of statistical data and then applying it to an unfolding sporting event, Roberts and CBS crafted the future of televised golf.

Form and Narrative

"In other sports, when we go to commercial, hopefully they stop playing. But when we go to commercial in golf, nobody stops playing. So you have to figure out how to work commercials in without missing too many golf shots" (Lance Barrow, coordinating golf producer for CBS, cited in Schiesel). Unlike arena sports, golf does not have timeouts or natural breaks in the action that conform naturally to the flow of television. Unlike a football or basketball game that is divided into four quarters of fifteen minutes each, a golf tournament meanders for several hours over four days. Golf tournaments may feature as many as 124 participants playing in groups of two, whereas arena sports usually include two teams of fifteen or so competitors. Therefore, the action in golf is very much created and controlled by the television producer and the on-air commentators. The producers provide the visual content, and the on-air commentators must then form a narrative for the viewers. Very often this means that coverage of golf shots is not live. Perhaps more than any other televised sport, golf relies on replays and taped segments.

A round of golf usually lasts about four and half hours. Tee times (when a round begins) start around 7:00 A.M. and are staggered every five minutes or so until all of the golfers are on the course. The initial pairings (which golfer plays with whom) are determined by a tournament official in conjunction with a network producer, thereby maximizing drama and creating a sense of televisual appeal. After the first two rounds, players are paired according to their scores; those with the highest scores (the most over par) tee off first and those with the lowest scores (the most under par) tee off last. Thus, by the time of the slotted telecast, the last golfers are still playing and the producers therefore have live footage. The live footage is

joined with edited clips of previous action and can be shown to create a narrative event, albeit one with a fractured sense of time.

At the very least, both the producers and the commentators manipulate and construct a narrative within these time constraints. In other words, the on-air broadcast consists of phrases like "moments ago at the thirteenth hole" and "earlier, Tiger Woods." Again, this is televised golf's unique appeal; most of the action has already happened, and in effect, the viewer is watching a narrated assembly of highlights. How is this done and what effect does it have on narrative?

ESPN's coverage of the 2003 Funai Classic opens with a telephoto shot from behind Tiger Woods on the fairway (see photo on reverse page). After Woods swings the club, a short zoom brings the viewer closer to his back and we see the flight of the golf ball. Following a unique version of continuity editing's 180° rule, ESPN cuts to a shot facing Woods from behind the green (some 180 yards away) as the ball drops on the green and settles. The camera reframes to include the flagstick and thus establishes space and distance. A third view is provided from behind Woods again, and a commentator announces, "So Tiger Woods after a birdie [one under par] at the first." The following shot is of Woods putting, and the announcer continues, "And this for yet another birdie." Woods sinks the putt, and the accompanying voiceover states, "And his sixth birdie of the day, and he would fire a 66 to open things up on the Palm Course." As Woods walks off the green a graphic shows "Woods: –6" (six strokes under par) and "Today's Round: 66."

This narrative demands further unpacking. ESPN shows Woods making an approach shot on the first hole, his ball landing on the green, Woods's perspective on the shot, and then his putt at the final hole. Woods's entire round was shown in four shots and exclaimed by commentators and accompanying graphics. Therefore, in thirty-one seconds of screen time, ESPN encapsulates Woods's opening round. Imagine if other sports broadcasts constructed time this way. A spectator tunes into a basketball game to learn that Michael Jordan has just won the game, or turns on a football game and hears, "The New York Giants' chances to win this one are all but over." Fans would be outraged at such coverage because basketball and football have very different constructions of time. Both usually open with a greeting by the announcers, shots of the arena and crowd, and a perfunctory ceremony such as the national anthem or the opening tip or coin toss. Spectators watch most arena sports live. The 2003 Funai Classic,

Tiger Woods on the fairway. Courtesy of ESPN.

The camera reframes to include the flagstick, establishing space and distance. Courtesy of ESPN.

Another shot from behind Woods.
Courtesy of ESPN.

As Woods walks off the green, a graphic shows his score. Courtesy of ESPN.

however, opens with Tiger Woods, the leading ratings draw in golf, having already completed his round. The notion of creating drama and narrative as pioneered by Roberts and CBS have come into play.

Roberts advised CBS that if one player dominated a tournament, the network should create a competition between the golfer and the record books. ESPN does exactly that with regard to Woods and tournament coverage. Regardless of Roberts's desire for the Masters to avoid the mention of prize money, golf is very much a capitalist sport. Beyond the

A dissolve links the image of Woods walking off the eighteenth green with the image of Singh putting. Courtesy of ESPN.

obvious fact that most tournaments are played on private courses and the fact that golf has traditionally been associated with the bourgeoisie and aristocracy, golf is rare among sports in that play is specifically aimed at winning prize money. Players wear advertisements of sponsors all over their clothing and golf bags, and their earnings are enumerated in conjunction with their scoring averages and tournament wins. Therefore, unlike other sports, golf is explicitly concerned with money and its relevance to players' success.

In 2003 the Funai Classic featured a tight race between Tiger Woods and Vijay Singh for the position of money list leader (the most money won over an entire golf season). (Second-place Singh ultimately won the tournament and surpassed Woods as the leading money winner.) Immediately after Woods's initial thirty seconds or so of coverage, ESPN cuts to Singh putting (see above and opposite-page photos). A sound bridge connects the two images as the announcer ends his commentary on Woods by labeling him "the leading money winner on the [PGA] tour." A dissolve links the image of Woods walking off the eighteenth green with the image of Singh

Singh putting for birdie. Courtesy of ESPN.

putting, and the sound bridge continues, "And the man in the second spot [on the money list] at the Magnolia Course at the ninth, Vijay Singh. This for birdie, just a moment ago."

The dissolve and the sound bridges linking these two images represent several significant aspects of the broadcast and the tournament.[1] The narrative element of the money leader is introduced and couched in terms of a hierarchy: Woods is first and is visually presented first, and Singh is second. Therefore, even though Woods's round is complete, and Singh's is only midway, ESPN and its commentators have created a narrative frame for the tournament. Whoever is leading the money list for the PGA Tour at year's end is generally considered a frontrunner for the coveted Player of the Year award. In addition, Woods is often positioned as the savior of the PGA Tour, both economically and in terms of publicity. Woods's high-profile sponsorship by Nike, Buick, American Express, and others—not to mention his domination of the PGA Tour—has been the impetus behind the 65 percent increase in prize money on the PGA Tour since 1996. Singh, on the other hand, is a dominant player but is not the media darling or the kind of public relations touchstone that Woods has become.[2] Further, Singh

was vilified earlier in the year for his critical statements about a female player (Annika Sorenstam) who played in a men's PGA Tour event.

Televised golf's unique construction of time and space is also evident in the tournament. Woods is playing in a distinctly separate and *other* place, the Palm Course, whereas Singh is playing the Magnolia Course. However, through the continuous fade and sound bridges, ESPN constructs a space where both occupy the space known simply as the "golf course." Again, this is one of the primary differences between golf and arena sports. Golf coverage by its very nature must be fragmented, and networks cannot be expected to follow each player's round completely. Complete coverage would result in a less than compelling broadcast. Woods's round was completed at some earlier point in the day and Singh's round is currently taking place, yet the narrative construction of space via editing allows the viewer access to both as if they are happening simultaneously. Such fictional creations of spatial-temporal continuity occur as the producers assemble a narrative.

After a brief introduction to the Walt Disney World complex, ESPN displays the current leader board. In addition to showing players' scores as over or under par, the leader board lists some players with "PC" after their names, indicating that they are playing the Palm Course. Again, this constructed spatial-temporal continuity is common for golf coverage, regardless of the network or event. In addition, while ninety players are listed on the leader board, less than one-third of them are actually playing golf when ESPN's coverage airs. Rather, live coverage and taped footage are shown as continuous action, creating a fictional continuum that exists solely for the purposes of television.

Golf tournaments are composed of four rounds, and a cut is made after the first two rounds. A cut stops the play of any golfer whose score is not a certain number of strokes under par. Therefore, ESPN's leader board shrinks by half after Friday's coverage. Although the players play both courses (once each) on Thursday and Friday, all players will play the Magnolia Course for the final two rounds. Again, golf contrasts sharply with arena sports in this way. While both the Palm and Magnolia are golf courses (a visual bridge of greenery that helps networks and producers to create spatial continuity), they are separate spaces. Basketball and baseball players might play in different arenas on consecutive nights, but they will not change arenas each quarter during the course of one game. This is a subtle point, but it is one that bears expansion.

The leader board at the 2003 Funai Classic. Courtesy of ESPN.

Sports coverage is by and large about the "liveness of the game. . . . The electronic reshaping of the game appears to have maintained the delicate balance necessary to the game while increasing spectacle" (Morse 54). Televised golf coverage not only reshapes the play of the game but also fundamentally alters the experience for the viewer in a unique way. If we were to attend a golf round in person, we would be faced with a choice: sit in one spot—a green or a tee box—and watch players come through or choose a group and follow their round. However, televised golf coverage enables us to watch both live coverage and action that previously happened as a continuous but nonlinear narrative. Therefore, golf spectators see endlessly *more* golf through televised coverage of an event than they would by actually attending the event.

An obvious question here is how televised golf coverage shapes the event any more than having a certain seat—be it the fifty-yard line, third-base line, or the upper deck in a sports arena—and seeing the game from *only* that vantage point? Golf is concerned with roughly ninety individual narratives, each occupying a different time slot, whereas arena sports feature opposing groups of roughly fifteen participants playing in the same time frame and spatial location. Therefore, golf is the pursuit of the

individual, and following individuals requires a separate videographic and editing scheme than following a team. Televised golf reshapes the action in terms of individual segments occupying a spatial-temporal continuum via the assembled footage, albeit a nonlinear one. To return to ESPN's opening package, Woods and Singh were in separate spaces at different times. No spectator could have occupied any vantage point at any time and seen both Woods and Singh. However, ESPN presented the play of Woods and Singh as though it was a linear and contiguous narrative event.

Although golf shares with other sports the presence of commentators, the role of commentators is subtly different in golf vis-à-vis the nature of the images they are commenting on. Ever since early film lecturers accompanied silent films, visual media producers have attempted to give context to images via commentary. Golf is no different than arena sports in that the commentators narrate and establish the context for the images that viewers see. The golf commentator must identify a variety of different elements without which the spectator would easily be lost or at least lacking in contextual information.

For example, the Funai Classic takes place on two separate golf courses, and the ninety players of the first and second rounds are dispersed over the two courses. Even a seasoned golfer or spectator would be hard-pressed to accumulate the knowledge of separate courses, let alone which golfer is under or over par, without commentary and the accompanying graphics. Therefore, as in other sports, the commentator is a guide to the sporting event's action—a descrambler of the sporting code, if you will. Margaret Morse notes, "The [commentators'] voices seem to emanate as part of a phantom crowd somewhere close behind and to the sides of the television viewer. It is as if the viewer were an eavesdropper on two magnificently informed experts and fellow fans, just outside his field of view" (Morse 55). However, because of the fractured nature of the coverage, the commentators' job as descramblers of the sporting code is a bit more complex than it is for other sports. The commentators give aural redundancy to images but also serve to clarify them.

Returning to the Woods/Singh image sequence, a spectator might have surmised that Woods hit his shot at the first hole and that the reverse camera shot facing back toward Woods from the green of the first hole was the result of Woods's shot. However, one would be hard-pressed to surmise that the ensuing footage of Woods putting was not a linear completion of

Curtis Strange and Roger Twibell shown in front of the course at the 2003 Funai Classic. Courtesy of ESPN.

the two former shots but rather an edited shot of Woods's finishing putt at the eighteenth hole. These details and context were provided not by graphics but rather by the commentators. The graphic device of a dissolve (which in the classic Hollywood style denotes the passage of some period of time) in this case has no narrative logic on its own, because there has been not only a passage of time but also a traverse of space. In addition, the commentators introduce the narrative scheme involving the money list competition between Woods and Singh.

After the initial framing of the Woods/Singh money-list narrative element, ESPN shows Walt Disney World and the spatial location of the courses, with commentary by professional golfer Curtis Strange and his counterpart Robert Twibell.[3] Both men are wearing suits and are framed in a medium shot in front of a golf course. The commentators then proceed to establish other narrative elements that are featured in the golf tournament.

Strange discusses the variety and characteristics of grass on the courses and how they may come into play throughout the course of the tournament. He notes that these golf courses have yielded low scores in the past

and that, if the weather permits (no wind or rain), there could be many players shooting scores well under par. He notes, "If you don't shoot 68 or 67, you're going to finish way back." Twibell introduces another narrative element—Woods's 112 consecutive cuts made. If Woods makes the cut this week (he did), he will tie Byron Nelson's record of 113 cuts made in the 1940s.[4] Finally, Strange and Twibell introduce the on-course commentators— at the holes, Ian Baker-Finch and Peter Alliss; and on the course (the fairways and so on), Steve Melnyck and Judy Rankin.

Let's examine what all of this narrative means and how the commentators and ESPN use this information to frame the tournament. First, Strange discusses the importance of the grass and technical characteristics of the courses. This information is important to the avid golfer, but it also explains to any spectator that if weather conditions continue to be favorable, there will be low scores, and that means exciting play. The information is not provided by graphics, so the commentators and network have provided a narrative framing of the information for the spectator. The approach reveals one of golf's unique attributes: the viewers of televised golf very often are golfers. Unlike viewers of arena sports, viewers of televised golf have the opportunity to use the same equipment and play the same courses as the professionals they watch on television. Again, this is a subtle but important difference with regard to golf's reception. No matter how fervent a New York Yankees fan, Chicago Bears fan, or Los Angeles Lakers fan a viewer might be, he or she will not be able to play on the same field or court using the same equipment as the beloved team. Golfers can and do.

Second, the commentators and ESPN are using Cliff Roberts's suggestion that CBS make the tournament a contest between a player and history. Woods's consecutive cut streak has historical significance and is not intuitive; therefore, the commentators and ESPN have provided a second narrative framing device through which the spectator receives the tournament coverage. Finally, Strange and Twibell reveal that they are not on the course themselves but rather that they will bring context and cohesion to the input being submitted from other commentators who actually are on the golf courses.

ESPN and other networks that produce golf tournaments use all of these framing devices in the hope of constructing a compelling albeit nonlinear narrative about ninety or so separate protagonists. Unlike arena sports, golf has no tip-off or coin toss, so introductions like ESPN's introduction to the Funai Classic coverage are common. However, the draw

Phil Mickelson putting on the twelfth green. Courtesy of ESPN.

of live sports is unpredictability; sporting events are compelling because anything can happen. Therefore, even though ESPN provided a variety of narrative framing schema—Woods/Singh money-list competition, course characteristics, and Woods's record book hopes—the network has no guarantee that Woods and Singh will really compete (they did not) or that the weather will withstand (it did) or that Woods will make the cut (he did). Therefore, ESPN must provide a preponderance of coverage of *all* golfers in case ESPN's initial framing strategies do not develop.

The more common depiction of tournament coverage, which consists of nonlinear taped and live highlights, provides a useful point of comparison. The assembly of these highlights is given context and significance by the commentators and very often by committee—that is, the on-course commentators provide information to the in-booth commentators (Strange and Twibell), who then further shape the footage for the viewer. For example, a randomly selected piece of coverage after a commercial break shows Phil Mickelson framed in long shot, putting on the twelfth green.

A graphic redoubles the player's name and score, indicates par for the twelfth hole (par 3), and indicates a possible outcome of Mickelson's

actions ("for par"). A second shot shows a medium view of Mickelson's putter behind the ball and the stroke, complete with the ball rolling into the hole. After the ball rolls into the hole, the camera reframes to accommodate Mickelson walking into the frame and then zooms out to frame him in a medium shot. On-course analyst Peter Alliss provides the voiceover for both shots: "Mickelson now for par at the twelfth; Jim Furyk has made his par. And now Phil for another good putt, third in a row if it goes in." Significantly, although Jim Furyk's play is mentioned, it is not shown. This omission is further evidence that televised golf must strive for narrative cohesion and structure via the on-air commentary and editing because the action shown is quite fragmented and in disarray.

Next a dissolve to Singh on the tee at the twelfth hole is shown (see page 82). Singh is framed in long shot in a perspective slightly more oblique than frontal. After his swing, a cut is made to a shot that golf producers call "tracking the ball" (see Schiesel). Essentially, this shot is a tilt or pan that follows the ball in the air. The shot is achieved by the cameraman and an engineer. If the camera simply tilts skyward, the iris will close quickly and the ball will be lost. Therefore, the cameramen, producers, and engineers must coordinate the ball-tracking shots so as not to wash out the image. The shot follows the ball with a tilt to the green and then a cut back to Singh as he walks away from the tee box.

Alliss announces in his commentary that Singh has a seven-iron. "Easy language swing. A super shot there." Alliss's commentary is functioning on a variety of levels. First, it provides the spectator with equipment information. A graphic displays the distance to the hole, and Alliss describes the club selection, which is one of golf's compelling elements of strategy. Second, this information also provides context for the spectator. Professional golfers, like other athletes, are professional because they have exceptional talents and abilities. Therefore, their club selection often provides narrative intrigue. Alliss also uses the positioning terms "here" and "there"—the former is used as Singh swings the club, the latter after the ball has landed on the green some 167 yards away. Again, via the ball-tracking shot and Alliss's commentary, the producers construct a fictional spatial continuum.

The use of this construct is also evident in another series of shots featuring the aforementioned but not seen Jim Furyk. A long shot pans as Furyk strides toward his golf ball on the thirteenth tee, positions him-

A medium view of Mickelson's putter behind the ball. Courtesy of ESPN.

Mickelson putting for par at the twelfth. Courtesy of ESPN.

A long shot of Singh on the tee at the twelfth. Courtesy of ESPN.

"Tracking the ball"
after Singh's shot.
Courtesy of ESPN.

The camera follows the ball to the
twelfth green. Courtesy of ESPN.

self, and swings. Before and after Furyk swings, the camera zooms a bit to reframe for a body language reaction from Furyk. A cut is made to another ball-tracking shot, in this case an aerial zoom shot provided by a sponsor's blimp. Furyk's ball is followed in long shot until it lands, and then the camera zooms out to an extreme long shot, providing context with regard to spatial position and how much yardage must still be covered. This harkens back to the club selection (which was covered in commentary), the results of that selection, and predictions for the remaining shots. This series of shots, like the Woods/Singh package and the Mickelson and Singh coverage, creates a spatial linearity that does not exist in reality. Golf coverage provides perspectives and relationships that can only occur within the televised event.

Discussion

Televised golf produces a narrative based on nonlinear highlights, both taped and live, which are given context and framing schema by on-air commentators. Golf tournaments like the Funai Classic do not actually occur in a linear progression but rather as many separate and fragmented narrative events with distinct protagonists. However, televised golf uses editing conventions, particularly dissolves and sound bridges, to generate a coherent and cohesive visual narrative. These images are then fleshed out with aural narration by on-air commentators who give context to the disjointed and discontinuous shots.

A spectator attending a football, basketball, or baseball game will have largely the same experience as one watching the televised game, given the obvious exceptions of commentary and the variety of perspectives provided on television. The progression of the narrative action will remain unchanged. Golf, on the other hand, achieves its unique and counterintuitive narration via its televised production. A spectator in attendance of the Funai Classic on Thursday would not have the opportunity to experience the opening segment of ESPN's coverage because that coverage was a fictional construction of space and time. Woods's round was taped and linked to Singh's via continuity editing because the two golfers were playing two different courses at two different times. Televised golf is unique among televised sports in that it relies strongly on the producers and commentators to construct the action and narrative, to give the action

context and significance, and to provide information about matters such as club selection and scores. Televised golf's reliance on taped footage and the intermingling of that footage with live coverage to construct a new narrative event is among the more compelling features of golf on TV.

ESPN and ABC are both owned by Disney, and the Funai Classic was held at two courses at the Walt Disney World Resort. These circumstances are intriguing, to say the least, with regard to the resulting production, and it would be interesting to examine the effects of sponsorship on coverage and to compare PGA tournament coverage with European Tour coverage. Additional research might also focus on how narrative changes over the course of a tournament as the number of protagonists dwindles via the cut. Does the narrative begin to resemble a more cohesive and coherent linear narrative like that of the arena sports, or does the ensemble nature of golf's participants simply make it a unique televisual sporting event?

Notes

1. A discussion of the dissolve as a technical device can be found in David Bordwell, Janet Staiger, and Kristin Thompson, *The Classical Hollywood Cinema: Film Style and Mode of Production to 1960* (New York: Columbia University Press, 1985); and Jeremy Butler, *Television: Critical Methods and Applications*, 2d ed. (Mahwah, NJ: Lawrence Erlbaum Associates, 2002).

2. In 2004 Singh not only won Player of the Year but also set a new earnings record as the first golfer ever to win more than ten million dollars in one season. In 2007 Woods was first in the world rankings.

3. Strange left ESPN/ABC in 2004, after a contract dispute, and has returned to professional golf, participating occasionally in the Champions Tour.

4. Tiger Woods missed the cut in the 1997 Bell Canadian Open. He withdrew from the 1998 AT&T Pebble Beach National Pro-Am because the tournament was postponed. Thereafter, Woods made the cut in 133 consecutive events, breaking the PGA Tour record of 113 events previously held by Byron Nelson. He missed the cut once in 2006 but again holds the longest streak, at 23.

Works Cited

Bordwell, David, Janet Staiger, and Kristin Thompson. *The Classical Hollywood Cinema: Film Style and Mode of Production to 1960*. New York: Columbia University Press, 1985.

Butler, Jeremy. *Television: Critical Methods and Applications*, 2nd ed. Mahwah, NJ: Lawrence Erlbaum Associates, 2002.

Eubanks, Steve. *Augusta: Home of the Masters Tournament.* New York: Broadway Books, 1997.

Morse, Margaret. "Sport on Television: Replay and Display." In *Regarding Television: Critical Approaches*, ed. E. Ann Kaplan. American Film Institute Monograph Series. New York: University Publications of America/American Film Institute, 1983.

Owen, David. *The Making of The Masters: Clifford Roberts, Augusta National and Golf's Most Prestigious Tournament.* New York: Simon & Schuster, 1999.

Schiesel, Seth. "Aiming for the Perfect Shot: Golf Is a Most Challenging Game—for the TV Crew." *New York Times.* October 6, 1999, C1.

What's Natural about It?

A Baseball Movie as Introduction to Key Concepts in Cultural Studies

WHEN THE NATURAL WAS released in 1984, critics generally agreed that, while beautiful, it lacked the substance of its literary predecessor of the same name (written by Bernard Malamud and originally published in 1952). As an adaptation it had clearly fallen short, turning a "brooding moral fable" into a "fairly tale," as Vincent Canby wrote in his *New York Times* review. He went on to call the film "eccentrically sentimental"—a "big, handsome, ultimately vapid screen adaptation." From a cultural studies perspective, Canby's insistence on comparing the film with the book, and finding the former a less worthy artistic endeavor than the latter, is far from surprising: such is typically the case when educated aesthetic critics pass judgment on texts that seem primarily concerned with popular pleasure. Roger Ebert was even less complimentary in the *Chicago Sun-Times*, reproaching *The Natural* for its descent into simplistic "idolatry" of the film's star, Robert Redford, resulting in a "cheap," "phony," and "unsubtle" work. The 1985 Academy Award nominations seemed to echo these feelings, primarily acknowledging (aside from Glenn Close's nomination for best supporting actress) the elements that built *The Natural*'s sensory lushness: art direction, cinematography, and the original score. But the film was a success, earning forty-eight million dollars at the U.S. box office and another twenty-five million dollars upon its video release. Since then, it has gained a whole new dimension of cultural capital on the Internet, basking in the praise of "Best Sports Movie" and "Best Baseball Movie" lists, memorabilia auctions, fan websites, film review sites, and the like. In this venue of popular opinion, it's next to impossible to find any negative critique of the film (aside from the archived reviews from its original 1984 release). The film's online afterlife reinforces its identity

as a text that strikes a highly resonant chord in our popular culture. This dichotomy between the critics' responses and popular opinion sheds light on the extremely challenging questions of how we make meaning and privilege certain messages through our cultural texts. Yes, *The Natural* is seductively beautiful in a fairly naive fashion, but is this really a weakness? Furthermore, how much is going on aside from the film's looks that might account for its popularity not only upon its release but more than twenty years later? *The Natural* has proven fruitful as a classroom text, encouraging students to consider and reconsider their role(s) as consumers of popular culture as they respond, first, to the film's simple idolizing of a heroic, almost mythic U.S. baseball figure, and second, to the complex elements beneath the film's rich surface.

As a cultural studies professor at an Ontario community college, I am frequently presented with the challenge of introducing students to the ways in which they might critically engage with popular culture. Since most of these students have been through a nonacademic (known as "applied") stream of courses in high school and have chosen a technological, hands-on program of postsecondary education, many are surprised—and not a little disgruntled—that they are required to take a general education course as part of their studies. Moreover, the scheduling demands outweigh the supply of these courses, so students usually find themselves placed in a general education course not because it piqued their interest but because it had space for them. And so, when I start an introductory course in popular culture or visual culture in this setting, I am faced with a group of individuals who not only are new to the basic functions and principles of the field (namely, critical thinking and textual analysis) but also are quite sure that they don't need or want to learn anything about the subject. For several reasons, I've found that one of the best ways to introduce students to key concepts in cultural studies is through *The Natural*. My approach to this film is perhaps best defined by the interdisciplinarity that often characterizes cultural studies' engagements with film and that often figures prominently in film theorists' ideas about how to renew and reinvigorate film theory.[1] Put simply, my take on *The Natural* is that it offers students a straightforward introduction to the ways in which film both constructs and reflects our ideas about gender, heroism, and nation, and—most importantly—how film poses its constructions and reflections as "natural." This last point is particularly salient, given its overt presence in the film and its pivotal role in cultural studies and film studies.

The idea of film critique as a fruitful project is often a difficult one to introduce to teenagers; they frequently see it as "ruining" films, which, as entertainment, are meant to be enjoyed. Another challenge is that in most of my classes, the number of male students far exceeds the number of female students, so much so that the class may be bereft of even one female (other than me). This can create a rather tense dynamic in discussing gender representation (a crucial element in film and cultural studies), and I run the risk of appearing to be lecturing young men on the evils of patriarchy. This demographic also forces me to reassess my dialogue-based teaching style, as the males in my classes are typically less verbal than the females. But I have found that *The Natural* enables me to deal effectively with these challenges. First and foremost, the film is well crafted, containing several motifs and symbols that students, once prompted, can easily detect and follow (in this case, it's a plus that the film is none too subtle in its visual and thematic coding). This straightforward, nonthreatening invitation to critical engagement leads the students into more challenging concepts. Furthermore, two of the criticisms that students most frequently lob at *The Natural* are that it is simplistic and that it is "cheesy." These sentiments seem to give students a certain degree of confidence and authority, thus diminishing some of the anxiousness they feel in tackling a new subject and a new set of skills, but at the same time, once we have completed our analysis, most students feel that the film has gained a significant amount of weight. In this case, then, their first experience with film critique yields a greater amount of value to the film, thereby debunking the myth that to interrogate a film is to "ruin" it. On another level, the film is, after all, a sports movie, and given that sports is a familiar subject that most of my students find sorely absent from the bulk of their formal education, they are more attuned to the notion of its relevance and more comfortable debating its merits and comparing it to other texts and social practices.

Ultimately, in teaching *The Natural* in this kind of classroom environment, my goal is to address the value of sport—how it gains significance in our culture and how it interacts with other elements of our culture. The historical framing of *The Natural* and its ongoing popularity as a, if not *the*, sports movie encourages students to recognize the ways in which cultural meanings are imbricated in sport as part of an ongoing mythology. I want my students to grapple with the question of why this particular intersection of classic narrative film and sport has had such resonance with the American public. In doing so, they will—I hope—learn to see greater

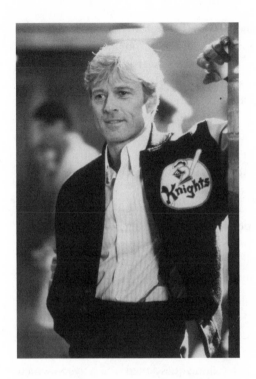

Even in the Knights basement locker room, sunshine creates a halo around Roy Hobbs's head. Courtesy of PhotoFest.

meaning and consequence in what they previously wrote off as "just entertainment," and they will be motivated to see the broader significance and interplay of other structures of power, such as those of Hollywood film and the great American pastime.[2]

What's Natural about It? Getting Started with Ideology

The title of *The Natural* makes it particularly suited to an introduction to the concept of ideology because it points to an especially widespread, readily accepted notion in our culture: that of talent, or the "God-given gift." The title makes explicit one of the major elements of ideological construction—the idea that something is accepted as natural, rather than constructed by sociopolitical conditions. At its outset, the film seems to question the power of talent through the protagonist Roy Hobbs's father, when Roy (Robert Redford) is young: "You've got a gift, Roy. But it's not enough. You've got to develop yourself. Rely too much on your own gift, and you'll fail." The film emphasizes Roy's choices and how they affect his destiny—how his gift slips away when he makes bad choices. So, in

a sense, the film tempers its belief in "the natural" by constructing overt references to our individual power to determine our own destiny—for better or worse. However, in a much more powerful, affecting sense, it packs its frame with elements that express otherwise. In order to stimulate the students' recognition of these elements, I ask them how "the natural" is represented in the film. Answers typically start with Roy's talent, then move on to the natural surroundings of his farmland upbringing and the almost supernatural connection he has to lightning and light in general. I guide students' attention to, for instance, the lighting techniques that repeatedly make Roy's blond hair glow and shimmer as if it were a halo— a simple technique to recognize and interpret. I encourage the students to really unpack these representations—how do they encode "naturalness" with cinematic technique? What is it about sunsets, cornfields, trees, and thunderstorms that is so much more natural than the desire to build skyscrapers and lay pavement? From there, we begin to identify things that are connected to "naturalness." Roy's relationship with his father is dominant in this sense; Roy plays catch with his father in a sun-drenched field and builds a bat from the tree under which his father dies—a tree split open by a bolt of lightning. It's rare to find a student in my classes who has consciously recognized, let alone questioned, the ways in which baseball, masculinity, and "nature" are constructed as concomitant, but this is a critical observation in any discussion of *The Natural*, and it leads into broader, related cultural representations.

I try to appeal to my students' affinity for surfing the Web by asking them to take a cursory look at polls and surveys determining the most popular baseball and/or sports movies. The two films that are mentioned most frequently are *The Natural* and *Field of Dreams* (1989). In the ESPN "Baseball Movie Tournament" of 2001, baseball movies squared off against each other until only two were left—*The Natural* with 58.7% of the vote and *Field of Dreams* with the remaining 41.3%. Both films link fatherhood, farming, and baseball, and *both* end with a scene of a father and son playing catch in a cornfield. Why is it that this kind of representation of baseball has found such resonance with the public? What makes it so popular, and what does this say about Americans' feelings about their national game? In deciphering ideological constructions, I suggest that students ask two questions: who profits, and at whose expense? In this case, I ask them what it means when Americans and the American media culture industry favor an agrarian, white male association with their na-

tional pastime. Who is excluded from this narrative of nationality? The cinematic representations of black males in baseball are typically urban and cynical—look at the recent *Mr. 3000* (2004) and the exceedingly dark *The Fan* (1996)—with none of the romantic, wholesome "love of the game" expressed in movies such as *The Rookie* (2002) and *Bull Durham* (1988). Does the dearth of baseball movies featuring black characters indicate that the United States would rather keep its national sport white? How does this dearth influence or reflect the popular notion that it is more natural for black men to excel at basketball—and that, as the film attests, *White Men Can't Jump* (1992)? What social and economic factors might influence which demographics are more likely to be represented in which sports? Again, we must return to the idea that certain people having a greater natural ability in a certain sport is an ideological construction; the sheer number of cinematic representations of white baseball heroes and black basketball stars (to take basketball as an example) makes this segmentation seem more natural by virtue of their ubiquity, which discourages the imagining—and material realization—of alternatives. In this respect, the emphasis on boyhood and sport in so many sports films is notable: the first step in becoming an athlete is dreaming one's way into the sport by imagining oneself in the image of one's hero. Next comes the material possibility of that dream, determined in large part by one's location and one's financial circumstances. It is crucial for students to recognize that our society has made basketball more available to inner-city youths not only through its representation of black basketball heroes but also through its urban basketball courts, which service and reinforce social stratification according to race. And so it goes with baseball, with its requirements for large open spaces (fields of dreams, as it were), and hockey, with its expensive rink times, and so on and so forth. Films about baseball are typically films about middle-class suburban or rural boys and men; students often resist the notion that films have had a role in restricting sporting activities to certain races, genders, and classes, arguing that films are a reflection of reality or are "just entertainment." This attitude generally recedes with the reminder that most Major League Baseball players are Latino or black, not white, and with some help from critics like Greg Smith, whose essay "It's Just a Movie: A Teaching Essay for Introductory Media Classes" discusses the ways in which social beliefs have a way of rising to the surface in our cultural texts. Moreover, critic Henry Giroux argues that mass media is our culture's foremost pedagogical tool today—it accounts for a significant

amount of what we learn about behavior and social positioning.[3] The idea that film is "just entertainment" is, of course, *ideological,* disguising film's pedagogical power and thereby allowing it to evade critique. But these are the stories we tell ourselves about ourselves: they are important, and our society pours tremendous amounts of its resources into their production and consumption. At its core, a film like *The Natural* plants father and son—man and boy—with their baseball mitts in a field, as if this kind of image were as natural as a stalk of corn springing from the earth. It is, of course, anything but natural, giving white middle-class masculinity a privileged sense of national belonging and entitlement by making it the primary occupant of the building and reiteration of a baseball mythology.

Roy Hobbs as America: Reading Metaphoric Characterization

The connection between baseball and American nationhood is fairly easy to make; it is, after all, the "official" national pastime of the United States. But *The Natural* intensifies this connection in a way that allows students to learn about the metaphoric power of cinematic characterization. It is unlikely that students will note this detail, but they should be made aware of the time in which the film takes place: as newspapers flash across the screen, a quick eye can catch their date—1939. Why is this important? With a quick history lesson, students can be briefed on the significance of this date. Although the United States did not join the war until 1941, Great Britain and France declared war on Germany in 1939, which marked the beginning of the U.S. economic boom, thanks to the factory production required to fuel the "machine of war." This boom, it can be argued, never busted, and thus it can be seen as the beginning of the United States' road to becoming a world superpower. In this context, when Roy Hobbs walks for the first time down the long dark tunnel toward the light of the dugout and the baseball field, on his way to making a success of the last-place New York Knights, it is not too much of a stretch to read his walk as the United States' progression toward its destiny. When pressed about where he's been for the last sixteen years, the "man from nowhere" (as he is dubbed by the press) only replies that he "sort of got side-tracked." This too can be read as part of Roy's construction as the United States itself. Before 1939 the United States did indeed get "side-tracked" amidst the extreme excesses and deprivations of the 1920s and 1930s, the latter—from a puritanical viewpoint—perhaps a punishment for the former. The term "side-tracked"

adds weight to this metaphor, given the appearances of trains in the film: The first sound in the film is that of a train whistle, as Roy waits at a train station. It is because of a train ride that a young Roy establishes his strength when he strikes out the (Babe Ruth–esque) "Whammer" and his weakness when he is attracted by the temptress/murderer Harriet Bird (Barbara Hershey). A shot of a train whizzing by marks young Roy's—and the film's—arrival in the big city. Here the film taps into a familiar sign: the train as a symbol of the United States' progress, or journey toward progress, as industrial advances led to locomotive expansion into the West and the attendant burgeoning of urban spaces.

The Natural's allusion to the thriving 1940s extends to its score, composed by Randy Newman. The music in the scene in which Roy strikes out the Whammer is remarkably similar to the "Hoedown" from Aaron Copland's *Rodeo* ballet. The bulk of Copland's work was composed and gained notoriety in the 1940s and 1950s; an aural reference to his distinctive style recalls the sense of optimism, vitality, and regional and national pride that characterized Copland's music and the American period that it defined. Most students will recognize "Hoedown" only as "the song from the beef commercials," but this is hardly a disadvantage in figuring out the ideological constructions of the film. The beef commercials aired on television in the 1990s as part of the U.S. federal beef checkoff program, which began with the 1985 Farm Bill. They included scenes of rugged cowboys, horses, and ranches where beef is "what's for dinner," with voiceovers by Sam Elliot—an actor known for his stoic cowboy roles. Baseball, beef, and the United States: over time, cultural texts like films and commercials contribute to what constitutes belonging and what is "natural." Our collective sense of what is intrinsically American is guided by these texts, although often unconsciously so. Many students will be surprised by how, through Copland's music, we can detect ways in which a currency of nationalism travels from text to text by virtue of its ability to call up shared notions of what signals "America."

Students may wonder why any of this is worth noting: what, really, does any of this "history stuff" have to do with a story about a ballplayer? I invite them to consider what it is that makes film different from other forms of communication; even with the rise of video rentals, movie channels, and digital formatting, film is still conceived and presented first and foremost as a shared public experience. By tapping into popular, longstanding cultural (and in this case, national) codes, the story becomes part of

the broader fabric of stories we tell ourselves about ourselves, and thereby gains greater resonance with its audience through its familiarity and the instant understanding it engenders.

New Incarnations of Old Mythologies: Celebrity, Fame, and Visibility

The Natural is quite self-aware of its endeavor to operate in this broader fabric. When Roy first talks with Harriet Bird, she waxes poetic about the heroic nature of baseball and compares baseball players to mythic figures like Sir Lancelot and the gods and heroes written about by Homer.[4] Later in the film, sports reporter Max Mercy (Robert Duvall) responds to an exasperated Roy's query as to whether Max has ever actually played baseball: "No . . . but I make it a little more fun to watch." These two moments—with Harriet Bird and Max Mercy—are crucial because they suggest the film's operation within a longstanding tradition of storytelling and encourage us as audience members to consider the role of storytelling—of mythology—in our lives. How do past myths persist? How do new myths grow out of the old? Do we use them for a passive kind of fun entertainment, as Max suggests, or is our relationship to them much deeper, and more serious, as Harriet Bird's behavior suggests? Roy himself adds another dimension to this issue with his frequent declaration that his only goal is for people to know his name and that he was "the best there ever was in baseball." His struggle to inject himself into the mythology of baseball creates the structure of the film and should encourage students to deliberate about whether or not he was successful and whether the film has a stance on the desirability of this kind of success. Since its inception, the film industry's driving inclination has been to create stars, and accordingly, baseball movies typically elevate one character or team above all the rest to star status. Such is also the case with baseball itself and its emphasis (as with all other sports) on records and championships. Despite the film's overt references to and reinscriptions of the modern mythologies of baseball and America and their connection to classical myths, *The Natural* can be read as slightly more complex in the way that it presents the notion of fame—the desire to be more visible and recognizable than others. Students are quick to pick up on the film's emphasis on light and dark, but their critique should go further than the simple codes of light equals good and dark equals evil (although the film certainly does exploit

these codes rather simplistically!). There are a number of instances when the film seems to find a relationship between fame and Roy's ability to see clearly: close-ups on camera flashbulbs popping in his face, for instance, are intercut with shots of Roy shielding his eyes from the glare as he tries to see into a crowd, searching for someone he thinks he recognizes. Roy and his childhood sweetheart, Iris (Glenn Close), discuss their separation in terms of visible recognition, or lack thereof: "I thought I saw you once at a train station," he says, and she replies, "I used to look for you in crowds." Roy's increasing visibility—illustrated with shots of his appearances on "Movie Time News," the cover of *Life* magazine, newspaper sports pages, and baseball cards—moves in lockstep with his decreasing ability to see clearly, as he is drawn deeper into a relationship with Memo Paris (Kim Basinger)—the second temptress who will interfere with his ability to play baseball. As Roy himself says, "I didn't see it coming." Indeed, he did not recognize Harriet Bird as a threat, and he almost does not recognize Memo as the same kind of dangerous, deceptive figure. Other examples that students might take note of are Gus the bookie's ability to see "all things" with his "magic eye"; Roy's comment to the Judge that the only thing he knows about the dark is that "you can't see in it"; and the shadows and light that construct Roy's pennant-winning, final home-run. This last example is particularly worthy of discussion: At his most visible moment—the pinnacle of his fame—Roy's face is all but indistinguishable, and he is almost a silhouette, rounding the bases amidst sparks and smoke. The lights go out in the stadium and then come back on—brilliantly—in the corn field where Roy is suddenly located, playing catch with his son in the golden light of late afternoon. Ironically, the film seems to argue, Roy can see most clearly where he is a father and a husband—not a baseball player and certainly not "the best there ever was in baseball." These elements of *The Natural* set up an interesting debate about how fame and the search for fame affect our ability to see clearly—to be visible not only to others but to ourselves. At its core, this debate should encourage students to consider how film, as a visual medium, operates within a culture that is wrapped up in being visible and being recognized as ultimate goals. It is part not only of the subject of *The Natural* but also of its production and consumption as a cinematic product. How can we see ourselves—audience members in a society where visual entertainment and celebrity are key ingredients—in Roy? Is his relationship with fame—his struggle to "see and be seen"—part of the reason why this film has resonated with the public?

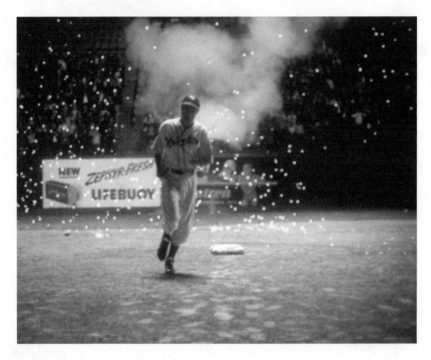

Roy's face is all but indistinguishable in the "New Incarnation." Courtesy of PhotoFest.

What makes a film popular? How does it strike a chord with an audience? The fact that *The Natural* is also a baseball movie opens up this topic to a consideration of spectator sports, how some resonate with audiences more than others, and how fame and celebrity might play a role in that resonance. Is there, in fact, much of a difference between the kind of narratives spun by sports movies and the kind of narratives spun by sports broadcasts and sports reporting?

Representations of Gender: "Natural" Archetypes and Patriarchies

Gender is a subject that students always enjoy debating. Race issues tend to intimidate them, and class issues seem to have been wiped from their consciousness, but gender is uppermost in their awareness. Despite this, they generally need coaching in recognizing how gender is represented and

encoded in popular visual texts, and *The Natural* provides several instances of some of the most common of these representations or codes.

The importance of the relationship between Roy and his father is set up at the very beginning of the film—it defines Roy, his love for baseball, and the journey Roy must make in order to reconcile his gift with his need to develop a keener recognition of truth in his life. This kind of paternal prioritization (does Roy even *have* a mother?!) continues throughout the film: it is interesting to note that when Roy is depicted with his Knights teammates, he is typically closest in proximity to Bobby, the batboy. Along with the more obvious details of their paternal connection (such as the interest Bobby takes in "Wonderboy" and the bat that he and Roy make together—the bat Roy uses to hit his final home run), they share a number of medium two-shots, which reinforce the solidity and centrality of this kind of father-son relationship. There is also a sense that when Roy rejects the Judge's bribe and wins the pennant to save Pop's stake in the team, he is somehow redeeming his boyhood self who could not save his own father. (Roy and Pop are brought even closer given Pop's repeated assertions that he "should've been a farmer" like Roy's dad.) And of course, there is Roy's complete patriarchal redemption/ascension in meeting his own son. When Iris tells Roy that she has a son (but not that he is Roy's), she says, "He's a great kid . . . but I'm starting to think he needs his father now." Roy, taken aback, responds, "Sure. A father makes all the difference." And every positive father-son relationship in the film is wound around baseball and a love of baseball. As Roy says to his young fans, to be a big leaguer, "you have to have a lot of little boy in you." Yes, a lot of little boy and a lot of fatherly guidance, because a father makes all the difference. One might wonder if these relationships would have been so positive—or would have been at all—without success in the game. Would Bobby have warmed to Roy if Roy hadn't winked at him as he started, much to everyone's shock, hitting balls out of the park at his first batting practice? Would Pop have warmed to Roy, and sought to protect him from Memo and the Judge, if Roy hadn't proven he could deliver success for the team? Would Iris have told Roy about his son if she hadn't felt that it would ensure his successful home run? Would Roy have met his son if he'd failed at his last at bat? Students should discuss the ways in which success in baseball is linked to success in father-son relationships. How does this film reflect on the ways in which successful fatherhood operates

in a broader power structure—in patriarchal structures?[5] Are relationships between mother and daughter figures as dependent on public signs of success? Indeed, how many major motion pictures focus on the achievement of a successful mother-daughter relationship, and how many connect this focus to success in a professional sphere? *The Natural* is one of a long line of films that privilege healthy father-son relationships and suggest their importance in enabling the father's successful professional life. Again, if these are the stories we tell ourselves about ourselves—if these are the stories that resonate with us—what kind of cultural norms are being set up? How is patriarchal power still being reinforced through seemingly innocent vehicles such as Hollywood film?

The film's depiction of its female characters is fairly heavy-handed, but the more prototypic motifs allow students entry into slightly more advanced critical strategies. Obviously, Harriet's and Memo's black costumes are a classic code for their wickedness (and Harriet Bird, with black hair, is a black bird—a harbinger of bad luck), but what of the times when Memo wears white, and what of her platinum blonde hair? Perhaps these costumes can be connected to the difficulty of seeing things clearly: these women are deceptive in their openness. Their seemingly straightforward advances appeal to Roy's ego, but they are not black and white. Iris, in her browns, yellows, patterns, and yes, whites, is reserved and chaste—relatively platonic, in fact—in all her communication with Roy after their long separation, and it is she who knows the whole truth about his life, not in the deceptive simplicity of black and white, but in all its grey reality. There are other small details to pick up on: Both Harriet and Memo are shown wearing fur (perhaps to be linked to the stuffed bear in the Judge's office?), and both meet Roy in a hotel. Both are shown firing a gun (one at Roy, one nearly at Roy), and both wear red nail polish. We know that Harriet is bad luck given her metaphoric identity as a black bird; Pop tells Roy that Memo is "bad luck." With all these clear indications of Harriet's and Memo's deceptive and threatening natures, students are often quick to congratulate the film on creating such a wonderful, giving woman in Iris. But of course, this kind of binary opposition between the temptress and the saint is classically archetypal. Put simply, their two-dimensional constructions as vixens and saint—as "bad luck" and "good luck"—render them simplistic devices present only insofar as they help communicate more about Roy's character. They are cinematic handmaidens trapped in the classic, static roles of good girl and bad girl, with none of Roy's

complexity or development. To reinforce this, the film begins with Iris, as a girl, watching Roy and his father play catch on the farm. At the end of the film, a grown Iris watches Roy and his son play catch on the farm. For Roy, going back to where he started has been a journey that has changed him dramatically. Iris, however, seems not to have changed at all; rather, she has been patiently working and waiting, holding onto the family farm, although she lives and works in Chicago. There is no indication that she is even slightly miffed at Roy for disappearing after promising to call for her and marry her. There is no bitterness that she has been left to raise their son on her own. Her character remains as innocent and hopeful and adoring as it was the day they parted as young lovers. And so her representation is no less damaging, from a feminist standpoint, than those of Harriet and Memo, because it suggests that such saintly behavior is the only alternative to sexualized wickedness. Should we really obfuscate any complex, three-dimensional representations of women and present them instead in these restrictive, narrow characterizations? Students are usually eager to debate this question. I ask them to consider what kinds of female characters dominate the media. In looking at video games, television shows, films, and advertisements, students generally are only able to come up with classic archetypes such as crone, temptress/whore, saint, mother/wife, virgin, and so on. Certainly, archetypes persist for male characters as well, but I encourage students to think about how many films feature static female archetypes orbiting around the central, complex male protagonist who must achieve some kind of epiphany, thus changing and bettering his life. How does this ideological construction affect us as viewers? Do we take on these representations? Do they become part of how we see ourselves and the world around us?

Lest students think that I take a superior stance against this film—or against all popular forms of entertainment—I am careful to tell them how important a role it has played in my life. I have long been completely estranged from my father, and yet this film, which he introduced to me when I was young, reminds me of one of the very, very few things we enjoyed together. The sensory appeal of the film—the golden light, the simple, quiet heroism, the stirring music, the sheer charisma of Robert Redford—works on me at a physical level, so to watch it is to feel good. In fact, the name "Roy" has had such positive connotations for me for so long that it is the name we've given our first son. These aspects of pleasure and personal response—

categories so often ignored by Cultural Studies—are crucial to introduce, because they allow students to be critical without losing something that has become so important in their lives. Our culture spends inordinate amounts of time engaging with mass media entertainment—to strip that entertainment down to nothing but a series of ideological manipulations is to devastate those who've gotten so much pleasure from it. They take it personally, and their resistance is such that they're in danger of closing themselves off completely from your course and your ideas. When I show them *The Natural*, I hope to show them that I love this film, and that as a popular cultural text, I get pleasure from it—a populist stance which is at odds with the notion that we are but a mass audience passively receiving whatever the culture industry gives us to consume. Despite this, I am still keen to critique it—something I enjoy as much as watching the film for pleasure, since it means my pleasure is not blind or uninformed. In other words: I choose my entertainment and find my pleasure from a position of power, taking on those elements which appeal to me, and undermining those elements which might impair my ability to recognize when I'm being manipulated by ideological representations. I believe that this is one of the greatest lessons we can teach to our students, as it will apply to those untold thousands of hours they will spend outside the classroom, and inside popular culture.

Notes

1. See, for example, the essays by Jane M. Gaines, Douglas Kellner, Toby Miller, Bill Nichols, Tessa Perkins, and Janet Wasko.
2. While I have begun this essay by outlining my experiences teaching at a community college, most of the strategies I've employed would be equally suited to most introductions to popular media critique, cultural studies, or film studies at the high school level. I've also implemented several of these strategies in my university teaching, where I once again face large groups of students who have taken an introductory course in Cultural Studies as an elective, and are therefore anxious and/or unfamiliar with the kind of critical engagement upon which they are—hopefully!—about to embark.
3. Henry Giroux has made this point in several of his publications. See, for example, his introduction to *The Mouse That Roared: Disney and the End of Innocence* (Lanham, MD: Rowman & Littlefield, 1999).
4. Detail-oriented students will relish the number of ways in which the film—and the book upon which it is based—roots itself in paradigmatic storylines. *The Natural* borrows from the medieval story of Sir Percival from

the Arthurian legends, as implied by Pop Fisher (a reference to The Fisher King), the broken bat (a reference to the broken sword), and the Knights (obvious enough). Roy himself is a reference to Odysseus, who journeys for years before finding home and the woman, Penelope, who has, for all those years, raised his son. One might also discern references to baseball's greatest mythic character: the attempt to bribe Roy, and Roy's "Wonderboy" bat, can both be connected to Shoeless Joe Jackson, who was caught up in a bribery scandal and whose bat, which he named "Caroliny," was also made from a tree struck by lightning.

5. There are many films that follow this pattern, including *Jerry Maguire* (1996) and *The Family Man* (2000), linking increased professional success with a growing role as a father. One of the more outlandish examples of this trend is in *Hollywood Ending* (2002), wherein a director (Woody Allen) suddenly goes blind and cannot finish his picture and regain his sliding professional status until he reconciles with his estranged son.

Works Cited

Bull Durham. Directed by Ron Shelton. Los Angeles: The Mount Company, 1988.

Canby, Vincent. "Film: Redford and Duvall in Malamud's 'Natural.'" *The New York Times*, May 11, 1984.

Ebert, Roger. "The Natural." *Chicago Sun-Times*, January 1, 1984.

The Family Man. Directed by Brett Ratner. Beacon Communications LLC; Howard Rosenman Productions; Riche-Ludwig Productions; Saturn Films, 2000.

The Fan. Directed by Tony Scott. Mandalay Entertainment; Scott Free Productions; TriStar Pictures, 1996.

Field of Dreams. Directed by Phil Alden Robinson. Los Angeles: Universal Studios; Gordon Company, 1989.

Gaines, Jane M. "Dream/Factory." In *Reinventing Film Studies*, ed. Christine Gledhill and Linda Williams. London: Arnold, 2000.

Giroux, Henry. *The Mouse That Roared: Disney and the End of Innocence*. Lanham, MD: Rowman & Littlefield, 1999.

Hollywood Ending. Directed by Woody Allen. Glendale, CA: Dreamworks SKG; Gravier Productions; Perdido Productions, 2002.

Jerry Maguire. Directed by Cameron Crowe. Culver City, CA: Gracie Films; TriStar Pictures, 1996.

Kellner, Douglas. "Culture Industries." In *A Companion to Film Theory*, eds. Toby Miller and Robert Stam. Malden, MA: Blackwell, 1999.

Miller, Toby. "Introduction." In *A Companion to Film Theory*, eds. Toby Miller and Robert Stam. Malden, MA: Blackwell, 1999.

Mr. 3000. Directed by Charles Stone III. Dimension Films; Spyglass Entertainment; Touchstone Pictures, 2004.

The Natural. Directed by Barry Levinson. Delphi II; TriStar Pictures, 1984.

Nichols, Bill. "Film Theory and the Revolt Against Master Narratives." In *Reinventing Film Studies,* eds. Christine Gledhill and Linda Williams. London: Arnold, 2000.

Perkins, Tessa. "Who (and What) Is It For?" *Reinventing Film Studies,* eds. Christine Gledhill and Linda Williams. London: Arnold, 2000.

The Rookie. Directed by John Lee Hancock. 98 MPH Productions; Gran Via; Walt Disney Pictures, 2002.

Smith, Greg. "It's Just a Movie: A Teaching Essay for Introductory Media Classes." *Cinema Journal* 41, no. 1 (Fall 2001): 127–34.

Wasko, Janet. "The Political Economy of Film." In *A Companion to Film Theory,* eds. Toby Miller and Robert Stam. Malden, MA: Blackwell, 1999.

White Men Can't Jump. Directed by Ron Shelton. Twentieth Century Fox, 1992.

Masculinity, Misogyny, and Race in Sports Films

DAYNA B. DANIELS

You Throw Like a Girl

Sports and Misogyny on the Silver Screen

SPORTS HAVE TRADITIONALLY BEEN accepted as a male domain. Incorrect beliefs about the histories of games and sports, and the invisibility of girls and women as participants, have created a foundation of myths upon which the contemporary culture of sports and the construction of masculinity have been built (see, for example, Messner). As is true in many aspects of recorded history, including motion pictures, women are not generally included in sports histories unless an individual woman or group of women is recognized as having been exceptionally outstanding. The invisibility of girls' and women's games and events, not to mention many events held for women and men together during certain periods of history, leads one to believe that only the Amazons, Annie Oakley, Mildred "Babe" Didrikson Zaharias, and the Edmonton Grads had any athletic skill or sporting prowess (see Simri).

Most contemporary North American accounts of girls and women in sports begin with the late 1800s. Acceptance of women in sports since that time is based to a great extent on myth and misunderstanding (see Cahn; Cochrane, Hoffman, and Kincaid; Henderson et al.; and Lenskyj). For the most part, facts about women and sports in the early twentieth century are limited to stories about health cautions around physical activity for white, middle- and upper-class, heterosexual women. The sports activities of poor and working-class women, certain groups of immigrants, and nonwhite, aboriginal, and lesbian women are not included in mainstream historical records, newspapers, newsreels, or the collective memories of most North Americans.

The participation rates of girls and women in sports and other physical activities skyrocketed in the twentieth century. Women began surpassing records previously set by men. Women now participate in activities such

as rugby, boxing, mountain climbing, tae kwon do, and hockey as well as in traditionally appropriate activities such as gymnastics, swimming, tennis, and figure skating. Although girls' and women's participation in these activities is increasingly accepted in North America, there persists an underlying attitude that they really do not belong in the male realm of sports. The abilities of women athletes are constantly compared to those of men. The femininity and sexuality of women athletes are often called into question, and the value of women athletes—both financial and personal—is based more on heterosexual femininity than on athletic excellence.

The first century of moving pictures (from approximately the 1880s to the 1980s), in all of its forms, contributed to common misconceptions about gender and therefore to the barriers preventing girls and women from participation in most of the sports featured in the first century of sport-based films. This essay investigates how the language used in sports films about male athletes might have contributed to beliefs about girls and women and their involvement in sports today. Has the practice of motivating men through language that demeans women—a practice promoted in twentieth-century Hollywood motion pictures about men and sports—perpetuated and reinforced the second-class status of girls and women as athletes?

Setting the Scene

Three factors from the fin de siècle can be critically analyzed to construct the contemporary foundation for many beliefs about girls' and women's physical activity and participation in sports: the social and economic conditions that led to the first wave of feminist activism in North America; the movement to rekindle the spirit of sports and manhood through the rebirth of the Olympic Games; and the development of the first motion pictures.

All Women Are Not Equal

At Seneca Falls, New York, in July 1848, the first women's rights convention in the United States launched a period of activism and education, sometimes referred to as first-wave feminism, which resulted in significant social change for women in the United States. Social rights, including access to education and the right to vote, became the agenda for a group composed primarily of white women and men. Women's universities and

state universities first opened their doors to women following the U.S. Civil War. Access to higher education spawned great criticism regarding the effects of education on women's health and their ability to reproduce (see Sayers). Educators and doctors, primarily males, wrote and lectured that girls' "education should . . . be tailored to their physiological functions, specifically to the biological requirements of menstruation and reproduction" (Sayers 9–10).

Dr. Stanley Hall, the first president of Clark University (1880–1920), was a strong proponent of an education for girls that was different and also less rigorous than that for boys. Hall said, "The 'data' from physicians showed, that the more scholastic the education of women, the fewer the children and the harder, more dangerous, and more dreaded is parturition, and the less the ability to nurse children. During menstruation, a girl should step reverently aside from her daily routine and let the Lord Nature work. Failure to tailor girls' education . . . to their physical need to rest during menstruation would endanger their reproductive powers" (Hall, quoted in Sayers 10).

Clearly, beliefs such as these, supported by physicians and educators, might lead the general public to believe that sports and physical activity, especially rough-and-tumble games, not only were inappropriate for girls and women but also could be physically (that is, reproductively) harmful, although no proof existed for such admonitions and no such cautions, however appropriate they might have been, were taken regarding boys.

These early criticisms were not applied universally to girls and women. They were only applied to females of certain classes and races. At the end of the nineteenth century, large numbers of immigrants poured into the United States and Canada. Racist and classist views relegated these people to second-class status. To protect the alleged superiority and desirability of white people as central to the leadership and development of North American society, it became important to make middle-class white women the focus of all educational and social matters (see Sayers). Reproductive health and the number of children born to white women were of particular concern. As women entered postsecondary schools and professions, they had a tendency to have fewer children. Immigrant and nonwhite populations, on the other hand, experienced an increase in birthrates as their basic needs were met in the "new world." Although white girls and young women were discouraged from engaging in any activities that doctors and educators of the day felt might interfere with their ability to

get pregnant and carry healthy babies to term, hard physical labor and rough-and-tumble activities and sports appeared to have no ill effects for poor women or women of color. Only the daughters and wives of the privileged classes of North America seemed to be negatively affected by heavy physical labor and participation in sports. The pale, thin woman of the Victorian era was a woman who did not have to labor hard in the sun. These were women of class, and they set a social and physical standard against which all women were judged.

Upper-class women, however, were no strangers to physical activity. There were many activities that were deemed appropriate for women of their social station, including horseback riding, croquet, lawn tennis, and golf (see Cochrane, Hoffman, and Kincaid). Winter activities such as curling and ice skating were also popular. Women's participation in these sports was not accepted without criticism and ridicule. However, women did participate, and as they were accepted into universities and private clubs, they demanded greater opportunity to be involved in sports at these institutions. Among the first Olympic events open to women were golf and tennis, sports that were played at country clubs, where participation was restricted and women's involvement was hidden.

Nationalism and Olympic Rebirth

The second event of the late 1800s that has had an impact on modern beliefs about girls and women in sports was the birth of the modern Olympic movement. Concerned about the health of aristocratic youth as the future leaders of France, Baron Pierre de Coubertin was instrumental in resurrecting the ancient spectacle of the Olympic Games. He saw the Olympics as a training ground for the bodies and minds of future soldiers and statesmen. The vision that de Coubertin had for the Games was not unlike that of the Greeks: "The first recorded Olympic Games (776 B.C.) barred women entirely from this religious and political event. For these sacred celebrations only the public beings—men—were allowed to be present. Women, the private beings, could not even view the Games and faced the death penalty for entering the sacred grounds" (Boutilier and San-Giovanni 221). Although de Coubertin's concept of the modern Olympic Games did not include death to women spectators, he did envision only male athletes. The role of women in the modern Olympic Games was to cheer on the male athletes and to garland the winners. Women were not

included as athletes in the first modern Olympics in Athens in 1896, but the Paris Games of 1900 did include nineteen women in three sporting events: golf, tennis, and croquet. Again, the athletes who participated were primarily upper-class, aristocratic, white women.

The inclusion of women in the modern Olympic Games generated struggle and controversy throughout the twentieth century, and certain sports still prohibit women competitors. The addition of women's events to the Olympic program has always been an uphill battle. Nineteenth-century notions of women's frailty and the potential dangers to their reproductive health have held sway for decades beyond the dissolution of these myths and the obvious success of high-performance women athletes with no negative health repercussions. Opposition to women's involvement in sports was strongest through the first six decades of the twentieth century, which was also a period of growth and development in the modern motion picture industry.

As women athletes of all social classes and more diverse races were succeeding as high-performance athletes in the Olympics, concerns regarding their femininity and sexuality persisted. Gold medal contenders in track and field and various team sports were suspected of being males masquerading as females. How could women be that good? In 1968 the International Olympic Committee (IOC) began testing all women athletes in the Olympics to ensure that they were female (Daniels, "Gender Verification"). This practice spread to other world championships as women improved in sports and shattered world records set by men not long before. The practice of sex testing or gender verification came under strong censure, and the IOC finally curtailed the practice for the 2000 Olympic Games in Sydney.

Questioning the sexuality and femininity of women athletes did not end when the testing was stopped. Girls and women in sports continue to face criticism from various media, school athletic departments, and many in the public who see women as trespassers into this still male domain (see Daniels, "Gender Verification"; and Suggs).

Lights, Camera, Action

Sports had a significant role to play in the creation of the very first moving picture. As the technology of still photography developed in the late 1800s, the ability to capture images of moving objects—mostly people and

animals—improved. The first moving pictures were actually series of still photographs shown at a rate that took advantage of the phenomenon of persistence of vision. This optical process tricks the brain into seeing normal motion when one image is superimposed on another at a rate of projection equal to that of the rate of pictures taken—generally, twenty-four images per second for normal human motion. Children's toys such as flipbooks and the early nickelodeons are designed on this principle.

Eadweard Muybridge, a California photographer, was the first known producer of serial motion photographs. As the science of photography advanced, he used a variety of techniques, including multiple cameras and trip wires, to obtain photographs in series. His early works were displayed on a device he called a zoopraxiscope (see Muybridge). The first images that Muybridge used in his work were of a running horse, but he quickly turned his interest to the human body in athletic actions.

In 1883 the University of Pennsylvania chose to support a program in photographic research, focusing primarily on human movement. Muybridge provided his services to the faculty. In the introduction to the book *The Human Figure in Motion*, Robert Taft, a professor at the University of Kansas, wrote, "The men and women who performed before his battery of cameras were, in part, connected with the university. The 'professor of physical culture,' 'the champion runner,' 'instructors at the Fencing and Sparing Club' and a 'well-known pugilist' were among the male performers. The women were chiefly—since many of them appeared nude—professional artists' models, but the *premiere danseuse* of one of the Philadelphia theatres also danced before the 48 cameras on the university campus" (Taft, quoted in Muybridge x). The hundreds of sequences, composed from thousands of individual photographs, showed women and men in a variety of movements. These sequences had an important impact on physical culture as well as visual art because accurate motion could finally be captured and the detail of human movement shown.

Muybridge took hundreds of sequences of photographs of men and women performing myriad tasks. Men were photographed performing actions from daily life such as swinging an axe, carrying a rifle, and digging with a spade, but the majority of the sequences of men's movements were related to sports. Muybridge captured men walking, running, jumping, hurdling, and throwing balls, a javelin, and a discus. He filmed sequences of men kicking balls and striking with tennis rackets and baseball bats. He captured boxing, wrestling, acrobatics, and fencing. The variety and

number of sporting activities show how well sports movements lent themselves to film.

Although Muybridge captured some women throwing balls, jumping, running, and dancing, the majority of the sequences of women illustrated women carrying out somewhat bizarre, if not presumably feminine, activities such as "walking with hand to mouth," "walking and turning while pouring water from a watering can," "turning, throwing a kiss, and walking upstairs," and "turning while carrying fan and flowers" (Muybridge xvi–xvii). The sporting movements caused great excitement in the audiences in both Europe and North America (see Taft).

Sports on the Silver Screen

The first commercial motion picture was made and shown in New York City in 1896. The film was a staged remake of the prizefight between Gentleman Jim Corbett and Pete Courtney (*Sports on the Silver Screen*, 1997). Boxing lent itself naturally to early motion picture technology restrictions. The ring became a stage on which the motion was confined to a small space and lighting was easily controlled. Because the plot of a fight was well understood by the audience, boxing was a good subject for silent films. However, even after talkies became possible, boxing remained a popular film subject. Within the genre of sports films, more movies have been made about boxing (a sport that might epitomize masculinity) than any other sport.

Sports heroes became natural movie stars because their popularity was already well established. Gentleman Jim Corbett became the first personality to sign an exclusive movie contract (see *Sports on the Silver Screen*). Many famous athletes became crossover stars in the movies, including Babe Ruth (*The Babe Ruth Story*, 1948), Jackie Robinson (*The Jackie Robinson Story*, 1950), Babe Didrikson Zaharias (*Pat and Mike*, 1952), Ben Hogan (*The Caddy*, 1953), and Gussie Moran (*Pat and Mike*). Many Hollywood stars fulfill their dreams of being professional athletes by creating or accepting movie roles as athletes. Kevin Costner (baseball) and Sylvester Stallone (boxing) have made numerous movies with sports themes. Some of Hollywood's most prolific and successful actors have played athletes: Robert Redford (*The Natural*, 1984), Robert DeNiro (*Raging Bull*, 1980), Gene Hackman (*Hoosiers*, 1986), Tom Selleck (*Mr. Baseball*, 1992), and even Frank Sinatra (*Take Me Out to the Ball Game*,

Pat Pemberton (Katharine Hepburn) with Mike O'Connor
(Spencer Tracy) in *Pat and Mike* (1952). Courtesy of Okla-
homa State University Special Collections.

1949) have taken up bats, balls, clubs, and gloves to play athletes on the
silver screen. Some actors have transformed themselves and their bodies in
order to depict a real or fictional athlete on the screen. Pat Morita knew
nothing about martial arts until he was cast as Mr. Miyagi in *The Karate
Kid* (1984) (see *Sports on the Silver Screen*), and Denzel Washington and
Will Smith trained and reinvented their bodies in order to become "Hur-
ricane" Carter and Muhammad Ali, respectively. Although fewer athlete
roles have been available to women, Elizabeth Taylor (*National Velvet*,
1945) and Katharine Hepburn (*Pat and Mike*) were among the first women
to take roles as athletes for motion pictures.

Sports can provide all the drama and excitement that Hollywood at-
tempts to capture in motion pictures. Drama and pathos, humor, ethos,

coming of age, fantasy, hope, and tragedy have all been captured on film through the grit, sweat, blood, sorrow, joy, and even corruption of sports. The range of films on sports includes everything from fictionalized biography (*Raging Bull; 61**, 2001), fantasy (*Field of Dreams*), make believe (*It Happens Every Spring*, 1949; *Angels in the Outfield*, 1951/1994), political issues (*Chariots of Fire*, 1981; *The Bingo Long Traveling All-Stars and Motor Kings*, 1976), prison movies (*The Longest Yard*, 1974), exploration of sexuality (*Personal Best*, 1982; *The Broken Hearts Club*, 2000), and musicals (*Damn Yankees*, 1958; *Take Me Out to the Ball Game*, 1949). Many family movies are about children and sports (*The Bad News Bears*, 1976; *The Big Green*, 1995). Sports movies cover themes from the ridiculous (*Flubber*, 1961/1997) to the sublime (*Bang the Drum Slowly*, 1973).

A film's importance can be judged to some extent by the recognition it is given through the Academy Awards. In just the third year of Academy Award presentations, *The Champ* (1931) won the Oscar for Best Actor (Wallace Beery) and Best Original Screenplay. This film about boxing was the first of many sports films to be recognized as excellent. Sports films have won the Academy Award in every major category except one. *Rocky* (1976) and *Chariots of Fire* (1981) won for Best Picture. Wallace Beery (*The Champ*) and Robert DeNiro (*Raging Bull*) won for Best Actor. Cuba Gooding Jr. (*Jerry Maguire*, 1996) and Ann Revere (*National Velvet*, 1944) were Best Supporting Actor and Actress winners. *The Hustler* (1961) won Oscars for both Art Direction and Cinematography. *Chariots of Fire* also won Academy Awards for Best Original Score, Best Costumes, and Best Original Screenplay. *Rocky* won for Best Director and Best Editing. Other Best Editing Oscars went to *Raging Bull, National Velvet*, and *The Pride of the Yankees* (1942). The one category obviously missing from this laudatory list is Best Actress.

The "All-American" Hero

One of the reasons for the popularity and success of the sports film genre is that male athletes fill a cultural need for heroes at times between wars and other aggressive political activities. "In America, sports continue to be the strongest reference point for promulgating the most sacred values of a male-dominated, success-oriented, and status seeking society" (Sabo and Runfola x). Reflection theory posits that sports are a mirror of society. If

a culture's values and beliefs are seen to be present in sports, then sports and the athlete will be seen to be a positive aspect of a society. Therefore, sports are a positive way for children to be socialized into the norms of that society.

However, sports are traditionally seen as a male activity, and the role of girls and women is tenuous at best. Sports and masculinity have become entwined to the point that the normative characteristics of a masculine male and the normative characteristics of an athlete are nearly identical. If athlete *means* masculine, where do femininity and females fit into the equation?

Another normative although generally unspoken requirement of the athlete, beyond masculinity, is that of heterosexuality.

> In our culture, male homosexuality is a violation of masculinity, a denigration of the mythic power of men. . . . In many important respects, the difference between an athlete who is homosexual and an athlete who is heterosexual is nonexistent. Sexuality has no bearing on the hitting of tennis balls, speed of skating, height of jumping, precision on gymnastics apparatus, or any other strictly athletic phenomenon. But in our culture, athletics has more than purely athletic significance. And sexuality is not just a matter of the pleasure of flesh meeting flesh. Both sexuality and athletics draw meaning from our culture's myths of sexuality and gender. Because homosexuality and athletics express contradictory attitudes to masculinity, violation and compliance respectively, their coexistence in one person is a paradox, the stuff of irony (Pronger 2–3).

To be an athlete is to be masculine and heterosexual. To be feminine and/or homosexual is antithetical to being an athlete. Thus, the foundation for the place of women in sports and in relation to sports is built. Women are assumed to be feminine, which is antithetical to sporting performance, and this reinforces the place of men as the only legitimate participants in sport.

The Distaff Side

If the majority of sports films are about men or men's sports, how does the treatment of women (and men) within these films contribute to or affect

contemporary attitudes about girls and women in general and as athletes in particular? Investigating the variety of roles for women in sport films and their relationships or the absence of relationships with men might tell us a great deal about the struggles that women athletes face today. Although there was an increase in films about women and sports in the late twentieth century, the number and popularity of these films in no way match those about men and men's sports in the same time period.

"Women Weaken Legs"

This phrase was spoken as a fact and an admonition by Burgess Meredith when he played the boxing manager in *Rocky*. A recurring theme in sport films is that women, specifically sex with a woman, will drain a man and interfere with his ability to perform as an athlete. The no sex before sport myth is a recurring theme in sports films. A scene in *Rocky* has Adrian attempting to get close to Rocky. Rocky, getting increasingly frustrated with her, emphatically states, "Hey, hey, come on. No foolin' around, awright? . . . Hey, Adrian! I'm serious now. There's no foolin' around during training. Ya unnerstan, I wanna stay strong." A similar scene in *Raging Bull* has Jackie, Jake LaMotta's wife, attempting to resist his advances, stating, "You said never to touch you before a fight" and "You made me promise not to get you excited." Jake, not able to resist his wife's eventual attention, gets out of bed and pours ice cubes down his shorts.

Whether films take the no-sex idea from sporting mythology or the myth is kept alive through sports films hardly matters. The message is that women are bad for athletes—at least during training and before competition. The curfew set for athletes is more about keeping them away from women than about getting them ready for a game. In the musical *Take Me Out to the Ball Game*, O'Brien, one of the baseball players, bemoans, "When I think of all the dames I lost because I had to be in bed by 10 o'clock. . . ."

Athletes are notoriously superstitious, and the no-sex rule is alive and well. Many professional teams still keep their players away from women before games, and the no-sex myth among boxers is as strong as ever (see Davidson). The notion of women interfering with athletic performance is taken to its ultimate conclusion in *Damn Yankees*. Lola is sent by the devil to seduce the star player from the Washington Senators and actually drain him of all his baseball skills.

"Ball Players? I Haven't Got Ball Players."

In *A League of Their Own* (1992) coach Jimmy Dugan, played by Tom Hanks, bemoans to the league representative, "Ball players? I haven't got ball players. I've got girls. Girls are what you sleep with after the game, not what you coach during the game." Once the games are over, women are for sex, and the only role for women during the game is to be a pretty cheerleader. In many films the treatment of women as sex objects is degrading and violent. Women are hardly even seen as human beings. Throughout the movie *Varsity Blues* (1999) the high school football players are constantly making crude remarks about girls and sex. Getting sex is the only reason to be with a girl. "Will ya listen to me? Awright. Bitches are all just panty droppers. Listen, you give 'em a Percoset, two Vicadin and a couple of beers, and the panties drop. Very nice. Very nice." Not only are drugs and coercion seen as appropriate ways to treat a woman, physical violence is also seen as normal behavior. A football player at a party, carrying a baseball bat, is singing, "She broke my heart, so I broke her jaw." His friends received this message with cheers.

Even in more lighthearted movies, such as the musical *Take Me Out to the Ball Game*, Ed, one of the players, says, "Danny, tell 'em about the girls, the quails, the mice." Danny goes on to sing a song called "Love 'Em and Leave 'Em." The notion that women, and by extension women athletes, are considered somewhat less than human is illustrated at a later point in this film when the three star players are spying on the team owner as she swims. She is never referred to as a woman, and the implication is that sex is all she wants:

O'BRIEN: Not bad for a dame who can field a hot grounder. Denny, I have a hunch that girl is human.

RYAN: No!

O'BRIEN: If she's a dame, she wants romance. And *she's* a dame.

GOLDBERG: It's been my experience that the athletic type girls, like Higgins, might go for the caveman approach, like this . . . come 'ere!

The roles that women are allowed to play in sports films are those of wife (usually seen sitting in the stands in the "Players' Wives" section)

and cheerleader. The cheerleader in sports movies is often viewed as a potential sex partner, and it is imperative that these women possess heterosexual femininity. In *What Price Victory* (1988), Robert Culp, who plays the arrogant president of the football boosters club of a fictional NCAA Division I university, remarks to team officials, "While we're at it, can we get some real good lookin' cheerleaders?" In *Eddie* (1996) the new owner of the New York Knicks announces to the crowd that the games will be more entertaining and that "you're gonna see cuter cheerleaders." This is done only to increase the number of fans and make more money. That cheerleaders supply something more than just enthusiasm to the players and fans is also evident in *The Longest Yard*. A football game between the prisoners and the guards is staged at a prison. The cheerleaders for this game are other prisoners, dressed in drag. If the only function of cheerleaders was to lead cheers, then the men would not have to dress in drag to play the part.

"We're Honored to Have the Lady Athlete"

In the made-for-television movie *Quarterback Princess* (1983), Tammy Maida has successfully tried out for quarterback on a high school football team. When a teacher in Tammy's school takes attendance on the first day, she makes the statement, "We're honored to have the *lady* athlete in our class." The teacher's emphasis on the word "lady" is troubling because it seems to imply that there are no athletic teams for girls in this school (that is, that the other athletes are all boys) and that the only way to be an athlete is to play on a boy's team. The idea that women cannot be real athletes is put forward in a number of sports films. In *What Price Victory,* the superiority of college football over women's sports is implied by the president of the booster club, who encourages the university to bend rules to recruit the best football players. He says, "Of course, we're not talking ladies' volleyball here or tippy-toe gymnastics. We're talking major ball."

When a woman athlete does appear in a sports film, she is generally the only woman on a team, which either causes conflict among the players and other teams or is looked at as some sort of joke. In *Necessary Roughness* (1991), when the coach recruits a woman soccer player to be a place kicker on a losing football team, the players either comment on their embarrassment at having a woman on the team or focus on the woman as a sex object. In one exchange, one of the players laments, "We'll be the

laughing stock of college football." Once the players see the skill of their new kicker, they are still less impressed with her as an athlete than as a woman: "She's got some foot . . . and it keeps getting better on the way up."

In both *The Big Green* and *Little Giants* (1994) a girl is the best player on her respective soccer and football team, but her presence creates conflict. In *The Big Green* an opposing coach pulls his all-boys team off the field, remarking, "Get rid of the girls." His comment implies that the game would be diminished and would embarrass his players if they had to compete against (and possibly lose to) girls. Becky (Icebox) O'Shea is the best player on her football team in *Little Giants*. A very cocky boy will not play on a team with girls. Because Becky likes this boy, she quits the team and becomes a cheerleader (with all the other girls). Of course, she comes back to the team in the final crucial moments to win the game, but she struggles with her role as an athlete because of the attitude of the boy.

Even when female players are seen to be skilled, their femininity is highlighted at the expense of their abilities. In *A League of Their Own* Marla Hooch, a powerful switch hitter, is going to be left behind because the scout does not think she is pretty enough. The uniforms the players are required to wear have short skirts and are designed to show off the femininity and sex appeal of the players. When the players comment on the inappropriate uniforms— "Excuse me, that's not a baseball uniform"; "What do you think we are? Ball players or ballerinas?"—the league representative lays down an ultimatum: "Ladies, if you can't play ball in this, you can't play ball with us. Right now there are thirty-eight girls getting train tickets home who would play in a bathing suit if I asked 'em." The players are also required to go to charm school so that they will appear feminine and ladylike on and off the field. The faux newsreels, which mimic the original ones made of the actual All-American Girls Baseball League (AAGBL) players, show the players powdering their noses, pouring coffee, and knitting, rather than playing ball. At the end of the first season, even though the league eventually became a very successful sporting and commercial enterprise, Mr. Harvey, the owner of the league, expresses his real feelings about women and sport when he states, "I love these girls. I don't need 'em, but I love 'em. . . . There is no room for girls' baseball in this country once the war is over." Although the actual AAGBL did continue for a few years after the war, American sensibilities in the 1950s did not support such a masculine activity for young women.

In the majority of sports-themed films, women are often invisible or

In *A League of Their Own* (1992), the "ladies" are required to wear short skirts. Courtesy of Oklahoma State University Special Collections.

silent. In sports films in which women actually are portrayed as athletes, the general atmosphere is less misogynistic, but sexist values are no less apparent. In films such as *National Velvet, Pat and Mike,* and *A League of Their Own,* in which women athletes are central to the story line, the principal female characters (played by Elizabeth Taylor, Katharine Hepburn, and Geena Davis, respectively) are strong and not willing to be maltreated by the men who control their sports and often their lives.

In sports films in which there are no women athletes (for example, *Rocky, The Longest Yard,* and *Raging Bull*) or in which they are present as an anomaly (*Necessary Roughness* and *The Big Green*), the women are rarely given the opportunity to rebuff the comments and come-ons of male athletes, coaches, fans, parents, and reporters who belittle or vilify them. In sports films about male athletes, if there is a leading role for a woman, she often contributes to the misogyny by referring to the male athletes as ladies or girls or by implying the sexual connection of women to the athletes (e.g., *Eddie* and *Bull Durham,* 1988).

Gender Slurs

The representation of girls and women in sports films reflects tolerance at best. Even in films that are primarily about women athletes, the players are judged in relation to men or have their femininity and sexuality questioned. In films that highlight highly successful women athletes, such as *A League of Their Own* or *Pat and Mike*, there is still an undercurrent of caution about women in sports, especially sports traditionally deemed masculine.

Organized youth, school, and professional sports were originally designed by and for boys and men. According to Messner, "Organized sport, as we know it, emerged largely as a masculinist response to a crisis in the gender order of the late nineteenth and early twentieth centuries. The world of sport gave men a retreat from what they feared was a 'feminized' modern culture, and it gave white upper-class men (initially) and working-class and minority men (eventually) a means of 'naturalizing' dominant forms of masculinity. Throughout most of the twentieth century, this masculine institution of sport existed alongside a vibrant but much less visible tradition of women's sport" (159). The beliefs that only males can participate in sports was reinforced through the popularity of sports films (and other media) about men and boys, which contributed to the invisibility of women's sports and helped to establish the normative domain for all sporting contexts as male.

Girls and women have always been involved to some degree in sports and physical activities. Age, race, and socioeconomic class might have dictated the "appropriate" activity for participants, but information to illuminate this issue is as absent from the silver screen as it is from historical accounts. What does show up repeatedly in sports films is the attempt to motivate male athletes through the vilification of women and homosexuals. If masculine males alone have a right to the domain of sports, then the implication that an athlete is not masculine (i.e., feminine or homosexual) would not only impute his ability as an athlete but would also raise the question of who he is as a man.

The relationships between male athletes and women, as represented in the movies, are primarily sexual, and if the woman is a teammate, she is the object of reluctant acceptance as a teammate at best. Nothing is a greater insult to a male athlete in these films than to imply that he is female, feminine, or homosexual. Gender slurs and insults that are directed toward men, implying that they are less than masculine or not completely

heterosexual, have been used time and again by coaches, fans, and other athletes to motivate a man to strive for greater athletic success. Countless sport films show this dynamic, as do real-life practice and game situations and locker room interactions (see Curry).

Girls Are the Worst!

Boys learn very early to believe that sports are their exclusive domain, no matter how good a girl is as an athlete. Girls are ridiculed and used as the basis for some of the worst insults that boys can hurl at one another. In *The Sandlot* (1993), a film about a group of misfit boys who join together to play baseball to support the one truly skilled athlete in their group, the accusation that a member of the rival team plays "like a girl" is the cause of a challenge between the two teams. In a toe-to-toe confrontation, the following dialogue is exchanged by one boy from each of the opposing teams:

SANDLOT PLAYER: Watch it, jerk.

TEAM PLAYER: Shut up, idiot.

SANDLOT PLAYER: Moron!

TEAM PLAYER: Scab eater!

SANDLOT PLAYER: Fart smeller!

TEAM PLAYER: You bob for apples in the toilet . . . and you like it!

SANDLOT PLAYER: You play like a GIRL!

This last insult, delivered with more gusto than any of the previous indignities, causes the other players on both teams to get very quiet. The looks on their faces turn to horror. The player from the organized team is so shocked by this barb that he is momentarily struck dumb, knowing that he could not possibly top this ultimate insult. The only possible response is for the team to accept the challenge of a game in order to prove themselves as athletes and as males.

It is not only young boys who lament any similarities between themselves and females. In one scene in *Raging Bull*, Robert DeNiro, playing Jake LaMotta, is lamenting that he will never be able to fight Joe Louis, the best fighter of his day. In a conversation with his brother, LaMotta

bemoans, "I got these small hands. . . . I got . . . girl hands. . . . Like a girl." He attributes his eventual failure to a quality that he deems feminine.

In sports movies that involve teenage boys and young men, the juxtaposition of sports, girls, and sexual innuendo is frequently present. Throughout the football film *Varsity Blues*, players are constantly talking about girls as sexual objects. They demonstrate their superiority over friends and other players by referring to them through slang expressions describing females. Lines such as "Hey, Mox, you skinny-assed bitch, let's roll!" are heard throughout the film. To show his contempt for the team's poor level of play, the coach in *Varsity Blues* says to the players, "Why don't you let the pom-pom girls play for you?" This slur is meant to humiliate the players by equating them with pretty girls, who have been referred to throughout the movie as sex objects. *Above the Rim* (1994), one of a relatively new genre of sports films that highlight entire groups of young black males, rather than the one breakthrough hero on an otherwise white team, includes street language in the dialogue between players. Throughout the film the basketball players refer to each other as "pussy" or "bitch" in lines such as "You're a pussy . . . without the hair." Using reductive language to equate women to animals, toys, food, and body parts is a hegemonic practice that keeps males in an artificially superior position to females (see Ayim; and Baker). The practice is used frequently in sport films about adolescent males.

Attempts to motivate male athletes through language that vilifies females are common in sport films focusing on a variety of sports and settings. The level of sophistication of the language may vary, but the common denominator is to slur women in an attempt to motivate male athletes to perform better or train harder. The following segments of dialogue are representative of the numerous examples in sport films: "You're playing like a bunch o' girls out there, everyone of ya!" (*The Longest Yard*); "Sit down and shut up you mouthy prima donna!" (*The Natural*); Crush: "I don't believe in fighting." Ebbie: "That's sweet, you pussy!" (*Bull Durham*); and "If you're going to act like a loser, raise your hand. If you're going to act like a pussy, raise your hand!" (*Any Given Sunday*, 1999). Even in the movie *Eddie*, in which Whoopi Goldberg plays a fan-coach of the New York Knicks, Goldberg's character repeatedly refers to the players as girls and ladies in both practice and game situations in an attempt to get their attention and performance.

Gender slurs can also be combined with other epithets to raise the

"You're playing like a bunch of girls" (*The Longest Yard*, 1974). Courtesy of Paramount Pictures.

level of some male athletes over other male athletes. In *Slap Shot* (1977), as a Franchophone hockey player from an opposing team is announced to the crowd, one of the home team players calls him a "frog pussy," slandering both his gender and his heritage. In a later scene in the same film, a teammate of the player who made this slur says to his own teammate, "You're the biggest fuckin' pussy in the league." It is not just rivals who are the objects of gender slurs.

The Only Thing Worse Is Bein' a Fag

Misogynistic comments are not the only slurs that coaches, athletes, and spectators use to put down or motivate male athletes. An even worse insult to an athlete's masculinity than implying that he is feminine or female is to question his heterosexuality. Because sports are seen as "overtly masculine and heterosexual," the very idea of homosexual male athletes is untenable and even frightening to athletes who share homosocial encounters on and off the field (Messner 155). The presence of a gay man in a team sports environment challenges the well-constructed myth of the masculine ath-

lete, not to mention the masculine male, at its very center. Homophobia in sports is demonstrated through words and actions in the same way and for the same purposes as misogyny.

In *Slap Shot*, one of the early age-restricted R-rated sports films, the hockey players are participating in a fashion show for publicity. One of the players exclaims in protest, "I look like some cock suckin' faggot. Nowhere in my contract does it say I gotta make a fool outta myself." Throughout this film players refer to each other and taunt each other with accusations of "faggot" or "fag." In *Bull Durham*, another R-rated sports film, the rookie pitcher is enticed into wearing black underwear and a garter belt to help his concentration. He defends this strange behavior and tells a teammate, "This underwear makes me feel kinda sexy. Don't make me a queer, right? Right! I ain't no queer, no, I ain't." Later in the film, a veteran player gets into a shouting match with an umpire and calls him a cocksucker. Not surprisingly, a fight breaks out.

Psyching players up in the locker room before a game or during half-time became an important vehicle in sports films beginning with the "win one for the Gipper" speech reenacted in the 1940s film *Knute Rockne— All-American*. The ever-present locker room inspirational speech was defamed by a football player in *Varsity Blues*, who intones over and over again before a game, "And, yea, though I walk through the valley of the shadow of death, I will fear no faggot from Bingville."

The Critic's Corner

At the end of the nineteenth century, cautiousness about girls' and women's participation in sports was related primarily to the perceived potential for harm to the female reproductive system. However, "ladylike" activities such as dance, gymnastics, and upper-class women's sports did not cause concern. Rather, it was the more rough-and-tumble activities, those considered more appropriate for boys, that were prohibited for girls. Although the notion that vigorous physical activity will harm women has been disproved, it still surfaces from time to time, and resistance to women athletes' participation still lingers in all sports.

Throughout the twentieth century two different but related themes have plagued women athletes: masculinization and lesbianism. The concerns over reproductive harm have been replaced by a possibly greater need to preserve the domain of sports for men. If the athlete is the epitome of

masculinity, then the female athlete must also be masculine. If the female athlete is masculine or wants to participate in masculine activities, then maybe she really wants to be a man. This idea often evolves into the idea that women athletes are lesbians (see Cahn; Daniels, "Woman/Athlete"; and Lenskyj). The association of women athletes with lesbianism "roils beneath the surface as a subtext of all discussions about women athletes and their appearance, prowess, and acceptability" (Griffin ix).

Sports films' language and innuendo about women in general and women athletes in particular support the stereotypes that have plagued women athletes for more than a hundred years. Many sports films, as well as other media, have reinforced misogynistic attitudes toward women athletes that have blocked their entry into sports, camouflaged their improvements and successes, and relegated them to second-class status with respect to sports. Attacks on femininity and homosexuality directed toward male athletes have solidified a popular understanding of athleticism as male—as masculine and heterosexual. Women, then, are trespassers in the domain of sports.

"Women's serious participation in sport brings into question the 'natural' and mutually exclusive nature of gender and gender roles. If women in sport can be tough minded, competitive, and muscular, too, then sport loses its special place in the development of masculinity for men" (Griffin 17). The sports film, and its often misogynistic celebration of male athleticism, might be one of the barriers to women's full acceptance into the sports world.

Social movements from the latter part of the twentieth century strongly affected social views about gender, race, and sexuality. Many recent motion pictures depict women and persons of color in a more positive light, although they still include many stereotypes. White women are most frequently cast in roles involving gender-appropriate activities such as figure skating, gymnastics, and cheerleading. Women and men of color are seen in films about basketball and boxing—activities traditionally associated with the lower socioeconomic classes to which nonwhites are often assigned. There are, of course, exceptions, but they are truly exceptions and not yet the norm in motion picture story lines.

That's a Wrap!

Nineteenth-century beliefs about gender and gender roles, Baron Pierre

de Coubertin's ideals in resurrecting the Olympic Games, and Eadweard Muybridge's breakthrough photographic techniques that led to the beginnings of the motion picture industry are all part of a complex tapestry that has sanctified sports as part of the North American male culture and, concurrently, vilified sports for women. It is unlikely that the gender and sexual slurs used in movie dialogue to motivate male athletes are included for the intended purpose of demeaning women and women athletes. The effect, however, frequently repeated and coupled with other misogynistic beliefs and practices, may be exactly that. One of the barriers that women athletes still must overcome is suggested in this piece of dialogue from *Pat and Mike*, a sports film primarily about women athletes. When a golf pro asks Katharine Hepburn's character "What's your handicap?," her response is simply, "A fellah."

Works Cited

Above the Rim. Directed by Jeff Pollak. Los Angeles: Alliance/Newline Cinema, 1994.

Any Given Sunday. Directed by Oliver Stone. Burbank, CA: Warner Brothers, 1999.

Ayim, Maryann. "Wet Sponges and Band-aids—A Gender Analysis of Speech Patterns." In *Women and Men: Interdisciplinary Readings on Gender*, ed. Greta Hoffman Nemiroff. Toronto: Fitzhenry and Whiteside, 1987.

Baker, Robert. "Pricks and Chicks: A Plea for Persons." In *Philosophy and Sex*, ed. Robert Baker and Frederick Elliston. Buffalo, NY: Prometheus Books, 1984.

The Big Green. Directed by Holly Goldberg Sloan. Burbank, CA: Disney/ Caravan Pictures, 1995.

Boutilier, Mary A., and Lucinda SanGiovanni. *The Sporting Women*. Champaign, IL: Human Kinetics Publishers, 1983.

Bull Durham. Directed by Ron Shelton. Santa Monica, CA: MGM (Orion), 1988.

Cahn, Susan K. *Coming on Strong: Gender and Sexuality in Twentieth-Century Women's Sport*. New York: The Free Press, 1994.

Chariots of Fire. Directed by Hugh Hudson. Burbank, CA: Warner Brothers, 1981.

Cochrane, Jean, Abby Hoffman, and Pat Kincaid. *Women in Canadian Life: Sports*. Toronto: Fitzhenry and Whiteside, 1977.

Curry, Tim. "Fraternal Bonding in the Locker Room: A Profeminist Analysis of Talk about Competition and Women." *Sport Sociology Journal* 8 (1991): 119–35.

Daniels, Dayna B. "Gender (Body) Verification (Building)." *Play and Culture* 5 (1992): 370–77.

———. "Woman/Athlete: Can You Tell One When You See One?" *Canadian Women Studies/les cahiers de la femme* 21 (2002): 64–72.

Davidson, Sean. "Debunking the No-Sex Rule." *The Toronto Globe and Mail*, April 30, 2002, R5.

Eddie. Directed by Steve Rash. Burbank, CA: Hollywood Pictures, 1996.

Field of Dreams. Directed by Phil Alden Robinson. Universal City, CA: Universal Studios, 1989.

Griffin, Pat. *Strong Women, Deep Closets: Lesbians and Homophobia in Sport.* Champaign, IL: Human Kinetics, 1998.

Henderson, Carla M., Deborah Bialeschki, Susan M. Shaw, and Valerie J. Freysinger. *Both Gains and Gaps: Feminist Perspectives on Women's Leisure.* State College, PA: Venture Publishing, 1999.

Hoosiers. Directed by David Anspaugh. Santa Monica, CA: Orion Pictures, 1986.

A League of Their Own. Directed by Penny Marshall. Culver City, CA: Columbia, 1992.

Lenskyj, Helen J. *Out of Bounds: Women, Sport and Sexuality.* Toronto: The Women's Press, 1986.

Little Giants. Directed by Duwayne Dunham. Burbank, CA: Warner Brothers, 1994.

The Longest Yard. Directed by Robert Aldrich. Los Angeles: Paramount, 1974.

Messner, Michael A. *Power at Play: Sports and the Problem of Masculinity.* Boston: Beacon Press, 1992.

Muybridge, Eadweard. *The Human Figure in Motion.* New York: Dover Publications, 1955.

National Velvet. Directed by Clarence Brown. Santa Monica, CA: MGM, 1945.

The Natural. Directed by Barry Levinson. Culver City, CA: TriStar Delphi/Columbia, 1984.

Necessary Roughness. Directed by Stan Dragotti. Los Angeles: Paramount, 1991.

Pat and Mike. Directed by George Cukor. Santa Monica, CA: MGM, 1952.

Pronger, Brian. *The Meaning of Masculinity: Sports, Homosexuality and the Meaning of Sex.* New York: St. Martin's Press, 1990.

Quarterback Princess. Directed by Noel Black. Los Angeles: Twentieth Century Fox, 1983.

Raging Bull. Directed by Martin Scorsese. Santa Monica, CA: MGM/UA, 1980.

Rocky. Directed by John C. Avildsen. Santa Monica, CA: MGM/UA, 1976.

Sabo, Donald F., and Ross Runfola. *Jock: Sports and Male Identity.* Englewood Cliffs, NJ: Prentice-Hall, 1980.

The Sandlot. Directed by David Mickey Evans. Los Angeles: Twentieth Century, 1993.

Sayers, Janet. *Biological Politics: Feminist and Anti-Feminist Perspectives.* New York: Tavistock Publications, 1982.

Simri, Uriel. *A Concise World History of Women's Sports.* Netanya, Israel: Wingate Institute for Physical Education and Sport, 1983.

Slap Shot. Directed by George Roy Hill. Universal City, CA: Universal, 1977.

Sports on the Silver Screen. New York: HBO Sports, 1997.

Suggs, Welch. *A Place on the Team: The Triumph and Tragedy of Title IX.* Princeton, NJ: Princeton University Press, 2005.

Take Me Out to The Ball Game. Directed by Busby Berkeley. Santa Monica, CA: MGM, 1949.

Varsity Blues. Directed by Brian Robbins. Los Angeles: Paramount, 1999.

What Price Victory. Directed by Kevin Connor. Burbank, CA: Warner Brothers, 1988.

As American As . . .

Filling in the Gaps and Recovering the Narratives of America's Forgotten Heroes

NOVELIST WILLIAM BRASHER'S *The Bingo Long Traveling All-Stars & Motor Kings* (1973), a fictitious representation of the black baseball leagues of the 1930s, is the definitive work on the leagues, its players, and the effects of race on the quality of life among blacks relegated to the margins of society. In 1976, three years after the novel's initial publication, the movie based on the novel, starring 1970s icon Billy Dee Williams as Bingo Long and the incomparable James Earl Jones as Leon Carter, made its debut on the big screen. Throughout the film, baseball represents a critical vehicle in the construction of African American life, the men who played the game, and the spectators in the stands. *The Bingo Long Traveling All-Stars & Motor Kings* reveals the game of baseball as a unique American institution, one that is capable of transforming the smallest man into the tallest hero. Throughout the film and the book, Long and Carter represent the amazing athletes of the Negro Leagues, who often "showboated and clowned, but never failed to play great baseball."[1]

As the film begins, the setting is a Negro Leagues baseball game, and we hear a stirring in the stands and then a chant that is unmistakably harmonious. "Invite pitch, invite pitch, invite pitch," the crowd yells in the direction of the home team dugout, as the star pitcher of the St. Louis Ebony Aces, Bingo Long, makes his way to the mound. Long listens as the crowd begins to resemble a congregation of hand-clapping, foot-stomping churchgoers whose spiritual leader has climbed into the pulpit and is preparing to lead his faithful flock on a spiritual journey.[2] From the home team's dugout, the remainder of the Ebony Aces run to the first-base line and stand at attention, as if forming a receiving line for the divine one,

Billy Dee Williams as Bingo Long in *The Bingo Long Traveling All-Stars & Motor Kings* (1976). Courtesy of Universal Home Video.

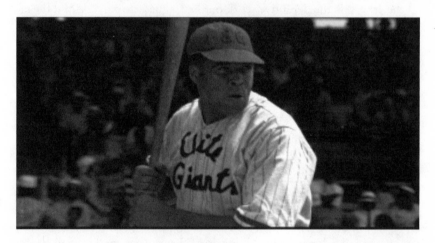

James Earl Jones as Leon Carter in *The Bingo Long Traveling All-Stars & Motor Kings* (1976). Courtesy of Universal Home Video.

waiting for him to command them to action. Long climbs to the top of the mound and turns to the crowd. As he raises his hands, a calm comes over the masses in attendance. They listen as Long answers their cries. With his arms uplifted and a smile on his face, Long breaks the silence and the crowd responds in a cadence familiar to the black church: the African American tradition of call and response. Calling for those sinners present to repent and be saved, Long begins his sermon on the mound:

LONG: Who's

CROWD: Who's

LONG: gonna hit

CROWD: gonna hit

LONG: my

CROWD: my

LONG: invite pitch?

CROWD: invite pitch?

The answer comes swiftly from the visitors' dugout, as we hear and see his footsteps moving toward the steps leading up to the field. Leon Carter of the Baltimore Elite Giants has waited patiently, anticipating the calling, and now will participate in the spectacle that has begun to unfold within the context of a black baseball game. Carter is a big man whose large, strong, and nimble hands are important to the drama's unfolding. He reaches down and picks up four wooden bats. He swings the bats to and fro, discarding three of the four as he strides to home plate to meet the man on his challenge.

"You put the ball over the plate, I'll put it over the fence," Carter shouts to Long on the mound. As Carter readies himself at the plate, Long knuckles the ball in his glove, winds up, and throws the ball in a straight line to the waiting catcher poised at the back of home plate. "Strike one," the umpire yells, as Carter looks down at the ball, still hot in the catcher's glove. As Long motions for the rest of his team to join him on the field, Carter calls out to him:

CARTER: Hey Bingo, I do believe you be slowin down.

LONG: It ain't nice to be throwin hard to old men.

CARTER: Don't make any excuses for your arthritis now.

LONG: Ah, okay Monkey Face, just for that you're going to get a taste of my vanish ball.

Playing along with Long, the catcher of the Ebony Aces replies, "Go on and show it to him, he can't see it—I can't see it." Long knuckles the ball in his glove once again as Carter digs in for the second pitch. The wind-up,

the pitch—"Strike two!" the umpire yells from behind the plate, as Carter begins to unfurl his twisted body. Embarrassed by his showing, and needing to gain the edge over Long in some way, Carter decides to try to distract him by humiliating him in front of his teammates, fans, and friends:

CARTER: Bingo, I heard that you done taken up with a hot number name of Violet.

LONG: Well, you heard right. Wait till you lay eyes on her.

CARTER: Well, if that's Violet Granite you talking about, I done laid more than eyes on her already.

In an instant Carter has gained Long's attention, distracting him from his previous concerted efforts. As Long winds up for the third pitch, he chides Carter, saying, "Ah Leon, you trying to get my dander up, but I is un-ruffable." Carter, however, connects with the pitch, hitting the ball long and straight over the centerfield wall, out of the ballpark. As Carter struts around the bases, smiling and tipping his "ball hat" to the ladies in the stands and the gents on the field, Long quietly tries to save face, like an adolescent in front of his peers. "I's getting tired of Violet anyhow," he says. Crossing home plate, Carter makes sure that Long sees him strut like the top cock on the block and then makes his way to his teammates waiting in the visitors' dugout.

Both dramatic and true to form as Hollywood productions go, what is most significant about this film is that it was produced by a major motion picture studio. What the film lacked in critical social commentary and story line, it more than made up for in its dialogue and true-to-form depiction of the life of the black ballplayer during the 1930s. The multiple stories involved in the production and maintenance of the black baseball leagues can only be fully understood by those privileged to understand the significance and various meanings associated with certain competitions and performances. Moreover, the film and the light it sheds on racial, class, and gender issues that are directly connected to the economic prosperity, political progress, and social reality of the community must be read as an interconnected narrative. In addition, the almost mythic quality of the film adds to the folkloric quality of the black baseball leagues and our understanding of the players who played during that era of American baseball.

Enhanced by shots of cotton fields, dirt-clogged baseball diamonds, and "joy houses" filled with whiskey, women, and what appears to be a

commercial rendition of the blues, *The Bingo Long Traveling All-Stars &*
Motor Kings celebrates the ability of "black folk" to take from life what
they will, leaving the rest for others to mull over. Indeed, within the film
we recognize the phenomenal survival skills of a people forged by the
fires of slavery. The black ballplayers used these skills to take advantage
of the competition between white players. By cloaking their abilities as
athletes beneath showboating and clowning, and "playing" with well-
known stereotypes to gain access to economic resources, the ballplayers
demonstrated their ability to survive and resist notions of their so-called
inferiority. These hard-learned, yet widely accepted survival techniques
proved to be an important source of inspiration for both white and black
ballplayers, enabling the further development of baseball as America's
national pastime. For many would-be black ball players, the constant task
of having to reinvent oneself for the sake of economic survival created the
opportunity to partake in a variation of the American dream unknown to
most white Americans.

More than a Game: Challenging White Supremacy through Narrative Performances

Throughout the twentieth century and into the twenty-first, Americans
have identified sports participation as a critical vehicle to achieving the
American dream. Sports advance social norms, goals, and values based
on participation, spectatorship, and what it means to be American.[3] Be-
cause they are viewed as heroic gestures of courage, fortitude, and faith,
outstanding athletic performances have traditionally determined who can
fully participate in athletic spectacles and receive the full benefits of that
participation. One would suppose, then, that African American males, who
make up a majority of the participants in both professional and collegiate
sports, would have a positive presence in major motion pictures, where
their individual successes and collective contributions to the development of
sports would be readily accounted for as narratives of transformation.

Within this collection of narratives, there are numerous individuals
who have bravely overcome circumstances such as poverty and racism,
repudiating notions of their inferiority by actively seeking access to the
exclusive rites of manhood coveted by white men. In fact, more than
fifty years after Jackie Robinson broke the color barrier in Major League
Baseball, African Americans in general and African American athletes in

particular still draw sustenance from Robinson's demonstration of strength and fortitude. Among the majority of sports fans and spectators, African American male athletes such as Robinson are regarded as heroic; in some cases these sports heroes become lionized examples of manhood, dignity, and nobility. Yet the big screen lacks fair and appropriate representations of African American male athletes as well-rounded, multidimensional men. Moreover, in relegating the achievements of African American sports figures to obscurity, by limiting and condensing their lives to documentary features and television treatises concerned more with revealing the "truth" about a majority of African American male athletes and their flawed and defective character, the industry discounts the individual and collective accomplishments of a majority of athletes as trivial and unimportant.

In order to understand the reasons for the film industry's lack of interest in representing the positive contributions of African Americans to the development of sports and the advancement of the American dream as a concept, this essay examines the absences, silences, and misrepresentations of black athletes in a number of films about baseball, both before and after 1991, the year that former Commissioner of Major League Baseball, Fay Vincent, publicly apologized for organized baseball's part in excluding African Americans from participation in America as full-fledged citizens. Indeed, within the last seventy-five years, several sports films about African American athletes have been produced for movie theater audiences, including *The Joe Louis Story* (1953), *The Jackie Robinson Story* (1950), and *Ali* (2001), all of which have sought to capture the essence of particular athletic performances and their intersecting meanings for the consuming black and white masses. However, when viewed in the context of the number of Hollywood films in which sports is a dominant theme, African American males are significantly underrepresented and overtly stereotyped.

Within the sports film genre, baseball films in particular have highlighted sports' nostalgic significance to American males' rites of passage, individuality, and creed of fair play. *The Pride of the Yankees* (1942) is widely acclaimed as an essential resource on Hollywood's influence on our understanding of the importance of athletes to the American identity.[4] This treatise on the life of professional baseball player Lou Gehrig, who was canonized as the "Iron Horse" because of his work ethic and consistency, captures the transfixing and mythologized essence of what a simple, hard-working, family-minded, clean-cut all-American boy could achieve.

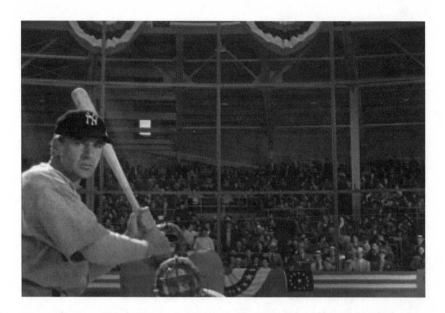

Gary Cooper as Lou Gehrig in *The Pride of the Yankees* (1942). Courtesy of Universal Home Video.

Gehrig, played by Gary Cooper in the film, is forced to retire from baseball after being diagnosed with amyotrophic lateral sclerosis, now known as Lou Gehrig's disease. The reality of Gehrig's mortality as an imperfect, flawed human being is explicit throughout the film. There is no doubt about the film's sentimentality. In fact, Sam Woods, the film's director, treats Gehrig's life with an easy familiarity, almost as if Gehrig's accomplishments in baseball were truly significant to a majority, if not all, Americans. However, it is Gehrig's ethnic background as the son of hard-working German immigrants (Gehrig's mother worked as a cleaning lady and his father did whatever work he could) who aspired to achieve the American dream through their own efforts and faith in the system and through their son's projected success, that is presented in the film as a form of contingent American whiteness. In other words, Gehrig's identity, as well as that of his parents, becomes deeply connected to his performance on the makeshift baseball fields of his youth and later on the football fields at Columbia University, where his status as an All-American is connected to his spectacular performances as a scholar-athlete.

Understandably, it is this easy familiarity with and appeal to working-class whites that Woods takes advantage of throughout the film. Fortunately

for Gehrig, his ability to achieve success on the playing field and thereby achieve the American dream was not limited by his ethnic background, religion, or the occupations of his parents. The absence of any such limitation is a reality that a majority of African Americans could not fully take advantage of or identify with. Therefore, one of the film's most dominant underlying themes—the opportunity that *all* Americans have to pursue success in sports—is both deceiving and cruel. The absence of African Americans in films such as *The Pride of the Yankees* obfuscates the reality of the opportunities the films present as universal.

Especially during the first half of the twentieth century, African Americans were considered second-class citizens. They were not included in the collective definition of Americans as people who were willing to work hard, sacrifice, and remain unapologetic for their place of origin. As a result, widely held notions of African Americans as biologically inferior and rampantly immoral became grounded in motion pictures, the most popular mass media source of cultural communication. As early as 1915, after years of honing his craft as a director, D. W. Griffith introduced Americans—African Americans included—to what he and a majority of whites had designated as the greatest threat to democracy and liberty: African American men possessing sovereignty. In *The Birth of a Nation* (1915), his film adaptation of the overtly racist novel *The Clansman* (1905), written by Thomas Dixon, Griffith's portrayal of whites losing power and control over African Americans and the country as a result of the Civil War, and his representation of miscegenation run amuck, frightened whites into believing that African American men were black beasts who needed to be controlled and regulated with brute force—in other words, through lynching.[5]

Indeed, *The Birth of a Nation* brought to the fore the history of the Ku Klux Klan and its intention to terrorize African Americans under the auspices of saving white women from the ravages of an integrated society. The view of African Americans presented by Griffith in the two and a half hour epic was widely endorsed by whites throughout the United States, including President Woodrow Wilson and Supreme Court Justice Edward White, who "had himself ridden with the [Ku Klux] Klan."[6] Griffith's portrayal of the perceived human deficiencies of African Americans perpetuated opportunities for abuses against this group of disenfranchised Americans. The movie's false judgment further influenced and subsequently became responsible for denying African Americans fair representation in

major motion pictures produced for and about whites. To ensure a proper reading of the film, Griffith used the century-old device of minstrelsy, using white actors in black face to portray highly stereotypical aspects of African American life and thereby privileging whiteness as the natural antithesis to blackness. Unquestionably, the absence of real African Americans was a critical factor throughout the latter half of the twentieth century. Griffith, along with a number of other white directors of the early twentieth century, influenced not only the quality of representation but also the social, economic, and political opportunities that African Americans could seek in American society.

Cinematic productions in the sports film genre have examined themes ranging from the pursuit and achievement of childhood dreams of heroism and stardom to the mending of a broken father-son relationship over a game of catch. Yet they have excluded African Americans as subjects of analysis. Indeed, a majority of the films produced in this genre have retraced or recreated tales of white American manhood within the context of the pursuit of the American dream. In doing so, they illuminate the reason why Americans love the game of baseball—the belief that the game represents the perfect example of a meritocracy. In other words, for some, baseball provides the perfect environment for individuals to succeed based on their own efforts, abilities, and sense of achievement within the realm of a team effort.

What is not discussed in the majority of the films of this genre, however, are the ways in which the institution of baseball has traditionally worked to exclude certain individuals from its narrative history, discounting their contributions to the development of the institution and its tenants and further denying participation based on manufactured perceptions and prejudices. Baseball, like the concept of the American dream, has been built on a foundation of contradictions wound tightly in a labyrinth of deceptions, allowing only the privileged few to take full advantage of its hidden transcripts. In particular, baseball's development as the most American of pastimes discounts the contributions of individuals excluded from fully participating and taking advantage of the uniqueness of the game, based primarily on inappropriate assumptions about race.

Within this context, very few, if any, historians have recognized the black baseball leagues and its players as significant contributors to the nostalgia for baseball enjoyed by uninformed Americans. Most baseball historians believe that African Americans' contributions to the game of

baseball began with one historical moment: Jackie Robinson's integration of the Brooklyn Dodgers in 1947. But before Robinson hundreds of African American men—and some women—played a significant role in the development of baseball during historical periods that threatened to bury the symbol of American pride forever: internal scandal, the Great Depression, and War World II.

Not until October of 1991, in an address at the Baseball Hall of Fame in Cooperstown, New York, did the commissioner of Major League Baseball, Fay Vincent, recognize those individuals who participated in the black baseball leagues as unique and decidedly integral contributors to the foundation of the most hallowed of American institutions. Vincent said, "We of baseball acknowledge our part in the shameful history of exclusion in this country. Baseball treated [African Americans] . . . badly and on behalf of baseball, I extend my sincere apologies. We want to recognize our wrong and your worth. . . . We owe you very much. For you kept baseball alive in your black community and in so doing, you did baseball a magnificent service."[7] Vincent's universal appeal was twofold. On the one hand, he clearly felt obligated, if not responsible, to recognize the pain that organized baseball caused in the lives of African Americans. What he endeavored to create in his public acknowledgment was the momentum needed to begin a healing process that was long overdue. It was not an argument for reparations but a revolutionary and sincere declaration of the wrongs that have shaped the lives of African Americans and white Americans for generations. Vincent also sought to recognize the contributions of black players who, although they had been excluded from Major League Baseball, continued to pursue the game's qualities of courage, fortitude, and faith.

Yet, more than a decade after Vincent's formal apology for the wrongs of racism and the exclusion of African Americans from organized baseball, the significance of those black ballplayers still is not fully understood by the majority of baseball fans, players, and coaches. Indeed, most Americans who have grown to love America's pastime still do not know the truth about the black baseball leagues and its players, whose experiences have been reduced to colorful tall tales of fantastic feats of athletic ability and loveable memories of gray-haired and fragile grandfathers and grandmothers. After the commissioner of America's pastime—the speaker for owners, players, and coaches of the present and the past—admitted to the shortcomings of the game, shouldn't there have been a major effort to

mend old wounds? Didn't the African American players deserve a tribute similar to that given to Lou Gehrig for their courage to endure as Iron Men during the time when the black baseball leagues coincided with the cruelty of Jim Crow? The challenges that African Americans have been forced to endure throughout the history of the nation in general, and the capacity of blacks to continue striving during the early part of the twentieth century in particular, have been inspiring. Even though their contributions to baseball persist as an anomaly, Hollywood continues to produce and promote cinematic eulogies to white American demigods, and the importance of the black ballplayers to the game is fading, being transformed from truth into fiction.

In his essay "The Ironies of Palace-Subaltern Discourse," Clyde Taylor writes that the "current crisis of knowledge and of criticism is just another circus spectacle unless it can be forced to deliver a more equitable redistribution of . . . power to represent in favor of the disenfranchised."[8] Clearly, the denial of African Americans' participation in organized baseball speaks to the resistance of the owners, the players, and the fans to having individuals on the margins challenging long-held traditions and symbols that the dominant group has identified as exclusive to their identity. As John Brenkman has observed, the "preserved and validated monuments of western culture are not only the achieved expression of meanings and values and a resource of potential means of expression for civilization; they also carry the imprint of the violence and forced labor, which have made their creation possible."[9]

Within the context of baseball, the violence of civilization has manifested itself as the disallowance of African Americans' participation. Although Western civilization continues to extend its boundaries through violent dissemination, it presents sports in general and baseball in particular as a quasi-democratic political tool representing the prototypical society—a body politic, constructed, maintained, and protected by the United States as an archetypal representation of itself. Yet within this constructed world made of plywood and plaster, smoke and mirrors, half-truths and whole lies, there exists a void—a chasm that remains unaccounted for. The hole in the fabric of the body politic is not an aberration, but it is needed to sustain what Benedict Anderson suggests is an "imagined community."[10]

Both Taylor and Brenkman speak truth to power about individuals who have been systematically marginalized and silenced throughout American history. These marginalized citizens, whose stories have been buried

by the revisionist and whitewashing efforts of the dominant discourse, reflect the contradictions suppressed under a crumbling façade. Indeed, in trying to maintain its myth of meritocracy, baseball directly advanced the "shameful history of exclusion" of African Americans in the United States. And Hollywood, through the power of exclusion and hyperbole, has played a significant role in perpetuating the ever-growing myths associated with race.

Nostalgic baseball films such as *The Sandlot* (1993) and *Field of Dreams* (1989) portray the idealism of adolescent and adult rites of passage played out on the baseball diamond. Prophetically, both films succeed in elevating past heroes by first canonizing them and then disclosing some of their shortcomings and the liberating events that led to their legendary status. In both films the impulse to believe that "everything was good" in the United States during the first half of the twentieth century is corroborated and validated by those who should know better. Conversely, comedic treatment of African American male athletes participating in professional baseball in films such as *Mr. 3000* (2004) strain relations between African American athletes and the public. To a majority of spectators, films such as *Mr. 3000* will be taken as a definitive portrayal of African American maleness and not as a parody woven from the threads of discontent in American culture. Although the three films differ in context, all three explore the ways in which blackness—in particular, African American masculinity—is used to validate certain historical moments, both real and imagined. In other words, for an athletic performance to be validated as sufficient, those individuals who are most proficient in the sport must be present to authenticate the performance.

In *The Sandlot* Kenny DeNunez, the only African American boy on the sandlot team (and probably the only African American boy in the Los Angeles suburb where all the boys live) wears a Negro National League baseball hat from the Kansas City Monarchs. His high-kicking and confident stride is suggestive of Monarchs legendary pitcher Satchel Paige. Yet throughout the film DeNunez never makes reference to the black baseball leagues or any of its players. If nothing else, DeNunez should have been able to mention the legendary catcher and power hitter Josh Gibson when the other boys were describing Babe Ruth to the newcomer in the neighborhood (who never heard of the Sultan of Swat or the Titan of Terror). DeNunez's unbiased confirmation of Ruth's ability juxtaposed against his inability to mention Gibson represents a lost opportunity for him to realize

his own potential based on the lived experiences of someone who looked like him, experienced the disallowances that he will have to endure, and is significant to the discussion initiated by his peers.

What further complicates the movie's treatment of African American baseball players is that one of the characters in the film, the blind Mr. Mertle (James Earl Jones), is a former Negro Leagues player who lives alone in a home filled with baseball memorabilia. To Benny Rodriguez and Scott Smalls's surprise, the blind Mr. Mertle knew the "Great Bambino" Babe Ruth by his first name, George. "And he knew me," claimed Mr. Mertle. "He was almost as good a hitter as I was. I would have broken his record but [I went blind]. I used to crowd the plate so that the strike zone almost disappeared. Pitchers hate that. That's the way I play, one hundred percent all the time. Baseball was life and I was good at it. Real good." In response to the two adolescent boys' inquiry into his level of talent, Mr. Mertle claims that he would have broken Ruth's record had he not gone blind; the numerous plaques, photographs, and trophies on display throughout his home attest to his knowledge of the game and his ability to play it. In reality, blacks and whites did not play in the same leagues during Ruth's era. Even if Mr. Mertle could have broken Ruth's record, his success would have been refuted by those who would discount the fact that the record was made in the black baseball leagues by a black man. The illusion of baseball as a liberating, meritocratic game of unknown possibilities lives within a liminal space, accessible only to those who qualify.

To claim that baseball has been even-handed throughout American history is to make a false claim, one that is easily perpetuated by those who believe the game is intrinsically wholesome and value driven but who simultaneously lock out competition that would force new definitions of manhood, masculinity, and citizenship. The feeble attempt to fill the empty space where African Americans should be is easily glossed over by critics of culture studies, who claim ignorance of life in the margins. Like *The Sandlot, Field of Dreams* advances the notion of redemption and forgiveness, claiming that throughout a century of change baseball has been a constant. Philosophically speaking, baseball is but a game made up of rules, rituals, balls, and bats, which always stay the same: people influence the definition of and adherence to rules.

Against the backdrop of a midwestern sky, in the middle of an Iowa cornfield, farmer Ray Kinsella (Kevin Costner) hears a voice that instructs him to build a baseball field as a gesture to bring forth an undisclosed

James Earl Jones as Terence Mann in *Field of Dreams* (1989). Courtesy of Universal Home Video.

individual. Succumbing to the ethereal voice coming from the rows of corn, Kinsella builds his temple to the baseball gods, waiting for the one who will come and save him from becoming his father. Throughout the film several themes emerge—baseball as an American institution, baseball and notions of masculinity, the cost of not pursuing one's dreams, and the price of failing to uphold one's integrity. The film itself is an exploration of the metaphysical realm of redemption and the imagination, concepts readily found in the work of African American novelists such as Toni Morrison, Toni Cade Bambara, and Ishmael Reed, to name but a few.[11] The possibilities of and opportunities for demonstrating one's faith are pervasive in the film. Indeed, once Kinsella builds his field of dreams, legendary players of the past who once were doomed to baseball purgatory come to reclaim their love of the game. Among the visitors, the eight Chicago White Sox who were banned from baseball for associating with known gamblers before the 1919 World Series take up residence in the corn and play baseball all day and all night. Apparently, the lack of opportunities to test our faith beyond the conventional daily grind can be made up for in quiet realities like farming or in simple pleasures like baseball.

Yet even in these reflective states of mind, body, and place, we must recognize the truth for all that it is, especially when represented in artistic mediums such as film. Indeed, from the silky stalks of corn emerge Arnold ("Chick") Gandil, Eddie Cicotte, Charles ("Swede") Risberg, Claude ("Lefty") Williams, George ("Buck") Weaver, Oscar ("Happy") Felsch,

Baseball players relegated to baseball's purgatory in *Field of Dreams* (1989). Courtesy of Universal Home Video.

Fred McMullin, and Joseph Jefferson ("Shoeless Joe") Jackson, baseball's unforgiven. But we never see John ("Bud") Fowler, Moses Fleetwood Walker, George Stovey, or Josh Gibson claiming their right to retribution for the denial of their contribution to the game. If baseball "reminds us of all that once was good," then there must be a place beyond the cornfields for black ballplayers denied the opportunity to achieve their full potential. The substantial absence of these African American men from the field of dreams suggests an anxiety in juxtaposing their abilities against the men who were allowed to partake freely and without bias in the national pastime. These absences, Philip Brian Harper suggests, generally indicate "more than simply a discriminary boundary that bars black men from a given, relatively discrete, social realm; it also suggests that realm's extensive implication in the defining problematics of the larger culture."[12]

In other words, even in cinematic presentations in which the past could be held accountable and the present manipulated to support it, Hollywood directors and producers still believe in keeping with the social graces and stock representations that will not isolate their consumers but will take full advantage of their fears and desires. This dynamic is evident in films like *Mr. 3000* (2004), a comedic crossover film that is designed to attract a wide audience but that denies a clear understanding and appreciation of the significance of baseball to the legacy of African Americans and the tradition of resistance advanced by Jackie Robinson. Without a doubt, *Mr. 3000* shuffles and jives, just enough to feed and cool consumer

anxieties about African American masculinity. Bernie Mack's portrayal of Stan Ross—the selfish, opportunistic, loud, and hypersexual professional athlete—not only advances traditional stereotypes of black masculinity but also contributes to the continued crystallization of the love-hate attitudes toward black males that are so prominent in American culture.

According to Robert Entman and Andrew Rojecki, "Mass media convey[s] impressions that Blacks and Whites occupy different moral universes, that Blacks are somehow fundamentally different from Whites."[13] If perception is reality, then the projection of perceived blackness has traditionally had adverse effects on relationships between the two races. The mass media's projection of animosities between blacks and whites has been responsible for disseminating quasi-racist ideologies that unrealistically achieve some semblance of resolution within the context of dramatic Hollywood productions while continuing to serve as vehicles of racist propaganda in the real world. The "wisdom and profit of loving black men while simultaneously hating them" drives an industry that seeks to capitalize on the epic struggles contained in the memory of a country that continually measures its progress based on the classic contest of good against evil: white versus black.[14]

Films such as *Mr. 3000* advance a formulaic binary discourse that mediates between the two races, reflecting both the tragedy and the irony of African American males' pursuit of the American dream through athletics. This type of film is presented as a comic release from the mundane, but it becomes responsible for diminishing the significance of athletic performances that are critical to the liberation and advancement of African Americans' sense of identity within the construct of a racist society. Major motion pictures such as these reveal that organized baseball, not unlike the majority of its fans and owners, has all but written off the contributions that African Americans have made individually and collectively to America in general, to baseball in particular, and to the advancement of the game during its modern era.

Nevertheless, there exists an opportunity to rewrite history, or at least the perception of it, through the production of truthful narratives that seek to reveal the real social significance of particular athletic performances. Yes, it is possible to replace untruths in poorly portrayed African American stories—the less than fantastic nostalgic moments of sensational homeruns, pathetically dry one-liners, and relentlessly easy women tak-

ing responsibility for grooming tomorrow's stars—with a more truthful account of the athletes' lives and accomplishments. What is needed is a movement of reconciliation that transcends the overdetermined, heteronormative, and flattened representations of African American masculinity by filling in the "empty space[s] in representation with movies about deeply complicated and brilliant black men that populate the African American narrative tradition."[15] In effect, revisit, rewrite, and represent history as it has truly unfolded.

Before the Year All Hell Broke Loose: Black Baseball and the Coming of Jackie Robinson

Before the turn of the twentieth century and long before Jackie Robinson challenged white supremacy with his body and his mind, African Americans participated and played baseball on the plantations of the South and on the streets and fields in the cities of the North. By the 1870s African Americans partook in league play with white organizations, although in limited numbers. They were players like John "Bud" Fowler, who in 1872 played second base for a professional white team in New Castle, Pennsylvania (when he was only fourteen years old), Moses Fleetwood Walker (along with his brother, Welday Walker), a catcher who played for the Toledo Blue Stockings in 1884, George Washington Stovey, a pitcher who played for Newark in the International League in 1885–1886, and Frank Grant, a second baseman who played in the Eastern League in 1886. These African American men had the opportunity to succeed on the playing field with their white counterparts, even though society saw them as second-class citizens. In 1887 Stovey became the focus of racial contention when one of the game's most popular white players, Cap Anson, refused to play in an exhibition game against any team with a black player on its roster. Newark, Stovey's team, initiated a meeting that would be the beginning of the exclusion of blacks from the major leagues (until Jackie Robinson in 1947).

From 1900 until the early 1950s African Americans migrated by the hundreds of thousands to northern industrial cities to escape brutal racism in the South and to take advantage of financial opportunities that they were entitled to as Americans. By moving to cities such as Chicago, Detroit, and Kansas City, African Americans challenged and created their

own definition of what it meant to be American. Most ethnic groups (immigrant, native, or displaced) have had the opportunity to assimilate and take advantage of the freedoms that American citizenship allows, but the same cannot be said for the majority of African Americans, who during slavery directly (although reluctantly) contributed to the development, wealth, and prosperity of the country they called home. By 1919 millions of African Americans had moved into urban centers, which were filled with European immigrants who had come to the United States eagerly seeking the American dream.

Excluded from enjoying the benefits of being American, most African Americans were denied jobs that were systematically given to European immigrants. Nowhere was this more evident than in baseball. In response to their unofficial exile, blacks formed their own teams to play against one another. Local organizations like churches, haberdasheries, grocery stores, and newspapers had teams. Taking advantage of the opportunity to create structured rule-based play, Rube Foster of the Chicago American Giants and other willing owners of the top black midwestern teams met on February 13, 1920, at the YMCA in Kansas City, Missouri, to discuss the formation of the Negro National League. Agreeing that there was a need for such an association, they established the first all-black baseball league, which was composed of eight teams: the American Giants, the Kansas City Monarchs, the St. Louis Stars, the Detroit Stars, the Indianapolis ABCs, the Chicago Giants, the Cuban Stars, and the Dayton Marcos. Except for J. L. Wilkinson, the owner of the Kansas City Monarchs, the owners of all of the teams were black. As long as segregation persisted, black baseball would generate streams of revenue for the African American communities where the teams played regularly, and frequent barnstorming (exhibition) teams brought excitement and, on occasion, interracial play to rural communities.

A majority of those who played did so under the mantle of the democratic ideal—the opportunity to use one's god-given talents, the ability to be one's own man, and the chance to achieve a sustainable degree of wealth and success through hard work and sacrifice. African American baseball players (and other athletes, such as Jack Johnson) earned more money than most other black men of the time. Some sought to define and defend their sense of masculinity, humanity, and individual identity through their athletic performances, by combining their physical gifts and talents

with showboating and clowning. The goal was clearly to play baseball in front of a paying crowd, thereby gaining access to economic opportunities. These athletes bodied forth through their performances a black masculine type of resistance that redirected feelings of resentment, which were the result of slavery, Reconstruction, and rejection from the white majors, into impressive and progressive displays of black power.

Under the direction of Rube Foster, baseball became an institution in African American communities across the United States during the first quarter of the twentieth century. Even as segregation limited the movement of African Americans into mainstream society, the ability of African American men to perform as well as (if not better than) their white counterparts endeared them to their communities. Indeed, these men were recognized as counter-narratives to the dominant discourse that was responsible for advancing notions of racial inferiority. Through participating in the Negro baseball league, these black ballplayers of the early twentieth century developed a philosophical approach to their athletic performances that imbued them with leadership qualities that would prove to be psychologically empowering to the black masses living vicariously through their examples of manhood, success, and achievement.

The significance of the players, the teams, and the black baseball leagues to African American community life in the North was demonstrated in various ways, ranging from the active sponsorship of local teams by various businesses such as grocery stores, insurance companies, and local businessmen, which both promoted their businesses and provided a distinctive form of civic pride, to attendance at and support of the black baseball league games and barnstorming games. The success of the black baseball leagues was contingent upon the fans placing value on the performances of the ballplayers. This significant factor was demonstrated in the attendance at the East-West All-Star Games from 1933 to 1950. G. Edward White writes that the "success of the All-Star Game reflected the economics and sociology of black communities in America in the thirties and forties."[16] Modeled after the major leagues and played during the midpoint of the season, these games featured what White identifies as the top players in black baseball leagues. Played annually at Comiskey Park in Chicago, these ballgames were designed to attract African Americans to the ballpark and to showcase the talent of the players while creating and promoting the ballpark as a "highbrow" arena filled with drama.

Between 1935 and 1950, as the East-West All-Star Game developed into a "spectacle frequented by society," attendance at the games ranged from nineteen thousand to fifty-two thousand.[17] This did not go unnoticed by the white major leagues, especially by one Branch Rickey, general manager and co-owner of the Brooklyn Dodgers. Rickey recognized that African Americans did not attend white ballgames, but they did attend the black ballgames, especially the East-West All-Star Games. By spending their hard earned money at the ballpark to support their favorite players, African Americans were demonstrating their economic power. This was important to Rickey, particularly because of where Major League Baseball was heading by the mid-1940s, both socially and economically.

By 1944 the United States had been in World War II for three years, and the numbers of young men available to play professional baseball had dropped significantly. The seriousness of the times was reflected in attendance of games and the talent-lean teams fielding as major league teams. By 1945 the long-time commissioner of baseball, Judge Kennesaw Mountain Landis, an avid segregationist, had died, and the southern Senator and former Kentucky governor Albert B. "Happy" Chandler took over as commissioner. This single event had two significant outcomes: First, Chandler, who had known Negro Leaguers Satchel Paige, Josh Gibson, Buck Leonard, and James Cool Papa Bell, believed that if African American men could fight for democracy and die in the war, they should not be denied the opportunity to play the game that also identified their allegiance to the United States. Chandler's claim opened the door for the reintegration of baseball, which brought Jackie Robinson to the attention of Americans. Robinson came to represent, demand, and advocate for justice and equality through his example of pride, courage, and dignity. Second, the unraveling of the black baseball leagues and their eventual closing was a result of Robinson's integration of the game and the success of the Brooklyn Dodgers organization. Robinson's perseverance and integrity helped advance race relations within America's pastime, thereby reclaiming the legacy of those early pioneers who kept playing the game of baseball despite the disallowances heaped upon them by the white majority.

Keeping the Legacy of Black Baseball Alive

During the 1980s and into the 1990s, a plethora of oral histories, docu-

Satchel Paige pitching in *The Bingo Long Traveling All-Stars & Motor Kings* (1976). Courtesy of Universal Home Video.

mentary films, and monographs about the Negro baseball leagues were produced by cable and network television as seasonal (Black History Month) or commemorative television series or specials (e.g., about Jackie Robinson's breaking of the color barrier in organized baseball). These programs began to account for the accomplishments of African American athletes who had been written out of history. They have proved to be rich sources of information about specific historical moments and have provided informative biographical sketches of the men and women who lived, suffered, and succeeded within an America that sought to deny them the opportunity to pursue and experience the American dream.

In his autobiography *I Was Right on Time* (1996), former Negro Leagues player, manager, and legend John "Buck" O'Neil recalls his fondest memories of playing in the Negro Leagues. O'Neil writes:

> It was the Negro leagues that gave me an identity. . . . I am proud to say it was the Negro leagues that turned me into a man. The big-leaguers might not have known who I was, but that was okay, because when I first thought of playing baseball for a living I never thought I would play major league baseball. I thought major league

baseball was a white man's game. It was a thrill and a privilege to play against the big leaguers in all-star games, and you know, we did pretty well against those boys, and it made us believe we did belong up in the bigs.[18]

In testifying to the significance of the Negro Leagues to the development of his identity and that of his teammates, O'Neil allows the reader to see and understand the importance of the sport in the quest to be fully recognized as male, manly, and American. O'Neil's experiences as an African American man in an overtly anti-black society tied him directly to the African American men with whom he played in the black baseball leagues. Although most are unaccounted for in the annals of baseball history, players such as John "Buck" O'Neil have been immortalized in oral histories, narratives, and documentaries.

Documentary films such as *There Was Always Sun Shining Someplace* (1984), *Kings on the Hill: Baseball's Forgotten Men* (1993), and *The Journey of the African-American Athlete* (1996) are priceless time capsules, prodigiously reflecting the past through the eyes of those who lived through it. These films showcase the lives of the men who played in what was called the *other* league or the "nigger league," depending on what company you kept. These exceptional athletes and tremendous baseball players helped change the game of baseball with their talent and ability, but mostly with their desire and drive for the right to call themselves Americans. Of the documentaries exclusively dedicated to African Americans in sports, *The Journey of the African-American Athlete* is the most comprehensive in its depiction of the intersecting historical, social, and political tensions, which created the opportunity for the Negro Leagues to evolve.

Narrated by Samuel L. Jackson, with appearances by sports historians Gerald Early and Randy Roberts, *The Journey of the African-American Athlete* covers the period directly following the American Civil War to the Civil Rights Era of American politics. The film is broken down into several overlapping sections in which sports figures such as horse racing champion jockey Isaac Murphy, boxer Jack Johnson, and professional football player Marion Motley are placed along a historical continuum, thus exposing the contradictions of America's claim of democracy for all its citizens while elevating the efforts African Americans made to secure their citizenship, humanity, and dignity.

Another film that cuts to the core of the reality of the black baseball

leagues and their importance to those who played in them is *There Was Always Sun Shining Someplace.* At the beginning of the film we are quickly told the reasons why the black baseball leagues were formed: the exclusion of individuals, not because of lack of ability or talent, but because of perceived deficiencies of the mind, based on stereotypes. Former Negro Leagues pitcher Chet Brewer recalls a story (perhaps a tall tale) about an African American boy who persisted in annoying a white manager of a traveling white baseball team for three straight days. Each day the white manager would tell him, "Go away black boy. I don't have no room for a black boy on my team." On the fourth day the kid sat in the stands right above the team's dugout, continuing to annoy the white manager until he was given a uniform and an opportunity.

> [On] this particular night the team they were playing had the ace relief pitcher in the whole league, a big giant of a white man who threw bb's. The opposing pitcher walked all the bases full. Now, the manager says this is where I'll show this black boy up. He said, "hey you, you pinch hit."
> So the kid ran by the bat stand and picked up the first bat he came to and he walked up there. The opposing manager summoned this big ace relief pitcher from this bullpen. And the first pitch this big white man threw, this black boy hit up against the right centerfield fence. And as he was rounding second base the white manager jumped up and said, "Look at that Cuban go."

"With one swing of the bat," Brewer would say, the black boy "progressed from a black male without a job to a Cuban with a job." The veiled reasons for exclusion from the majors, as well as other sections of American life, are revealed in this simple story in which race determines the number of opportunities a boy will have to achieve success in America. But allowing the performance to speak for the "quality of the man" certainly challenges institutionalized notions of difference and privilege within the context of the American dream.[19]

Documentaries such as these testify to the significance of the Negro Leagues as a self-referential entity that provided the opportunity for its participants as well as its spectators to develop a positive identity. These films, acting as truthful narratives, allow the viewer to engage with the past in a constructive fashion, recognizing the significance and the importance of sports to African American definitions of manhood, masculinity, and

citizenship. Through it all, these men endured. They were as American as their white counterparts and deserve the same recognition.

Notes

1. *The Bingo Long Traveling All-Stars & Motor Kings,* DVD (Los Angeles: Universal Studios, 1976).

2. A more complete reading of this film appears in Pellom McDaniels, "We're American Too: The Negro Leagues and the Philosophy of Resistance," in *Baseball and Philosophy: Thinking Outside the Batter's Box* (Peru, IL: Open Court Publishing, 2004), 187–200.

3. Howard Nixon II, *Sport and the American Dream* (New York: Leisure Press, 1984), 10–14.

4. I personally think *The Pride of the Yankees* (Metro-Goldwyn-Mayer, 2002) is a touching story that deserves several looks, including an examination of the ethnic tensions throughout.

5. Ed Guerrero, "The Black Man on Our Screens and the Empty Space in Representation," *Callaloo* 18 (February 1995): 397.

6. Geoffrey C. Ward, *Unforgivable Blackness, The Rise and Fall of Jack Johnson* (New York: Knopf Publishing, 2004), 372.

7. Fay Vincent, *The Last Commissioner: A Baseball Valentine* (New York: Simon & Schuster, 2002), 263.

8. Clyde Taylor, "The Ironies of Palace-Subaltern Discourse," in *Black American Cinema,* ed. Manithia Diawara (New York: Routledge, 1993), 177–99.

9. John Brenkman, *Culture and Domination* (Ithaca, NY: Cornell University Press, 1987), 4.

10. Benedict Anderson, *Imagined Communities: Reflections on the Origin and Spread of Nationalism* (London: Verso, 1991), 5.

11. *Song of Solomon* (1978), one of Morrison's most acclaimed novels, incorporates African and African American folklore as a way to connect the past with present and future endeavors. Morrison's command of African American history puts her work at a distinct advantage because she knows exactly where the pieces fit and where they do not.

12. Philip Brian Harper, *Are We Not Men: Masculine Anxiety and the Problems of African American Identity* (New York: Oxford University Press), 171.

13. Robert Entman and Andrew Rojecki, *The Black Image in the White Mind: Media and Race in America* (Chicago: The University of Chicago Press, 2000), 6.

14. Guerrero, "The Black Man on Our Screens," 395.

15. Ibid., 396.

16. G. Edward White, *Creating the National Pastime: Baseball Transforms Itself 1903–1953* (Princeton: Princeton University Press, 1996), 139.

17. Ibid., 141.

18. Buck O'Neil, *I Was Right On Time* (New York: Simon & Schuster, 1996), 16–17.

19. Elisabeth Badinter, *XY: On Masculine Identity* (New York: Columbia University Press, 1992), 9.

Works Cited

Anderson, Benedict. *Imagined Communities: Reflections on the Origin and Spread of Nationalism.* London: Verso, 1991.

Badinter, Elisabeth. *XY: On Masculine Identity.* New York: Columbia University Press, 1992.

The Bingo Long Traveling All-Stars & Motor Kings. DVD. Los Angeles: Universal Studios, 1976.

Brasher, William. *The Bingo Long Traveling All Stars and Motor Kings.* New York: Harper & Row, 1973.

Brenkman, John. *Culture and Domination.* Ithaca, NY: Cornell University Press, 1987.

Entman, Robert, and Andrew Rojecki, *The Black Image in the White Mind: Media and Race in America.* Chicago: University of Chicago Press, 2000.

Guerrero, Ed. "The Black Man on Our Screens and the Empty Space in Representation," *Callaloo* 18 (February 1995): 395–400.

Harper, Philip Brian. *Are We Not Men: Masculine Anxiety and the Problems of African American Identity.* New York: Oxford University Press.

The Jackie Robinson Story. DVD. Directed by Alfred Green. Los Angeles: MGM/UA Video, 2001.

The Joe Louis Story. DVD. Directed by Robert Gordon. Los Angeles: Miracle Pictures, 2003.

The Journey of the African-American Athlete. VHS. Produced by Ross Greenburg. HBO Sports, 1996.

McDaniels, Pellom III. "We're American Too: The Negro Leagues and the Philosophy of Resistance." In *Baseball and Philosophy: Thinking Outside the Batter's Box,* ed. Eric Bronson. Chicago: Open Court Publishing, 2004.

Nixon, Howard II. *Sport and the American Dream.* New York: Leisure Press, 1984.

O'Neil, Buck. *I Was Right On Time.* New York: Simon & Schuster, 1996.

The Pride of the Yankees. DVD. Directed by Sam Wood. Los Angeles: MGM, 2002.

Taylor, Clyde. "The Ironies of Palace-Subaltern Discourse." In *Black American Cinema,* ed. Manithia Diawara. New York: Routledge, 1993.

There Was Always Sun Shining Someplace: Life in the Negro Baseball Leagues. VHS. Directed by Craig Davidson. Westpoint, CT: Refocus Films, 1984.

Vincent, Fay. *The Last Commissioner: A Baseball Valentine.* New York: Simon & Schuster, 2002.

Ward, Geoffrey C. *Unforgivable Blackness: The Rise and Fall of Jack Johnson.* New York: Knopf Publishing, 2004.

White, G. Edward. *Creating the National Pastime: Baseball Transforms Itself 1903–1953.* Princeton, NJ: Princeton University Press, 1996.

RON BRILEY

Basketball's Great White Hope and Ronald Reagan's America

Hoosiers

IN 1986 FIRST-TIME feature director David Anspaugh and Orion Pictures released the commercially successful basketball film *Hoosiers*. The popular film has remained a staple for video rentals and cable television, leading *Sports Illustrated* to name *Hoosiers* as the sixth best sports movie of all time.[1] Based on a screenplay by Angelo Pizzo, who met Anspaugh at the basketball-infatuated University of Indiana, *Hoosiers* attempts to reconstruct the "Milan Miracle" of 1954 in which the Milan Indians, a school of only 161 students, defeated Muncie Central, with an enrollment of more than two thousand students, for the Indiana boys' state basketball championship. Milan's victory was a classic David and Goliath story in which the underdog, through hard work, virtue, and cunning, defeats the seemingly invincible adversary.

This story line resonated well with audiences during the 1980s, as President Ronald Reagan attempted to lead the United States back to a mythical, patriarchal 1950s in which divisions of race, gender, and class did not exist among the homogeneous middle class. In an effort to restore the simplistic certainties of the post–World War II liberal consensus, Reagan reinvigorated the Cold War with the "evil empire" of the Soviet Union and assumed that issues of inequality could be addressed through sustained economic growth spurred by tax cuts and supply-side economics.[2]

For contemporary Americans beset by recession, loss of jobs, a divisive conflict in Iraq, and the threat of international terrorism, the exploits of the Milan basketball squad continue to evoke a nostalgic yearning for a mythical garden in which life is easier and simpler. After ESPN Classic showed the 1954 Indiana state basketball championship in 2004, National Public

Radio commentator Bob Cook noted Milan represented the "triumph of the small-town way of life and perhaps the pull-up-your bootstraps ideal, that no matter where you are from and what disadvantage you may have, if you work hard, you'll succeed."[3] This is the imagery that Reagan used in asserting that the United States must be restored to a city upon a hill where all things are possible, and it is a concept rendered in less oratorical splendor by President George W. Bush in 2008. But it is questionable whether such rhetoric reflects the realities either of contemporary American life or of the 1980s and 1950s.

The Milan Miracle was achieved against the background of school consolidation. In 1954 there were 754 high schools in the state of Indiana. Consolidation has reduced this number to 383 schools, and seven of the eight schools that Milan beat in the 1954 tournament no longer exist. The last time a school with an enrollment of under a thousand students won the Indiana state basketball tournament was 1982. With the small schools increasingly being dominated in tournament games, school principals from around the state split the 1998 championship into four classes based on school size. As radio commentator Cook concluded, "The small-town ideal, it seemed, didn't meet reality."[4]

Hoosiers, the film version of the Milan Miracle, also took considerable liberties with the actual story. Hollywood placed even more obstacles to the team's success, providing an even more dramatic Cinderella story than the one experienced by the 1954 Milan basketball squad. Despite its small size, Milan, led by young local coach Marvin Wood, was a basketball powerhouse that reached the final four in the 1953 state tournament and then had most of the players from that team return for the following season. In the 1954 championship against Muncie Central, the ten-man team from Milan used a stalling strategy against a more athletic opponent. Milan guard Bobby Plump made the tying and winning shots after holding the ball for agonizing minutes. With the shot clock used in today's game, Coach Wood would be unable to use the strategy that gave Milan the 32-30 victory. Holding the ball provides an opportunity for undermanned teams to keep their opponents from scoring, but it also bores spectators and undermines the athleticism of basketball. Needless to say, holding a basketball for four to five minutes is not the material from which Hollywood drama is fashioned.[5]

Hoosiers tells the story of Norman Dale (Gene Hackman), who gets

Cletus (Sheb Wooley) and Norman Dale (Gene Hackman) question the referee's call, in *Hoosiers* (1986). Courtesy of Movie Goods.

a second chance at coaching after his noted collegiate career is terminated because he strikes a player. After a stint in the Navy, Dale is hired by his friend Cletus (Sheb Wooley) to coach the Hickory High School Huskers. The school's beloved former coach has died, and the small Indiana town resents the outsider taking his place. After he dismisses his recalcitrant players (who are portrayed by nonprofessional Indiana actors, to provide the film with a touch of authenticity), Dale is left with only six team members, including the less than athletic team manager Ollie (Wade Schenck). The season gets off to a rocky start, and at a town meeting held at the local church, Dale is about to be ousted as coach by the local townspeople, whose identity is attached to the success of the local high school team. Dale's job is saved, however, when reluctant basketball star Jimmy Chitwood (Maris Valainis) agrees to play only if Coach Dale is retained. Jimmy, whose father is dead and whose mother is an invalid, views the former coach as a father figure. He lives with English teacher and assistant principal Myra Fleener (Barbara Hershey), who is convinced that Jimmy should forgo basketball and concentrate on academics. Of course, Dale is

able to convince Jimmy to stay with basketball, and at the same time he begins a romance with Fleener, who concedes and becomes an enthusiastic supporter of the Hickory basketball program.

Meanwhile, with the addition of Jimmy's pure and accurate jump shot, the Huskers begin to coalesce and advance through the state tournament, reaching the state finals in Indianapolis. Here for the first time in the film they encounter a racially integrated team. Although the young men and their coach comment on the size of the arena and city buildings in Indianapolis, they never mention the racial theme. The small town boys from Hickory are triumphant over South Bend Central, the movie's version of the Muncie Central that opposed Milan in the 1954 championship contest. When the game ends on Jimmy's true jump shot, whites jump and shout in exhilaration and black players and fans slump to their knees in shock and disbelief. The African American coach of South Bend Central is played by Ray Crow, who coached Indiana's first all-black high school basketball champions, Crispus Attucks High School, in 1955.

An important subplot in the film involves the theme of second chances. One of the Hickory athletes, Everett (David Neidorf), has a father, Shooter (portrayed by Dennis Hopper in an Academy Award–nominated performance), who is the town drunk. Shooter is an outstanding former high school basketball player who has succumbed to drink. However, he has an encyclopedic knowledge of Indiana high school basketball. Coach Dale decides to ask Shooter to serve as an assistant coach. While Shooter does revert to the bottle, by the film's end he is seeking medical help and has regained the respect of his son. And Myra Fleener is impressed by Coach Dale's noble experiment.[6]

Audiences echoed Fleener's sentiments, although Orion Pictures initially seemed to lack confidence in *Hoosiers*. The film was released in the West and Midwest before appearing in theaters on the East Coast. In fact, *Hoosiers* did not premiere in New York City until after the film garnered Academy Award nominations for Dennis Hopper as Best Supporting Actor and Jerry Goldsmith's musical score. Eastern Coast audiences, however, were not callous to the film's sentimentality. Janet Maslin of the *New York Times* described *Hoosiers* as "irresistible" and "admirable," concluding that Anspaugh's theatrical film debut was "about as sweetly unselfconscious as a film can be."[7]

Film critics generally shared Maslin's enthusiastic response to the film. Roger Ebert identified with the film's example of the purity of high school

athletics. Acknowledging that the story line of *Hoosiers* was predictable, Ebert, nevertheless insisted that the film worked magic by getting the audience to "really care about the fate of the team and the people depending upon it." In a similar vein, Richard Schickel of *Time* credited *Hoosiers* with accurately portraying the values of small town America during the 1950s—a time "when there was nothing better to chew on than last week's game and nothing better to savor than next Friday's." David Edelstein of the *Village Voice* echoed the idea that *Hoosiers* exhibited the fundamental positive values of American society, noting that Angelo Pizzo's script displayed "an immigrant's innocence about the backbone of America." Rob Barker of *Women's Wear Daily* concluded that *Hoosiers* touched "a chord that is honest, basic and true to the small-town dreams it depicts."[8]

Other reviewers, however, found the film to be overly simplistic and banal in its description of the American experience. Mike McGrady of *Newsday* considered *Hoosiers* as derivative, drawing on clichés from films such as *Rocky* (1976) and *The Karate Kid* (1984) as well as the work of Frank Capra. McGrady observed that the *Hoosiers* script was heavy-handed and that the writers had been unwilling to "let maudlin enough alone." Nigel Floyd, writing for the *Monthly Film Bulletin*, agreed with McGrady, asserting, "The rural setting, the alleged innocence of the pre-teen 50s, and the aura of naïve high-school enthusiasm rule out any troubling considerations of professionalism and gamesmanship, leaving the film rather soft at the centre."[9]

Although some critics questioned the film's originality and assumptions regarding American innocence in the 1950s, few challenged the absence of blacks in *Hoosiers*. As Ralph Ellison noted in his epic novel *Invisible Man*, the whiteness of middle-class and small-town America was simply assumed. Stanley Kauffmann of *The New Republic* and Robert B. Frederick, writing for *Films in Review*, noticed that African Americans, who played a crucial role in college and professional basketball during the 1980s, were missing from the film. Frederick, however, dismissed any charges of racism against the filmmakers because the exclusion of black athletes from scenes in rural Indiana might have been "diplomatically uncouth but historically correct."[10]

Frederick's observation is misleading in a number of ways. It assumes that the 1950s were years of consensus rather than a period of paradox and ambiguity in which complacency was challenged by events such as the civil rights movement. Indeed, *Hoosiers* completely ignores the existence

of one of the most profound moments of social change in American history. For perhaps the *Brown v. Board of Education* decision of 1954 was of greater historical significance than the Milan Miracle. And in the arena of sports the civil rights movement had a considerable impact that young basketball players in the 1950s would have found difficult to ignore. In 1947 Jackie Robinson shattered major league baseball's color line, and in 1951 the National Basketball Association (NBA) drafted its first African American players. In addition, given the troubled history of race relations in the state of Indiana, where the Ku Klux Klan dominated state politics during the 1920s, it is difficult to believe that the coach and players from the all-white Hickory community would comment on the intimidating size of the city of Indianapolis but fail to notice that for the first time they would be playing against African American athletes.[11]

Indeed, even having the boys from Hickory confront no black competition until they meet South Bend Central in the finals is historically inaccurate. In the semifinal round of the 1954 tournament, Milan defeated Crispus Attucks High School, with its star sophomore guard Oscar Robertson, 65–52. Crispus Attucks High School, named after the mulatto martyr of the Boston Massacre, was an all-black Indianapolis school founded in 1927, during the heyday of Klan influence. In his study of the impact of blacks on the game of basketball, Nelson George writes, "The city fathers were both proud and fearful of Attucks's chances for the title. These were men only a generation or so removed from the Klan-dominated state government of the twenties. At one point Attucks's principal, Russell Lane, was summoned to City Hall, where he had to reassure a mayoral deputy and the board of education, as well as the fire and police chiefs, that an Attucks championship would not incite an antiwhite riot."[12]

But Robertson and his Attucks teammates would not be denied, winning both the 1955 and the 1956 Indiana state championships. Indianapolis city officials, fearing the exuberance of Attucks supporters, rerouted the 1955 celebratory motorcade away from the downtown business district into Indianapolis's African American community. The lads from Milan, however, suffered no such slights from city officials. In fact, Pat Stark, an Indianapolis policeman assigned to provide security for the Milan team, led a procession of Cadillacs carrying players from Butler Fieldhouse, where the championship game was played, to the heart of the city. The impromptu motorcade snarled traffic as the Milan heroes were hailed by delighted admirers.[13] A similar outburst by supporters of Crispus At-

tucks might have appeared a bit more threatening to the white citizens of downtown Indianapolis.

Just as *Hoosiers* ignores the issue of race, so apparently did the boys of Milan, where no African Americans resided. Even in a fifty-year retrospective on the Milan Miracle, the immortal Bobby Plump made no mention of the race question. He did, however, observe that Oscar Robertson was "pretty fluid and a heck of a basketball player."[14] The significance of a five-on-five white against black basketball contest seemed lost on the Milan players and many observers, at least as long as the white athletes were triumphant. Yet in 1966 the basketball world would sit up and take notice when five black players from tiny Texas Western University (now UTEP) toppled Adolph Rupp's mighty all-white squad from the University of Kentucky.[15]

Nevertheless, the filmmakers of *Hoosiers*, working with hindsight of the civil rights movement and ostensibly worldlier than the boys from Milan, attempted to render invisible the racial context of black basketball in Indiana. Of course, by the time *Hoosiers* was made, African Americans dominated the NBA. Basketball historian Ron Thomas reports that by the 2000–2001 season, African Americans filled ten out of every twelve slots on an NBA roster, while eight head coaches were black. In addition, Michael Jordan helped to internationalize the game: in 1998 Jordan enjoyed an estimated ten billion dollar impact on the U.S. economy. The basketball star became the embodiment of what historian Walter LaFeber terms an American of world culture that "has become a powerful, tempting and frequently destabilizing force, challenging every traditional society."[16]

Given the success of African Americans on and off the basketball court, one might argue that the exclusion of race from *Hoosiers* simply does not matter. On the other hand, in a world populated primarily by people of color, Jordan, or any other NBA athlete for that matter, is hardly representative. Nor have sports proven to be a model avenue for black social mobility. Focusing on balls rather than books has not been the answer for black Americans, as the experiences of Arthur Agee and William Gates, the topic of the 1994 documentary *Hoop Dreams*, exemplify so well. Nelson George insists that the visibility of Michael Jordan and other multimillionaire black athletes has "not made white Americans more tolerant of the average Black man. Nor has it, in any measurable way, overturned the tide of low self-esteem that has overwhelmed the mortality of too many of their brothers. In fact, the triumph of a gifted elite has only bred a frustrated fatalism in those left behind."[17]

Race mattered in the 1950s and 1980s, just as it does today. In his study of post–World War II American sports and society, Richard O. Davies concludes, "The truth remains inescapable: the American dream of equality for all remains as elusive as ever in the world of American sport." In the larger national social arena, President Reagan's economic policies did little to foster a more level playing field. In the 1980s conditions grew worse, not better for African Americans, as more than one-third of the black population in the United States fell below the poverty line. High school dropout rates in the inner cities of the United States exceeded 50 percent, while the number of black female-headed households jumped to approximately 60 percent. Nearly 90 percent of black female heads of household under the age of twenty-five lived below the official poverty line.[18]

These grim statistics indicate that race in Reagan's America was a significant issue, even if it was ignored by the president, white Americans who attempted to avoid the inner cities, and filmmakers such as Anspaugh, who provided 1980s film audiences with a nostalgic view of a nation in which race and color were not relevant. This is not to suggest that the producers of *Hoosiers* were consciously perpetuating racism. Rather, as Alan Nadel observes in his critical study of "the films of Reagan's America," the issues of race, gender, and class were exposed in the 1980s through the medium of cinema, revealing the societal reservations often hidden behind the clichés of boosterism and optimism. Nadel writes, "Films are particularly useful in analyzing that subtext in that they are commercial products that represent a large collaborative consensus about ways to commodify a culture's values, to which commercial success lends affirmation." Nadel asserts that the middle class was destabilized economically and demographically by the Reagan economic policies of reductions in government spending and by record deficits, which in turn were fueled by tax cuts for the wealthy, resulting in increased social stratification. Yet through nostalgic films about a mythical American past, often situated in the 1950s, the middle class "maintained its ostensive status through its ability to consume narratives about itself." Nadel concludes that the nostalgic back-to-the past films of the 1980s, such as *Hoosiers*, were especially insidious in their "attempts to erase blacks from American history."[19]

Deborah Tudor's analysis of *Hoosiers* maintains that the filmmakers were quite aware of the film's racial implications and subtext. Ostensibly, *Hoosiers* makes the case for historical realism as a reason for black exclusion, but in fact, through dialogue, sound, and framing, the film establishes

the black players from South Bend Central as a threat to the harmony and stability found in the small white town of Hickory. The seven players from Hickory represent rural values that were under assault from the black urban centers, which threatened not only the homogeneity of the small town but white control of a sport such as basketball. The climatic black-white confrontation between South Bend Central and Hickory is dominated by an extremely percussive music track, while the crowd noise is distorted, creating a menacing sound. A long shot of the South Bend Central team entering the court establishes a sense of size and power, while a reaction shot of Coach Dale displays a sense of apprehension and foreboding. The Hickory team at this point becomes the equivalent of the "Great White Hopes" combating black heavyweight champion Jack Johnson in the early twentieth century; they too sought to restore white order and tame blackness.

Initially, the boys from Hickory are intimidated by the athleticism of the black players. One shot especially makes this point. A jumper from a Hickory player bounces off the front rim, which is framed in the shot. Then two black hands enter the frame and aggressively pull down the rebound. Viewers are certain who has the ball. However, the Huskers rally, and with their ingenuity and work ethic they are able to subdue the black menace. Tudor concludes that the film text suppresses the race issue "at its manifest level. This strategy denies any importance to the issue of race with sports. However, analysis reveals that the text creates an image of the opposition as menace and threat to the values with which the Huskers are associated."[20]

And what are the values that the Huskers must defend? They are the ideas of small-town America rooted in the heartland of the American Midwest. The positive values of rural Indiana are embodied in the seven Hickory athletes, whose decency, innocence, hard work, ingenuity, discipline, and sense of team and community allow them to slay the urban serpent that stands in the way of their miracle. This mythical Midwestern garden reflects a longing for an America free of racial and class division. Not surprisingly, it was in the Midwestern state of Iowa that Ronald Reagan came of age.[21]

David Zang argues that the popularity of *Hoosiers* can be attributed to the fact that the film transported "viewers back to a pre-Vietnam period and place of lost innocence." *Hoosiers*, Zang concludes, "appeared to stress all of the aspects of character and value that modern sport seemed

to have ceded in the name of dollars, image, and media hype in post-sixties culture."[22] It is ironic that in his Hollywood career, as well as in the excesses of deregulated capitalism, which were typified by the savings and loan scandal of the 1980s, Reagan and his administration were often the antithesis of the simplistic agrarian values that the president appeared to embrace in his rhetoric. The Reagan presidency fostered a growing class divide in the United States in which the intersection between race and class was most apparent. Reagan's economic policies created more jobs for Americans, but relatively well-paying industrial jobs were being replaced by jobs that paid wages well below the poverty level for a family of four. Accordingly, William Chafe wrote, "The number of low wage earners increased substantially during the 1980s at the expense of high wage jobs that either disappeared or moved overseas. Given existing conditions, some economists predicted, every new job created in America for the foreseeable future would be in the service sector of the economy."[23]

Confronted with these economic realities, it is no wonder that the shrinking middle class sought solace in the cultural embrace of films such as *Hoosiers* and *Field of Dreams* (1989). In the latter, an Iowa cornfield becomes a metaphor for reconciliation when a deceased father returns to reaffirm the domestic security of an earlier, more innocent America. In a similar fashion, the benevolent Reagan rhetoric and policies would absolve the United States of the divisiveness of the 1960s and restore a sense of community and consensus. In reality, the Reagan administration reduced farm subsidies, resulting in the foreclosure of family farms and the growth of agribusiness. The plight of the family farm in the 1980s was addressed in Hollywood films such as *Country* (1984) and *The River* (1984), both of which challenge the mythical nature of *Hoosiers*.[24]

There are discordant factors in the Anspaugh film and the historical story of the Milan Miracle, which undermine the narrative of a lost sense of community. Contained within the sense of group identity in *Hoosiers* are troubling issues of conformity and the loss of individualism. The film opens with a shot of Coach Dale driving down the winding roads of rural Hickory into a beautiful sunrise. In the words of President Reagan, "it's morning again in America." Hickory is a town in which the residents own small businesses such as diners, barbershops, feed stores, and family farms. The people are portrayed as self-reliant, industrious individuals who believe in democracy and God. In short, as Deborah Tudor suggests, "It is a well-ordered totally white universe."[25] In fact, the seven Hickory

The Hickory High School athletes are homogeneous—white and clean-cut. Courtesy of Movie Goods.

athletes are so homogeneously white and clean-cut that it is often difficult for the viewer to distinguish among them.

The locals are not particularly welcoming to Coach Dale, whom they initially perceive as an East Coast outsider. At a town meeting held in the local church they attempt to get rid of Dale, whose job is saved by Jimmy Chitwood's intervention. In the town meeting scene it becomes apparent that there is only one church in town, and no resident appears to be concerned with the separation of church and state. The meeting and vote regarding the public school employee are held in the church. The local pastor leads the team in prayer before games, and although the minister's son, Strap, is more devout in his pregame rituals than the other boys, he is not the subject of derision.

Hoosiers also addresses the complex interaction between team and individual that is a staple in sports films.[26] In order to succeed, the individuals must learn to work as a team and suppress their egos. Thus, Coach Dale is willing to accept defeat in some early games in order to instill the discipline the boys will need later during the pressures of the state tournament. Ollie, the equipment manager turned player, provides

an excellent example that hard work pays off, in the best tradition of Ben Franklin's *Poor Richard's Almanac*. Although limited athletically, Ollie never misses a practice and is willing to do whatever Coach Dale asks. In the semifinals, the starters foul out and Dale is forced to insert Ollie in the game's crucial last seconds. The opposition fouls Ollie, assuming that he will be unable to handle the pressure of making critical free throws. But all the long hours of practice in the gym culminate in Ollie making his shots, and Milan moves into the state finals. Nevertheless, it is difficult to conceive of Hickory advancing without the natural athletic talent of Jimmy Chitwood. It is the coach's job to see that this natural athleticism is used in the service of the team.

The film ultimately seems to embrace the values of conformity within small-town America.[27] It is supposed to be heartwarming to observe a caravan of cars from Hickory, outlined against the beautiful Indiana sky, following the team bus on a journey to do battle against the neighboring communities. Of course, what is really going on here, as Deborah Tudor suggests, is that school athletic programs are being used as socializing institutions that "channel the students into structured activities that reproduce dominant cultural values."[28] Sports divide the community into participants and spectators, with the majority being prepared to assume their roles as more passive consumers of American culture. On the other hand, Coach Dale assures Jimmy that success on the athletic field allows a young man to become a god.

Yet adulation can quickly turn to recrimination when a community's sense of self-worth becomes invested in a high school athletic contest. The high profile of a high school athlete in a small town places tremendous pressure on the young person. In a recent profile of high school sports for *Sports Illustrated*, reporter Alexander Wolff writes that an adult obsession with winning is stealing the joy of athletic competition and youth from adolescents. Historian Richard O. Davies asserts that rather than building character, as adherents of high school athletics maintain, the social pressures of performing up to parental and community standards lead many young people to abandon their athletic pursuits. He concludes that "school sport has become something much more than a game played for fun."[29]

Of course, in the case of the 1954 Milan Miracle the young basketball players achieved the immortality of a state championship and did not disappoint the community. The aftermath of the championship, however, suggests a degree of ambivalence among the players as well as the

town. While generating tremendous civic pride—the town's prominent water tower still proudly proclaims the 1954 basketball title—the Milan Miracle did little to promote economic growth in the small community. Fifty years after the championship, Greg Guffey described Milan as a town of approximately a thousand residents that has changed little since the 1950s. Like many small towns, Milan downtown stores are now mostly boarded up; interstates, bypasses, and suburbanization have left the community increasingly isolated. Yet Guffey concludes, "The town remains locked in the fifties as the twenty-first century approaches. The prospects are grim for revival, but when you've had the greatest moment in the greatest game in the greatest sport the state has ever known, does anything else matter?"[30]

Guffey's statement is a rather depressing one for Milan residents. It highlights the limitations of sports for the more passive consuming public. For the players on the championship squad, however, success on the basketball court did result in a degree of social mobility. The boys used their fame to parlay basketball scholarships and a ticket out of Milan, an indication of one's prospects in rural America during the 1950s. Perhaps the reality of provincial life was not quite as appealing as cultural narratives such as *Hoosiers* would have us believe.

The celebrated Bobby Plump used the legacy of the Milan Miracle to foster a life and career. The athlete received a basketball scholarship to Indiana's Butler University, where he enjoyed a solid if unspectacular collegiate career. Following college, Plump entered the insurance profession, and he was able to draw upon his athletic fame to develop business contacts. He frequently speaks to civic groups around the state of Indiana and provides commentary for high school basketball games. Some might find it depressing that Plump has spent most of his adult life reliving and recounting a brief moment of adolescent glory during a high school basketball game—reminiscent of the bittersweet memories evoked in Bruce Springsteen's "Glory Days"— but Plump insists that the Milan Miracle and the winning shot were the highlights of his life. The Indianapolis insurance agent defended the film that captured him in the persona of Jimmy Chitwood. He failed to understand why residents of Milan disliked *Hoosiers* and its celebration of the town's greatest moment. Townspeople were upset that *Hoosiers* was set in the fictional locale of Hickory, but the film was shot in neighboring communities that, according to director Anspaugh, displayed a more rustic look than Milan. Plump said of

Hoosiers, "I loved it. I thought it was great. The emotions that the movie portrayed caught what the fifties were really all about. Everybody knows the movie was about Milan. I don't care whether you're talking about the state of Washington, the Denver papers, or the Los Angeles papers. To me that's pretty significant. I disagree with the people of Milan on this. I'm very gratified that somebody would even use Milan loosely to make a movie. I think if the people in Milan are disappointed, they're being a little unrealistic in their expectations."[31]

Of course, those who continued to live in rural Indiana, rather than Indianapolis, were perhaps less nostalgic about the era. The much ballyhooed tax cuts of the Reagan administration did not offer much relief for residents of towns like Milan. Perhaps they knew better than to be hoodwinked by a cultural narrative that maintained that issues of racial and class divisions could be addressed by returning to the mythical garden of small-town America during the 1950s.

Hoosiers also raises some troubling issues regarding gender. The story line is about a masculine world in which the patriarchy must be restored in order to ensure a sense of stability. The film is ultimately about redemption and second chances for its male characters. A position as assistant coach, and finally hospital rehabilitation, provide the alcoholic Shooter an opportunity to reconnect with his son Everett. Everett visits his father in the hospital and observes that when his father is released, he will rejoin the family in their home. The presence of Everett's mother is assumed, but she is never shown on the screen.

Hoosiers is concerned with taking us back to a more mythical time in which women supposedly posed no threat to the patriarchy. This is most evident in the story of Jimmy, whose father is deceased. His disabled mother—who never appears in the film—is unable to raise Jimmy, so he lives with assistant principal and English teacher Myra Fleener. According to the ideology of the film, what Jimmy really needs is a father figure. Alan Nadel notes that *Hoosiers* told the story of fathers who were "protector[s], provider[s], and, as it now appears, dead. But surely it cannot be death, just a death rehearsal. Our founding fathers cannot have abandoned us; we cannot be subject to the poverty, homelessness, economic and emotional scarcity that exists elsewhere, that we know about only through television."[32]

On the political scene it is Ronald Reagan who assumes the symbolic role of father to make us whole again, and in *Hoosiers* it is Coach Dale

whose leadership restores Jimmy to his rightful place on the team. But Jimmy's restoration to the masculine world and competition is blocked by Fleener, who insists that Jimmy's future would be better served through academics. Fleener encourages Jimmy to embrace the more feminine values of the English classroom rather than the masculine preserve of the basketball court. However, based on the quality of instruction Jimmy is receiving in his history class (Coach Dale has also been hired to teach history and government, but he appears to devote little of his time to lesson planning or correcting papers), basketball probably provides a more realistic avenue for Jimmy's future.

Fleener's independence clearly poses a menace to the masculine order. She left Hickory for college but returned to take care of her mother following the death of her father. In assuming such duties, as well as serving as school principal after Cletus's heart attack, Fleener is undermining the patriarchy. As Deborah Tudor maintains in *Hollywood's Vision of Team Sports*, Fleener is blocking Jimmy's relationship with a surrogate father in Dale. The coach must tame Fleener and create a family unit, which he accomplishes by courting the English teacher. According to Tudor, after Dale kisses Fleener, "Myra's face displays her gradual change. The hard lines around her mouth vanish; her face becomes softer in expression. At the climactic state championship game, Myra becomes the supportive woman in the bleachers, nervous over the game's progress."[33] By the film's conclusion, Myra Fleener is no longer an active character. She has assumed the 1950s stereotypical female role of the consumer, who will sit on the sidelines rooting her men, Dale and Jimmy, on to victory in the competitive world of basketball. Fleener beams at Dale in a fashion reminiscent of Nancy Reagan's way of gazing at her man. Like Ronald Reagan, Dale has banished the forces of racial, class, and gender divisiveness by restoring the white patriarchy to power.

This politicized reading of *Hoosiers* is not meant to detract from the outstanding performances and entertaining nature of the film. Anspaugh directed a film that, no matter how manipulative the text, pulls at the heartstrings and makes one stand up and cheer for the boys of Milan. After all, it is the stuff of *Man of La Mancha*'s "Impossible Dream." On a more analytical level, however, it is important to note that film narratives, such as the nostalgic one in *Hoosiers*, helped to pave the way for the middle-class acceptance of Reaganism. Although class, racial, and gender divisions—including the feminization of poverty—were growing in

America during the 1980s, they were often masked by cultural narratives and presidential rhetoric that emphasized a longing for a mythical past—usually in the 1950s—in which Americans were united in a consensus based on sustained economic growth and in a community whose security was threatened by the evil Soviet Union. If only life were as simple as the movies.

Notes

1. "The 50 Greatest Sports Movies of All Time!," *Sports Illustrated*, August 4, 2003, 62–71.

2. For more about the post–World War II liberal consensus, see Geoffrey Hodgson, *America in Our Time* (New York: Doubleday, 1976).

3. Bob Cook, "Commentary: Enduring Memory of Milan High's Winning of the 1954 Indiana State Basketball Championship," National Public Radio, February 18, 2004.

4. Ibid. For a discussion of basketball in Indiana see William Gilden, *Where the Game Matters Most: A Last Championship Season in Indiana High School Basketball* (Boston: Little, Brown and Company, 1997); and Todd Gould, *Pioneers of the Hardwood: Indiana and the Birth of Professional Basketball* (Bloomington: Indiana University Press, 1998).

5. For more about the 1954 Indiana state basketball tournament see Greg Guffey, *The Greatest Basketball Story Ever Told* (Bloomington: Indiana University Press, 2003), 74–96.

6. *Hoosiers*, videocassette, director David Anspaugh (Los Angeles: Orion Pictures, 1996); and Frank Magill, ed., *Magill's Cinema Annual, 1987* (Pasadena, CA: Salem Press, 1987), 245–49.

7. Nina Darnton, "In New York, A Late Start on *Hoosiers*," *New York Times*, February 27, 1987, C9; and Janet Maslin, "*Hoosiers*," *New York Times*, February 27, 1987, C10.

8. Roger Ebert, "*Hoosiers*," *New York Post*, February 27, 1987, 27; Richard Schickel, "*Hoosiers*," *Time*, February 9, 1987, 74; David Edelstein, "*Hoosiers*," *Village Voice*, March 10, 1987, 58; and Rob Barker, "*Hoosiers*," *Women's Wear Daily*, February 27, 1987, 19.

9. Mike McGrady, "*Hoosiers*," *Newsday*, February 27, 1987, 3; and Nigel Floyd, "*Hoosiers*," *Monthly Film Bulletin*, May 1987, 141.

10. Stanley Kauffmann, "*Hoosiers*," *New Republic*, April 6, 1987, 26; and Robert B. Frederick, "*Hoosiers*," *Films in Review*, April 1987, 229.

11. For the history of the Ku Klux Klan in the United States and in Indiana during the 1920s, see David M. Chalmers, *Hooded Americanism* (Durham: Duke University Press, 1987); and Frank Cates, "The Ku Klux Klan in Indiana Politics, 1920–1925" (PhD dissertation, Indiana University, 1970).

12. Nelson George, *Elevating the Game: Black Men and Basketball* (Lincoln: University of Nebraska Press, 1992), 120–21.

13. Guffey, *Greatest Basketball Story Ever Told*, 4–5.

14. Ibid., 83.

15. Bert Nelli, *The Winning Tradition: A History of Kentucky Wildcat Basketball* (Lexington: University Press of Kentucky, 1984).

16. Ron Thomas, *They Cleared the Lane: The NBA's Black Pioneers* (Lincoln: University of Nebraska Press, 2002), 238; and Walter LaFeber, *Michael Jordan and the New Global Capitalism* (New York: W.W. Norton & Company, 1999), 163.

17. *Hoop Dreams*, videocassette, directed by Steve James (Hollywood, CA: New Line Home Video, 1994); and George, *Elevating the Game*, 239.

18. Richard O. Davies, *America's Obsession: Sports and Society Since 1945* (Philadelphia: Harcourt Brace College Publishers, 1994), 61; and William H. Chafe, *The Unfinished Journey: America Since World War II* (New York: Oxford University Press, 1999), 487.

19. Alan Nadel, *Flatlining on the Field of Dreams: Cultural Narratives in the Films of President Reagan's America* (New Brunswick, NJ: Rutgers University Press, 1998), 4 and 206.

20. Deborah V. Tudor, *Hollywood's Vision of Team Sports: Heroes, Race, and Gender* (New York: Garland Publishing, 1997), 152–56.

21. John C. Tibbetts, "The Midwest," in *The Columbia Companion to the Film*, ed. Peter C. Rollins (New York: Columbia University Press, 2003), 421–29. On Reagan, see Edmund Morris, *Dutch: A Memoir of Ronald Reagan* (New York: Random House, 1999); and Garry Wills, *Reagan's America: Innocents at Home* (Garden City, NY: Doubleday, 1987).

22. David W. Zang, *Sports Wars: Athletes in the Age of Aquarius* (Fayetteville: University of Arkansas Press, 2001), 153.

23. Chafe, *Unfinished Journey*, 487.

24. For an excellent discussion of cinema in the 1980s, see William J. Palmer, *The Films of the Eighties: A Social History* (Carbondale: Southern Illinois University Press, 1992).

25. Deborah Tudor, "Hoosiers," *Jump Cut* 33, no. 2 (1988): 2.

26. Aaron Baker, *Contesting Identities: Sports in American Film* (Urbana: University of Illinois Press, 2003).

27. For the dark side of the small town experience, see Ima Honcker Herron, *The Small Town in American Drama* (Dallas: Southern Methodist University Press, 1969).

28. Tudor, *Hollywood's Vision of Team Sports*, xviii.

29. Alexander Wolff, "The High School Athlete," *Sports Illustrated*, November 18, 2002, 74–78; and Davies, *America's Obsession*, 127.

30. Guffey, *Greatest Basketball Story Ever Told*, 11.

31. Davies, *America's Obsession*, 103–9; and Guffey, *Greatest Basketball Story Ever Told*, 24.

32. Nadel, *Flatlining on the Field of Dreams*, 50.

33. Tudor, *Hollywood's Vision of Team Sports*, 96–97.

VICTORIA A. ELMWOOD

"Just Some Bum from the Neighborhood"

The Resolution of Post–Civil Rights Tension and Heavyweight Public Sphere Discourse in Rocky

THE ENDURANCE OF THE motion picture *Rocky*, the 1976 Oscar winner for Best Picture, has recently been reaffirmed in twenty-first-century popular culture. The movie's twenty-fifth anniversary rerelease in 2001 and the accompanying publicity in high-profile entertainment magazines like *Entertainment Weekly* suggest that, despite the mockery garnered by formulaic sequels in the 1980s, the character of Rocky Balboa continues to be a powerful icon with a semiotic currency for those born in the 1980s. This essay explores why the 1970s blockbuster boxing film became and continues to be a stable commodity in the American cultural meaning market over the past twenty-five years.

The boxing film genre recently has been the subject of a modest amount of scholarly attention from critics interested in its distinct set of characters, values, symbols, and identifiable narrative contours. Works by Aaron Baker, Dan Streibel, Tony Williams, and Leger Grindon have been crucial in linking the ideology of the boxing film to a set of material and political circumstances related to increasing industrialization in the twentieth century. Their research has helped constitute the critical lens deployed in this essay to better understand the American mainstream's affection for the character of Rocky and, more importantly, the extent to which the film provides an appealing resolution of national tension during a time of considerable anxiety regarding the fragmentation of traditional values. This analysis focuses on the film's finessing of race and gender alliances

at a time when such questions were vexed, to say the least. Foremost here is the film's overwhelming and unexpected success and what it signifies in terms of how American audiences deal with social change through the invocation of certain narratives within a specific context.

Rocky's narrative is one that invokes a recognizably American film genre while retooling the ideological valences of that genre to respond to historical changes confronting the country during the late 1970s. The film's characters and its outcome provide a neoconservative resolution to the challenging social, economic, political, and military shifts that took place after World War II. A culture of burgeoning consumerism, the unsuccessful campaign in Vietnam, and the loss of faith in the democratic experiment implicit in Watergate all elicit a response within the film's world. However, it is the social advances made by African Americans and women in the quarter-decade after the war that receive the most intense and shrewdly plotted resolution in the ideological implications of the film's narrative. The popular appeal of such a resolution is bolstered both by a desire to reaffirm the sociopolitical status quo and by the film's reliance on and invocation of specific values and beliefs that are pivotal to the invention and articulation of an American character. Thus Rocky recasts a national ethos that responds nominally to the social and political changes of recent decades. More specifically, the film reaffirms traditional gender boundaries and values while simultaneously expanding the parameters of national citizenship to include African American men. Rocky offers masculine status and national citizenship to a previously rejected group in exchange for their allegiance in a quest for the remasculinization of white men (and, by extension, the nation) and offers a bond of solidarity in rolling back the advances made by feminism. In particular, this rolling back focuses on reinforcing the primacy of reproduction as women's social (and civic) duty.

Rocky tells the story of a failed boxer who is given the chance to fight the world heavyweight champ, Apollo Creed, in a novelty match that is designed to fulfill promotional contracts that threaten to fall through after Creed's original opponent breaks a hand six weeks before the event. While training for the fight, which is promoted more for its symbolic implications than its significance as a sporting event, the title character falls in love with his best friend Paulie's sister, Adrian, and makes amends with his estranged coach-cum-father-figure, Mickey. What begins as a regimen of harsh physical training turns into a spiritual rebirth for the failed boxer-

turned-loan-shark's enforcer, and the film ends not with Rocky's victory in the ring against Creed (in fact, the underdog loses) but with a mutual declaration of love between Rocky and his girlfriend, Adrian, which also takes place in the ring immediately after the bout is called.

A sleeper hit released in November of the American bicentennial year and set in Philadelphia, *Rocky* is inspired by an actual bout that screenwriter and star Sylvester Stallone witnessed between Muhammad Ali and Chuck Wepner, the eighth-ranked heavyweight in the nation but an unknown compared to Ali (*Rocky*, 25th edition DVD liner notes). Wepner managed to last an unprecedented fifteen rounds, give or take a few seconds, without being knocked out by the high-profile champion and member of the Nation of Islam. The film itself has an underdog quality that matched its eponymous main character; it was made on a shoestring budget during a period in Hollywood when studios were banking on lavish returns from big budget, star-studded blockbusters like *The Godfather* (1970). A depressing film about a failed boxer made by a cast of unknowns and minor actors was low on MGM's list of priorities. Because of its small budget, however, and the amount of unpaid work undertaken by the film's makers and actors, the film went through production successfully—and not a minute too soon, as the script was purchased with the proviso that Stallone play the starring role just as the actor's bank account balance dipped below a hundred dollars.

Following its surprising success at the box office, *Rocky* became a franchise in American culture with a regular presence that extended beyond the 1980s with the release of *Rocky V* in 1992. A testament to the longevity of the character, the sixth installment in the Rocky franchise (*Rocky Balboa*) was released in 2006 and garnered some modest success at the box office. Moreover, the 2008 premiere of *Rambo*, the fourth film in its own respective franchise, suggests the sustained appeal of Stallone's iconic characters. *Rocky's* sustained commercial success results in part from the recycling of deeply ingrained American ideological and political motifs, values, and beliefs from previous historical eras—specifically, the nineteenth-century populist movement and the Jeffersonian confidence in the virtues cultivated by the rugged lifestyle of the yeoman farmer. This updated colonial philosophy is combined with a male masochism that both reinvigorates the American man's virility and mitigates the perceived compromise of American manhood resulting from the military withdrawal

from Vietnam and from African Americans' and middle-class women's advancements in political standing.

A 2004 television commercial for Starbucks coffee features the band Survivor playing their hit theme from *Rocky II*, "Eye of the Tiger."[1] The lyrics of the familiar anthem had been rewritten to apply to white-collar corporate ambition rather than to the prospect of overcoming a difficult imminent physical conflict:

> Glen's the man, going to work.
> Got his tie, got ambition.
>
> He knows one day he just might become
> supervisor.

In its original version, the song helped to usher in a decade of blockbuster action films that prominently featured the hyper-muscular physique of the male body builder and epic trials and suffering for the movies' heroes. For many, "Eye of the Tiger" is the quintessential training song, playing as it does during Rocky's grueling training for his rematch with Apollo Creed in *Rocky II*. The comic reinterpretation of the song for the Starbucks commercial appeals to white-collar professional men by making corporate ascendancy the metaphor for physical prowess and strength, thus downplaying the need for the latter by replacing it with a bottled iced latte, available in the local grocer's freezer section. Meant for in-home domestic consumption, the drink is implicitly realigned with ruggedness and competition, which safely edges it away from the more feminine symbolic domain of the home and bolsters the masculinity of the white-collar corporate male employee by mere dint of association with the song.[2]

A 2000 commercial for Lipton Brisk Iced Tea in a can invokes the Rocky mythology more directly. Set in a boxing ring, the ad features a downtrodden Claymation Rocky returning to his corner of the ring to the tough-love-style scolding of his aged trainer. Clearly exhausted, Rocky chugs down a twelve-ounce can of Lipton's Brisk and, reinvigorated, exclaims "That's Brisk!" before going on to fight in the next round. *Rocky's* downtrodden, unlikely hero, known as much for getting the tar beat out of him as for overcoming impossible odds, is invoked in order to underline the drink's supposed regenerative powers.

The variety of capacities in which the figure of Rocky Balboa is still called on in daily life in the United States suggests that the popular movie character has maintained a noteworthy cultural currency. Key to this currency is the success with which Rocky invokes an earlier American narrative and ideology to respond to the new challenges confronting white masculinity in the late 1970s and beyond. The roots of white masculinity's perceived challenges extend back at least to the political situation of the United States at the end of World War II. Consequently, it is to these social, military, political, and economic challenges that we must first look to understand the broader historical context in which an unlikely, low-budget film, written and starred in by an unknown actor, garnered surprising success in a period of high-budget, high-stakes gambles intended to dig the movie industry out of the slump of the late 1960s (Guerrero 71–73).

Rocky's *Historical Context: The Post-Vietnam Predicament*

Among the challenges to traditional white masculinity that had been coalescing since the end of World War II was the shift from a production economy to a consumption economy, one in which greater importance was placed on retail sales, distribution, and marketing than on human labor. Manufactured goods, appliances, luxuries, and vehicles were being produced in unprecedented numbers, in part to meet the anticipated demand created by the nascent baby boom of the late 1940s. Women were responsible for a considerable portion of the consumer demand for time-saving household conveniences and luxuries as well as child-rearing and -bearing aides. Their husbands, who enjoyed the benefits of mobility and the fruits of their wives' consumption, were bound to their urban jobs to finance the suburban lifestyle of the family, including leisure activities. The guarantee of free time on weekends and in the evening that came with the standard nine-to-five workday gave rise to a greater demand for mass entertainment and recreational activities like sports and games. The spread of the mass communications and entertainment markets constituted the inception of a culture industry with greater reach than was ever imagined.

These economic and demographic shifts presented a surprisingly strong challenge to the popular model of masculinity in the United States in which manhood was aligned with the literature and folklore of the frontier, of the Wild West and its pioneers. Although the midcentury American man enjoyed an unprecedented degree of comfort, it was, ironically enough,

this very comfort that posed an ideological threat to gender ideals deeply grounded in a sense of national destiny and distinction. Although capital and commercial success were thought of as quintessential indicators of "Americanness," they clashed notably with the idealized masculine traits associated with the cowboy figure invented and promoted by Owen Wister and President Theodore Roosevelt at the turn of the century. This ideology, in part a reaction to the exaltation of the obscenely wealthy captains of industry during the Golden Era of the late nineteenth century, invoked the trope of the frontier and the eighteenth-century separation between East and West as an organizing contrast at the core of American values. Implicit in this system of values was a specific division of family labor that was seen as under attack by suffragists and the significant numbers of women who were working in factories during the fin de siècle in the United States.

The stereotypical husband, father, and company man of mid-twentieth-century U.S. culture, represented by the icon of the "man in the grey flannel suit," failed to satisfy some key indicators of frontier masculinity. Two sets of social roles stand out as the key indicators of postwar manhood's shortcomings, which quite notably refer to two principal means by which patriarchal power is maintained in late Western culture: the man's position in the home and his position in the workplace. Although the white-collar white man might have been king of his castle, it was his wife who decorated, cleaned, peopled, and regulated it. The consumer lifestyle of the suburban middle class, which provided incentive for the man to keep his nose to the grindstone, was marked by the decidedly feminine traits of comfort, visual pleasure, children, and community membership. Furthermore, the intellectual work of the corporate office and the increased mechanization of production deemphasized the value of the male body and its labor, prioritizing instead the power of the intellect. The laborer, giving way to increasingly complex machines, became an administrator or a clerical worker. Combined with the diminution of the man's control in the domestic environment, these large-scale changes in industry required character traits associated with femininity and the effete, learned, appearance-obsessed, and physically debilitated Easterners of frontier literature—for example, the yellowback Beadle dime novels of the late nineteenth century and the westerns of early twentieth-century cinema.

Further compounding this climate of compromised masculinity were the political tensions and military engagements of the Cold War. The

uneasy impasse between capitalism and communism became increasingly unstable with the mounting political and ideological tensions between the United States and the Soviet Union, both of which had stepped into the power vacuum left by the destruction of France, England, and Germany to build superior arsenals of weapons of mass destruction. The major military conflicts of the Cold War, the Korean War, and the police actions in Vietnam ended in uneasy stalemates, suggesting that the military might of the United States was insufficient to counter the insidious power of the red tide. The repulsion of U.S. forces by men thought to be racially inferior was a particularly strong blow to the pride of the American armed forces, and the use of nontraditional warfare by communist guerillas precluded any possibility of a triumphant, heroic victory like the ones memorialized in representations of World War II conflicts. Growing fear of the downfall of American geopolitical dominance was bolstered by internal dissent over the United States' policy in Vietnam, but it was not until President Richard M. Nixon launched his "Vietnamization" plan and secured a second term in office that the 1973 scandal of Watergate dealt a powerful blow to American confidence in its own democracy. Thus, by the middle of the 1970s a considerable number of U.S. citizens had begun to question both the might and the right of their own government and its faithfulness to the ideals of democracy. Questions about the democratic state were magnified by the nation's poor civil rights track record, which communist leaders often noted. In addition, as cultural theorists such as Cynthia Enloe and Joanne Nagel point out, the military and political struggles of the 1950s, 1960s, and 1970s tested the mettle of the United States in areas that had traditionally been reliable gauges of specifically *masculine* national power —political management, military might, and international leadership. Indeed, Enloe asserts that "in any kind of distribution of political power there is probably a gendering going on," suggesting the extent to which virility and national well-being are often conflated (Enloe 145).

The final and, some might argue, more enduring challenge to the white man's traditional dominance in U.S. society and culture were the social movements of the postwar period, all of which sought to garner equal protection by the law, equal access to the nation's resources, and equal civic standing as a legal right historically ensured only to white men. The civil rights movement, feminism, and gay rights movement, as well as nascent groups of agitators like the Brown Power movement in the Southwest, sought to have legislation passed, won seminal Supreme Court battles,

organized strikes, and even brawled in the streets against state forces sent to silence them. Although all of these movements sought what they viewed as their entitlement to equitable protection under the law according to the U.S. Constitution, they were perceived as a threat by the predominantly white, male constituency of federal and state representatives as well as law enforcement officials and private citizens. White men were, to a large extent, threatened by the changes called for by these revolutionaries, all of whom were seen as attacking a system of sexual and racial superiority at the heart of the Constitution and national history, both in theory and in institutionalized practice. To understand *Rocky*'s response to these circumstances, we first need to consider the boxing film as a politically significant genre with its own features and cultural politics.

Ideology and the Boxing Film: The Industrial Yeoman of the Urban Frontier

A popular genre in the early days of cinema, the boxing movie saw its first boom between 1910 and the 1940s. More than seventy boxing films—in which the boxer's social position was aligned with the working man's desperate financial and domestic struggles—were produced in the Depression Era (Grindon 65). Boxing film ideology drew on the same set of principles as populism in order to maintain an appeal similar to that of the political movement. The early boxing film in particular has been associated with specific ideologies, using elements of melodrama to broadcast a unique blend of progressive and conservative politics. Invoking these two (often conflicting) sets of political values, populism developed at a time when the nation's economy had shifted its emphasis from agriculture to urban industry and mechanical reproduction. This shift enabled (and was enabled by) the immigration of increasing numbers of people from other countries into the United States, which in turn reinforced the growing economic and political distinction between country and city. Populism was aimed at "middle-class, rural Americans," and it ennobled the values of initiative and entrepreneurship in contrast to monopolistic corporate control. Over time, the movement came to be associated with "farmers or small-time mercantile capitalists" (Baker 165). Peculiar to populism was the ability to appeal to progressive values by elevating the individual common man while at the same time extolling the virtues of ruggedness and self-reliance. According to Aaron Baker, populism's "attacks on monopoly capital and

its defense of the 'common man' appealed to the left, but the solutions it offered—free enterprise, the work ethic, return to the land—also fit the conservative agenda" (Baker 165). The boxing film maximized its appeal to American audiences by representing a broad range of values from the Depression's political spectrum. This hybrid system of checks and balances relied on familiar ideological binaries such as city/country, ingénue/débauchée, individual/community, and official/outlaw (with gangsters, bookies, and loan sharks principally occupying the latter category).[3] As a genre, then, the boxing film of the Depression Era became a mouthpiece for the (sometimes inconclusive) airing of some of the nation's most politically charged ideological debates, which were often centered on race, opportunity, and success.

Tony Williams has a slightly different reading of the boxing film as a genre of particularly American symbolic resonance that builds on both Grindon's and Baker's earlier work. He describes the boxing film as a "discontinuous genre"—discontinuous in relation to other genres like film noir and westerns in that, while noir and westerns have distinct generic traits and implied social values, the boxing film disappears and reappears in different incarnations at different periods of American history. Williams links the implicit values of the boxing film to progressivism, politically, and to the American naturalist school of artists and writers, both of whose heydays took place during the decades before and after the turn of the century. Williams notes the influence of post–Golden Age progressivism (belief in social aid, collective bargaining, and political reform) as key to the genre. However, he also emphasizes the presence of a darker, counterbalancing aesthetic of bleak determinism in reaction to the new urban frontier of the cold metropolis and a correlated resurgence of confidence in the civic model of the independent yeoman farmer. The lone, self-reliant boxer is thus an updated and remodeled version of the pioneer who now is situated in the urban jungle, a stand-in figure for the old frontier (Williams 308). However, Williams blames the chronologically sporadic popularity of the boxing film on its tendency to emphasize external social factors as key obstacles to the success of the yeoman-farmer-cum-ethnic-urban-prizefighter. The attention devoted to social obstacles and their deleterious effect on the individual's capacity for self-improvement is problematic for traditional American ideology in that it contradicts the faith that democracy and egalitarianism place on self-reliance and meritocracy. Given the boxing film's tendency to highlight some embarrassing contradictions implicit in the fundamental

ideas essential to validating the American dream, particularly in relation to race and class, mainstream viewers enjoying times of prosperity (for example, during the 1950s) were unlikely to be as receptive to characters and story lines that found problems in a system that was demonstrably working to the viewers' benefit (Williams 305–7).

As the sport of boxing increasingly became an arena for the exposure of racial tensions and competition, black boxers came under particular pressure to maintain an aloofness regarding racial politics. Boxers like Joe Louis were rewarded for their neutrality by being honored as national mascots or representatives (as with the Louis-Schmeling fights during World War II) and with Hollywood bit parts and even biopics. However, boxers like Jack Johnson and Muhammad Ali, who actively flouted convention through ostentation and transgression of racial and political taboos, tended to tread a rockier path to fame or, rather, notoriety (Williams 309). *The Great White Hope*, the 1970 biopic about early-twentieth-century boxer Jack Johnson, dramatized racial antagonism within the sport as an index of larger racial antagonism. It told the story of a famous black heavyweight champ who was toppled from greatness by a white boxer chosen and championed to regain lost racial ground and uphold the crumbling myths of racial superiority that bolstered segregation and white supremacy. In some ways as reflective of Muhammad Ali's career as it is of Johnson's, this film's foregrounding of racial (racist) antagonism, combined with its production during a period of struggle for civil rights and its marketing to both black and white audiences, suggests that the sustained attitude of Darwinist racial determinism is coterminous with the sport of boxing. Ali had repeatedly proven himself to be "the Greatest," and he had pledged allegiance to the Nation of Islam, which many whites felt threatened by. *The Great White Hope* garnered notable criticism from both black and white audiences, for its hero's status as a passive victim and for its allegations of high-level white political conspiracy. Nevertheless, the film demonstrates the continuity of racial antagonism as a ubiquitous and compelling source of anxiety throughout twentieth-century American culture (Naylor, pars. 35–40).

It is this keen anxiety that *Rocky* responds to and seeks to smooth over with its eponymous ethnic white underdog hero and its Muhammad Ali–like adversary, Apollo Creed. *Rocky*, however, conveniently avoids the underlying racial trouble at the heart of the sport that has been suggested in boxing films like *The Great White Hope*, and the relationship between

the two boxers hints at what Tony Williams refers to as "an alternative tradition within the boxing genre that has often remained neglected within Hollywood, one involving race and revolution" (Williams 314). Although the 1976 Oscar winner for Best Picture pays homage to the typical boxing film's pessimistic view of "a life within capitalism, which competitively pits individual against individual in a divide-and-rule strategy," it also seeks to incorporate this "alternative current" by emphasizing the common personal goals that each of the two boxers calls forth in his adversary. A neat, masculine unity is enforced by the mutual remasculinization that both boxers bring about in each other at a time when each man suffers diminishment in masculinity from different circumstances. Here, gender is the ideological means by which tension between men of different races is disavowed and by which the film's main female character is safely ensconced within a heteronormative relationship in which she fulfills the traditional, domestic, and (implied) reproductive roles of the wife.

In some ways Rocky Balboa and Apollo Creed act as mutual saviors of both spirit and athleticism, and it is this reciprocal reform that separates *Rocky* from boxing films that trade on racial antagonism. However, the film does not quite fit into Williams's alternative tradition of "race and revolution" boxing films; instead, it walks an uneasy line between dealing with the question of race and simply ignoring it. Race is evacuated of any particular socioeconomic conditions or related material or political disadvantages and is instead invoked as a powerful symbolic tool that is ahistorically invoked for the greater good of the boxing spectacle. For example, we first glimpse Creed in his promoter's office, throwing a tantrum upon hearing that his opponent for the upcoming national heavyweight title fight is injured and that no replacement can be found. Mainly eager to avoid losing money from the many publicity contracts he has already signed, Creed turns the fight into a meta-spectacle, and the discourse surrounding the spectacle threatens to eclipse the event itself. Musing over the match-up, Creed chuckles, "Apollo Creed versus the Italian Stallion . . . sounds like a damn monster movie!" The fight's organizers count on promotional success partly due to public enthusiasm for revolutionary rhetoric in the temporal and geographical situation of the fight itself: in Philadelphia, the site of the signing of the Declaration of Independence, on the first day of the United States' bicentennial anniversary year. By relying on the capital-friendly idea of "opportunity," Creed engineers the salvation of his own earning potential. Not only does he discount any possibility

"Apollo Creed versus the Italian Stallion . . . sounds like a damn monster movie."
Courtesy of Oklahoma State University Special Collections.

that a contender, ranked or not, might defeat him, he also deliberately requires sportsmanship to take a backseat to pageantry.

The champ further develops the stilted historical rhetoric of his heavyweight title fight when he discovers Balboa's name, the Italian Stallion. The fight's significance changes from patriotic rhetoric to racial melodrama when Creed muses, "Who discovered America? An Italian, right? What would be better than to get it on with one of his descendents?" Miscegenational double entendre notwithstanding, Apollo leaves any further, distinctly racial implications of the fight's narrative unspoken here by responding with a jovial rhetorical rejoinder. When asked later by reporters if "it['s] any coincidence that [he's] fighting a white man on the country's most celebrated day in history," Creed quips jovially, "I don't know. Is it any coincidence that he's fighting a black man on the country's most celebrated day in history?" In this press conference scene, the signs of race war are again briefly conjured and then effaced just as quickly when Creed throws his arm around Rocky, addressing him as "Rock, my man." The complete reversal of social status that characterizes the characters in the film is implicit in Creed's fame, wealth, and clout and also in Rocky's obvious disenfranchisement resulting from the social displacement of the white man in the wake of the civil rights era. However, Rocky's expression of admiration for the heavyweight champ in an argument with a local bar owner tactfully deflects the blame for the white man's downfall *away* from

black privilege. When the bar owner laments the decline of "real" boxers and calls Creed "a jig clown," Rocky defends Creed from the portly owner's disparagement: "What are you talkin' about? This guy's the heavyweight champion of the world. He took his best shot. . . . When was the last time *you* took a shot?" The implication here, of course, is that the black champ deserves his position and fame, having earned it by dint of hard work and determination. The boxing film genre, noted for its ability to sew together sometimes conflicting political ideologies, agitates for the empowerment of the ethnic white man but simultaneously attempts to compensate by avoiding the nationally scarring racial antagonism of the previous decades by appealing to traditional Protestant and egalitarian ideals. Furthermore, Creed is characterized as the poster child for racial uplift when we glimpse him in a television interview addressing disadvantaged American youth who want to improve their lot in life through athletic achievement: "Stay in school and use your brain; be a doctor, be a lawyer, carry a leather briefcase. Forget about sports: sports make you grunt and smell. See, be a thinker, not a stinker."

To contextualize the question of racial tension in *Rocky*, we might do well to note the similarities between the fictional Creed and his actual counterpart, world heavyweight champion Muhammad Ali—similarities that would have been plain to most adult viewers at the time. Like Ali, Creed is cast as intellectual but also vain and arrogant, devoting visible aplomb to the ring as a theatrical space as well as an athletic one. Like Ali, Creed travels with a large, all-black entourage and is given to ostentation and an unusual degree of "performativity." But these two details are about the only ones that link the two boxers. Unlike Ali, Creed is ambiguously apolitical in his outlook, yet he keenly grasps the political and symbolic overtones of the fight he plans between himself and the Italian Stallion during the U.S. bicentennial year. Preoccupied with mass media and theatrics, Creed figures as the capitalist par excellence rather than as a political radical, reducing everything to surface values, media hype, and profit; the champ surpasses even his slick promoter, Jergens, when posed with the dilemma of choosing an opponent. Here, ruthless entertainment capital stands in for the Depression Era bookies and gangsters responsible for fixing fights and parasitically living off of the boxer's physical labor while also disregarding the importance of implicitly masculine athleticism. In his involvement with this branch of sports management, Creed has plainly fallen into the dreaded decadence of early boxing films. Although the boxer's decadence

was traditionally brought on by jezebels, crooked managers, and ruthless mobsters (Baker 168), in *Rocky* that decadence is caused by the faceless machinery of the entertainment industry, an arm of mass media capital notorious for corrupting (or at least disregarding) the rugged individual. Not only has it negatively affected Creed's character, but the boxer has also become adept at the game itself, having so completely appropriated and redeployed the master's tricks that he enjoys greater successes in their manipulation than the master himself. Creed steps in with a plan to save profits from the heavyweight title fight when his promoter fails to find him an opponent. When Creed unveils his gimmick of offering "a [literally] snow-white underdog a chance at the title," his promoter responds, "Apollo, I like it! It's very American." Creed counters, saying, "No, Jergens, it's very *smart*." Rather than opposing the racist fervor fueling the appeal of fights between black and white boxers, Creed exploits it for his own personal gain.

In *Rocky* the sinister underworld element has been eliminated, or at least downplayed. The underground moneymaking industry that exploits fighters in earlier films has gone legit; their business is now legal and reputable. The individual men who continue to bet small sums on local fights are depicted as harmless neighborhood drunks and local color characters, and whether to take a dive never even comes up as a question for the Italian Stallion. Even the loan shark for whom Rocky works seems to be a relatively decent guy who helps bankroll Rocky's training with no apparent strings attached. Creed, his entourage, and the sports and media representatives are fallen largely because of their flagrant profiteering and eagerness to exploit the labor of athletes for their own economic gain, with little or no regard for the integrity or fairness of the competitions they promote. Rocky steps in from below, as a representative from the community of athletes, to steer Creed back into the fold, true to the pattern of boxing films from the earlier half of the century. Only with the near-loss of his heavyweight title to Rocky Balboa does Apollo Creed abandon pageantry to reassert his status as an athlete.

The spectacular elements of the Creed-Balboa fight further articulate a relationship between Rocky and Apollo, who have little contact until they meet in the ring. Just before the fight, after we have witnessed Rocky's grueling and unusual training regimen, he declares to Adrian, "I can't do it. I can't beat him." Nonetheless, he affirms the procapital values of individuality, determination, and self-reliance in declaring his intention to

"go the distance with Creed." Because this is something no other fighter has done, it will assure Rocky that, as he says to Adrian, "for the first time in [his] life that [he] weren't [sic] just some bum from the neighborhood." Rocky replaces the gimmicky rhetoric of his bout with Creed, the appeal to the ideal of opportunity, with his own revision of masculinity as independent of the imperative for triumphant success. Rather, Rocky acknowledges the champ's superiority as an athlete and redefines victory as the ability to oppose the champ to an unprecedented degree, still foregrounding the traditional masculine requirement of physical strength and endurance by embracing masochism and discipline. The failed boxer banks on Creed's fame as a guarantor of his own masculine mettle and hopes to parlay physical capital into social capital, envisioning himself as distinct from the local, marginally employed men who populate his neighborhood streets.

Discursive Arenas: Boxing Ring as Metaphor for Civic Exchange

Worthy of note here, too, are the figurative implications of this match-up for the status of citizenship and national membership. The real-life tension surrounding black heavyweight titleholders combined with the tacit proviso that the black champ cast an apolitical persona suggests an unacknowledged link between sports, especially violent sports, and political or civic agency. As numerous feminist critics of nationalism have remarked, the abstract national subject is a masculine one whose civic responsibilities include and even highlight the responsibility for national defense.[4] Indeed, as political champs like Jack Johnson and Muhammad Ali became dissociated from the nation of their birth, so did the less inflammatory boxers like Joe Louis garner public approval for fulfilling their perceived patriotic duty by joining the military during wartime and, in Louis's case, soundly defeating Max Schmeling, Nazi Germany's heavyweight champ, in a rematch.[5]

As Gamal Abdel-Shehid suggests, the separation between the athlete and the solider is tenuous, particularly in American culture (Abdel-Shehid 317). Although the fear of race war is the most obvious cause of white American sensitivities regarding black heavyweight champs, more subtle conclusions might be drawn about the civic implications of a black man occupying a national title endowed with such metonymic resonance. Indeed,

The mutual remasculinization of Apollo Creed and Rocky Balboa. Courtesy of Oklahoma State University Special Collections.

it is no small wonder that white American boxing fans feared and hated the black champ who did not clearly demonstrate loyalty in his politics and identity outside of the ring. Taking Kath Woodward's observation that the boxing match constitutes a manifestation of the Bakhtinian carnivale, an event or occasion of libidinal indulgence that reverses dominant hierarchies, then the implication of social reversal within the ring needed a strong ideological counterbalance to downplay the champ as a subversive figure outside of the ring (Woodward 14).

Given the tacit conflation of male citizen and national athlete in the sport of boxing in the United States, it makes sense to conceptualize the ring as an alternate political venue. Quite appropriately, the sport supports some key ideological underpinnings of democratic philosophy—most importantly, the idea of a level playing field on which appropriately matched competitors engage in a formalized (although physical) exchange, the victor of which is determined by his ability to incapacitate his opponent. These parameters are reminiscent of the Enlightenment belief in debate or verbal discourse as a perfectly transparent media for the contestation of intellectual or ideational dominance.

Racial tensions of the previous twenty-five years are embodied in the flesh of the two boxers so that they may literally be violently beaten out. *Rocky*'s narrative reverses the tendency of blackness to confer subordinate class status in order to disavow the continuing presence of racial inequality

while still relying on the traditional ideological vocabulary of the boxing narrative's progression from innocence to decadence to rebirth. The white man, in reasserting his prophetic strength and power as equal to that of the black man, also plays a redemptive role, returning his dark brother to the pursuit of the sport itself, safely out of the clutches of effeminate pageantry. Not only does the ethnic white underdog prove his mettle against all odds but he also brings about a transformation in his opponent that, typical of the early boxing film, moves toward the rehabilitation of a once-great figure fallen into decadence and excess. At the same time, this movement supports elements of both procapital and progressive political alignments: self-reliance and individuality on one side and racial equality on the other.

Michael Warner's work on Enlightenment public sphere print discourse supplies us with a basis for comparison between the fight scene in *Rocky* and the public sphere of the late colonial period constituted by the distribution of civic-minded print pamphlets. Warner draws largely on Habermas's analysis of the structural transformation of the public sphere, in which he articulates the Enlightenment change in the public sphere as shifting from one in which power is invested in a privileged individual through whom it is represented to the public to one in which power relations are negotiated as a result of discourse between representative individuals in a printed discourse. The latter requires not only a reading public but also a set of protocols or rules under which the discourse takes place within the print medium (Warner 39).

The boxing match bears some curious similarities to the functioning of public sphere print discourse. As the public sphere is a highly mediated discursive space for verbal contact, so is boxing a highly mediated space for physical contact. Although the contenders in the ring are anything but disinterested, the rules of boxing abstract the circumstances under which the opponents face off. In a hyper-embodied endeavor, these rules articulate an objectified, generalized protocol for an event of specific discourse. Boxers are weighed in and matched according to body mass, fights are divided by rounds into discrete time periods, and matches are mediated by an impartial referee. Not only are there restrictions on the situation of the fight, but certain fighting maneuvers are outlawed or, alternately, essential to the sport. Kicking, butting, and hitting below the belt are proscribed while jabs, upper cuts, and right-left combinations abound in a match. Boxing is a formalized kind of fighting done in a highly organized physical

space attendant with a set of rules and norms concerning the boxers, the referee, and even the audience (Woodward 8).

While one might analogize the sport of boxing to any number of other cultural phenomena, public sphere discourse is a noteworthy analogy here because it, like boxing, arguably plays a role in the characterization of the nation and the individual subject's relation to it. Not only the outcome of a boxing match but also the ways in which the sport is organized make it one stage for the playing out of national tensions and the determination of national identity. *Rocky* derives a large part of its symbolic significance from its appeal to the spirit of the American Revolution, of which public sphere print discourse is certainly a part. *Rocky* downplays contemporary national problems of race and gender relations by supporting formal Enlightenment processes of public political resolution that rely on the very discursive philosophical process at the center of the ideal of the democratic nation. The match assembles a tableau that represents, albeit rather sketchily, a highly divided polity, and the blows traded in the boxing ring mimic the Enlightenment paradigm of print discourse in the public sphere, the very discourse that proved instrumental in negotiating the political ethics of the U.S. system of government. The democratic participation constituted by the fight in the ring further links it to a common national identity and specifically American ideals of civic participation. A closer look at the fight sequence itself will turn up details that further dramatize the deliberate symbolic connections that imply a strong consonance between the boxing ring and the nation.

As the two boxers prepare for the fight, going through the same prefight rituals, the camera rapidly switches from Creed to Balboa and back, creating a twinning effect that suggests agonistic brotherhood in a context and on a scale as national as the title fight itself. We alternately see both boxers taping their hands, using nasal inhalants, and praying/meditating. Rocky modestly walks out to the ring with his support crew, wearing an endorsement on the back of his robe for the meat company where Adrian's brother works, clumsily exposing the complex commercial relations involved in the event and prefiguring the commodity spectacle that will follow him.

Creed rides in on a float, throwing money and dressed as George Washington crossing the Delaware (and wearing reverse-blackface), with a white wig and coarse navy cloak. Once in the ring, he throws off the cloak to reveal an Uncle Sam costume, and he begins crying "I Want You!"

Apollo Creed as Uncle Sam: "I Want You." Courtesy of Oklahoma State University Special Collections.

at both the audience and Rocky. Expecting to win in three rounds, he has not prepared for the fight and does not expect much of a challenge. It might be surmised that Creed's racial cross-dressing signifies a liberatory dissolution of racial identities and social constraints via spectacular two-dimensional symbols. However, it seems more likely that this unironic reversal acts rather to up the racial ante of the symbolic power dynamics affected by the fight's outcome than to undercut any racial tension implied in the fight. Creed has deployed various hallowed national symbols and personalities as a result of his hunger for capital while the humble Balboa has only trivialized himself by allowing a friend to advertise on his robe out of a sense of personal loyalty—a contrast that underscores Rocky's role as a savior of athleticism and dignity.

As Creed warms up in the ring, his manager brushes his hair as a sports announcer comments that he's "never seen a boxer so concerned with his hair." In the first round of the fight, Creed taunts Rocky as he jabs effortlessly at him. The festive mood ends abruptly when Rocky lands a punch that topples Creed. From this point on, the fight is no longer pageant or meta-spectacle but an athletic spectacle of the first order in which Rocky seriously threatens Creed's claim to the heavyweight title. Implicit in Rocky's near-victory is the rebirth of Creed's passion for boxing and athletic excellence. Whereas Creed had once muttered, "Think after this I'm gonna run for emperor," he must now struggle to maintain his

A racially ambiguous Statue of Liberty announces the rounds. Courtesy of Oklahoma State University Special Collections.

title in what had promised to be a milk run. The significance of the fight, then, is recast in terms of the personal rather than the financial as the two men stumble and totter, both determined to be the one left standing. The fight continues for fifteen rounds, each round announced by a woman of racially ambiguous appearance, painted silver and dressed as the Statue of Liberty.

With both fighters left standing, the bout is called in favor of Creed, but Rocky is oblivious to his formal loss, having accomplished his own personally set goal of simply making it to the end of the fight without being knocked out. Only when Adrian struggles into the ring to declare her love to him does the music reach its climax, ending the film. Rocky achieves both the personal goal of "going the distance" and the bourgeois prerequisite of romantic and (implied) nuptial bliss.

This relationship between Creed and Rocky shows a reversal of a relationship common in American literature, one that Leslie Fiedler calls "the Sacred Marriage of males" (Fiedler 148). This archetypal relationship features an outcast white hero in an emotionally intense relationship with a black or "savage" male companion; Fiedler's prime examples are Huck and Jim, Ishmael and Queequeg, and Natty Bumppo and Chingachgook (Fiedler 145). After the white hero is outcast, the black or savage "beloved" acts as a comforter of an almost literally spousal nature. Implicit in this comforting relationship is the absolution of the white man's crimes against

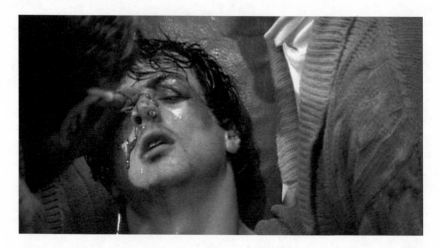

Rocky goes the distance, oblivious to his formal loss. Courtesy of Oklahoma State University Special Collections.

his darker brother—a melodramatic pardoning of white crimes against other races accomplished in the interaction between a single representative from each group. Sadly, the white man is often the only one to survive until the end of the story. His dark spouse perishes or endures severe pain for his sake in all of the narratives that Fiedler discusses (Fiedler 150).

In *Rocky* we see a more mutual rendering of this relationship: an outcast white man becomes responsible for bringing about a healing effect on a black man. Although the film contains none of the nuptial metaphors that Fiedler identifies in the novels that he examines, the fates of the two men are similarly intertwined. Both characters survive their equally painful trials, and in this narrative it is the white man who acts as the healing agent, bringing about a remasculinization of both himself and his opponent. The potential for homoeroticism is deflected both by Creed's final words to his opponent ("ain't gonna be no rematch") and by Adrian, who runs into his arms, preempting any further exchange between the two men at the film's close. *Rocky*'s revision of a traditional trope in the American novel allows both halves of Fiedler's biracial male couple to survive, although the two part ways after they undergo crucial psychosocial changes at each other's hands. The two boxers are so hyper-masculine that the only contact they have is through the blows they trade, foreclosing any potential for any kind of feeling between the two fighters that might be construed as anything but heteronormative. Not only do Rocky and Apollo struggle

together to recuperate each other's gender identity, but Creed's effeminate obsession with surfaces and Rocky's inability to "unlock [his own] hidden potential" (to quote the Soloflex ad) both serve to reaffirm broader traditional gender thresholds.

Apollo's marital status is left indeterminate in the first film of the series, a detail that supports a reading of Creed as a prima donna who is preoccupied with self-advancement and adulation. Indeed, Adrian's presence in the film is pivotal. She too is healed by Rocky's presence, going from a painfully shy, spinster kitchen servant for her abusive, alcoholic brother Paulie to the supportive and self-possessed, if still somewhat shy, wife of Rocky. While Adrian's servitude merely shifts directions, her connection with Rocky steers her toward procreative, uxorial behavior rather than the sterile, abstinent caretaking of her brother that had prolonged her adolescence until her thirties. As Rocky reminds Apollo Creed what it is to be a man, so does he bring Adrian in line with what it is to be a woman. Although his trainer views Rocky's love for Adrian as an obstacle to his fighting prowess ("Women weaken legs," the old man barks), it is clear that the moral universe of the film relies squarely on Adrian's efforts to fulfill a properly feminine role by serving the champ and humanizing him. When Rocky reveals his doubts about the fight, Adrian asks, "What are *we* going to do?" Her fate is determined by his fight: the redemption of her femininity as reproductive and thus normative is contingent on Rocky's ability to redeem his own inadequate masculinity. Although he is his own kingmaker in a sense, his drive is fueled by Creed, and his victory works largely to return all those affected to their proper gender roles. Rocky and Apollo return to positions within the pale of accepted professional athletic demeanors and attitudes, and Adrian is ushered into a dependent, romantic, and potentially procreative relationship (confirmed in *Rocky II*) with a potent white male protector.

Further propping up the beleaguered American masculinity of the late 1970s is the film's final segment, in which Adrian declares her love for Rocky. Not only does the Italian Stallion's self-declared goal of going the distance recast his inability to defeat Creed into a victory, but Adrian's decision to wait in the locker room during the fight safely isolates her from the violent space of the arena. It is only when the fight's violence is over that she runs down the aisles, entering a space historically forbidden to women, and breaks into the ring to declare her devotion.

The association of sportsmanship and citizenship, combined with white

American anxiety about racial politics and the dominant group's desire
to forestall the political radicalism of black champs, suggests a kind of
heightened political agency associated with the titleholder. In *Rocky* the
fear of black male civic agency is defused as a result of its circumscrip-
tion by the gender solidarity implicit in the mutual remasculinization that
takes place in the ring. Ideologically, the black man is allowed to retain his
citizenship/championship and agency in exchange for his support in the
fortification of beleaguered white male dominance. What goes unobserved
here is the fact that the dominance into which the champ is welcomed is the
same kind of male dominance whose very currency and power depended
on white supremacy. As white male privilege had secured its dominance
by feminizing African American men, the new coalition of American
men implied by the mutual remasculinization of Creed and Balboa in the
championship match focuses on reinforcing traditional gender binaries in
order to roll back the advances made by women's rights advocates in the
1960s and early 1970s.

One of the most popular films of 1976, *Rocky* promoted a reconfiguration
of the American ideological terrain. The quest to reempower the white man
is merged awkwardly with civil rights demands of the 1950s and 1960s, all
within a genre characterized by its ability to combine seemingly conflicting
political causes. The antagonism between Rocky and Apollo is carefully
negotiated to articulate a now interracial brotherhood of American men
who possess the traditional traits of both the rugged individual and the
Jeffersonian yeoman farmer by way of the urban frontiersman character.
Accordingly, the American woman is placed back in the home and back
into dependence on her supporting male. The film uses melodrama as its
key device to provide a soothing resolution of the social stresses of the
previous decades in the personal, individual relationships between Rocky,
Apollo, and Adrian. Addressing a mass audience, the film prescribes an
identity for a highly divided polity. In addition, the blows traded in the
boxing ring mimic the discursive paradigm of print discourse in the public
sphere, the very type of structured exchange that proved instrumental in
negotiating the political ethics of the U.S. system of government.

 Rocky redefines the requirements of masculinity in much the same
way that Nixon attempted to redefine victory in order to save face after
withdrawing from Vietnam—by stressing the process of struggle over its

results. In addition, as critics like Benjamin DeMott argue, these inter-racial buddy narratives give the white man a crucial role in restoring the nonwhite man to a position of former glory (see DeMott). In this fashion, the film attempts to create a masochistic white hero who responds to the social changes of the 1960s and early 1970s. Rocky's loss to Creed con-stitutes a precedent for the cinematic rebirth of manly toughness without an attendant demand for triumphant victory, by privileging "how [he] performed rather than that [he] lost"—an attitude that Susan Jeffords claims "distinguishes Vietnam representation from earlier periods in U.S. cultural expression" (Jeffords 5). The film's sequel, however, not only renders Balboa as a less nuanced white national hero who finally defeats Creed but also relegates the black former champ to a watered-down buddy role that facilitates a greater focus on the professional status of the white man. From here, Creed recedes even further from his role as rival to become Rocky's trainer in *Rocky III*, only to be killed in the ring by a Soviet boxer, sacrificed to provide Rocky's motivation to return to the ring after retirement. The gradual diminishment of Creed's stature in the series allows the white (ethnic) man to become the avatar of, as David Savran suggests, "the recuperation of 'macho' during the '70s and '80s" (162). Although the black man is increasingly relegated to the sidelines, nowhere more literally than when Creed becomes the Stallion's coach in *Rocky III*, his presence as a motivating figure enables a soothing distrac-tion from racial and class differences. As a result, the film places greater stress on traditional gender roles and enacts a renewal of male vigor. Not surprisingly, Apollo Creed's role in *Rocky IV* is almost identical to that of John Rambo's African American Vietnam buddy in *Rambo: First Blood*, who appears only in an old photograph and whose death presages the violent rampage of the Green Beret veteran. This new white male hero of the 1980s reclaims a more unequivocally dominant status in that he is only nominally required to share power with the (absent) black man. The original *Rocky* is a transitional text whose popular success enabled the emergence of the hyper-masculine blockbuster heroes of the late 1970s and 1980s—characters like Rambo and the Terminator, whom Jeffords argues are excessively invested in "relentless flirtation with pain, injury and death that exceeds the requirement of self-sacrifice and veers more in the direction of self-torture" (Jeffords 163). Furthermore, Adrian's crucial role in the film's reassertion of male power suggests that most shifts in

gender values significantly involve both halves of gender's binary structure. Indeed, we might think of gender as a discursive product of the exchanges in positionality or value between the two wings of this binary system.

Notes

1. The chorus captures the song's overall mood:

It's the eye of the tiger
it's the thrill of the fight
rising up to the challenge of our rival
And the last known survivor stalks his prey in the night
and he's watching us all in the eye
of the tiger.

2. In contrast to the character of Glen in the men's version of the commercial, the iced latte affects Stacy Rumple, the central character of the version targeting women consumers, in a very different way. While calming her in the middle of a busy workday, the beverage also wards off unwanted suitors and stalls insistent colleagues. Here, the product takes on the qualities of a nice day at the spa, a softly cooing black male soul revue repulsing those male coworkers who would interrupt Rumple's glorified coffee break.

3. Baker elaborates on the tension between these binaries as it appears in several films of the era, relating it back to the political climate of the time; see Baker, ". . . A Left-Right Combination: Populism and Depression Era Boxing Films," in *Out of Bounds: Sports, Media, and the Politics of Identity*, eds. Aaron Baker and Todd Boyd (Bloomington: Indiana University Press, 1997), 165–170. Baker writes, "By adopting a populist view of the causes and solutions for the economic problems of the Depression, Hollywood boxing films could appear socially conscious while avoiding deep analysis of the real economic issues. . . . These films at least attempted to represent the problems of ethnic working-class youth, who saw boxing as a possible means of escape from . . . [the] slums. . . . Moreover, while these films celebrate individuals . . . they also demonstrate that . . . 'no one makes it out on their own'" (169).

4. Foremost among feminist critics of nationalism are Jeanne Nagel, Anne McClintock, Cynthia Enloe, and Deniz Kandiyoti, as well as other scholars of American literature such as Thomas Couser and Dana Nelson.

5. We might also consider the persona projected by Floyd Patterson, another black heavyweight fighter who fought Ali (and lost) in a bout that was billed as a match-up between a Christian avenger and a heathen Muslim. The symbolic power of the fight and the promotion behind it accounted for a great deal of the symbolic meaning behind the persona of a boxer. The boxers' theatrics in the weeks before a match have become spectacular in their own right, providing a binary choice in values and rhetoric in a way that is

much more difficult to create for team sports, particularly given frequently fluctuating lineups.

Works Cited

Abdel-Shehid, Gamal. "Muhammad Ali: America's B-Side." *Journal of Sport and Social Issues* 26, no. 3 (2002): 317–25.

Baker, Aaron. " . . . A Left/Right Combination: Populism and Depression Era Boxing Films." In *Out of Bounds: Sports, Media, and the Politics of Identity*, edited by Aaron Baker and Todd Boyd, 161–74. Bloomington: Indiana University Press, 1997.

Couser, G. Thomas. *Altered Egos: Authority in American Autobiography.* New York: Oxford University Press, 1989.

DeMott, Benjamin. "Put on a Happy Face: Masking the Differences between Blacks and Whites." *Harper's Magazine*, September 1995, 31–38.

Enloe, Cynthia. "Feminist Theorizing from Bananas to Maneuvers." *International Journal of Feminist Politics* 1, no. 1 (1999): 138–46.

Fiedler, Leslie. "Come Back to the Raft Ag'in, Huck Honey!" In *The Collected Essays of Leslie Fiedler*, 142–51. New York: Stein & Day, 1971.

Grindon, Leger. "Body and Soul: The Structure of Meaning in the Boxing Film Genre." *Cinema Journal* 35, no. 4 (1996): 54–69.

Guerrero, Ed. "The Rise and Fall of Blaxploitation Cinema." In *Framing Blackness: The African American Image in Film*, 69–112. Philadelphia: Temple University Press, 1993.

Jeffords, Susan. "Fact, Fiction, and the Spectacle of War." In *The Remasculinization of America: Gender and the Vietnam War.* Bloomington: Indiana University Press, 1989.

Kandiyoti, Deniz. "Identity and Its Discontents: Women and he Nation." *Millennium: Journal of International Studies* 20, no. 3 (1991): 429–44.

McClintock, Anne. "'No Longer in a Future Heaven': Nationalism, Gender, and Race." In *Dangerous Liaisons: Gender, Nation, and Postcolonial Perspectives*, edited by Anne McClintock, Aamir Mufti, and Ella Shohat, 89–112. Minneapolis: University of Minnesota Press, 1997.

Nagel, Joanne. "Masculinity and Nationalism: Gender and Sexuality in the Making of Nations." *Ethnic and Racial Studies* 21, no. 2 (1998): 242–69.

Naylor, Nicholas. "Muhammad Ali, Jack Johnson, and the 'Problem' of Interracial Relationships: A Review of Martin Ritt's *The Great White Hope* (1970)." *Scope: An Online Journal of Film Studies.* November 11, 2004. http://www.scope.nottingham.ac.uk/article.php?issue=nov2003&id=263 §ion=article&q=naylor%2C+nicholas.

Nelson, Dana. *National Manhood: Capitalist Citizenship and the Imagined Fraternity of White Men.* Durham, NC: Duke University Press, 1998.

Rocky. Directed by John G. Avildsen. Los Angeles: MGM, 1976.

Savran, David. "The Sadomasochist in the Closet." In *Taking It Like a Man: White Masculinity, Masochism, and Contemporary American Culture,* 161–210. Princeton, NJ: Princeton University Press, 1998.

Streibel, Dan. "A History of the Boxing Film 1894–1915: Social Control and Social Reform in the Progressive Era." *Film History* 3, no. 3 (1989): 235–57.

Warner, Michael. "The *Res Publica* of Letters." In *The Letters of the Republic: Publication and the Public Sphere in Eighteenth Century America,* 34–72. Cambridge, MA: Harvard University Press, 1990.

Williams, Tony. "'I Could've Been a Contender': The Boxing Movie's Generic Instability." *Quarterly Review of Film and Video* 18, no. 3 (2001): 305–19.

Woodward, Kath. "Rumbles in the Jungle: Boxing, Racialization, and the Performance of Masculinity." *Leisure Studies* 23, no. 1 (2004): 5–17.

CLAY MOTLEY

Fighting for Manhood

Rocky *and* Turn-of-the-Century *Antimodernism*

SYLVESTER STALLONE'S *ROCKY*, winner of the Academy Award for Best Picture in 1976, not only began one of Hollywood's most lucrative and recognizable film "franchises," it began a battle of interpretation over the film's meaning. The iconic rise of the underdog from south Philadelphia, serendipitously plucked out of obscurity to fight the heavyweight champion of the world, clearly *meant* something to the packed, electrified theatres cheering Rocky on as if he were a real fighter. As *Rocky*'s legacy grew to become one of the most recognizable films of all time, the importance of understanding its significance equally increased. Critics curious about the film's surprise conjectured that it was simply a fairytale of the American dream or sentimental bicentennial pap; or perhaps it was an important statement about the neglected American working class or a sign of growing "ethnic" American pride; maybe it was a dangerously racist film or a portent of a vigorous and violent New Right. Regardless of individual interpretations, critics of the film then and now agree that *Rocky*, for better or worse, somehow caught the zeitgeist—it was a film for and of a precarious moment in American society that spoke passionately to a large segment of the population.

While we are correct to view *Rocky* as imbedded within a particular cultural and historical context—that of 1970s America and the coming bicentennial—profitable insight into *Rocky*'s significance can be had by looking nearly one hundred years earlier, to another tumultuous time in American history and culture, the late nineteenth century. It is through the context of the end of the nineteenth century that we can better understand the tensions, hopes, and fears of the 1970s and thus can gain a valuable lens through which to understand *Rocky*'s massive cultural appeal and

significance. Rocky Balboa's rise from inner-city failure to a boxer who could fight Apollo Creed to a draw was an injection of much-needed bicentennial optimism in the midst of one of America's most troubled decades: what is less obvious is *Rocky*'s significance as an *antimodernist* force. Historian Jackson Lears, when writing of the late nineteenth century, terms *antimodernism* a quest for "authentic experience," for "self-control and autonomous achievement" in the face of modern society's "cultural strain, moral confusion, and anomie" (Lears xix). The America of the 1970s and that of the 1890s were both cultures that questioned themselves intensely, particularly because their present reality felt curiously unreal as it drifted away from traditional economic, political, gender, and moral norms. In the face of such unsettling modernizing forces, both cultures—and particularly the men of those cultures—sought authentic experiences that would reaffirm their own and their nation's sense of greatness. Thus, *Rocky* is an example of Americans seeking what was genuine, manly, and true in a society that perceived itself as losing its original purpose, toughness, and authenticity.

Of course, the parallels between the 1970s and the late nineteenth century only go so far; in many ways, the society that produced New York's Studio 54 disco club and protested the war in Vietnam could not be more different than the Victorians who rallied around "Remember the Maine" all the way to San Juan Hill. However, by looking at the historical and cultural similarities between the two periods, particularly the economic and social disruptions that endangered American men's sense of autonomy and power, we can see that the 1890s and the 1970s have much more in common culturally than a superficial glance would suggest. In fact, both societies were searching for a transcendent sense of identity in the midst of modernity-inspired confusion. Particularly, both societies looked to what was considered an earlier, more essential and violent manhood that would invigorate their listless nation. These antimodernist sentiments explain the significance of Rocky Balboa, the out-of-shape loser, a drifter in an urban underworld, who is steeled by passing successfully through a time of crisis and is reborn a winner. Rocky's trajectory from a symbol of urban decay to a prototypical "self-made man" mirrored many Americans' desire to recapture their lost sense of power and purpose on the eve of America's bicentennial year.

We often consider the turn of the century to be a jaunty and confident age, conjuring up images of Teddy Roosevelt's "strenuous life," somehow

embodying both the young American empire abroad and Progressive Era reforms at home. Below this self-assured surface, however, dwelled a large group of men who repeatedly expressed fears of being "over-civilized," which meant being feminized, cut off from an essential and virile source of manhood due to modern society's perceived emasculating qualities. From approximately the founding of the nation through the early postbellum years, the notion of the self-made man—a term coined by Henry Clay in 1832—heavily influenced middle-class men's concept of manhood. The idea of the self-made man, according to Michael Kimmel, embodied "success in the market, individual achievement, mobility, wealth," and "economic autonomy" (Kimmel 23). Recognized "manly passion [such as] assertiveness, ambition, avarice, lust for power" became assets so long as they were saved for the marketplace (Rotundo 16). Men could engage in the "manly" competition of the marketplace outside the home, win economic victories, vanquish business foes, and then return to the domestic home for a dose of "feminine" nurturing, morality, and rest. As long as the nation's economic status quo remained, there were no complaints about the feminization of American society or over-civilization at the end of the century.

However, American men's idea of themselves as vigorous, individualistic competitors could not withstand the vast changes that initiated the shift from a relatively small, producer-oriented capitalist economy to a mammoth corporate, consumer-oriented economy following the Civil War. The growing corporate economy increasingly compromised the all-important economic autonomy of the self-made man as "the drive for maximum profits through the adoption of the most efficient forms of organization [moved] into high gear. . . . Instead of the small workshop, the dominant mode of economic organization was becoming the monopolistic corporation [consisting of] hierarchical bureaucracy of salaried executives, geared to dominate an ever-larger share of an emerging national market" (Lears 9). The myth of the self-made man, along with the ideas of economic independence and vigorous competition in the marketplace, still held currency in this transforming society, but increasingly myth lagged behind reality. Men found themselves defining their worth through economic means that became decreasingly attainable for the middle-class man.

In this environment, the emphasis on channeling manly passions toward greater economic productivity—the mythic means to becoming a self-made man—was undermined by the ascendancy of the stifling corporate culture. In place of the seemingly antiquated self-made man who

After the Civil War, American men, used to defining their worth through personal and economic autonomy, found it increasingly hard to feel "manly" in the modern, urbanized, industrialized economy famously lampooned by Charlie Chaplin in *Modern Times* (1936). Courtesy of PhotoFest.

restrained his passions arose what Anthony Rotundo calls "passionate manhood." In the era of Teddy Roosevelt and his call for the strenuous life, "ambition and combativeness became virtues for men: competitiveness and aggression were exalted as ends in themselves. Toughness was now admired," and there was "positive value put on male passions" (Rotundo 5–6). The male body joined the uncertain marketplace as the proving ground for masculinity as athletic contests and physical fitness became the vogue. To combat the perceived over-civilization (i.e., feminization) of society, Darwinist theories about men's primal nature and atavistic tendencies emerged and were encouraged in popular culture.

Thus cultural definitions of manhood began to extend beyond the traditional self-made businessman. If mainstream society had been feminized, then, as Elliot Gorn notes, men "turned to a more elemental concept of manhood" that emphasized "toughness, ferocity, prowess, [and]

Teddy Roosevelt, here as a Rough Rider in 1898, symbolized the "anti-modern," autonomous, and rugged manhood that many turn-of-the-century men yearned to recapture. Courtesy of PhotoFest.

honor"—traits often idealized in the boxing arena, on the football field, and on the baseball diamond (Gorn 141). The end of the nineteenth century saw the crowning of baseball as the national pastime and football as one of the dominant forces on college campuses. The emergence of large-scale spectator sports was a male-dominated phenomenon; not only did men compete in them but hundreds of thousands of other men also watched the games and followed the outcomes, vicariously partaking in the thrill of manly competition and male-only bonding. Kim Townsend writes of the late nineteenth century, "In no context does the word 'manly' appear more often and more insistently than in the context of discussions of athletics during this period" (Townsend 97). This flight from a feminized culture included increased emphasis on locations for male bonding, such as "saloons, pool halls, and lodges as well as in gangs, firehouses, and political clubs" (Gorn 141). Outside of leisure time and recreation, the almost exclusively male professions of science, politics, and law also began to take on heightened significance as men sought the manly fulfillment that they decreasingly found in the now-feminized home.

To a great extent, American men in the 1970s equaled their turn-of-the-century counterparts in fearing the loss of an essential, virile manhood in the face of an emasculating modern society. Moreover, their fears were rooted in similar social and economic dynamics. The economic boom following World War II resurrected traditional masculine ideals of male economic autonomy and empowerment. Fresh from helping the United States with the war, many American men of the 1950s and 1960s returned to civilian life with relatively high-paying, seemingly stable jobs in the humming American economy. Steel factories thrived in places such as Cleveland and Pittsburgh; the automobile industry reigned unrivaled in Detroit; and white-collar workers enjoyed the benefits of the growing corporate economy and stock market stability. With an expanding suburbia in places such as Levittown, Pennsylvania, an individual home was affordable for the first time to average workers providing for their families.

By the 1970s, of course, these postwar economic successes had painfully reached their limits. David Frum reports that the 1970s experienced "the worst economic slump since the Great Depression, followed four years later by the second-worst economic slump since the Depression" (Frum xxiii). "Stagflation" entered the American vocabulary to describe the particular economic malaise the country was experiencing. OPEC began its oil embargo in 1974; Detroit's automobile industry lost a staggering amount of its market to the smaller, cheaper, and more efficient Japanese imports, while the once-thriving industrial towns of the Midwest and Northeast turned into the Rust Belt. As Americans faced increasing economic instability and depression, they "commonly described their world and their future in a language of loss, limits and failure" (Bailey and Farber 4). With American economic fortunes flagging, American men mirrored their turn-of-the-century counterparts in sensing a loss of manly independence and self-worth.

A host of other social and political problems combined with the economic difficulties of the 1970s to undermine American men's sense of manly identity and success. The fall of Saigon in 1975 sent a clear message that the last decade of America's military and foreign policy efforts had failed. In the wake of the antiwar movement, ROTC programs were removed from many elite campuses; military enlistment plummeted, and there was a clear "uneasiness about outspoken patriotism" (Capazzola 38). Many American men, who were themselves veterans of World War II, saw their country impotent in Southeast Asia and unable to curb the

growth of communism in South America and Africa, while many of their sons openly rebelled against the patriotic ethos that was an important part of their identity. On the political front, in the wake of the Pentagon Papers (1971), Watergate (1972), and Nixon's resignation (1974), the U.S. government, once a trusted source of pride and patriotism, appeared to have "rotted to the core" and was portrayed with contempt in mainstream media (Schulman xvi).

While economic, military, and political troubles slowly chipped away at American men's personal and national sense of power and autonomy, the emerging women's liberation and gay liberation movements directly attacked prevalent definitions of manhood and sought to reconstruct "American institutions along nonpatriarchal lines" (Schulman 11). With the founding of *Ms.* magazine in 1972, the *Roe v. Wade* decision in 1973, and the increasing visibility of homosexuality as a viable "lifestyle," American men found themselves standing on shifting sands as their undisputed primacy in society began to be questioned. Women increasingly demanded equal economic and social opportunity, and homosexuals "made the counterclaim that gay men were as much 'real' men as straight men" (Kimmel 279). More than any other decade in U.S. history, the 1970s openly questioned what it meant to be and act as a man.

In this questioning atmosphere arose a men's liberation movement, a "curious mixture of a social movement and psychological self-help manual" (Kimmel 280). In books such as Warren Farrell's *The Liberated Man* (1974), Marc Feigen Fasteau's *The Male Machine* (1975), Herb Goldberg's *The Hazards of Being Male* (1975) and *The New Male* (1979), Jack Nichols's *Men's Liberation* (1975), and Pleck and Sawyer's *Men and Masculintiy* (1974), the movement earnestly argued for men to be more sensitive, emotional, and passive (Kimmel 280). Liberal, sensitive Phil Donahue gained a nationally televised talk show in 1970 and began broadcasting the needs of average American women, and the sensitive Alan Alda became the "new representation of maleness" (Schulman 177). Alda became famous through starring in the decade's most popular television comedy, $M*A*S*H$, in which he played a concerned army doctor often at odds with the military and political establishment. As David Frum notes, "the laconic style [of manhood] we associate with the GI generation" was replaced in the 1970s by a popular male image "reminiscent of the moist, voluptuous sentimentality of a hundred years ago, with the television interview replacing black crepe" (Frum 117).

Alan Alda, one of the most popular actors of the 1970s, symbolized to many men everything that was wrong about modern American manhood and culture: he was liberal, sensitive, intellectual, and emotional. Courtesy of PhotoFest.

It was at that moment in the 1970s, when the meaning of American manhood was at its most contentious and American self-confidence was at its nadir, that the United States celebrated its bicentennial. Christopher Capazzola notes that "the Bicentennial prompted debates over the meaning of American history and American identity, and the political turmoil of the previous decade made national celebration a challenge" (Capazzola 34). Thus, it is remarkable that on the eve of the bicentennial *Rocky* would appear, with its climactic fight between Apollo Creed and Rocky taking place on January 1, 1976. The movie fully recognizes the social and economic turmoil of the 1970s, but it uses the occasion of America's bicentennial celebration as a moment of rebirth, of a recapturing of its perceived traditional values of confidence, virility, and success. More specifically, *Rocky* is a paean to the antimodern man, one who shakes off the emasculating trappings of modernity and rediscovers the essential, primal, and successful self. *Rocky* attempts to define true manhood, providing its audience with the confidence that, like Rocky, American men can fight back and succeed, both personally and nationally.

Rocky's theme of masculine resurrection and redemption is emphasized

from its opening shot of a close-up of the face of Jesus, which, we see upon the camera panning out, is painted on the wall of a defunct church now being used as a low-class boxing gym. This juxtaposition of the sacred and the profane captures the mood of the first half of the movie: urban decay, lost potential, and hopelessness. In a better time this once-sacred space brought hope and meaning to the lives of its parishioners; now the squalid scene of end-of-the-line fighters and jeering fans captures the loss of that hope and the degradation of those dreams. The fetid atmosphere in the gym is replicated outside in the surrounding city; the audience sees long shots of Rocky wandering through blighted neighborhoods, passing rusting train tracks, and collecting for loan sharks on dilapidated wharves. The decaying industrial center of south Philadelphia symbolizes America's lost economic might and virility. On the shipping wharves, instead of proud workers and productive industry, we see only low-grade vice and worn-out men struggling to survive. One of them is willing to give Rocky his winter coat so that Rocky, who is collecting for a loan shark, won't break his finger. Of course, we must remember that this is Philadelphia, birthplace of the Declaration of Independence, on the eve of the bicentennial. Like the face of Jesus in the failed church, *Rocky* shows us the face of modern Philadelphia and by implication the face of America, asking us to compare its past vitality to its present ruin.

Rocky Balboa's personal and professional failings are an extension of Philadelphia's blighted modern environment. Rocky wins the opening fight of the movie, but he is physically wrecked, makes only forty dollars for his efforts, and is told by the fight promoter that he can fight again in a couple weeks. At the gym Rocky loses the locker he has had for six years, an indication that he is no longer considered a contender with any potential. When he confronts the crusty trainer, Mick, about the loss of his locker, Mick tells him that the boxer who took it is a contender but that Rocky is a "tomato." Mick ends the exchange by asking Rocky, "You ever think about retiring?" Outside of boxing, Rocky makes ends meet by being the muscle for a local mob boss. However, he does not even excel at this, getting into trouble for failing to break a guy's finger and being taunted with the nickname "meat bag" by the boss's driver. Rocky's personal life is equally barren; awkwardly and without success, he flirts with Adrian, a pet store clerk, and then retires alone to his meager apartment.

Each of Rocky's failings, both the professional and the personal, emphasizes his failed manhood and America's cultural malaise. We see this

Rocky's loss of his locker at the gym emphasizes that he is no longer a contender. His professional and personal failures mirror America's sense of failure in the 1970s. Courtesy of PhotoFest.

most clearly in a scene in Rocky's apartment in which he looks intensely at his childhood photograph; the audience sees the fresh boxing wounds on Rocky's haggard face contrasted with the youthful face in the picture. The flat-topped, smiling youth in the picture represents America in the 1950s, a place of success, potential, and optimism. The modern, wounded fighter, declared past his prime, symbolizes the loss of that potential by the 1970s, the failing of the United States to live up to the promises of its past. We also see that although Rocky is now a man, as opposed to the boy in the photograph, he has none of the traditional traits of manhood. He is a professional, economic, and romantic failure, with no obvious hope for redemption or success. He is no longer a virile contender; he is merely an inert meat bag, a "tomato" fit for mocking. He is an emblem of the failed modern man in a failed society.

Rocky Balboa, a boxer in the ethnic enclave of south Philadelphia, might seem an unlikely choice as a symbol of American manhood. After all, few of the millions of middle-class viewers of the film could person-

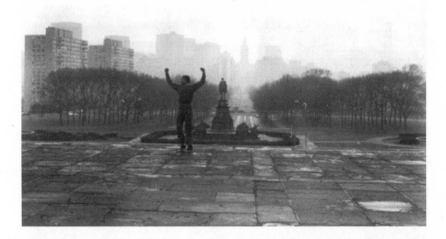

Rocky's revitalization suggests the potential for America to recapture its vitality, represented visually by the juxtaposition of the victorious Rocky and the skyline of Philadelphia. Courtesy of PhotoFest.

ally relate to boxing, loan sharks, ethnic neighborhoods, and the other trappings of Rocky's meager existence. However, viewed through the lens of turn-of-the-century antimodernism, Rocky's symbolic import becomes clear and persuasive. Elliot Gorn remarks, "Toward the end of the [nineteenth] century, however, [the] working-class ideal of masculinity took on a vicarious appeal for middle and upper classes. Internalized self-control—a crucial component of bourgeois manliness—grew ever less satisfying in an age of diminishing autonomy" (Gorn 252). As Gorn points out, one of the "touchstones of maleness" for a middle-class man seeking authentic manhood was boxing (Gorn 141). Anthony Rotundo notes that modern men, "like their turn-of-the-century counterparts," attempted to "restore their confused or missing sense of manliness through immersion in the mythology and rituals of premodern men" (Rotundo 287). Thus, to a middle-class audience of the 1970s seeking a primal sense of manhood, Rocky's ancient and brutal profession of boxing, his silent demeanor, and even his Italian heritage were the qualities of something ancient and more primal than the modern American man. All that was missing was

Rocky's chance for rejuvenation, and that would allow the audience to be cathartically resurrected as well.

Of course, Rocky's chance for manly redemption comes when Apollo Creed surprisingly offers the unknown challenger a chance to fight for the heavyweight crown. Much has been made of the white Rocky fighting the African American Creed—the most extreme interpretation being Joel Martin's assertion that the film's "nasty ideology" is a "New Right vision [which] includes an attack on the civil rights movement, glimpses of a race war, and a call for the resubjugation of African Americans" (Martin 126). However, rather than viewing Creed as some sort of racialized monster that the white American must slay, an antimodernist interpretation clearly shows Creed to be a representative of the jaded, affluent class that mocks and makes money from the traditional notion of the American dream. Creed, a black man who, in Rocky's words, "took his best shot and became champ," clearly has attained the classic American dream of rising from humble origins to attain wealth and notoriety (echoing another famous Philadelphian, Benjamin Franklin). However, now successful, Creed believes in no American "creed" and instead uses the bicentennial and the American belief in the underdog for monetary gain. If Rocky and south Philadelphia represent the losers in modern America, Creed represents the winners in the sense that their very affluence has choked them off from America's core values of earnest work and a straightforward belief in traditional American values. Apollo Creed is not a symbol of a struggling African American population whom Rocky is symbolically fighting to keep down; the heavyweight champion of the world is a symbol of the corrupt modern establishment.

This reading of Creed's antimodern significance comes mainly from his manipulation of traditional American symbols and values to promote his fight with Rocky. When hatching his scheme to give Rocky a chance at the title, Creed states, "There's nothing [the public] would like better than to see Apollo Creed give a local Philadelphia boy a shot at the greatest title in the world on the country's biggest birthday." This American dream–inspired plan is quickly revealed as a marketing tool when the fight promoter says, "It's very American," to which Creed coyly responds, "It's very smart. . . . The media will eat it up." During the press conference for the fight, Apollo manipulates events from U.S. history for his marketing ends, stating, "If history proves one thing, American history proves that everyone has a chance to win. Didn't you guys ever hear of Valley Forge or

Bunker Hill?" Of course, Creed has no intention of being defeated by the underdog the way the British were defeated by the American colonists. It is Apollo's trainer, Mack, who tells Apollo, "[Rocky] doesn't know it's a damn show." Finally, as Apollo enters the arena in full costume, he enacts a caricature of George Washington crossing the Delaware, with the modern twist of throwing money into the crowd. Thus, Creed comes to symbolize a gilded American dream, one that has lost its authentic, traditional meaning and is only used for crass commercialism, using (and abusing) the bicentennial celebration as a marketing ploy. Rocky, as Mack recognizes, does not think the event is a show. "He thinks it's a damn fight," Mack says. And Rocky's triumph will be the triumph of a traditional understanding of the American dream over the jaded contemporary one symbolized by Apollo Creed.

That Apollo Creed embodies the corruption of the traditional American dream should not be construed as evidence of a racist subtext to the film. For Rocky's fight with Creed to be racialized, Creed would have to in some sense symbolize black America in the 1970s. Although the argument can be made that Creed's function as Rocky's nemesis represents working-class whites' resentment of black social and economic gains since the civil rights era—gains that implicitly must be defeated—there is little evidence of this. Apollo Creed is almost exclusively shown reveling in wealth, status, and power—the unique kind that accompany being the heavyweight champion—which is not consistent in the least with the modest social advances for African Americans in the age of rampant housing projects, the Watts riots, and South Boston bus riots. One could argue that the black boxer represents the aggressive and prideful black power movement that many white Americans found threatening in the 1970s. However, the complacent and pampered Creed in no way fits the identity politics and militant demands for social justice associated with black power. Ultimately, Creed is a symbol of a corrupt contemporary America, a "Rocky" figure who has been ruined by modern material success. Like Rocky, Creed is a traditional outsider to mainstream American culture; he fought his way to the top and attained the classic American dream of success. However, Creed's corruption is America's corruption, as the American dream is now devalued and jaded, detached from its original moral purpose, a fate mirroring how many Americans felt about their country's fate. Rocky is not combating a black threat; he is fighting the corrupted American dream.[1]

Creed's manhood and Rocky's manhood are also contrasted for antimodernist purposes, particularly during Rocky's training sequence. Rocky's path to becoming a successful man is paved with rugged work, such as rising from bed before dawn, eating raw eggs, and running through sleepy city streets. He is reclaiming his sense of purpose and power through the training that will slough off his soft exterior, leaving only his virulent manhood. The most powerfully antimodernist scene of Rocky's training is the one in which he trains by punching raw sides of beef in a freezer. With his ancient trainer Mick, a throwback to the authentic and rough days of boxing, Rocky becomes an antimodernist fighter; he pounds his fists bloody on frozen carcasses, implicitly eschewing softer, more modern training methods. Rocky's contrast with Apollo, who is the modern fighter, becomes clear when we see scenes of Rocky punching frozen beef for a television reporter juxtaposed against Apollo in his business office ordering coffee from a secretary, discussing market shares and advertising, and discussing where to send flowers. Apollo becomes the embodiment of a bloated elite that uses the working class for profit. Rocky's antimodernist training methods and throwback trainer highlight his authenticity in the face of Apollo's corrupted values.

The most crucial aspect of Rocky's resurrected manhood is the fact that it is his body that he is sculpting while he trains for the title fight. We see Rocky, on the first day of his training, covered in sweat, holding his side in pain, barely able to climb the steps of the Philadelphia Museum of Art. His inability to excel physically emphasizes his failed manhood. However, after a montage of punching frozen carcasses, beating punching bags, and doing sit ups, Rocky is able to sprint joyously to the top of the museum's steps, all while the lyrics of the rousing Rocky theme music repeats, "Getting strong now / Going to fly now." It is through the physically arduous, antimodernist sculpting of his body that Rocky is able to morph into a true man, marked by the authentic masculine badge of physical prowess. Significantly, the apex of Rocky's training comes at the top of the museum's steps, as he overlooks the city of Philadelphia at dawn, down the long vista of the Benjamin Franklin Parkway. As the new dawn symbolizes the rebirth of Rocky's manhood, Rocky's triumphant pose over the city's business district represents the renewal of America itself. If Rocky can steel himself and become a true man, then so can Philadelphia on the eve of the bicentennial, and by implication, so can America itself. Rocky's vista down Benjamin Franklin Parkway hearkens to America's founding principles

represented by Franklin himself, a figure from America's authentic past, who is resurrected to revive the modern culture of the 1970s.

Rocky's redeemed manhood is also symbolized by his rejuvenated romantic life with Adrian, the introverted, bespectacled pet store clerk. Early in the movie, Adrian's brother, Paulie, calls her a loser, echoing Mick's early assessment of Rocky. Significantly, Rocky and Adrian's relationship grows as Rocky's professional success increases. Rocky's first date with Adrian takes place immediately after Apollo picks Rocky to be his opponent in the title fight, and Rocky first kisses Adrian just before he finds out about Apollo's offer. Just as Rocky shapes his body to become a true man, Adrian sloughs off her confining glasses, hat, and frumpy coat and begins dressing in more sleek and colorful clothes, becoming more of a model of traditional femininity to accompany Rocky's renewed masculinity. Rocky's triumph at the end of his fight with Creed is equaled by Adrian's declaration of love in the middle of the ring. Thus, out of the sterile and decaying wasteland portrayed in the first half of the movie, we see a fertile relationship growing, contributing to the theme of rebirth, hope, and redemption, cast in explicitly gendered terms.

Rocky's final act of manly redemption is, of course, his match with Apollo Creed. Interestingly, Rocky does not win the fight outright. Instead, the two fight to a draw, with the result that the champion, Creed, retains the title. However, as Rocky makes clear to Adrian on the eve of the fight, "Nobody's ever gone the distance with Creed, and if I can go the distance, when that bell rings, and I'm still standing, I'm going to know for the first time in my life that I'm not just another bum from the neighborhood." Importantly, Rocky identifies his goal as proving he is not a bum. A bum is not considered a true man; he has no power, whether economic, social, or physical, and is the constant pawn of forces beyond his control. By equaling the powerful Creed, Rocky is doing what no man has done before: he is proving that he is a man instead of a bum. Through the violent crucible of boxing and training, Rocky has chiseled away at his unsuccessful and unmanly exterior and shown the world the essential, powerful, and manly qualities underneath. Creed's retaining the title also signifies that Rocky is protected from the corrupting wealth and privilege that comes with being crowned the champion (at least until the sequel). Fighting simply for manhood rather than titles and riches emphasizes that his quest is for antimodern redemption against the contemporary corruption represented by Creed. Creed can keep his title; Rocky will lay claim to his manhood.

It is clear to the casual viewer that Rocky's rise from bum to equaling the heavyweight-boxing champ is a feel-good story produced to coincide with America's bicentennial celebration. However, by understanding the cultural similarities between the 1890s and 1970s, we can view *Rocky* not simply as a modern fairytale but as a profound social antimodernism expression, particularly as it relates to recapturing and promoting a perceived virile, essential, and premodern manhood. By looking at the turn of the century, we are better equipped to understand *Rocky*'s persuasive power and significance. Rocky's manly redemption symbolizes the hopes of 1970s America to once again find its power, promise, and success.

Note

1. Significantly, *Rocky III*, *Rocky IV*, and *Rocky V* each explore Rocky's struggle with wealth, luxury, and success once he becomes the champion. Rocky fights to remain the true self we see at the end of the first film. This supports the interpretation that Apollo Creed is more a symbol of jaded success than a racialized threat being vanquished. In terms of U.S. history, this theme echoes the founding generation's eighteenth-century view of wealth and luxury as a symbol of moral degradation.

Works Cited

Bailey, Beth, and David Farber. "Introduction." In *America in the 70s*, edited by Beth Bailey and David Farber, 1–8. Lawrence: University Press of Kansas, 2004.

Capazzola, Christopher. "'It Makes You Want to Believe in the Country': Celebrating the Bicentennial in an Age of Limits." In *America in the 70s*, edited by Beth Bailey and David Farber, 29–49. Lawrence: University Press of Kansas, 2004.

Frum, David. *How We Got Here: The 70s: The Decade That Brought You Modern Life (For Better or Worse)*. New York: Basic Books, 2000.

Gorn, Elliot. *The Manly Art: Bare-Knuckle Prize Fighting in America*. Ithaca, NY: Cornell University Press, 1994.

Kimmel, Michael. *Manhood in America: A Cultural History*. New York: The Free Press, 1997.

Lears, T. J. Jackson. *No Place of Grace: Antimodernism and the Transformation of American Culture, 1880–1920*. Chicago: University of Chicago Press, 1994.

Martin, Joel W. "Redeeming America: *Rocky* as Ritual and Racial Drama." In *Screening the Sacred: Religion, Myth, and Ideology in Popular Ameri-*

can Film, edited by Joel W. Martin and Conrad E. Ostwalt, Jr., 125–33. Boulder, CO: Westview Press, 1995.

Rocky. Dir. John G. Avildsen. Los Angeles: MGM, 1976.

Rotundo, Anthony E. *American Manhood: Transformations in Masculinity from the Revolution to the Modern Era*. New York: Basic Books, 1993.

Schulman, Bruce J. *The Seventies: The Great Shift in American Culture, Society, and Politics*. New York: Da Capo, 2002.

Townsend, Kim. *Manhood at Harvard: William James and Others*. New York: Norton, 1996.

National Identity and Political
Confrontation in Sports Competition

David J. Leonard

Do You Believe in Miracles?

Whiteness, Hollywood, and a Post-9/11 Sports Imagination

After watching Miracle (2004), a film about the 1980 U.S. Olympic hockey team, for what felt like the tenth time, I was struck by my emotional and visceral reaction to the film. Despite my "oppositional gaze," my tendency toward critique, and my disdain for patriotism, cheesy dramas, and hyperbole, I found myself rooting for a U.S. hockey team that I knew had conquered the great Soviet team. Whispering "USA . . . USA" along with the film, I experienced pride and excitement in the team's onscreen success. I found myself celebrating their amazing accomplishments and wondering if we would ever see another miracle again. Without a doubt, this pride, these emotions, and the excitement of the movie resulted from its depiction of race, nation, and sports cultures.

Both Miracle and its documentary companion, Do You Believe in Miracles? The Story of the 1980 U.S. Hockey Team (2001), made the following "historical realities" quite clear: The 1980 U.S. Olympic hockey team overcame their lack of athletic ability (their whiteness) and the lack of class privilege that was evident in the poor facilities because of their work ethic, intelligence, belief in team, fortitude, self-determination, and heart—because of their whiteness, their masculinity, and their working-class identities. In these qualities and identities, and not just in victory, we

This chapter contains parts of (and is based on the ideas first written about in) a prior essay by the author, entitled "'Is This Heaven?' White Sporting Masculinities and the Hollywood Imagination," which appeared in the Visual Economies of/in Motion: Sport and Film, edited by C. Richard King and David J. Leonard, 164–94. New York: Lang, 2006. The reprinted portions of the essay are included here with the permission of Peter Lang Publishing, © 2006, 29 Broadway, New York, NY 10066, http://www.peterlang.com.

learn the reasons to enjoy, praise, and support the world of sports. Ultimately, the success of the two films lies in their ability to codify ideologies of whiteness, masculinity, and nostalgia all within a coming-of-age story that makes even the most cynical race scholar well up with tears. Like their sports film predecessors, these films celebrate the underdogs—a theme that, in a post-9/11 context, offers an increasingly powerful cinematic trope. Just as America is an underdog in the war on terror (i.e., fighting an enemy that doesn't play by the rules), so have been the country's greatest sports heroes, each of whom demonstrates the power and possibility of a collective white masculinity.

America's love affair with these films cannot be understood outside the cinematic hegemony of whiteness and the relationship between race, sports, and the American historical imagination. "Our love of the underdog is probably most noticeable in our affection for David-versus-Goliath sport movies. We love to cheer for unlikely champions" (see Garner). Following in the tradition of Hollywood films that recoup hard work and whiteness—films such as *The Natural* (1984), *Field of Dreams* (1989), *Rudy* (1993), *Hoosiers* (1986), and *Seabiscuit* (2003)—*Miracle* and *Do You Believe in Miracles?* successfully link athletic success to effort and determination. It is quite clear that the "unlikely champions" of these films convey whiteness, thereby reclaiming sports as a space of white American possibility and illustrating the work ethic, intelligence, and source of pride of white athletes. They provide white kids like myself the hope and dream of "making it," while simultaneously erasing white privilege and replacing it with hard work, meritocracy, and the Protestant work ethic. In bringing to life narratives about a national team, they also link work ethic and determination to a national body that is whitened, gendered, and classed in the process.

Thus, the power of the films resides in their deployment of conservative ideologies under the guise of emotional storytelling. Equally powerful is their construction and dissemination of ideologies and tropes of white supremacy in the absence of a clear racial text. Neither of these films explicitly reflects on the value of whiteness or the problematic portrayal of black athletes; yet each plays through widespread discourses of race and sports, reinscribing nostalgia for a time of white dominance (see Baker, *Contesting Identities*; Kibby; Kusz, "BMX"; and Leonard). While legitimizing meritocracy and the American dream, the genre of white-centered sports films gives face, narrative, and legitimacy to "the logic of white supremacy" that has been

"premised on the inherent inferiority of blacks and the equally fallacious assumptions of the superiority of whites" (Crenshaw 105).

This essay gives voice to the racialized, gendered, class- and nation-based textual inscriptions within these two films as well as their contextual place of meaning. It attempts to make the familiar unfamiliar, to challenge the process of naturalization imbued in categories of whiteness, through a critical interrogation of Hollywood's vision of a miracle on ice. The essay explores the cultural significance of these two films at a historical moment of consumption in which white masculinity has been constructed as under attack, from both Islamic terrorists, multiculturalism, and the domination of athletes of color inside the United States (see King and Springwood; and Kusz, "'I Want to Be the Minority'").

The celebration of the 1980 U.S. Olympic hockey team through both a Hollywood film and a documentary underscores the power and potential of white masculinity to unify the nation and procure true freedom. The films represent a response and a remedy to the national malaise and the uncertainty and fear in the dominant cultural landscape. Through the lenses of these films, we are taught that "freedom from terror" can only come through the bodies of (athletic) white men, patriots who became world-class athletes, who became part of a gold-medal-winning team because of their hard work, commitment, dedication, and heart. Although miracles are difficult, they are possible, especially when white working-class males are empowered to lead and change, whether on the battlefield or on the ice rink.

Rememory: 9/11 and a Changing American Imagination

The "events of September 11" are often described as having changed America forever, dramatically altering its political, cultural, and ideological landscape. Although this response is clichéd in many respects, and certainly erases the continuity of issues facing the United States and authoritative power, it is true that 9/11 has dramatically affected the logics of the United States. Cornel West describes this process—whereby white Americans first experienced the fear and demonization that has long plagued communities of color—as the "niggerization of America." "The ugly terrorist attacks on innocent civilians on 9/11 plunged the whole country into the blues. Never before have Americans of all classes, colors, regions, religions, genders, and sexual orientations felt unsafe, unprotected, subject to random violence and hatred," notes West. "Yet to have been designated

and treated as a nigger in America for over 350 years has been to feel unsafe, unprotected, subject to random violence, and hatred" (20). Ruth Frankenberg concurs, arguing that 9/11 exists as an "amorphous site, as a reference point without referent, as something signified, as a significance, both global and local" (555).

To understand *Miracle* and *Do You Believe in Miracles?* is to understand the cultural and ideological climate of post-9/11 America. For example, the media coverage that surrounded September 11 and its aftermath focused on the efforts of everyday Americans who, despite tragedy and crisis, showed themselves to be courageous and heroic. "The dominant representations of the events of September 11, 2001, drew on images of rugged individuals, weak and uncoordinated governmental agencies, and a wounded but brave nation," writes Frankenberg. "This discourse retained key elements of hegemonic US self-understandings even as it provided ground for rationalizing military vengeance and a radical rolling back of civil rights in the domestic arena" (Frankenberg 556). It is within this context that we must understand the cinematic meaning and widespread celebration of *Miracle* and *Do You Believe in Miracles?* because both films illustrate the history of American courage, the ways in which patriotism can serve as a vehicle for overcoming national strategies and foreign enemies, and ultimately the ways in which white masculine heroes embody what is needed to win a war against opponents of democracy and freedom, whether they are the Soviet Union or Islamic terrorists. The meaning of these films and their discursive referents were certainly overdetermined by the post-9/11 cultural landscape and contemporary discourses concerned with race and sports. That is, although the post-9/11 cultural landscape gave new meaning to the retelling of the story of the 1980 U.S. Olympic hockey team and the cinematic tropes deployed in both films, the films' narrative meaning and the context in which they were received by audiences were equally defined by longstanding constructions of white athletes within and outside of American cinema.

Why? The Importance of Studying White-Centered Sports Films

The power of sports lies not just in their popularity in the United States but in their role as disseminators of ideology. Critical inquiry into sports is crucial because of the ways in which sports (stars, teams, and ideolo-

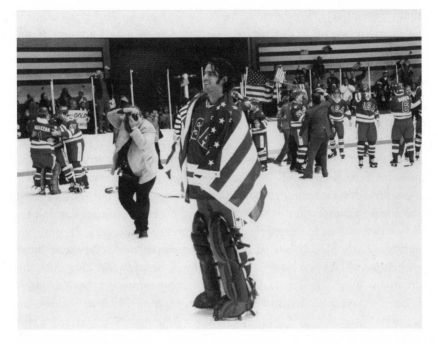

Jim Craig (Eddie Cahill), literally and ideologically wrapped in the American flag. Courtesy of MovieGoods.

gies) exist as "a free floating racial [class/gender] signifier representing a complex fluid process that both engages with and disengages from an economy of signifiers related to stereotypical depictions of black [white] masculinity" (McDonald and Andrews 24).

Films, like sports, represent powerful cultural products that inhabit and construct social meanings—they not only offer entry into imaginative or historically based athletic spaces but also provide vehicles or lenses of understanding for present and future discursive fields. As a source of racial imagery, which "is central to the organization of the modern world," Hollywood necessitates serious analysis (Dyer 9). "Radio, television, film and the other products of the other industries provide the models of what it means to be male or female, successful or a failure, powerful or powerless," argues Douglas Kellner. "Media culture also provides the materials out of which many people construct their sense of class, of ethnicity and race, of nationality, of sexuality, of 'us' and 'them.' Movies manufacture the way we see, think of, feel and act toward others" (Kellner 1). Sports

films, particularly those that center on whiteness on America's athletic fields, are powerful in this regard, teaching a tremendous amount about the meanings of whiteness (and blackness), masculinity (and femininity), the value of a Protestant work ethic, and the potential value of sports within an American identity.

Finally, the task of understanding sports films requires a serious discussion of whiteness. In an effort to understand the processes of racialization, racism, and the construction of the "other," we must begin to interrogate the meanings, constructions, and depictions of whiteness. In other words, in order to truly comprehend blackness, brownness, and redness, as well as realities of white supremacy or Eurocentrism, the locus of analysis must include an examination of whiteness. Toni Morrison argues that whiteness represents an imagined binary to "figures of blackness." Despite her inscription of a black/white paradigm, she simultaneously elucidates "how whiteness is blackness" and how the "other" bestows meaning onto the dominant subject position, demonstrating how whiteness signifies intelligence, industriousness, and enabling culture, while blackness represents laziness, ignorance, and disabling culture (Ammons 277; Bernardi xviii; and Morrison).

Moreover, Aaron Baker, in his article "Hoop Dreams in Black and White," notes that an examination of films is crucial to understanding the context of the post–civil rights, new racism: "Because they incorporate the new difference yet are still strongly bound by formal and thematic conventions that have been used for decades to privilege the values of whiteness, Hollywood films provide a good locus of analyzing competing discourse of racial difference" ("Hoop Dreams," 216). Baker argues further that Hollywood basketball films "reaffirm the values of whiteness that still dominate American culture" ("Hoop Dreams," 216). While Baker focuses on the discourse of blackness, this essay elucidates the correlative binary of Hollywood's vision of white athletics in a post-9/11 context.

The failure to see race in whiteness, and thus ignoring the attached ideologies, limits our understanding not only of the films but of racism as well. "Indeed the function of whiteness in the racial formation gives the meanings of race and the power of racism sociocultural and historical currency" (Bernardi xvi). Bernardi concludes, "If we are to critically interrogate the forms and functions of color . . . we must look at the pervasiveness of whiteness." Exploring the centrality of whiteness to the development and trajectory of American films, Bernardi demonstrates

the necessity of examining whiteness within any effort to elucidate the nature of American racial formation.

The cinematic rendering of white males as hardworking, team-oriented, fundamental, and the embodiment of all that is good in sports is central to the power of a majority of sports films. Likewise, within a larger discourse of race, these films construct blackness (often in its absence) as athletic, selfish, individually oriented, lazy, and otherwise destructive of sports. Bryan Burwell captures the nature of this discourse with his description of the contemporary National Basketball Association (NBA): "An entire generation of slammin', jammin', no jump-shot, fundamentally unsound kids who have bought into NBA's and Madison Avenue's shallow MTV-generation marketing of the game. People with no soul for the essence of the game turned the poetry into gangster rap" (Burwell, quoted in Andrews 195). The literature ignores this larger context and the discursive field that must be present to properly analyze sports films, and in its absence we see little significance in the representation of hockey player Mike Eruzione as hard working and able to compensate for his limited athleticism through dedication and intelligence or of the 1980 U.S. Olympic hockey team as just that—a team. Because the two films are situated within a sports discourse that includes daily denouncements of contemporary sports as a shadow of its former self, given the lack of attention to team, fundamentals, and fans (as well as the overwhelming number of black athletes), it is crucial to read the films within their larger context. We must move beyond questions of truth and authenticity to ask whose narrative is being told (and whose is erased), how such narratives are told, and what the cultural and ideological significance is of the context in which they are received.

The reimagination of the 1980 U.S. Olympic hockey team plays through a series of racialized frames and tropes; they reflect a larger effort to reclaim sports as a space of white dominance and mastery, to revamp the "golden age" of white athletics. At a time when the NBA is more than 70 percent black and the National Football League is overwhelmingly black in both aesthetics and star power, films like *Miracle* and *Do You Believe in Miracles?* reflect a cultural colonization of a space lost, a space that once served as the definition of American (white) identity. By representing the positive influences of sports on community and by illustrating the ubiquity of teamwork, camaraderie, and work ethic, both films construct a world of sports inscribed with positive and implied white values.

Miracle and *Do You Believe in Miracles?* equally construct and deploy ideologies and meanings of whiteness through working-class male bodies, memorializing a time lost—a time when whites dominated sports. Each film indirectly offers commentary on the golden age of sports as a white era (countering those who see the post-integration era as the golden age) and, given broader sporting discourses, unknowingly provides legitimacy and voice for the demonization of contemporary sporting culture as too hip-hop, too driven by ego, and just too black.

Miracle: *A Found Nation*

Miracle begins its narrative not with images of triumph or even hockey but with a historical montage emphasizing the difficulties of the 1970s. Not solely a function of the presumed realism of the narrative, the constant references to the oil crisis, Iran hostages, Watergate, inflation, and the Cold War underscore the power of the 1980 U.S. Olympic hockey team. In a time of deep-seeded pain and suffering, this team of improbable stars successfully brought the nation together—at least that is the argument of both films, both of which position this historic moment as one in which sports and the efforts of a group of "everyday Joes" brought a once-fragmented nation together. The focus on national unity through the Olympic hockey team, rather than on the ongoing racial, national, and class fissures that defined America then and now, is illustrated not just through the historicity of the films but also through the images, particularly those in *Miracle*. As the team prepares to enter the stadium for the game against the Russians, the camera pans past a hallway lined with telegrams and cards of support. The constant chants of "USA . . . USA" and the visual emphasis on the American flags function both as signifiers of patriotism and as representations of national pride in the 1980 Olympic dream team. "Listen to them," Herb Brooks tells the team, as the crowd, a once-divided nation, chants "USA . . . USA." "That is what you have done."

The importance of *Miracle* and *Do You Believe in Miracles?* lies not just in the historic context of 1980—the societal malaise connected to recessions, oil prices, the Cold War, and fears about whether America would continue to dominate as a world power—but in the atmosphere in which they were received by audiences—a time defined by recessions, increasing oil prices, the never-ending war on terror and war in Iraq, and bewilderment, if not concern and fear, about America's future, given

the realities of terrorism, SARS, avian flu, Islamic fundamentalism, and "their" hatred of "us." At such a moment, *Miracle* and *Do You Believe?* offer powerful reminders of the potential of white American working-class masculinity and its power to unify and unite Americans under one flag. Their narratives remind us of the ways in which patriotism and American hard work can provide an anecdote to hard times. Yet such a message is not merely a simplistic historic lesson; it provides needed inspiration and patriotic fervor to propel America through the difficult waters it faces in the wake of 9/11.

In fact, much of *Miracle* is dedicated to the context of this victory, emphasizing its importance as a remedy for "the darkness that hung over the nation," for "a nation losing its way," its edge, and its pride amid a "crisis of confidence." Similarly, *Do You Believe in Miracles?* begins with a series of stills, capturing the drama of this history: flags, USA jerseys, CCCP jerseys, hockey action, and Iran hostages, with the following back-drop commentary:

> MIKE ERUZIONE: It was war, in a hockey game. It was us against them; it was freedom against communism; nobody gave us a hope.

> AL MICHAELS: It was a sliver of the Cold War played out on a sheet of ice. Here you got a group of fresh-faced college kids taking on the big bad Soviet bear in the United States in the Olympics. The confluence of events was so extraordinary—it can never happen again.

> UNKNOWN SPEAKER: Nobody paid attention to what America said in the world anymore. Our hostages had been taken and we couldn't get them back. The Red Army went into Afghanistan and we couldn't get them out.

> JIM LAMPLEY: It might have been an all-time low point for American public self-esteem.

The narrative not only highlights the historic importance of the team's victory, which is further amplified by their positioning as the ultimate embodiment of hard work, teamwork, discipline, and toughness, it also signals the importance of memorializing the team at a moment in history when flag waving and patriotism were imagined as the greatest weapons against the "crisis of confidence."

Inferior Athletes, Superior Teammates and Workers

Two of the commonplace tropes employed by *Miracle*, and to a lesser degree by *Do You Believe in Miracles?*, are hard work and teamwork. The emphasis on teamwork in *Miracle* begins in the initial moment of the film, which establishes a clear cinematic trope. While interviewing for the Olympic coaching job, Herb Brooks tells the hiring committee that to compete with the Eastern Bloc, particularly the often-feared Russian national team, the United States needs to change its work ethic and approach, to give greater attention to conditioning, creativity, and team chemistry. "All-star teams fail because they rely solely on the individual's talent. The Soviets win because they take that talent and use it inside a system designed for the betterment of the team." Through both narrative structure and dialogue, the film makes clear that the U.S. victory was the result not of the team's talent or god-given athleticism, but its ability to harness the skills and efforts of twenty individuals as one team. Likewise, *Do You Believe in Miracles?* emphasizes the physical weaknesses of the players, who despite their "toughness" and "discipline" were just kids seeking to dethrone "the big bad Soviet bear," a professional team of masculine and intimidating men. Yet in both films the dedication of the players, their willingness to put aside personal goals and grudges for the good of the team and nation, and ultimately their mental toughness are portrayed as the reasons for their victory over the Soviets, their winning of a Gold Medal at the 1980 Olympic Games, and their importance in "revitalizing the American spirit" during the most desperate of times. Moreover, the efforts of Herb Brooks and the players themselves to unify the team, setting an example for the nation, further propelled them toward national greatness.

In *Miracle* we see three clear illustrations of the team's fragmentation within the initial moments of the team's training camp. First, after an early practice, the entire team is seen at a local bar; yet the team sits not as one group but according to their college allegiances: Minnesota players at one table, Boston players at another table. This is not a team but a collection of players fragmented and full of hatred because of their differences and conflicting histories.

Second, each of the players initially shows little investment in the team. In addition to their constant references to school allegiances and

individual hopes that they make it to the National Hockey League, the team shows its fragmentation on the ice. They play like an all-star team, although they are a collection of less than talented individuals. At an early practice, Mark Johnson successfully takes the puck the length of the ice, making one beautiful move after the next, and then slips the puck into the net. Instead of praising him, Coach Brooks instead reprimands Johnson for his individualized play, telling the team that selfish hockey will not work against the Soviet team.

Third, the film chronicles the feud between Jack O'Callahan and Rob McClanahan, whose college rivalries result in an on-ice fight following a payback cheap shot by O'Callahan. As Brooks allows the two "to go," they square off and their college teammates voice support. Only after O'Callahan and McClanahan are exhausted and bloody, Brooks instructs Coach Patrick (the assistant coach) to separate the two players, and he tells them, "The name on the front means a whole lot more than the name on the back." Success is certainly the derivative of teamwork.

The focus of the narrative on a team coming of age, one transforming itself from a collection of individuals to Team USA, goes beyond the efforts of Coach Brooks to "blur the boundaries of regional differences." It also reveals the hard work and discipline of the team members. In the absence of the best players, and facing the formidable task of competing against the Russians, Brooks puts the team through the most rigorous training imaginable. He tells them, "I can't promise we will be the best team at Lake Placid, but we will be the best conditioned." The film's narrative structure focuses on training camp, with lengthy practices always containing dramatic music, and further highlights the values of the team's work ethic.

Along with their admirable work ethic, the team displays a high level of discipline. After a poor game performance, during which the players focused more on blondes in the stands than pucks in the net, an exasperated Brooks forces his players into an impromptu practice in which they skate back and forth on the rink until they are on the brink of exhaustion. At one point Brooks scolds, "You think you can win on talent alone. . . . Gentlemen, you don't have enough talent to win on talent alone." "Again," he says, telling Coach Patrick to send them up and down the rink again. Despite Coach Brooks's anger, none of the players question his authority or contemplate quitting. Overcoming unfathomable pain, the players continue to skate back and forth, even after the stadium manager

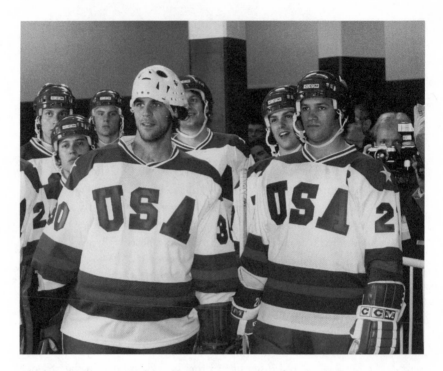

The U.S. hockey team celebrates a victory, proving that their greatest strength is their ability to become one. Courtesy of MovieGoods.

turns out the lights. With no end in sight, Mike Eruzione, a player with "no shot of making the team," announces, "Mike Eruzione, Winthrop, Mass." The coach had demanded introductions from each player, and up until this point all of the players had stated only their name, birthplace, and college affiliation. Brooks responds to Eruzione by asking, "Who do you play for?" Eruzione proudly announces, "I play for the United States of America." Brooks immediately ends the impromptu practice. Through their hard work, discipline, and Brooks's dictatorial style, they have finally come together as a team worthy of America's pride and admiration.

The ultimate sign of the team's growth into a unified body (symbolizing the nation) is the budding friendship between O'Callahan and McClanahan. The bitter rivals are able to put aside their differences for the good of the team. Their concern for each other, their friendship, and teamwork shows the greatest strength of the 1980 U.S. Olympic hockey team: their ability to become one.

The film concludes with the triumphant victory over the much-hated Russians. It represents not a U.S. victory over the Cold War but a victory for American intelligence, creativity, work ethic, and white male athleticism. Brooks's commentary on the American victory in the film's final scene encapsulates the source of pride in the victory. "I have often been asked in the years since Lake Placid 'what was the best moment for me?' It was here [the film flashes to images of the team receiving their gold medals]. It is the sight of twenty young men with such differing backgrounds now standing as one; young men willing to sacrifice so much of themselves all for an unknown." Interestingly, Brooks then calls them a "true dream." The reference to the 1992 Olympic basketball team speaks to a larger discursive field of race and sports. Whereas the 1992 Olympic basketball team possessed numerous black athletes propelled by their physical superiority and financial incentives, the 1980 Olympic hockey team found success in their ability to become a unified group in spite of their differences, lack of talent, and the seemingly impossible feat they faced. Given that whiteness signifies hard work, determination, heart, and teamwork, compared to blackness as an oppositional binary, the whiteness of the 1980 U.S. Olympic hockey team holds a dialectical relationship to the desired values the film bestows on the team. Likewise, the nostalgia for this particular moment in history cannot be understood outside the whiteness of the team. In other words, the film locates pride in the team's ability to bring a nation together, to overcome its members' differences and limitations (both of which are connected to their whiteness), and to form a team that can defeat the powerful Russian national team in a common understanding of white athletics. In the absence of talent, and faced with a diversity of players (whiteness lacks an essentialist or single subjectivity as compared to blacks in the white imagination), the film attributes the team's success to its "familial camaraderie," its "tenacity," and its ability to play like a "well-oiled unit" (see Arledge; and Clinton).

While our comprehension of this cinematic text is imbued with racial (and gendered and class-based) meaning, the context in which audiences receive the film is equally affected by race. The popularity of the film and the popularity of this story reflect dominant racial discourses about sports. Oliver North, in his commentary on *Miracle* at the time of Brooks's death, describes how the dominant racial discourse plays through our celebration of both the film and the hockey team.

You can't watch television these days without seeing a story about Kobe Bryant and the allegations that he sexually assaulted a 19-year old woman in a Colorado hotel. Bryant is yet another in a long list of athletes who can't seem to keep themselves out of trouble and who have contributed to the demise of professional and amateur athletics. It is a sad commentary that the most admired athlete in America today is *Seabiscuit*—a horse that has been dead for 56 years.

Last week's untimely death of hockey coach Herb Brooks is a reminder of how society once found heroes in sports and how great athletic achievements can renew pride in a city, or even a nation. Herb Brooks was the 1980 U.S. Olympic hockey coach for a team that was given little chance of success—by anyone except their coach. Brooks demanded excellence because he believed in his team. They responded by beating the unbeatable and capturing the gold.

As is evident in *Miracle*, white-centered sports film reifies a dominant racialized sports discourse that offers conclusive binaries between black and white. Whiteness embodies hard work, sacrifice, team, determination, heart, and nation. As whiteness and blackness function as oppositional binaries (see Collins), these films elucidate or legitimize racial logics that govern hegemonic sports talk. As a source of corruption and denigration, black athletes, with their emphasis on the individual, materialism, and a pathological black masculinity, signify the declining values in sports. Moreover, the celebration of the 1980 U.S. Olympic hockey team in both *Miracle* and *Do You Believe in Miracles?* captures the nationalist yearning for nostalgia-driven desire for a unified America. That is, the celebration of this team highlights the hope and desire for an assertive white masculinity that once brought America from the brink of self-doubt and destruction. Amid the war on terror, the aftermath of Katrina, ongoing recessions, high oil prices, declining U.S. global hegemony, culture wars, and divisions inside the United States, the historic memorialization of the 1980 Olympics through these films provides a "vehicle for making people excited and proud to wave a flag again" (Jim Lampley, *Do You Believe in Miracles?*). More importantly, the films celebrate the ways in which this team told the world that America's enemies would not be able to walk over its citizens and its way of life without a response, one that would be characterized by an aggressive and assertive masculinity.

Both films leave viewers with a sense of power and excitement and a

reminder that there was a time when the team transcended the individual, when hard work meant more than athletic talent, and most importantly, when sports held the potential to bring people and communities together. Today the 1980 Olympic hockey team continues to be positioned as both a national savior and a treasure, as an embodiment of an American spirit (white working-class masculinity) that will continue to be the basis of American greatness.

No More Miracles

Miracle—the dramatic retelling of the miraculous 1980 U.S. Olympic hockey team—will certainly go down in history as one of the greatest American sports films, one that has resulted in consistent praise for white-centered sports films and the historic contributions of white athletes (see Shields). Its authenticity and power are enhanced by *Do You Believe in Miracles?*, which lends it legitimacy by telling an identical story. *Miracle*'s power thus rests in its ostensible truthfulness.

Despite the purported historical accuracy of the film's representation of post–Cold War America, the emphasis placed on the David versus Goliath narrative and the nostalgia for sports in years past can only be understood through whiteness and the constructed working-class male identity surrounding the team. Like the media coverage and discourse during the Olympics, which emphasized the work ethic of these "average American boys" (i.e., working-class, middle America), the films frame Americans' support for the team as a manifestation of the adoration for American fortitude, toughness, and wherewithal, all of which are entrenched in the tropes associated with white bodies. The films and the historic moment of their release thus serve as reminders of the racialization of hope and redemption. As the all-white Team USA restored hope to a nation in crisis, it simultaneously inscribed the undeniable whiteness of being a sports hero. Fast forward from *Miracle*'s 1980 to today, and we are once again mired in a nation raced by its redemptive tendencies, in which the salvation of brown Iraq and Afghanistan must come at the hands of white Americans. Hollywood offered *Miracle*, which succeeded not so much because of the brilliance of the film but because of the imagined drama of this historical moment and the yearning for patriotism and nationalist fervor that seems always to bubble below America's surface. *Miracle* provided pleasure and satisfaction through its constructions of whiteness and nation, its

celebration of the working-class work ethic, and its ability to tap into an American populace in search of national pride.

While there was most certainly no miracle on ice in the 2006 Winter Olympics, the participation of the U.S. hockey team was not without interest and importance. Leading up to the games, there was increased interest in the "best team ever," which again fueled patriotic fervor and hopes that Olympic success could serve as the ultimate medicine for a nation plagued by bipartisanism, the aftermaths of Hurricanes Katrina and Rita, and the war on terror and war in Iraq. In the estimation of many sports commentators, a successful run by the U.S. hockey team could have provided a needed shot in America's arm, offering spirit and hope to a divided and distraught nation. Interestingly, hockey, a bastion of whiteness in which the clichés of white sports—from being a team sport played by people who love the game to being a sport without the showboating and flash of other (i.e., black-dominated) sports—run rampant, once again carried the hopes of a nation.

The denunciations of Shani Davis, the first African American to win a gold medal during the Winter Olympics, for his decision not to race in a team speed-skating event that would have helped teammate Chad Hendricks in his effort to win five Olympic Gold Medals reflect the dialectics between race and nation. The opportunity to recapture the patriotism, pride, and flag waving was missed, yet this failure was constructed as the result of the me-first attitude of this particular black athlete. Interestingly, only a limited amount of criticism was found in the post-competition commentary regarding Bode Miller, who, despite much hype and celebration, secured no medals and finished only two ski races. Although he too failed those who rested their nationalist hopes on his success, his whiteness and the emphasis on his passion and work ethic, notwithstanding his party-first (me-first) approach to life, which many described as "Bode being Bode," insulated him from critique. Thus, the 1980 miracle and its celluloid retelling remain crucial in America's effort to remain positive, to hold flags high even as the rest of the nation and the world fall apart. In other words, the failures of the 2006 U.S. Olympic hockey team, partially attributed to their being professionals rather than amateurs, and of U.S. participation in the Winter Games as a whole rest not only with low medal counts but also with a wasted opportunity to bring the nation together through a collective and imagined national celebration of whiteness. In this context, *Miracle* and *Do You Believe?* become even more important as sources of

pride and nationalism, as reminders of possibility and patriotic spirit, all carried on the backs of these white working-class hockey players.

Works Cited

Ammons, Linda. "Mules, Madonnas, Babies, Bathwater: Racial Imagery and Stereotypes." In *Critical White Studies: Looking Behind the Mirror,* edited by Richard Delgado and Jean Stefancic, 276–79. Philadelphia: Temple University Press, 1997.

Andrews, David L. "Excavating Michael Jordan's Blackness." In *Reading Sport: Critical Essays on Power and Representation,* edited by Susan Birrell and Mary McDonald, 166–205. Boston: Northeastern University Press, 2000.

Arledge, Nicholas. "Russell a 'Miracle' in Hockey Film." *Daily Texan Online,* February 6, 2004. http://media.www.dailytexanonline.com/media /storage/paper410/news /2004/02/06/Entertainment/Russell.A.miracle .In.Hockey.Film-599872.shtml.

Baker, Aaron. *Contesting Identities: Sports in American Films.* Urbana: University of Illinois Press, 2003.

———. "Hoop Dreams in Black and White: Race and Basketball Movies." In *Basketball Jones,* edited by Todd Boyd and Kenneth Shropshire, 215–39. New York: New York University Press, 2000.

Bernardi, Daniel, ed. *Classic Hollywood, Classic Whiteness.* Minneapolis: University of Minnesota Press, 2001.

Clinton, Paul. "Olympic Hockey Film 'Miracle' a Winner." CNN.com, February 5, 2004. http://www.cnn.com/2004/SHOWBIZ/Movies/02/05/review .miracle/.

Collins, Patria Hill. *Black Sexual Politics: African Americans, Gender and the New Racism.* New York: Routledge, 2004.

Crenshaw, Kimberle Williams. "Color-blind Dreams and Racial Nightmares: Reconfiguring Racism in the Post–Civil Rights Era." In *Birth of a Nation 'Hood: Gaze, Script and Spectacle in the O.J. Simpson Case,* edited by Toni Morrison, 97–168. New York: Random House, 1997.

Dyer, Richard. "The Matter of Whiteness." In *White Privilege: Essential Readings on the Other Side of Racism,* edited by Paula Rothenberg, 9–14. Boston: Worth Publishers, 2004.

Frankenberg, Ruth. "Cracks in the Façade: Whiteness and the Construction of 9/11," *Social Identities Journal for the Study of Race, Nation and Culture* 11, no. 6 (2005): 553–71.

Garner, Jack. "Miracle." *Democrat and Chronicle* (Rochester, NY), February 4, 2004. http://www.toptenreviews.com/scripts/eframe/url. htm?u=http%3A%2F% 2Fwww.democratandchronicle.com%2F goesout%2Fmov%2Fm%2Fmiracl.shtml.

Kellner, Douglas. *Media Culture*. New York: Routledge, 1995.

Kibby, Marjorie D. "Nostalgia for the Masculine: Onward to the Past in the Sports Films of the Eighties." *Canadian Journal of Film Studies* 2, no. 1 (1998): 16–28.

King, Charles Richard, and Charles Fruehling Springwood. *Beyond the Cheers: Race as Spectacle in College Sport*. Albany: State University of New York, 2001.

Kusz, Kyle. "BMX, Extreme Sports, and the White Male Backlash." In *To the Extreme: Alternative Sports, Inside and Out*, edited by Robert E. Rinehart and Synthia Sydor, 153–78. Albany: State University Press of New York, 2003.

———. "'I Want to Be the Minority': The Politics of Youthful White Masculinities in Sport and Popular Culture in 1990s America." *Journal of Sport and Social Issues* 25, no. 4 (2001): 390–416.

Leonard, David J. "'Is This Heaven?' White Sporting Masculinities and the Hollywood Imagination." In *Visual Economies of/in Motion: Sport and Film*, edited by C. Richard King and David J. Leonard, 164–94. New York: Peter Lang Publishing, 2006.

McDonald, Mary, and David Andrews. "Michael Jordan: Corporate Sport and Postmodern Celebrityhood." In *Sports Stars: The Cultural Politics of Sporting Celebrity*, edited by David L. Andrews and Steven J. Jackson, 24–35. New York: Routledge, 2001.

Morrison, Toni. *Playing In The Dark: Whiteness and the Literary Imagination*. New York: Vintage Publishers, 1993.

North, Oliver. "The Miracle on Ice Remember." Humanevents.com. August 19, 2003. http://www.humanevents.com/article.php?id=1571.

Shields, David. "Is this Heaven? No, It's a Sports Movie." ESPN.com, August 28, 2002. http://espn.go.com/page2/movies/s/shields/020827.html.

Tudor, Deborah. *Hollywood's Vision of Team Sports Heroes, Race, and Gender*. New York: Garland Publishing, 1997.

West, Cornel. *Democracy Matters: Winning the Fight against Imperialism*. New York: Penguin, 2005.

DAVID SCOTT DIFFRIENT

An Olympic Omnibus

International Competition, Cooperation, and Politics in Visions of Eight

BECAUSE THE INAUGURATION of the modern Olympic Games—founded by social theorist and *rénovateur* Baron Pierre de Coubertin and held in Athens in 1896—roughly coincides with the birth of cinema, it should come as no surprise that the two served as mutually enriching sources of dramatic material throughout the twentieth century. From Leni Riefenstahl's poetic yet problematic record of the 1936 Berlin games, *Olympia* (*Olympische Spiele*, 1938) to such cinematic and televisual biopics as *Jim Thorpe: All American* (1951) and *The Jesse Owens Story* (1984), the Olympics have inspired numerous documentary and fiction films around the world. Such works have in their own way contributed to the popularity of the quadrennial event as well as to the global proliferation of its governing ideals, thus promoting international camaraderie, the physical health of iconic heroes, and the solidarity of humankind. Although Riefenstahl's two-part *Olympia* is often singled out as a sensual and transcendent celebration of the human form in flight and, despite its links to the Nazi Party, is generally thought to be "the definitive cinematic treatment of the Games," it nevertheless falls short of the pyrotechnics on display in what is perhaps the most unusual of Olympic documentaries, *Visions of Eight* (*München 1972—8 berühmte Regisseure sehen die Spiele der XX Olympiade*, 1973).[1]

On the surface, *Visions of Eight*, a multi-episode, feature-length film produced by legendary documentarian David L. Wolper and Stan Margulies (then-vice-president of Wolper Productions), appears to be curiously "empty," at both the diegetic and extradiegetic levels, insofar as it captures only fleeting, impressionistic glimpses of the festival held in Munich (from August 26 to September 11, 1972) and furthermore only begrudgingly alludes to the deadly act of terrorism that capped the Summer Olympics

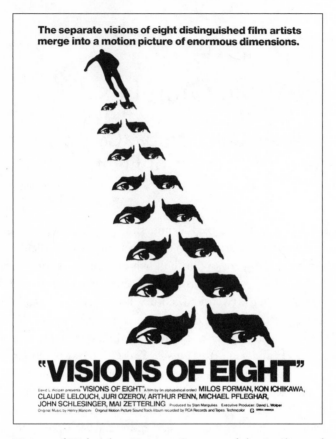

Visions of Eight advertisement. Courtesy of the Academy of Motion Picture Arts and Sciences.

that year. Nevertheless, as an omnibus film comprising eight discrete yet connected sections, each averaging ten minutes in length, *Visions of Eight* is in fact a very full evocation of the Olympic experience, for it manages to convey both the personal and the collective aspirations of the partici-pants involved (athletes as well as filmmakers) through a narrative form naturally amenable to political allegory and the interrelated themes of competition and cooperation. Because this multinational, multidirector film foregrounds the spirit of competition and cooperation so intrinsic to the Olympic ideal, it provides an illuminating case study for charting out the ways in which the narratological genre of the omnibus film not only problematizes conventional paradigms of authorship and nationhood but

also supplies a textual correlative to the sometimes contradictory modes of participation inscribed in sporting events. Before examining the film and its historical context, it is helpful to examine the importance of Wolper to the project, not only as a producer overseeing the day-to-day details of this logistical nightmare, but also as someone whose diverse filmography attests to a consciousness of major world events.

A Producer's Package

Visions of Eight should be situated not only within the historical context of documentaries about the Olympics but also within the narratological context of the episode film, which had come into vogue in the years immediately preceding its 1973 theatrical release. Although there had been dozens of such works produced throughout the world during the first five decades of the twentieth century (multidirector omnibus films such as *La vie est à nous* [1936], an agitprop joint effort by members of the popular front group Ciné Liberté, as well as single-director anthologies like Roberto Rossellini's *Paisà* [1946]), it was not until the 1960s that the episode film became a marked component of national cinemas in Europe and Asia. For it was during that decade that such famous and diverse examples of this narratological genre as *Teen Kanya* (1961), *Boccaccio '70* (1962), *Kwaidan* (1964), *Paris vu par . . .* (1965), *Loin du Vietnam* (*Far from Vietnam*, 1967), *Histoires extraordinaires* (*Spirits of the Dead*, 1968), and *Amore e rabbia* (*Love and Anger*, 1969) were released to a public becoming ever more accustomed to the combined fragmentation and integration unique to these apparently contradictory texts. By the early 1970s, feature-length episode films were still thought to be attractive to audiences because of their inherent heterogeneity—that is, their ability to combine in a single frame several genres, stars, and stories that were nevertheless presented in a piecemeal and consecutive, rather than blended and simultaneous, way.

While multidirector episode films emphasize the marquee value of several auteurs (a point made conspicuous with the acronymic *RoGoPaG* [1962], which features the individual contributions of Rossellini, Godard, Pasolini, and Gregoretti), they are nevertheless conceptualized as a whole and subsequently put together by producers. In his study of Italian cinema (a hotbed of episodic activity during the 1960s and 1970s), Peter Bondanella argues that the vogue for multidirector omnibus films during

those politically volatile and financially unstable years "clearly reflects the domination of economic imperatives over artistic ones." Because men like Dino de Laurentiis and Carlo Ponti "encouraged such works," which could be "done in sections by different directors and combining box-office attractions that would normally be employed in three or four separate films," these low-cost alternatives to the regular feature not only muddy the waters of conventional critical categories but also represent a transformative shift in the motivations and role of the producer, who was expected to arrange the episodes into a compelling composite.[2] As the brains behind *Visions of Eight*, a film that combines the efforts of eight directors from eight different countries, David L. Wolper consolidated talents and resources from around the world and thus gestured not only to the spate of omnibus films that predated his own but also to the many nonepisodic documentaries he produced during the 1960s (effectively making up for his inexperience in one particular genre by drawing on his experience in another).

After scoring an Oscar nomination for Best Documentary Film with *The Race for Space* (1958), an independently produced look at the Cold War era's competing space programs that drew on Department of Defense footage and was scored by Elmer Bernstein (with a young Mike Wallace supplying narration), David L. Wolper became renowned as a filmmaker willing to take chances—someone who wasn't afraid to depart from genre conventions and couch geopolitical and social issues within a lyrical frame. Although he is today best known for his nondocumentary productions— most notably the theatrical motion picture *Willy Wonka and the Chocolate Factory* (1971), the television movie *Murder in Mississippi* (1989), and the groundbreaking miniseries *Roots* (1977), *The Thorn Birds* (1983), and *North and South* (1985)—and claims, in his recently published memoir *Producer*, to know "little about the history of documentaries," Wolper remains a towering and influential figure in the sphere of nonfiction film-making. Before *Visions of Eight* he had produced a dozen documentary series, including National Geographic programs from 1965 to 1975, a three-episode study of the rise and fall of the Third Reich, telecast in 1967, and a quartet of 1968 programs exploring the undersea world of Jacques Cousteau. On top of these were another twenty political and corporate films covering the campaign trails of individuals like Pat Brown, Dan K. Moore, and Raymond P. Shafer, as well as fifty documentary specials for network television. These one-episode specials ran the gamut from exposés

of pop culture icons (*The Legend of Marilyn Monroe* [1964]; *007: The Incredible World of James Bond* [1965]) to ethnographic excursions into East Asia (*Korea: The 38th Parallel* [1965]; *Japan: A New Dawn over Asia* [1965]; and *China: Roots of Madness* [1967]) and anecdotal accounts of sports-based entertainment (*October Madness: The World Series* [1965]; *Pro Football: Mayhem on a Sunday Afternoon* [1965]).

Ironically, it was this latter interest in the ostensibly apolitical world of sports that gave Wolper—by then a master of staging live events for the camera—a decided advantage in the race to make the official film about the 1972 Summer Olympics, an event that would become mired in political debate and controversy when, in the predawn hours of September 5, six Palestinian guerrilla fighters known as "Black September" climbed the cyclone fence surrounding Olympic Village, entered a building at 31 Connollystrasse, and took eleven members of the Israeli wrestling team hostage and then killed them.[3] Led by Issa (the mysterious "Man in the White Hat," who was believed to have been Lebanese national Mohammed Mahmud Essafadi) and joined inside the village by two more Palestinians, the terrorists felt that, by taking the men hostage, their demand for the release of 236 revolutionary prisoners would be met. The standoff between the Black Septembrists and the German armed forces finally ended that evening when five of the eight terrorists were killed during a climactic melee at the Fürtenfeldbruck military airfield (fourteen miles west of Munich).[4] A memorial service was held the next day (September 6) at Olympic Stadium, with flags at half-mast and eighty thousand mourners in attendance. After the Munich Philharmonic performed the Funeral March from Beethoven's *Eroica*, Olympic Organizing Committee member Willi Daume spoke of the Games as a "great and fine celebration of the peoples of the world . . . that had been dedicated to peace." International Olympic Committee (IOC) president Avery Brundage echoed those words and announced that the Games would go on.[5]

Dedicated to the memory of the martyred athletes, *Visions of Eight* actually makes only passing reference to the actions of the terrorists, who easily circumvented the minimum-security measures that fateful day in Munich and put all of Germany—a nation eager to dissociate itself from Hitler's Berlin Games—on high alert.[6] That the film at first appears so uncommitted in its political aspirations, that it seems so disinterested in the ideological implications of the Olympics, can be partly attributed to the fact that 90 percent of its principal photography had been completed

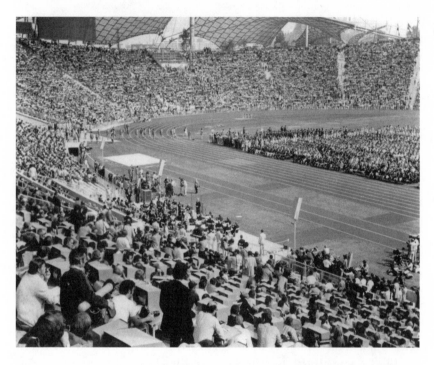

Munich, 1972. Courtesy of the Academy of Motion Picture Arts and Sciences.

by the time the terrorists took their hostages. Wolper, who had no inten-tion of extending the schedule to include footage of an event that would already be telecast around the world before the film's theatrical debut the following year, left the task of footnoting the tragic occurrence to the one filmmaker who had not yet completed his contribution to *Visions of Eight*: John Schlesinger. Appropriately, Schlesinger's twelve-minute film, an exposé of British research scientist-turned-marathon runner Ron Hill (who appears disturbingly nonchalant toward the terrorist act, which has delayed the twenty-six-mile race one day and thrown many runners off their game), brings *Visions of Eight* to a ruminative and somewhat self-incriminating conclusion. Although Schlesinger wanted to change his subject during those final days and make a short film about the effects of the killings (a topic vetoed by Wolper), his ultimate decision to focus on human endurance offers the viewer opportunities to ponder not only humankind's capacity to weather misfortune but also the spectatorial perseverance needed to appreciate this and other multi-episode films that shuttle from one nar-

rative event to the next. Before delving into Schlesinger's and the other directors' episodes, let us first turn to the idealistic early days in the film's production, when its structural premise and narratological principles were being carefully worked through by Wolper with no inkling of the events about to unfold.

The honor of making the official Olympic film has traditionally been bestowed on citizens of the host countries. However, in 1972 Wolper was given the green light by executives at Bavaria Studios once he convinced them that a fresh, innovative approach to the Olympics was necessary both to distinguish the film from previous journalistic examples and to convey less obvious emotional, psychological, and aesthetic dimensions of the heavily telecast event. What he had in mind, in fact, was a poetic exposé, one that would stray from the traditions of documentary report-age and be—like the Games themselves—multidimensional, episodic, and discursive. Selective rather than comprehensive, fragmented as opposed to unified, the resulting film effectively communicates what Wolper describes as the "well-organized chaos" of the event, and it is shot through with the democratic spirit so intrinsic to the Olympic ideal.[7]

Although the making of any documentary is rife with potential prob-lems, filming the Olympics proves to be particularly challenging, even for those producers like Wolper who are experienced in the fine art of location shooting, crowd-control, juggling simultaneous events, deploy-ing large numbers of crew members, and maintaining a balance between investigative proximity and objective distance. Given the vast nature of the event, just choosing what to shoot can be a vexing and time-consuming endeavor. Fortunately, Wolper and coproducer Margulies had hit upon the novel idea of apportioning those choices to a group of the world's top directors, and they began assembling a who's-who wish list consisting of past contributors to omnibus productions. Initially, Wolper approached pantheon auteurs like Ingmar Bergman and Federico Fellini—both of whom, it turned out, were busy making their own films and thus unable to work on the project. Nevertheless, the legendary Italian director, an oc-casional dabbler in the short-story and omnibus formats, temporarily lent his name to Wolper's project so that the producer's other choices—Milos Forman, Claude Lelouch, Michael Pfleghar, Arthur Penn, Kon Ichikawa, John Schlesinger, Juri Ozerov, and Ousmane Sembène—would agree to sign on (each director received a paycheck of ten thousand dollars as well as a piece of the speculative profits).

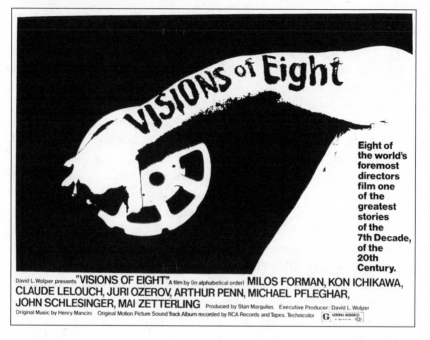

Eight of
the world's
foremost
directors
film one
of the
greatest
stories
of the
7th Decade,
of the
20th
Century.

David L. Wolper presents "VISIONS OF EIGHT" A film by (in alphabetical order) MILOS FORMAN, KON ICHIKAWA, CLAUDE LELOUCH, JURI OZEROV, ARTHUR PENN, MICHAEL PFLEGHAR, JOHN SCHLESINGER, MAI ZETTERLING Produced by Stan Margulies Executive Producer: David L. Wolper Original Music by Henry Mancini Original Motion Picture Sound Track Album recorded by RCA Records and Tapes. Technicolor G GENERAL AUDIENCES

Promotional image for *Visions of Eight*. Courtesy of the Academy of Motion Picture Arts and Sciences.

As Sweden's cinematic representative, Bergman was replaced by Mai Zetterling, an actress-turned-filmmaker whose dedication to political and sexual themes made her one of the leading voices of feminist discourse in front of and behind the camera. Additional changes were made to the roster when Franco Zeffirelli, Fellini's replacement, refused to participate after hearing that several African nations (including Ethiopia, Sierra Leone, Tanzania, and Zambia) had threatened to withdraw from the Games due to the IOC's controversial decision to invite white-ruled Rhodesia (that country's team was eventually sent home after a second IOC vote on the issue).[8] Also, legendary Senegalese writer and filmmaker Ousmane Sembène apparently never completed his minifilm and, according to Wolper, disappeared before the producers could contact him.[9] With the subtractions of Sembène's incomplete episode (a short documentary about his home country's basketball team) and Zeffirelli's intended sequence (which would have shown the lighting of the torch by Germany's champion 1500-meter runner Günther Zahn), *Visions of Ten*—the working title of the produc-

tion—became *Visions of Eight*, a leaner if not meaner distillation of the Munich Games.

Warming Up and Cooling Down: Athletics as Metaphor for Cinematic Episodicity

Fittingly, the film kicks off with "The Beginning," Yuri Ozerov's tension-filled depiction of athletic preparation. Through powerful yet whimsically juxtaposed images that inversely foreshadow the yawning judge in Milos Forman's "Decathlon" episode, Ozerov and cinematographer Igor Slabnevich capture the pre-performance jitters faced by the world's greatest athletes—men and women fluttering between patience and nerve-jangling anticipation as they limber up for their races. A Soviet film-maker who would later direct the feature-length account of the Olympic Games held in Moscow, *O Sport, Ty-Mir* (1981), Ozerov—an outspoken communist—draws upon the theories of dialectical and poetic montage launched by his cinematic predecessors (Eisenstein, Vertov, and Pudovkin) and turns the clash between individuality and community, between secular and spiritual comforts, into a profound (if all-too-brief) meditation on the underlying ideals of western culture.[10] Significantly, this episode is set to composer Henry Mancini's 7/4-meter "Warm Up" theme, subtly insinuating the audience's own mental preparation for the upcoming events of an episodic film still in its earlier stages.

Following Ozerov's episode is Mai Zetterling's contribution to *Visions of Eight*, an acerbic look at the men's weightlifting competition, entitled "The Strongest." Although initially attracted to the idea of filming the women athletes in Munich, Zetterling instead set her sights on what she described (in her 1985 autobiography, *All Those Tomorrows*) as the most "sensual" and "obsessive" of Olympic events. As a result, this pioneering feminist filmmaker, who (unlike the ex–alpine skier Leni Riefenstahl) admits in the episode's intro to not being interested in sports, was able to expand her already diverse repertoire of key themes—sexual awakening, personal isolation, and the various forms of violence perpetrated against women—to accommodate these mutually impacting images of masculine hegemony and physical prowess. Zetterling, a Swedish actress of the 1940s and 1950s who gravitated toward directing in the 1960s (when she tackled the above themes in films such as *Night Games* [*Nattlek*, 1966], *Doktor Glas* [1968], and *The Girls* [*Flickorna*, 1968]), has throughout her

career nurtured an interest in the "psychological terrain" of Eastern and Northern Europe, and this episode finds her camera (operated by Swedish cinematographer Rune Ericson) gravitating toward the boulder-shaped bodies of Bulgarians, Poles, Hungarians, and Norwegians, weightlifters who slowly, methodically psych themselves into their lifts and whose demonstrable strength casts in relief the comparative weakness of the five German soldiers who struggle to carry the barbells offstage at the end.[11] The record-setting Russians (in particular the 337-pound world champion Vassily Alekseyev) also get a lot of screen time, as does the bounty of beef required to feed the athletes.

The footage of the caterers laying out food for consumption slyly conveys the enormity of the event as well as the underlying excess of the Olympics, whose grandeur is frequently undercut by images of kitsch and impersonal technology. Promoted as a monumental extravaganza of the senses and performed under newly built steel and Plexiglas structures that promoted Germany's preeminence in the realm of architectural design, the Munich Olympics were indeed excess incarnate, a television-age spectacle that—besides bringing 7,131 athletes from 122 countries together in a stadium full of eighty thousand onlookers—promoted the technological developments of a democratized and multicultural nation through gratuitous, globally circulated images (seen by one billion people worldwide) of machines in action. As if conscious of this, Zetterling deftly cuts between the obese men pumping iron and a battery of machines outside lifting enormous sections of steel, a witty visual commentary on the human toil and toll inscribed in any nation-building process. As much as this episode can be read as a "subversive carnivalesque mocking of masculinity," it seems equally critical of the kind of nationalistic pageantry that had been associated with the Berlin Games of 1936 and was thought to have been absent from the supposedly more restrained Munich Games, despite the fact that the latter's opening ceremony was announced by a blast of alpenhorns and brought to a close with a *Böllerschützen* ("a traditional Bavarian gun salute of three rounds from 20 guns").[12]

"The Highest," Arthur Penn's contribution to *Visions of Eight*, comes next. Having scored back-to-back successes with *Bonnie and Clyde* (1967), *Alice's Restaurant* (1969), and *Little Big Man* (1970), Penn was eager to continue his trailblazing trek across the countercultural heartland of America when Wolper invited him to be a part of the project. The director,

who had already begun filming the story of a South Carolina ex-convict's bid to make the U.S. boxing team, was forced to choose another, less potentially political subject after the reformed flyweight, Bobby Lee Hunter, failed to make the cut. Scrapping the four hours of footage he had already shot back home, Penn opted to make something completely different once he arrived in Munich: a decidedly apolitical and poetic vision of pole vaulters reaching for the heavens. With little to no sound to accompany the balletic movements of the vaulters' bodies rising and falling in midair, this sequence (lensed by self-described "itinerant cameraman" Walter Lassally and edited by Dede Allen) is the most abstract and impressionistic of the film, capturing in slow motion (ninety-six to six hundred frames per second) and soft-focus shots the sense of transcendence and freedom only a select few experience in their gravity-defying struggle to clear the bar.[13]

After witnessing these men plant their poles in the ground and push themselves upward, the viewer, perhaps struck by the conflation of sexual and spiritual aims implicit in such imagery, can be excused for feeling disappointed when literally brought back to earth in the fourth episode. Entitled "The Women," this episode might initially appear to be a set of sensitive interviews with important female athletes like Heidi Schüller, the German long jumper who became the first woman in modern Olympic history to take the athlete's oath in the opening ceremony. Instead, Schüller's countrymen—filmmaker Michael Pfleghar (who had previously contributed an episode to the prostitution-themed omnibus film *The Oldest Profession* [*Le plus vieux metier du monde*, 1967]) and cinematographer Ernst Wild—cast a decidedly male gaze at her and other women athletes. Among the cinematically fetishized bodies are those of fifteen-year-old Australian swimmer Shane Gould and West German pentathlete Heidemarie Rosendahl (world record-holder in the long jump), whose accomplishments in Munich and capacity for liberating mobility and agency are undercut by Pfleghar's leering close-ups and fragmented editing.[14] Only robust Russian gymnast Ludmilla Tourischeva is given an opportunity to really shine; her graceful performance on the uneven parallel bars is shown in its entirety, without flashy editorial intervention. Putting as much emphasis on their hairdressers as on the finish lines, Pfleghar's episode (which is partially set to Rita Streich's operatic rendition of Johann Strauss's "Voices of Spring") nevertheless says less about women than about men. Its reliance upon film's traditional visual paradigm—masculine viewing subject and

feminine object of desire—unwittingly underscores an engrained facet of western culture, which continues to perpetuate gender stereotypes through ocularcentric fictions and phallocentric structures.

Thankfully, this low point in the film is followed by one of its most effective and self-reflexive sequences: Kon Ichikawa's "The Fastest." Armed with a battalion of overcranked cameras, Ichikawa and his principal cinematographers (Masuo Yamaguchi, Michael J. Davis, and Alan Hume, not to mention Claude Lelouch, who lent a much-needed hand) filmed the men's hundred-meter dash as it had never been filmed before, effectively transforming this most accelerated of sports into a decelerated evocation of the dedication and training that goes into the Olympics.[15] By stretching a ten-second race into a grueling, eleven-minute mini-marathon of facial contortions and wobbling muscles, Ichikawa not only conveys a Muybridge-like fascination with human physiognomy and locomotion but also taps into the very technological preconditions behind their cinematic recording (the medium's ontological grounding in photographic realism plus the various apparatuses that confer the illusion of movement onto still images). This reflexive gesture is compounded by the director's decision to show all eight sprinters in a line, head-on, with their individual yet contiguous lanes connoting the eight separate yet linked episodes of the film. A voiceover draws the spectator's attention to the runners' expressions, their eyes focused and full of yearning. After the gun is fired, one of the runners falls behind and gives up. These small details, in addition to Ichikawa's decision to show each runner individually with a 600mm telephoto lens before capturing the entirety of the event in a wide shot, evokes the sense of humanity that comes, ironically, from selfhood—a theme for which the filmmaker has become famous.

Indeed, Ichikawa's ability to convey a humanistic awareness of others through assertions of uniqueness and individuality is what elevates his most poignant films, particularly his antiwar dramas—*The Burmese Harp* (*Biruma no tategoto*, 1956) and *Fires on the Plain* (*Nobi*, 1959)—to the level of art. This is particularly true of his first documentary feature, *Tokyo Olympiad* (*Tokyo Orimpikku*, 1965), a similarly episodic film that—for all of its importance as a technological achievement—ultimately triumphs as a panoramic depiction of humanity in all its ethnically, racially, and culturally diverse forms. If, due to its brevity, "The Fastest" necessarily lacks the all-encompassing sweep of the Techniscope *Tokyo Olympiad* (which

devotes three hours to the 1964 Summer Games and—after numerous episodes filled with disappointment, tragedy, and humor—culminates with a euphoric sequence in which Ethiopian marathon champion Abebe Bikila sprints into the stadium followed by his many blister-footed competitors), so much of this episode's combined simplicity and grandeur harkens back to the earlier masterpiece that it can rightly be seen as *Tokyo Olympiad*'s extension and distillation, a filmic miniature that moves beyond national pride to accommodate the universally acknowledged importance of international solidarity. Coincidentally, the most breathtaking sequence besides the marathon in *Tokyo Olympiad*, a film that evokes the cyclical nature of life through bookend images of the rising sun and the Olympic flame (whose fire, the closing subtitles emphasize, "returned to the sun"), is an episode devoted to the hundred-meter dash, which in 1964 was won by the electrifying Floridian Bob Hayes. That Ichikawa would choose to return eight years later to the track and its scene of suggested circularity (which could also be said to evoke the cyclical nature of life) in lieu of the many other competitions already covered in *Tokyo Olympiad* (marksmanship, gymnastics, swimming, the hammer throw, and so on) says a lot about his interest not only in the kinesthetic thrills of man's mobility but also in the sometimes circuitous, time-tested paths people take in their quests for personal achievement.

Like Ichikawa, Claude Lelouch was no stranger to the Olympics. Four years before *Visions of Eight*, the French director had teamed up with François Reichenbach to chronicle the 1968 Winter Olympics held in Grenoble. Titled *Thirteen Days in France* (*Treize jours en France*, 1968), this documentary gave international audiences a taste of the joy of victory, juxtaposing images of heroic gold medalists such as skater Peggy Fleming and skier Jean-Claude Killy with political figures such as President Charles DeGaulle. In Munich, however, Lelouch was drawn not to the Flemings and Killys of the world, not to the record-setting swimmer Mark Spitz (the famous Californian who in 1972 took home seven gold medals), but rather to the nearly seven thousand "nameless" men and women who, like the runner who gives up mid-race in Ichikawa's episode, know the bitter taste and sudden loneliness of defeat.[16] These imbricated themes inform "The Losers," Lelouch's appropriately titled episode, which segues from a defeated boxer throwing a hissy fit to an injured bicyclist to weeping women athletes to equestrian collisions to dejected swimmers to injured

yet persistent wrestlers. Most of these below-bronze participants partake in a kind of emotive performance akin to melodrama, a genre to which Lelouch was sympathetically attuned and one that is as exhibitionist and physically expressive as any Olympic event. Through it all, the filmmaker drives home the idea that defeat—the very thing that unites all of humanity (for everyone must deal with loss at some point in their lives)—is an existential given, something intrinsic to one of life's great paradoxes. With loss, Lelouch seems to be saying, people from all social, political, national, and religious backgrounds share something that isolates them. Notably, omnibus films, due to their inherently contradictory status as single yet multiple texts, are particularly attuned to the subtleties of said paradox. Much like Lelouch has admitted (in various interviews) to being equally fascinated with winners and losers (two opposing poles structuring his career, which encompasses films that are comprised of episodic miniatures yet are epic in length), omnibus films like *Visions of Eight* betray a similarly paradoxical interest in group dynamics and individual desires.

Interestingly, "The Losers" comes in sixth, not last, among the eight episodes, immediately preceding Milos Forman's humorous interlude "The Decathlon." Ostensibly concerned with the most demanding and drawn-out of the physical disciplines (ten different events performed over the course of two days), Forman's episode opts for a satiric critique of Olympic officialdom and spectatorship itself, a mode of dispassionate engagement personified by a green-suited judge who struggles to stay awake in the stands during the decathlon. Departing periodically from the games to explore the city's various manifestations of local color (yodeling, bell ringing, and folk dancing by bosom-shaking, lederhosen-clad Bavarian women; plus the Munich Symphony Orchestra's performance of "Ode to Joy" from Beethoven's Ninth), Forman and cinematographer Jörgen Persson manage to convey yet another aspect of Olympic spectatorship, which is pulled in several directions by cultural as well as sporting events and therefore dispersed or discursive in a way that resonates with both the multi-event decathlon and episodic film spectatorship (a mode of engagement that can be literally wrenching insofar as viewers are habitually yanked from one story, setting, or group of characters to a completely different one). Indeed, viewers of omnibus films often react negatively to this internal discursiveness, to this slap in the face of narrative tradition; for any radical departure from the foundational tenets of classical storytelling (clarity, motivation, cohesion, causality, unity, and symmetry,

all on top of a central organizing consciousness) threatens to undermine the hermeneutic activity brought to bear on the text by the "classical spectator"—a hypothetical yet historically conceivable entity who (like the dozing official) is in constant need of regulated shocks and narrative developments. The shocks and developments in episodic cinema, however, appear to be unregulated, haphazardly strewn throughout the text. Its seemingly endless stream of beginnings and endings, its parade of ruptures and discontinuities, is what partially distinguishes this narratological genre yet contributes to its diminished status in the eyes of audiences accustomed to traditional narrative.

If Forman's comic juxtapositions undercut the grandeur of the Olympics, if his reflexive gestures implicate the sometimes-fickle whims of film spectators, this irreverence seems downright irrelevant in light of the tragedy that befell the "Games of Peace and Joy." As mentioned earlier, the only episode that references the act of terrorism is the final one: John Schlesinger's "The Longest." Like runners with tunnel vision, the first seven contributing directors focus exclusively on the nonpolitical aspects of the Olympics. Ironically, the concept of tunnel vision is personified by British runner Ron Hill, the ostensible subject of Schlesinger's episode whose utter refusal to see beyond his personal goal and whose outward indifference toward the incident disquieted the politically committed filmmaker.

Although Schlesinger was as unprepared for the shocking news at Munich as the rest of Wolper's crew, he was the most prepared for the shoot insofar as he had done extensive filming back in England. Having set up camp in the perpetually overcast Lancashire countryside where Hill did his rigorous training (running approximately 130 miles a week outside his Manchester home), the director was able to interview his subject about the upcoming marathon—a twenty-six-mile race that he and his forty-five camera units would eventually cover with sixty-five cameras. In a sense, Schlesinger had been preparing for this moment for his entire career, which stretches back to the mid-1950s, when he was first drawn to the documentary form during his prep school days at Uppingham. There he shot *Sunday in the Park* (1956), eventually cutting his teeth making dozens of short nonfiction films for *Tonight* and *Monitor*, two BBC television series enjoying popularity during the 1950s. His television documentaries, although made outside the British Free Cinema documentary movement, betray an interest in problems faced by the working class—British Sisyphuses struggling against an indifferent society. In representative works such as

The Circus (1958), The Innocent Eye: A Study of the Child's Imagination (1959), and The Class (1961), Schlesinger's trademark probing camera conveys his indefatigable sense of curiosity as well as a restlessness borne out of this interest in class struggles. He followed up these early apprenticeship films with his most critically successful documentary, Terminus (1961), a comically inflected yet humane look at the bewildered travelers and abandoned waifs passing through Waterloo Station.

Unlike the other seven contributors to Visions of Eight, Schlesinger opted to deal with a particular individual; and yet, despite this focus on a single person, the sensitivity he displayed in Terminus (and later in Midnight Cowboy [1969] and Sunday, Bloody Sunday [1971]) toward a broad range of people and social problems resurfaces in "The Longest." Beginning with a voiceover narration in which the director says that he was drawn to the idea of someone who trains alone and competes against himself, and ending with an image of Hill disappearing into his house, the episode nevertheless departs from this "Loneliness of the Long Distance Runner" premise to incorporate reports of the hostage situation and images of other marathon runners who come in before and after Hill's sixth-place finish. Images of the last runner finally trickling into the stadium in the rain are intercut with a shot of the autocratic Olympic official Avery Brundage declaring the Games officially ended (this would also mark the end of the octogenarian's twenty-year tenure as IOC president).[17] The flame is extinguished, the German farewell "Auf wiedersehen" goes out, and shots of the Olympic flag at half-mast and the Israeli flag provide sobering reminders that, behind the joyful façade, several lives have been wasted. A sign reading "Montreal 1976" is visible in these final images, which bring closure to Visions of Eight and gesture toward the next Olympics.[18]

Giving Out Golds: Spectatorial "Scorecards"

Uniting disparate sporting events in an anthology or omnibus package had been done before Visions of Eight. For example, Leni Riefenstahl's Olympia could be considered an anthology of discrete episodes, one organized, as David Bordwell and Kristen Thompson point out, according to certain categorical principles. Divided into ten self-contained sections (plus prologue and epilogue) marked off by fade-outs and musical fanfares, Olympia Part Two takes us to gymnastics, yacht races, the pentathlon,

women's calisthenics, the decathlon, field games, bicycle races, cross-country riding, rowing, and diving and swimming, all in an episodic yet serial fashion. The patterns of formal and stylistic development collectively traced out by the individual episodes in Riefenstahl's film, which are unified by the overriding presence of composer Herbert Windt's Wagnerian score and the continuing comments of an off-screen narrator, point toward the "well-organized chaos" of *Visions of Eight*.[19] And although not an Olympic-themed film, the 1963 Paramount feature *Sportorama* similarly strings together a half-dozen *Sports Illustrated* shorts ("Boats A-Poppin," "A Sport is Born," "King of the Keys," "Speedway," "The Big Z," and "Ten Pin Tour") in a way that emphasizes the distinctive characteristics of the individual events. Also, the idea of filtering the Olympics through eight different lenses or perspectives (the titular "visions" of a group of established and up-and-coming art-house filmmakers) was not entirely unique either, insofar as it was an extension of the omnibus phenomenon popular throughout Europe during the 1960s and early 1970s. But *Visions of Eight* differs from other, non-sports-related omnibus films in the way that it foregrounds the theme of competition, something diegetically inscribed in the guise of competing athletes and extradiegetically implied in the presence of many directors whose talents are showcased under a single "roof." Indeed, each contributor to an omnibus film knows that his or her work will be seen alongside a handful of others. This understanding of the inherent juxtapositionality of the text, which facilitates the passing of spectatorial judgment based on the relative success or significance of a given episode, surely informs a director's decisions about what to film and how.

In a recent interview, Sidney Cole, one of the associate producers of the 1945 film *Dead of Night*, referred to the "friendly rivalry" that existed between the film units at Ealing Studios, which was responsible for shooting the five separately directed episodes of that horror classic—units that worked in a spirit of combined competitiveness and collaboration unique to omnibus films.[20] Don Boyd, the iconoclastic British producer behind the operatic omnibus *Aria* (1987), said much the same thing when he was interviewed: that the film's ten directors (Robert Altman, Bruce Beresford, Bill Bryden, Jean-Luc Godard, Derek Jarman, Frank Roddam, Nicolas Roeg, Ken Russell, Charles Sturridge, and Julien Temple) "wanted to do their best" in the spirit of competition.[21] One can easily imagine similar

friendly rivalries brewing behind the scenes of *Visions of Eight*, a film that critics and historians have spoken of as itself an Olympiad, a gathering together of filmmakers intent on proving their skills to an international audience.[22] Coproducer Stan Margulies corroborated this interpretation when, in an interview, he testified to the "natural competition" between the filmmakers whose various "ego problems" forced him and Wolper to act as referees throughout the sixteen-day shooting schedule.[23]

Los Angeles Times film critic Charles Champlin even went so far as to conclude his article on *Visions of Eight* with "a scorecard as well as a collective judgment," handing out "three golds, two silvers, two bronzes and one out-of-the-metal . . . with a special producers' trophy for an imaginative idea brought off in the face of monumental logistical problems."[24] Champlin's metaphorical scorecard is not unlike the mental notes taken by the majority of moviegoers—nonprofessional critics or "line judges" who, upon viewing an omnibus or anthology film, will often rate the success of specific episodes according to the logic and language of relationality and rank. Curiously, this reliance on sports metaphors in adducing the value of episode films manifests where one would least expect it. For instance, numerous reviewers of the omnibus feature *New York Stories* (1989) referred to it as "an all-star game" highlighting the talents of three American auteurs: Martin Scorsese, Francis Ford Coppola, and Woody Allen. David Ansen in particular put a pithy spin on this figure of speech, arguing that omnibus films such as *The Seven Deadly Sins* (*Les Sept péchés capitaux*, 1962) and *Aria* "rarely bat better than .333. That's great for a ballplayer but bad for a movie. *New York Stories* . . . hits a happy two out of three. The one strikeout—Coppola's contribution—is tucked in the middle, so you can't avoid it."[25]

Given the fact that the eight directors draw inspiration from a variety of sources and deploy different styles to suit their individual topics, it is not surprising that many critics bemoan what Gene D. Phillips describes as "the uneven quality" of *Visions of Eight*. Phillips, a biographer of John Schlesinger, is not alone among the film's semi-detractors in thinking that, "in retrospect, it would have been better to have had a single director shoot the entire film in order to provide some sense of stylistic and thematic continuity throughout."[26] What Phillips and his auteurist ilk overlook are the many consistencies and reverberations within the film, which celebrates rather than denounces cultural difference yet allows

similarities of intent to creep in (several directors, for instance, attempt to balance the theme of selfhood with that of togetherness). In fact, due to the immensity of its production, *Visions of Eight* practically demanded the cooperative as well as competitive involvement of the contributors, who (like Lelouch lending Ichikawa a hand) assisted one another when they themselves were not shooting.

And for all the talk of stylistic discrepancies, there are actually a number of sonic and visual flourishes that resurface throughout the film, lending the eight separate visions a unified appearance. This cohesiveness is due in no small part to the contributions made by film editor Edward Roberts and composer Henry Mancini. Although interwoven with bits of other music (Willheim Killmayer's "Rainbow Chorus," Claude Debussy's "Quartet in G Minor," Carl Orff's "Rota-Sommerkanon," and the afore-mentioned Beethoven), Mancini's jazzy yet melodic score is spread evenly throughout the film, its percussive rhythms the perfect accompaniment to the stop-start time signatures of the episodic narrative. Also, each segment begins with black-and-white snapshots, and this repeating visual element helps to structure the entire piece. Along with these still-frames, each director's national affiliation is displayed in parentheses below his or her name. This lexicographic imprint of the personal and the national onto the (potentially and, indeed, eventually) political backdrop effectively brackets the various countries as constituent characteristics of the filmmakers' personal visions and subtly connotes the "containability" of a nation (Germany) that not only was a temporary container of other nations but also was forced to contain the threat of terrorism.

A Vision of the Future

Although *Visions of Eight* was shown outside of competition at Cannes in 1973 and eventually won the award for Best Documentary Film at the Golden Globes in 1974, it has since been brushed aside in historical accounts of the Olympics in favor of better known films like *Olympia* and *Tokyo Olympiad*. That this multinational, multidirector sports documentary has received only a modicum of critical attention since its theatrical release indicates just how neglectful historians have been of anthology and omnibus films in general. And yet *Visions of Eight* in particular offers us a unique opportunity not only to expand the preexisting framework of

narrative and authorship studies but also to ruminate about the way in which its eight directors—like a team—"pass the baton" to one another in the course of cinematically capturing other teams and individuals.

Allen Guttmann, a preeminent American studies professor and Olympic historian, stands virtually alone when he calls it a "brilliant collective documentary."[27] Suggesting that the film's power resides in its ability to unite disparate elements into a single producer's package, Guttmann points out David L. Wolper's significance to the project as well as the latent political and ideological meanings inscribed in the word "collective," which has historically been mobilized to describe a consolidation of potentially revolutionary groups, goals, and ideas. However, there are considerable differences among the episodes, and this underlying dissimilarity creates textual as well as phenomenological ruptures that are not so easily surmounted by viewers who, for instance, might find Zetterling's implicit critique of masculine power and national industrialization progressive, yet feel that it is undercut by Pfleghar's regressive fixations on the female form.

In his liner notes accompanying the album release of Henry Mancini's eclectic score for *Visions of Eight*, magazine editor Harvey Siders describes how the music (written, we are reminded, to satisfy not one but eight directors) "breaks down language barriers; leaps over national boundaries; and shatters all diplomatic and political hurdles."[28] Much the same could be said of the film itself. *Visions of Eight* is that rare sports documentary that speaks a universal language yet structurally accommodates the ethnic, racial, cultural, and national diversity on which Olympic organizers pride themselves. Moreover, the film's episodic structure, consisting of several openings and closings, resonates with historian George G. Daniels's description of the Olympics as a "symbol of regeneration." Writing about the Munich Games in particular, Daniels states, "One spirit passed and was gone; four years later another rose in its place. On they came, the Games of resurrection, following one after another in an unbroken chain."[29] Each episode comprising an anthology or omnibus film forms part of a chain, each one signaling a regenerative break from the past. Set in the Bavarian capital, which had once been home to the Nazi Party and was located just eleven miles away from a World War II concentration camp, *Visions of Eight* as a whole may not signal a complete break from the past, but its discrete segments—brought together in the spirit of cooperation and goodwill—suggest that the importance of sports resides in their capacity to build a better future.

Notes

1. Gene D. Phillips, *John Schlesinger* (Boston: Twayne Publishers, 1981), 37.

2. Peter Bondanella, *Italian Cinema* (New York: Continuum Publishing Company, 1996), 159.

3. Having already claimed responsibility for an attack on Wasfi al-Tal, the prime minister of Jordan, Black September—an organization independent of Fatah that took its name from the autumn month in 1970 when at least four thousand *fedayeen* (fighters for the faith) were slaughtered by Jordanians—was nevertheless not as well known to the Western world as other Palestinian liberation movements at that time.

4. The remaining three terrorists were captured and imprisoned, only to be released from custody in late October 1972 when two gunmen claiming to be Black Septembrists hijacked a Lufthansa airplane and demanded that their comrades be returned to Libya as free men. The Bavarian authorities quickly capitulated to the skyjackers' demand, not only to put the bungled rescue attempt at Fürtenfeldbruck behind them, but also to prevent the "propaganda bonanza" that a public trial would inevitably entail. For an elaboration of the hostage situation in Munich and the German government's response, see George G. Daniels, *The XX Olympiad: Munich 1972, Innsbruck 1976*, Vol. 18 in The Olympic Century Series (Los Angeles: World Sport Research & Publications, 1996), 49–65, 106–7; and Simon Reeve, *One Day in September* (New York: Arcade Publishing, 2000).

5. Brundage's decision to suspend the competition for just one day angered many people who wanted the Games to be canceled.

6. The tragic events eventually became the subject of French journalist Serge Groussard's book *The Blood of Israel* (1975) as well as subsequent films: first, the ABC television movie *21 Hours at Munich* (1976); then the Oscar-winning documentary *One Day in September* (2000), an adaptation of Simon Reeve's same-titled book (see footnote 4). Unlike Reeve's book, the latter film only vaguely alludes to the motives of the terrorists, who demanded the release of more than two hundred Palestinian prisoners. Like the book, however, it not only memorializes the eleven slain members of the Israeli wrestling squad but also savagely dissects the failures of Germany's unarmed security guards (who bungled numerous attempts to capture the hijackers) and government authorities (who evinced an astonishing lack of competence and efficiency throughout negotiations). The events in Munich also influenced David Wolper's decision to make the ABC movie *Victory at Entebbe!* (1976), which deals with an Israeli commando force's rescuing of hostages in Uganda.

7. David L. Wolper, *Producer: A Memoir* (New York: Scribner, 2003), 194.

8. Although initially allowed to participate in Munich, the forty-six Rhodesians (only seven of whom were black) were expelled from the Games following an emergency vote by IOC officials that rescinded the original invitation.

For more information about the Rhodesian situation and the Organization of African Unity, which exerted pressure on the IOC, see Allen Guttmann, *The Games Must Go On: Avery Brundage and the Olympic Movement* (New York: Columbia University Press, 1984), 231–55.

9. For a long time rumors circulated that Sembène's piece was dropped for political reasons. The director, who was pro-Palestine, supposedly irked Wolper's sensibilities about the murders.

10. This profundity could also be partly attributed to the postproduction tinkering of editor Mel Stuart, who was brought onboard by Wolper after Ozerov's first cut had been deemed below par. The director approved of Stuart's recutting, saying that it accurately conveyed his intended vision.

11. Appropriately, "The Strongest," besides providing a glimpse of Zetterling's interest in man's peculiar fixations, finds her tapping into her own strengths as a satirist as well as a technical virtuoso attuned to the short-film format. Indeed, she was particularly well suited to the demands of short film-making and episodic narrativity, something to which she was introduced as an actress in 1948, when she starred in one of the four segments of the British omnibus production *Quartet*. Another literary drama, *Of Love and Lust* (*Giftas*; 1960), gave Zetterling an opportunity to flex her thespian muscles in "The Doll's House" ("Ett dockhem"), one of the two episodes comprising veteran Swedish director Anders Henrikson's adaptation of August Strindberg stories ("The Doll's House" was itself a parodic adaptation of Ibsen's play, which Zetterling had performed during her theatrical years). And after *Visions of Eight*, Zetterling returned once more to the omnibus form in the generically titled *Love* (1982), a six-episode film helmed by her and three other female directors.

12. The first quote is from Allen Guttmann, *The Erotic in Sports* (New York: Columbia University Press, 1996), 116. The definition of *Böllerschützen* comes from George G. Daniels, *The XX Olympiad: Munich 1972, Innsbruck 1976* (Los Angeles: World Sport Research & Publications, 1996), 5. Daniels paints a vivid picture of the Munich Games, describing such things as the "immense, 800,000-square-foot roof of suspended acrylic panels, undulating across the landscape" (which ended up "costing more than $120 million") and the expressions of local culture in the opening ceremony (which included "40 Bavarian shepherds . . . snapping bullwhips, followed by a cadre of lederhosen-clad *Schuhplattler*, or folk dancers").

13. Given Penn's penchant for character studies of youthful insolence and neuroses, it is somewhat surprising that he chose not to delve into the personal anguish of reigning Olympic champion and world-record holder Bob Seagren, who suffered a demoralizing loss to East German vaulter Wolfgang Nordwig after his lightweight "catapole" was deemed illegal and replaced by an older model. Daniels, *The XX Olympiad*, 31.

14. Given its compartmentalizing of the female form, Pfleghar's episode in *Visions of Eight* is not unlike his contribution to *The Oldest Profession*.

Titled "The Gay Nineties," that episode not only features Raquel Welch in various stages of undress but also renders her figure as fragmented images (an eye reflected in a compact mirror, close-ups of plunging necklines, zoom shots zeroing in on the actress's derriere, and so on).

15. The idea for this episode came from Shuntaro Tanikawa, then Japan's most celebrated poet, who earlier had collaborated with Ichikawa on several documentary shorts as well as on *Tokyo Olympiad*.

16. Mark Spitz, who is fleetingly shown in another episode of *Visions of Eight*, had to be whisked away from Olympic Village during the terrorist debacle because of fears that the Jewish athlete's life might be at risk.

17. The eighty-five-year-old Brundage, who had been in attendance at various Olympic Games since 1912, had only one week left in office when the Palestinians stormed the Israeli dormitory.

18. Coincidentally, *Games of the XXI Olympiad Montreal 1976*, another multidirector film (featuring Jean-Claude Labrecque, Georges Dufaux, Jean Baudin, and Marcel Carriere), was the product of that event; one that took a more straightforward approach to the subject and profited from the familiar faces of Nadia Comaneci and Bruce Jenner.

19. For a lengthier discussion of *Olympia*, see David Bordwell and Kristin Thompson, *Film Art: An Introduction*, 5th ed. (New York: McGraw-Hill, 1997), 132–39, 368–70.

20. Brian McFarlane, ed., *Sixty Voices: Celebrities Recall the Golden Age of British Cinema* (London: British Film Institute, 1992), 64.

21. Bob Strauss, "*Aria* helps Don Boyd satisfy creative urges," *Chicago Sun-Times*, July 3, 1988.

22. See, for instance, Nancy J. Brooker, *John Schlesinger: A Guide to References and Resources* (Boston: G. K. Hall & Co., 1978), 26.

23. Lee Margulies, "Filming the Olympic Games—A Producer's Nightmare," *Los Angeles Times*, September 17, 1972, 26.

24. Which directors deserve which "medals" Champlin does not say; but one can surmise—based on his dismissal of Pfleghar's "chauvinistic ogling of the nubile swimmers and other pretty ladies"—who the recipient of the "out-of-the-metal" is. Charles Champlin, "Olympics as an Art Form," *Los Angeles Times*, August 17, 1973. Early precedents for this type of critical maneuver can be found in Philip K. Scheuer's review of the Italian episode film *Times Gone By* (*Altri tempi*, 1952). Scheuer reveals the "50–50 results" of his scoring, saying "I jotted two 'fairs,' one 'good,' and one 'better.'" Philip K. Scheuer, "Omnibus Film Stories Good, Bad and So-So," *Los Angeles Times*, April 17, 1953. Ten years later, a reviewer writing for the *New Yorker* rates each of the three episodes comprising *Of Wayward Love*, "zero, zero, zero." *New Yorker*, April 4, 1964.

25. David Ansen, "Make Mine Manhattan," *Newsweek* (March 6, 1989): 58.

26. Phillips, *John Schlesinger*, 36.

27. Allen Guttmann, *The Olympics: A History of the Modern Games*, 2d ed. (Chicago: University of Illinois Press, 2002), 138.

28. *Visions of Eight*, RCA, 1973 (rereleased in 2000), liner notes by Harvey Siders reprinted at www.soundtrackfan.com/mancini/notes/visions8 .htm.

29. Daniels, *The XX Olympiad*, 67.

John Hughson

Why He Must Run

Class, Anger, and Resistance in
The Loneliness of the Long Distance Runner

"THE WAR BETWEEN THE classes has never been joined in British films as openly as it was this week. In the forties the working class were idiom-talking idiots, loyal or baleful. In the fifties they grew rightly articulate and angry. Now we get what may be the prototype for the sixties: Colin Smith, boy hero of *The Loneliness of the Long Distance Runner*, a youth beyond anger, almost beyond speech, joining battle"—so wrote the *Sunday Telegraph* film critic P. Williams (cited in Hill 213) in a review of Tony Richardson's film *The Loneliness of the Long Distance Runner* after its British cinema release in September 1962. The film, based on the 1959 novella by Alan Sillitoe (the screenplay for the film version was also written by Sillitoe), was produced by the independent film company Woodfall, started by Richardson and playwright John Osborne as an avenue for the making of films that afforded artistic control to directors. According to Richardson, "It is absolutely vital to get into British films the same sort of impact and sense of life that what you can loosely call the Angry Young Man cult has had in the theatre and literary worlds" (Hill 40).

This essay examines *The Loneliness of the Long Distance Runner*, a key film within the "angry young man" genre of British cinema in the early 1960s. Of particular interest is the film's portrayal of the tension between class background and individualistic temperament through sports in both metaphoric and real-life institutional contexts. The film challenges the idea of sports being used as a means of behavioral reform for working-class de-linquent youth, contrarily exposing the socially divisive potential of sports and their proneness to ideological manipulation by those in position of authority and power. The essay begins with a discussion of Sillitoe's work within the angry young man literary genre and moves on to consider the

emergence of the angry young man within film when the novels by Sillitoe and other writers were translated into screenplays. The essay then goes on to discuss the rather unique location of sports within *The Loneliness of the Long Distance Runner* and attempts to tease out the implications of the treatment and depiction of sports for relevant discussion by sports and film historians and cultural historians more generally.

Looking Back at "Angry Young Men"

The term *angry young man* was originally applied to John Osborne by the English Stage Company publicist George Fearon, following the 1956 stage release of *Look Back in Anger* (Rebellato 116). Fearon associated playwright Osborne with the play's protagonist, Jimmy Porter, an articulate yet highly disgruntled young man who, in a series of vituperative tirades delivered within his own living room, relentlessly lambastes what he perceives as social hypocrisy. Later the term was used to identify a number of young male writers whose works feature opinionated and sometimes belligerent lead characters. Most of the characters have working-class backgrounds and invariably are dissatisfied with their lot in life. Some, particularly Joe Lampton in John Braine's *Room at the Top*, are socially ambitious and seek upward mobility on the British class ladder. Others tend toward hyper-frustration and, despite possessing facility for sharp criticism, are unable to transcend their working-class milieu. Such is the case with the characters in Alan Sillitoe's two best-known works—Arthur Seaton in *Saturday Night and Sunday Morning* and Colin Smith in *The Loneliness of the Long Distance Runner*.

Although dissatisfied and restless, neither Arthur Seaton nor Colin Smith can shake his class moorings. Indeed, both exhibit class fixity in the tension between a sense of belonging—a begrudging class loyalty—and a feeling of suffocation. Their escape from the working class is not up the class ladder but on an imagined or realized trip to the country or seaside. In the film version of *The Loneliness of the Long Distance Runner* Colin Smith visits the east England coastal town Skegness with his best friend and their new girlfriends. The temporary escape by first-class rail is funded by Colin's share of a small inheritance following his father's death from a work-related chronic illness. The return by third-class passage, once the money has dwindled, is a stark reminder to Colin of the inferior status of his working-class existence.

Unlike Kingsley Amis and other well-known writers of his generation, Alan Sillitoe is working-class born and bred, and although his success as a writer provided escape from that background, a working-class consciousness and memory pervades his writing. According to Maloff, "Sillitoe is obsessively concerned with a single idea, the discovery of self through the discovery of class solidarity" (Maloff 97). With regard to imagery, the gray working-class suburbs of Sillitoe's native Nottingham provide an evocative backdrop to a number of his books and essays, including *Saturday Night, Sunday Morning* and *The Loneliness of the Long Distance Runner*. Biographer Stanley Atherton suggests that Sillitoe's novels give a kind of auto-ethnographic insight into the hardships of working-class life with which Sillitoe was all too familiar. Sillitoe left school in his early teens and worked in an engineering plant in the same type of machinist job as that performed by Arthur Seaton in *Saturday Night, Sunday Morning* (Atherton 111). Humphrey Carpenter contends that the "brutality" of Seaton makes contemporaneous protagonists such as Joe Lampton (in John Braine's *Room at the Top*) and Jim Dixon (in Kingsley Amis's *Lucky Jim*) "seem prim and timid by comparison" (Carpenter 203). Colin Smith is not as brutal a character as Seaton, but like Seaton he displays a seething and ingrained bitterness that prohibits the possibility of upward mobility.

Angry young man is at best a term loosely applied to novelists of a particular time and mood. Cultural historian Robert Hewison believes the term to be a myth, but even if we dismiss the idea of a school or genre of angry young man works, the term remains useful to the discussion of works that seem to aspire to this mythical canon (Hewison 130). In *Representations of Working-Class Life, 1957–1964*, Stuart Laing suggests that Sillitoe's characters sit at the end of a continuum of angry young men. This is not just because of the sheer angriness expressed by Seaton and Smith but also because the characters' anger and resentment is targeted at postwar cultural change in Britain, particularly the conspicuous consumption that emerged in tandem with the arrival of the "affluent society"—a term coined by economist J. K. Galbraith—of the 1950s. The film versions of the novels, particularly *The Loneliness of the Long Distance Runner*, extend this dimension of cultural criticism. In an especially poignant scene Colin Smith burns a bank note from his father's compensation money. This scene follows one in which Colin's mother takes the recently acquired payout and goes on a shopping spree for new household items. While the rest of the family members sit gleefully in front of the new television, Colin sulks

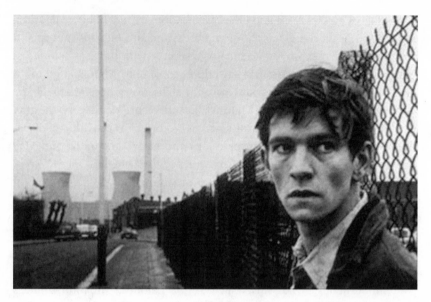

Colin, the angry young man. Courtesy of the Cannes Film Festival.

back to his bedroom, mumbling that he wants no part in this frittering of the tragic inheritance, an amount he believes to be a pittance given his father's years of service to an injurious occupation.

The New Wave: The Angry Young Man on Film

The representation of conspicuous consumption in the film version of *The Loneliness of the Long Distance Runner* expands the level of social criticism beyond that in the novella, in which the reader is restricted to an engagement with Colin's internal monologue. In the film, Colin interacts with a range of characters, from his best friend to the governor of the "borstal" (a British juvenile detention center). The viewer gets a view of Colin's social world from his perspective and is also able to see this world through a sociological lens, through which it is possible to place Colin's life within a broader social canvas of the period. Along with other films based on the Angry Young Man literature, *The Loneliness of the Long Distance Runner* is often placed in the category or genre of *social realism*. Although the writers of the time never formed a dedicated movement, a number of cinematographers of social realist disposition—principally Tony

Richardson, Lindsay Anderson, and Karel Reisz—joined together in an aesthetic group known as Free Cinema (Richards 148).

The Free Cinema directors adopted a naturalistic and unscripted approach to filmmaking, taking their cameras out to the streets to capture the feeling of what was going on in neighborhood life. Free Cinema also involved a geographical shift from the main London-based studios to regional working-class locations familiar to directors such as the Yorkshire-born Richardson. While the Free Cinema group's connection to social realism was through the writers on whose works their films were based, they also were aligned with British painters of their generation known as the "Kitchen Sink School" (this term is often used interchangeably with *angry young men* [Marwick 55]). There was something of the social reportage tradition about the Free Cinema projects. The factory shots in *Saturday Night and Sunday Morning* and the workshop shots in *The Loneliness of the Long Distance Runner* suggest a historical connection to George Orwell's depiction in *The Road to Wigan Pier* of exploited labor in the north of England in the 1930s. The Free Cinema ethos also bears relation to contemporaneous academic writing on culture. With the publication of *The Uses of Literacy*, Richard Hoggart brought a critical view to the cultural pursuits of the British working class in the postwar period. Hoggart's contention was that the "candy-floss" culture associated with new media and style copied from American youth threatened the rich yet "concrete" tradition of working-class cultural life in Britain. A similar statement can be found in Free Cinema films, particularly *The Loneliness of the Long Distance Runner*.

The Free Cinema continued the social realism captured in the 1930s John Grierson documentaries on working-class life in Great Britain (Hill 69). Grierson was concerned with film being used as a realistic means of showing what was going on in the world from the position and perspective of people in their everyday lives, working lives in particular. He was committed to representing, as realistically as possible, the routine aspects of working-class life, warts and all. Grierson also recognized that documentary making is a creative process, defining documentary as "the creative treatment of actuality." In a sense the Free Cinema directors operated with inverted ambition. They imposed a representation of social actuality onto their fictional accounts of working-class life. They shared with Grierson a democratic desire to give voice to the majority

of people, those who had historically been written out of British culture. Both Richardson and Lindsay Anderson (director of *This Sporting Life*) were explicit advocates of the democratic possibilities of film. According to Anderson, the mainstream tradition of British films excluded "three quarters of the population." This he regarded as a "ridiculous impoverishment of cinema" and a "flight from contemporary reality" (quoted in Hill 127–28). Anderson called for films reflecting the everyday activities of ordinary people and a cinema that was relevant to the life experiences of all people. Sounding rather like Grierson, he claimed a shift in filmic tradition to be "an essential part of the creative life of the community." Similarly, Tony Richardson believed that "films should be an immensely dynamic and potent force within society" (quoted in Hill 128).

However, the aesthetic preoccupation of the Free Cinema directors distanced them from the social documentary tradition. Anderson clarified the difference by redefining the achievement of the Free Cinema as "poetic realism." According to Anderson, "The best realist art should not remain at the level of mere reportage but should transform its material into 'poetry'" (quoted in Hill 128). The style of the poetic transformation was derived from French art-house filmmaking. French "new wave" techniques such as speeding up the film, jumbling the chronology of events, and using contemporary jazz music were incorporated into Free Cinema films, especially in *The Loneliness of the Long Distance Runner*. The chronological sequence is broken down by Colin's flashbacks while he is in training for the cross-country run. The flashbacks allow views of Colin's life before he was sent to borstal for stealing money from a bakery. The viewer gets a good glimpse of Colin's home life and the resentment that he builds up following the death of his father. The speed-up film technique is cleverly deployed on a couple of occasions to show Colin's frivolous attitude toward his thievery and to satirize Colin's mother's spending spree with the compensation money.

The effectiveness of these techniques owes as much to the camerawork of Walter Lassally as to the directorial abilities of Tony Richardson. Lassally, who worked as chief cameraman on a number of Free Cinema productions, was largely responsible for what could be regarded as the "British wave"—that is, British social realism stylized through a French lens. Some critics were disconcerted by this cinematic development. For example, a *New Statesman* commentator declared of *The Loneliness of the Long Distance Runner*, "You can almost hear the clashing of the

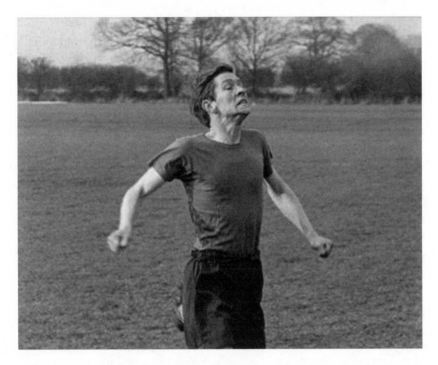

Colin in training. Courtesy of the Cannes Film Festival.

new waves, English and French" (quoted in Laing 129). However, Free Cinema films, including *The Loneliness of the Long Distance Runner*, did not attempt to reconcile the respective traditions from which they drew. The tension embedded in the films adds to their appeal and provides the important poetic ingredient. According to Lassally, the "remarkable thing" about the new wave was not its "strictly realistic view," nor its treatment of "working-class problems," but its "very poetic view of them" (cited in Hill 129)—a view afforded them by innovative filmic technique.

Individualism, Collectivism, and the Sports Trope

Another thematic tension in Free Cinema, arising from association with the angry young man literature, is between individualism and collectivism. This tension is lived out by the central protagonists and is most keenly witnessed on screen in Sillitoe's antiheroes, especially Colin Smith in *The Loneliness of the Long Distance Runner*. Smith undoubtedly is a loner, but

he is a loner with a strong attachment to his working-class background, which is marked in pedigree by his father's reputation as a trade union activist. Colin's individualist spirit and his resulting actions at the borstal are incongruous with the collectivist ideals he constantly and vituperatively espouses. While Colin shows no indication of following his father's example of militant engagement, he is prone to launching into quasi-Marxist tirades, evoking catch-cries such as "united we stand, divided we fall," seemingly an indication of paternal inspiration and fraternity with his class cohorts. Atherton sees Sillitoe's protagonists as placed within a British literary tradition of "working-class heroes" (Atherton 159). For Atherton, these heroes (or antiheroes, which is a more appropriate label in the cases of Seaton and Smith) display two basic attitudes emanating from their working-class habitus—"a strong sense of class solidarity" and "a hostility towards those who are thought to treat the working man unjustly." In *The Loneliness of the Long Distance Runner* Colin constantly grizzles against the exploitation of workers by bosses, and he associates all forms of authority with exploitive power relationships. His grievances against the police officer who eventually arrests him and the governor of the borstal in which he finds himself incarcerated are expressed on this basis. In the novella Colin describes both of these figures as "in-law blokes," upholders of the system, who maintain vigilance against "out-law blokes," the rule breakers such as Colin and his kind (Sillitoe, *Loneliness of the Long Distance Runner* 10). Again, though, Colin's highly individualistic spirit militates against his ability to form the fraternal bonds that might facilitate the type of collective engagement that he rhetorically advocates. Colin's fight against systemic injustice is conducted alone and is ultimately doomed to represent little more than an annoying nose tweak of the officials to whom he is institutionally answerable. Sports provide the grounds on which Colin is able to register his symbolic protest.

In his critical biography of the author, Stanley Atherton remarks on the lack of attention to organized sports in Sillitoe's novels (Atherton 105). Atherton suggests that, given the undeniable centrality of sports to British working-class cultural life—a centrality recognized by such politically diverse cultural commentators as T. S. Eliot and Raymond Williams (see Hughson, Inglis, and Free)—it would seem appropriate for Sillitoe to have given sports more prominence in the lives of his characters. The best-known novel of the period to incorporate sports into the story line, and of similar Angry Young Man temperament, is David Storey's *This Sporting Life. This*

Sporting Life focuses on rugby league player Arthur Machin and his difficulty with coming to terms with success in professional sports and with the requirement of submitting to the hypocritical dictates of a wealthy club owner. Storey converted the novel into a screenplay, which was successfully adapted to the screen by Lindsay Anderson in 1963. Anderson maintained, "*This Sporting Life* is not a film about sport . . . but a film about a man of extraordinary power and aggressiveness" (cited in Hill 216). Be this as it may, it would be trite to dismiss the cultural significance of sports to the film, given David Storey's own background as a rugby player.

In contrast to Storey, Sillitoe has no background in sports, and in fact, in an essay written at the time of the 1972 Olympic Games, he declared an open hostility to organized sport:

> I have never practised any kind of sport. It has always seemed to me that sport only serves to enslave the mind and to enslave the body. It is the main "civilising" weapon of the western world ethos, a way of enforcing collective discipline, which no self respecting savage like myself could ever take to. Society was built on "competition," and "sport" is a preliminary to this society and an accompaniment to it. It is a sort of training ground for entering into the war of life. The Olympic torch is a flame of enslavement—run from it as fast as you can, and that in itself will give you plenty of exercise. ("Sport and Nationalism" 84)

Sillitoe thus continues a criticism of sports that resides within English cultural commentary. Best known is George Orwell's 1945 essay *The Sporting Spirit*, which scathingly attacks the link between sports and nationalism as it was taking shape at the dawn of the Cold War era. In his essay, Sillitoe is particularly critical of International Olympic Committee president Avery Brundage for allowing the 1972 Munich Games to continue after the killing of Israeli athletes by Palestinian terrorists. Sillitoe believed that Brundage's decision was indicative of the emptiness of the Olympic ideal in modern times. He viewed the continuation of the Games as little more than kowtowing to corporate interests that would have lost money had the Games been abandoned. The fallacy of sports nationalism emerges in the film version of *The Loneliness of the Long Distance Runner* when the governor suggests to Colin that he might set his sights on becoming an Olympic athlete for Great Britain. The antisports message of *The Loneliness of the Long Distance Runner* is most apparent in Colin's ultimate

rejection of the appeal of national representation through sports. The athletically gifted Colin Smith comes to personify Sillitoe's own antisports ethos in the filmic context.

Sillitoe's quasi-Marxist position on class relations also disallows him from a positive reading of sports within British working-class culture. In this way he is at odds with cultural commentators of working-class origin such as Richard Hoggart, who viewed sports clubs and associations as means of bolstering waning working community bonds, especially amongst youth (Hoggart 268–69). For Sillitoe, sports tend to have a divisive affect on class relations, particular with regard to fan involvement with professional sports. He loathed what he saw as the fatuous separation of working-class people into support of rival soccer teams and the subsequent creation of deeply embedded and long-held hostilities along sports axes. For Sillitoe, this type of misplaced cultural affiliation does little more than distract members of the working class from uniting against the exploitative nature of the capitalist system. Sports are thus to be resisted in all of their institutional and organizational manifestations, from weekend park competitions to sports within school curricula.

The Rebellion of the Long Distance Runner

The institutional location of sports within *The Loneliness of the Long Distance Runner* is particularly interesting, and the rejection of it is especially poignant. Sports in the borstal are used ostensibly as the prime means of reforming wayward working-class young men to accept appropriate societal goals and to pursue these goals through conventional and acceptable means, principally hard work. However, as is clearly obvious in the film, sports, in the form of the annual cross-country race against the elite public school, are of interest to the borstal governor mostly as a means of pursuing his own glory. This is a particularly insidious situation in which sports, rather than having a genuine reformist purpose, are deployed as a means of social control over the young inmates and as a means of self-aggrandizement by their chief superintendent.

Colin's rebellion against this institutional manipulation of sports in the borstal is his heroic achievement. In the novella Colin, in an internal monologue, complains of the disciplinary function served by athletics within the borstal. Furthermore, showing insight into the reforming uses of sports promulgated by often well-meaning social officials, Colin ridicules

as authoritarian the use of sports as a means of diverting delinquent youth from criminal activity (Sillitoe, *Loneliness of the Long Distance Runner* 8, 10). In the film we are able to see early on Colin's intention to undermine the authority relations in the borstal, and because of the prominence of sports in the institution and Colin's own sporting prowess, sports becomes the means through which Colin can directly challenge the governor. Shortly after Colin's incarceration, Colin intercepts the ball, eludes defenders, and scores a goal during a training soccer match, causing the governor to recognize his sports potential. More impressively, Colin goes on to outrun the borstal's leading athlete, Stacey, in a cross-country trial. Colin soon surpasses Stacey as the great hope for the annual race against the visiting lads from the public school. Having caught the governor's eye, Colin receives special privileges, and after showing compliance if not deference, he is allowed to leave the borstal confines to undertake unsupervised training runs on the cross-country course. It is during these runs that—in the film—Colin experiences flashbacks to his life before the borstal.

Colin's ascendant status within the borstal is mirrored by Stacey's equally rapid demise from leading athlete and house-captain to recalcitrant and deviant exemplar. Replaced by Colin as the governor's "blue eyed boy," purely on the grounds of his sports ability, Stacey lapses into delinquent behavior, physically attacking Colin and eventually escaping from the borstal. From this point on, Stacey's appearance in the film is reduced to a flashed scene during a musical interlude, in which he is shown being beaten by a warden upon recapture. Subsequently, the governor refers to Stacey in an address to the young inmates, warning them how not to behave. The sports metaphor is resplendent. Stacey has gone from "playing the game" to total rejection and defiance of it. Colin, on the other hand, appears to have completely accepted the game and made the most of the opportunity offered to him by the governor. Colin's rebellious intention is made obvious enough throughout the film; he tells the other boys that he is merely going along with the governor's plan until it suits him. However, the boys' doubts about Colin's true intentions are brought to a head when his old friend from the streets of Nottingham, Mike, is also sent to borstal. When the boys around the lunch table tell Mike of Colin's athletic success and his special status afforded by the governor, Mike questions, "Whose side are you on?"

A viewer watching the film without having first read the book might well ask the same question, as Colin's tough talk is not confirmed in ac-

tion until the penultimate scene, when the annual cross-country race takes place. Ahead in the race by some distance, on approaching the finish line Colin pulls up short and watches with hands on knees as the leading runner from the public school catches up. As the runner passes, Colin waves him through to the finish line in mock politeness. Despite his rhetoric of class solidarity, Colin is no team player in life or sports; his losing the race is a highly individual gesture despite its intended symbolism of collective action. Such is the contradictory nature of the angry young man. Running, a metaphor with "multiples levels of significance," illuminates this complexity (Denny 7–8). Colin's running allows him personal solitude and communion with nature in isolation from his age and class cohorts, and it eventually affords him the chance to register a symbolic protest on their behalf. Before the denouement, Colin the individualist cannot trust his fellow inmates. He is thus caught in a bind: he is on the side of the other borstal lads, even though this can never be expressed or consummated in personal terms. Nevertheless, his "private pronouncements" can be read as "collective desires" (Hitchcock 102). Ultimately, Colin must be regarded as a rebel within the institutional context. By throwing the cross-country race, he not only refuses to play the game, he completely subverts it. More broadly, according to Karl, for Colin to win the race would be "tantamount to playing society's game . . . in losing the battle, he wins the war" (Karl 281–82).

Colin Smith: Rebel with a Cause?

In the final scene of the film Colin is punished with the menial task of assembling gas masks. By turning his back on the opportunity for a successful athletic career, which the cross-country race might have initiated, Colin accepts the self-fulfilling prophecy that had no doubt been made for him over the years by the authority figures in his life that he so reviles. The outcome of Colin's action is "reproduction," a term discussed by Paul Willis in *Learning to Labour: How Working Class Kids Get Working Class Jobs*. Willis says that relationships with institutional authorities—pertaining to secondary school in his study—have the unintended consequence of reproducing the social conditions they are supposed to overcome (Willis 178). Willis conducted an ethnographic study in the England west midlands industrial town of Wolverhampton, in which he tracked the lives of a group of young men he referred to as the "lads," from their final years

The race. Courtesy of the Cannes Film Festival.

at school to their immediate post-school working lives. The lads were the school tough guys, and Willis was interested in how they established an informal oppositional culture within the school aimed at rebelling against social conformity and targeted against both teachers and compliant students. Although they succeeded in creating their own subculture within the school, with a set of tacit norms to which they subscribed, the lads ended up with poor educational results that destined them to futures in unskilled jobs such as those in which their fathers were employed.

The borstal is a less benign institution than the secondary school, and such institutions in the Britain of the 1950s would have been less genuinely reform orientated than the youth remand institutions of current times. The severity of authority in the borstal in *The Loneliness of the Long Distance Runner* coerced the young inmates into accepting the disciplinary regime, and there was no evidence of an oppositional subculture, although on one occasion a mass revolt broke out in the dining hall when the inmates voiced dissatisfaction with the appalling borstal meals. However, such disruption was highly sporadic, and this was apparent enough to the perceptive Colin,

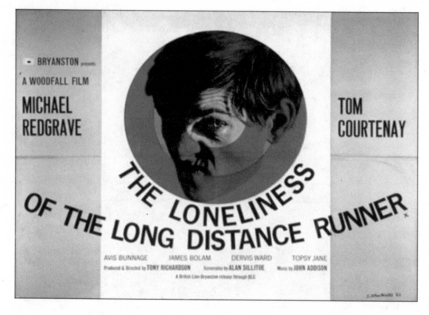

Film poster for *The Loneliness of the Long Distance Runner.* Courtesy of Oklahoma State University Special Collections.

who decided that any more significant and eventful act of rebellion had to be planned secretly and conducted single-handedly. Colin's deception in appearing to embrace his role as an athlete at the borstal before revealing his rebellion in the most telling manner possible ensured not only his immediate punishment but also his likely condemnation to a life of working-class drudgery and, perhaps, further episodes of incarceration.

Colin's plight is saddening, but this should not detract from the significance of his protest. Willis identified the lads' actions within the school as resistance, and we should do the same for Colin's more individual expression of anti-institutionalism. As the cultural geographer John Bale argues, "By transgressing the norms of achievement sport and (literally) stepping outside of the sport's space, this [Colin deliberately losing the race] can be read as a form of resistance against the repression of 'the system' of both sport and society" (Bale 169). When we consider the increasing metaphorical use of sports as an index of possibility for success in various social quarters, Colin's protest does take on a particular poignancy and relevance in the contemporary context. Colin's story in *The Loneliness of the Long Distance Runner* continues to offer a fascinating literary and

filmic caveat to the promotion of sports as an overwhelmingly positive socialization agent—and thus a counter to such continuing representations of sports within popular discourse. The film thus has continuing relevance to academics working with a critical sociology stance on sports.

For some American film critics who were writing at the time of the film's release—it was released in the United States under the title *Rebel with a Cause*—*The Loneliness of the Long Distance Runner* was too overt in its pro-proletariat pleading (Zucker and Babich 289; Landy 71). However, such criticism appears narrowly conservative and overly wary of a British brand of Marxism creeping into American culture via the cinema. To dismiss the film on these political grounds ignores the dimensions of contemporary social critique that were contained in *The Loneliness of the Long Distance Runner* through the linkage of the themes of class, sports, institutionalization, masculinity, and youth angst. *The Loneliness of the Long Distance Runner* was a pioneering film that raised questions in a rather unsettling yet necessary manner. Nationalism—more precisely, antinationalism—intersected with each of the themes mentioned above. Sillitoe was trenchantly opposed to nationalism and patriotic fervor, and this critical sentiment is captured evocatively in the film version of *The Loneliness of the Long Distance Runner*, particularly through the aural juxtaposition of that most English of hymns, "Jerusalem" (William Blake's "Preface to Milton" set to music by Hubert Parry), with scenes of brutality, subservience, and hard labor within the borstal (Bowden 73). Colin's retreat from victory in the cross-country race is an ultimate rejection of the patriotic myth attached to "Jerusalem." To win the blue ribbon would have been to endorse the ideology of patriotism that it represented within the official culture of the borstal. Colin had no desire to represent England or the society that he believed had betrayed and imprisoned him (Guttmann 155).

Sports historian Allen Guttmann has claimed that *The Loneliness of the Long Distance Runner* is a "fine novel and a magnificent film" (256). The film introduces more characters than the novella and contains a number of scenes from Colin's life before he entered borstal, shown via flashbacks while he is training on long-distance runs. The inclusion of other characters also gives hearing to other voices, as well as the first person narrative of Colin that comes from the novel. Impressively, the film maintains a level of suspense that is not aroused in the novel. In the novel it is fairly clear early on that Colin intends to throw the cross-country race and upset the

borstal governor's plans. However, in the film, although the impression is given that an upset is brewing, it is not clear until the finale what course of action Colin will take. It is difficult for anyone with a modicum of sporting instinct to watch Colin pull up short of the finish line and allow the public school champion to run past him to claim a hollow victory. While not all that surprising, Colin's "surrender" evokes a discomfiting mixture of condolence and disappointment.

Films can be regarded as historical documents pertaining to sports in two ways: First, they can raise issues within their own time that reflect on the cultural status of sports within society. Second, they can attempt a fictionalized account of a particular episode in the history of sports. *The Loneliness of the Long Distance Runner* fits into the first of these categories. While set in an English borstal of the 1950s, the film has implications for other settings in which sports are used in an institutionally pervasive way. Indeed, when the posh lads from the local public school join the borstal lads in competition, the movie takes an explicit swipe at the English public school system. A comedic exchange between the two groups of lads in the dressing room before the cross-country race suggests that their respective institutions might not be all that different—variance in accents notwithstanding.

Although it reflects its time, *The Loneliness of the Long Distance Runner* is not a dated film. It holds a position of prominence within an interesting genre of British films that were made at what is arguably the high point in British filmmaking. The British Film Institute recognized the film's importance by releasing it on DVD in 2003, so any grainy and disintegrating video copies can be dispensed with and viewers can experience renewed enjoyment of Walter Lassally's "poetry in motion" camerawork. The new DVD package includes a commentary by film historian Robert Murphy and a video essay by Lassally, both of which are highly informative and useful for teaching purposes. The high quality of acting in the film is still apparent today. *The Loneliness of the Long Distance Runner* was Tom Courtenay's major film debut, representing the emergence of one of Britain's leading actors of a generation. Courtenay gives an unsettling air of intelligent menace to Colin, arousing both sympathy and scorn in the viewer. He is entirely successful in providing the "organizing consciousness" of the film, a key function of the central character in Free Cinema productions (Higson 150). The tension between the collective ideal and the individual

temperament smolders within Courtenay's angry young Smith, and sports as both metaphor and institutional province are expressed and enacted in this tension. *The Loneliness of the Long Distance Runner* deserves and has received a wide audience, as is exemplified by the fact that a number of non-English scholars have written about the film (and the novella) over the years. The release of the film on DVD should heighten interest within sports, film, and cultural history and the general viewing public.

Work Cited

Atherton, S. S. *Alan Sillitoe: A Critical Assessment*. London: W. H. Allen, 1979.

Bale, J. *Sports Geography*, 2nd ed. London: Routledge, 2003.

Bowden, M. J. "Jerusalem, Dover Beach, and Kings Cross: Imagined Places and Metaphors of the British Class Struggle in *Chariots of Fire* and *The Loneliness of the Long-Distance Runner*." In *Place, Power, Situation, and Spectacle: A Geography of Film*, edited by Stuart C. Aitken and Leo E. Zonn. Lanham, MD: Rowman and Littlefield, 1994.

Carpenter, H. *The Angry Young Men: A Literary Comedy of the 1950s*. London: Penguin, 2002.

Denny, N. "The Achievement of the Long-distance Runner." *Theoria*, 24 (1965): 1–12.

Guttmann, A. *From Ritual to Record: The Nature of Modern Sports*. New York: Columbia University Press, 1978.

Hewison, R. *In Anger: Culture in the Cold War 1945–60*. London: Weidenfeld and Nicolson, 1981.

Higson, A. "Space, Place, Spectacle: Landscape and Townscape in the 'Kitchen Sink' Film." In *Dissolving Views: Key Writings on British Cinema*, edited by Andrew Higson. London: Cassell, 1996.

Hill, J. *Sex, Class and Realism: British Cinema 1956–1963*. London: British Film Institute, 1986.

Hitchcock, P. *Working Class Fiction in Theory and Practice: A Reading of Alan Sillitoe*. Ann Arbor, MI: UMI Research Press, 1989.

Hoggart, R. *The Uses of Literacy: Aspects of Working Class Life with Special Reference to Publications and Entertainments*. London: Chatto and Windus, 1957.

Hughson, J., D. Inglis, and M. Free. *The Uses of Sport: A Critical Study*. Oxford: Routledge, 2005.

Karl, F. R. *A Reader's Guide to the Contemporary English Novel*. New York: Octagon Books, 1975.

Laing, S. *Representations of Working-class Life 1957–1964*. London: Macmillan, 1986.

Landy, M. "The Other Side of Paradise: British Cinema From an American

Perspective." In *British Cinema: Past and Present*, edited by Justine Ashby and Andrew Higson. London: Routledge, 2000.

Maloff, S. "The Eccentricity of Alan Sillitoe." In *Contemporary British Novelists*, edited by Charles Schapiro. Carbondale, IL: Southern Illinois University Press, 1965.

Marwick, A. *The Sixties: Cultural Revolution in Britain, France, Italy, and the United States, c.1958–c.1974*. Oxford: Oxford University Press, 1998.

Orwell, G. "The Sporting Spirit." In *The Collected Essays, Journalism and Letters of George Orwell, vol. IV: In Front of Your Nose (1945–50)*, edited by S. Orwell and I. Angus. London: Secker and Warburg, 1968 [1945].

Rebellato, D. *1956 and All That: The Making of Modern British Drama*. London: Routledge, 1999.

Richards, J. *Films and British National Identity: From Dickens to Dad's Army*. Manchester, England: Manchester University Press, 1997.

Sillitoe, A. *The Loneliness of the Long Distance Runner*. London: W. H. Allen, 1959.

———. "Sport and Nationalism." In *Mountains and Caverns*, selected essays by Alan Sillitoe. London: W. H. Allen, 1975.

Willis, P. E. *Learning to Labour: How Working Class Kids Get Working Class Jobs*. Farnborough, Hants: Saxon House, 1977.

Zucker, H. M., and L. J. Babich. *Sports Films: A Complete Reference*. Jefferson, NC: McFarland, 1987.

TOBIAS HOCHSCHERF AND CHRISTOPH LAUCHT

"Every Nation Needs a Legend"

The Miracle of Bern *and the Formation of a German Postwar Foundational Myth*

A STRONG DISPARITY EXISTS between soccer as the world's most popular sport and the comparative lack of interest it has traditionally enjoyed in the United States, the world's biggest sports market.[1] As historian Bill Murray points out, the unparalleled expansion of soccer, or "football" as it is called outside the United States, has made the game "the ruling passion in virtually all of Europe and Latin America, as well as most of Asia and all of Africa, [with] only the English-speaking nations outside Great Britain [remaining] unconquered."[2] In Germany alone, the Deutscher Fußball Bund (DFB), the national soccer association, has about 6.27 million members, making it the world's largest sports association.

Apart from the worldwide television coverage of major international tournaments such as the Fédération Internationale de Football Association (FIFA) World Cup and the Union of European Football Associations (UEFA) Champions League, with their global advertising campaigns and merchandise, the influence of soccer has by far exceeded the realm of sports.[3] As historian Ramanchandra Guha puts it, sports in general should rather be seen as "an illustrative example to point out themes of a wider interest and relevance . . . as a *relational idiom*, a sphere of activity which expresses in concentrated form the values, prejudices, divisions and unifying symbols of a society."[4] Given this popularity, it does not come as a surprise that soccer in general and German soccer in particular have recently been key issues in cultural discourses.[5]

Germany, which hosted the 2006 World Cup, has not remained untouched by this growing interest in soccer. More than a decade after the fall of the Berlin Wall and the ensuing unification of East and West Germany, Sönke Wortmann's 9.4 million dollar epic, *The Miracle of Bern*

(2003) reconstructs what is perhaps the most outstanding achievement of postwar German soccer: the victory of the West German team in the 1954 World Cup against the favored Hungarian team. The film uses a variety of Hollywood's emotionally driven entertainment formulas and personalized histories to represent the German postwar foundational myth emphasized in the tag line from the film's poster, "Every nation needs a legend." In so doing, the movie by director Wortmann bears striking similarities to popular American treatments of history in films such as *Pearl Harbor* (Michael Bay, 2001), *Alamo* (John Lee Hancock, 2004), and films by Ron Howard such as *Far and Away* (1992) and *Cinderella Man* (2005).

This essay maintains that the filmic representation of the events leading to the soccer victory at Bern, which have long since become part of German popular memory, offers valuable insights into both post-unification German self-perception and the manner in which the country would like to be seen abroad. Based on the underlying premise that sports are always inseparably intertwined with their sociocultural and historical contexts, the essay is structured in four main sections. The first part delineates the West German quest for "normalization" of the state's foreign relations and the movie's selective portrayal of history. The second section discusses how the film deals with Germans' coming to terms with their Nazi past. The third section analyzes the 2003 movie's construction of soccer's unifying power. Finally, the last section focuses on the representation in the movie of the relationship between the economic boom of the 1950s and the victory of Bern.

"Normalization" through Soccer? West Germany's Quest for Acceptance

Set in the turbulent postwar decade of reconstruction and restoration, Wortmann's epic reflects an increasing interest in the origins of the post-wall Federal Republic of Germany (FRG). By capturing the zeitgeist of an era that was characterized by the hope of a quick economic recovery, the movie presents the post-unification audiences of the so-called Berlin Republic (named after the relocation of the German capital) with a foundational myth of the early "Bonn Republic" (Bonn being the capital of the FRG from 1949 until 1990). Today, Germans tend to see the 1950s as the beginning of a success story that turned a devastated pariah nation into a prospering, unified, and well-respected international partner.[6] Particularly

since German unification, writers have constructed a more differentiated picture of the era.[7] *The Miracle of Bern* condenses these complexities into a simple, highly romanticized and nostalgic view of the past.

Thus, the movie epitomizes in many ways the move from a politically engaged auteur cinema à la Rainer Werner Fassbinder to Hollywood-like genre entertainment. This seismic shift toward an Americanized entertainment industry, which can be seen in all strands of German culture, is associated with a general trend toward regarding post-wall Germans as a rehabilitated people. Rather than drawing upon the nation's Nazi past or its national division, artists and numerous other public voices have called for "normalization," a catchphrase that coincided with the widespread depoliticization of popular culture.[8] As Sabine Hake argues, German national cinema of the 1990s followed this general development toward a "new *Erlebniskultur* (culture of diversion) that, in embracing commercialism with a vengeance, tried to move beyond the legacies of the 1960s and 1970s, including the credos of political radicalism and radical subjectivity."[9] Notwithstanding criticism by those who have favored German auteur cinema and socially critical films, lighthearted movies helped to increase the market share of German productions on the domestic market from about 5–8 percent during the 1980s to about 10–18 percent around the year 2000.[10]

On the worldwide market, the production company X-Filme Creative Pool played a crucial part in the internationalization of German films. Founded by directors Tom Tykwer, Dani Levy, and Wolfgang Becker in 1994, the company enjoyed overwhelming box office successes with *Run Lola Run* (Tom Tykwer, 1998) and *Good Bye Lenin!* (Wolfgang Becker, 2003), helping to promote German films at home and abroad and paving the way for future large-scale productions. At the core of German producers' marketing strategies, and also favored by the makers of *The Miracle of Bern*, lies the combination of "authentically" German stories and common American blockbuster formulas.

Accordingly, *The Miracle of Bern* not only retrospectively offers a foundational myth for the unified FRG, but it does so in internationally recognizable terms. By mixing themes of German guilt and postwar history with questions of German national identity in the form of an emotional family drama, Wortmann's film serves as an example of Hake's conclusion that "the old distinction between those periods instantly available to sentimental or sensationalist treatments and those periods requiring special

considerations yielded to more fluid constellations." It thus confirms the "diagnosis by postmodern theoreticians of a gradual disappearance of history into simulation and spectacle. . . ."[11]

Although historical simplification is common and to some extent unavoidable within the limited time frame of a film, The Miracle of Bern intentionally omits a number of crucial historical events that would blemish the ideal victory being presented. An example of this selective portrayal of history is found in the absence of the FRG's highly problematic relations with the Soviet-sponsored German Democratic Republic (GDR). Whereas the film shows people in both German states celebrating the soccer victory as a joint triumph, the division between East and West Germans had in actual fact already been cemented. A possible unification of the German states had indeed become very unlikely as early as 1949, when first the FRG and later the GDR were established. What is more, not only did the West German government officially reject the government of the GDR, but Bonn also claimed the sole right to represent Germany internationally.[12]

The Miracle of Bern reduces—if it does not altogether neglect—the deep-rooted fight of ideologies in the two German states to some understated scenes in which, for instance, the eldest son, Bruno, fixes a placard of the West German Communist Party on a wall and, later, argues with his father, Richard Lubanski, over politics. The movie takes a correspondingly West German position in a brief conversation between Bruno and Matthias. Confronted with Bruno's decision to leave for East Berlin, where he seeks to find equality, freedom of speech, and employment, Matthias dismisses Bruno's view of the GDR as a mere utopia. Despite his young age, Matthias questions the existence of such a place. Given the historical distance of post-unification audiences, Bruno's blind faith in East German socialism appears to be somewhat naïve, especially given that today's cinemagoers are more likely to identify themselves with Matthias's more realist views. This attitude, however, bears the peril of ahistorical, after-the-fact reasoning.

In addition, it is important to note that the GDR praised itself as the "new Germany," the one that was not responsible for the cruelties of the Third Reich and sought rehabilitation among the civilized nations by the Soviets' side. The FRG, on the contrary, took full responsibility as the legal successor of Nazi Germany and could thus be held accountable for all juridical consequences that resulted from the period of the Third Reich.[13]

Apart from domestic German problems, *The Miracle of Bern* also downplays the political dimensions of the final World Cup match against Hungary. Official documents of the GDR Sekretariat für Körperkultur und Sport (Secretariat of Body, Culture and Sports) regarding matches between Hungary and England reveal that the games were generally seen as contests between capitalism and communism.[14] Sönke Wortmann's soccer epic, however, makes no significant references to the Cold War. Throughout its depiction of the final, the diegetic radio commentator underlines the extraordinary quality and fairness of the Hungarian team without ever referring to the political system of the country. Only a tiny red star on their jerseys identifies them as players from the other side of the Iron Curtain.

Relations between East and West Germany and the political implications of the final are not the only issues omitted or simplified in the 2003 motion picture. Both the national team and their fans celebrate the German World Cup victory in a modest way. Yet this humble attitude as presented in the movie was created retrospectively and bears little relation to the actual events of 1954. Immediately after the match, German fans sang the first stanza of their national anthem, formerly used by the Third Reich, instead of the third stanza, which had become the official anthem of the FRG. As a consequence, radio and television audiences across Europe, particularly those countries that suffered tremendously from Nazi occupation, were shocked. The Swiss radio station broadcasting the game even ended the transmission when the fans chanted the notorious lines. The film follows the DFB's official press release, completely omitting the postgame dismay.[15]

The Bern incident was not the only occasion during which the DFB was confronted with the Nazi past. During the official festivities in Munich, for example, DFB president Peco Bauwens gave his infamous speech in which he praised supposedly German virtues like the "Führer principle" and Wotan, the Germanic god of war. Once again, like the DFB in 1954, *The Miracle of Bern* does not mention these scandals, which were condemned by both German and international newspapers at the time.[16] In its quest to portray the unspoiled triumph of the German national soccer team, *The Miracle of Bern* avoids the use of military metaphors and forms of national chauvinism that can be found, for instance, in the British press to this day.[17] During the 1996 European Cup in England, for instance,

the lowbrow daily newspaper *The Sun* published an article entitled "Let's Blitz Fritz," and the *Daily Mirror* also referred to the common German national personification, Fritz, in its headline "Achtung! Surrender. For You Fritz, ze Euro 96 Championship Is Over."[18]

The improper behavior of Germans like Peco Bauwens and negative headlines abroad were counterproductive to Chancellor Konrad Adenauer's attempt to integrate the FRG economically and politically into the Western Bloc. *The Miracle of Bern*, however, does not depict any of the Adenauer administration's attempts to play down their compatriots' behavior in Bern, nor does it give credit to the FRG's quest for sovereignty and Western integration as Adenauer's primary goal. Ironically, the French National Assembly refused to ratify the European Defense Community (EDC) treaty, which was to include the FRG as a sovereign member, in the immediate aftermath of the German World Cup victory. Contrary to the widely held popular belief that the Germans returned instantly to the international scene after Bern, it actually took until May 5, 1955, for West Germany to regain its status as a sovereign nation and a full member of NATO.[19]

Along with its quest for integration into the Western alliances, the Adenauer administration was also making an effort at remilitarization. Although left out in Wortmann's motion picture, the rearmament of the FRG was a contested topic during the first half of the 1950s, especially with the Korean War heating up the Cold War. In 1950 Gustav Heinemann, Minister of the Interior, resigned from his post and left the ruling party, the Christian Democratic Union (CDU), as a result of the Adenauer administration's official policy of remilitarization and Western integration. Fearing that a rearmed and sovereign FRG might obliterate all hopes of German unification, Heinemann became significantly involved in the Gesamtdeutsche Volkspartei (All-German People's Party, GVP), which also alluded to soccer on its official election campaign posters, which featured a violent soldier and a pacifist soccer player in juxtaposition.[20]

The Miracle of Bern also draws on the binary opposition of soldier and soccer player, for it is only after Richard Lubanski finds his love for soccer again that he is able to understand his family and turn into a more loving and concerned father. In other words, the moment he plays soccer after years in captivity, he changes from a soldier to a civilian who is able to cherish the simple things in life and learn not to pity himself or to be too hard on himself.

In the political arena, soccer also served as a means of reconciliation

Gesamtdeutsche Volkspartei (All-German People's Party, GVP) campaign poster, circa 1953. Courtesy of Deutsches Historisches Museum, Berlin.

Reconciliation through soccer: the Lubanski family. Courtesy of Filmmuseum Berlin—Deutsche Kinemathek.

with Germany's former foes. Ironically, the West Germans' defeat by the Soviet national soccer team in 1955 helped Chancellor Konrad Adenauer tremendously on his trip to Moscow the same year to secure the release and return of fifteen thousand German prisoners of war (POWs)—the so-called *Spätheimkehrer*—who were still held captive in the Soviet Union.[21]

Soccer as a Means of Repressing the Nazi Past

Before the POWs' return, their situation was one of the major issues in the young Bonn Republic. While Sönke Wortmann's film neglects various contentious themes, it does incorporate this story for its emotional potential. The movie's lead character, Richard Lubanski, returns home nine years after the unconditional surrender of the Third Reich. As a consequence of his late return, his relationship with his wife and his children is tense and faulty. This is especially apparent in the numerous conflicts between Richard Lubanski and his elder son Bruno, who accuses his father of having been a fellow traveler of the Nazis. Representing a generation of grown-ups who distanced themselves from the alleged "perpetrator generation" of their parents, Bruno's attitudes can only be understood against the background of Germans' attempts to cope with their history. In many ways their dispute foreshadows the student revolution of the late 1960s.

Although changes in Germany in the year 1968 were reminiscent of those in the United States and France, one major difference was the call for a *Vergangenheitsbewältigung*, a coming-to-terms with the Nazi past. However, *The Miracle of Bern* evades this underlying conflict. Moreover, the rift between father and son bears a striking similarity to the initial problems the Allies faced with their de-Nazification and reeducation programs in Germany. Accordingly, Richard Lubanski's excuse—"One person couldn't do a thing. You had to join them!"—is reminiscent of the argument put forth by many fellow travelers after the war. Referring to the Western Allies' de-Nazification measures and their resonance in the FRG, historian Ulrich Herbert notes that "two elements of the West German response stand out: the rejection of 'victor's justice' and the accusation of 'collective guilt.'" Moreover, Herbert continues, "As Germans quickly confined 'the guilty' to Hitler and his satraps, who were of course already dead, every attempt to widen the circle of responsibility was stonewalled with this extremely popular slogan, which soon evolved into a sort of historical-political legitimization of West German society: since collective

guilt did not exist, and Hitler and the leading Nazis were gone, everyone else was innocent."[22] The philosopher Hermann Lübbe accordingly refers to the early Cold War period as a "certain stillness in the 1950s" and even argues that Germans accepted democracy because they initially did not deal with the Nazi regime. According to Lübbe, their behavior led to the stabilization of democracy in West Germany with "quiet opportunism as the foundation of democracy."[23] As Ulrich Herbert puts it, "The abstraction and derealization of the past also had a distancing effect, placing time between events and individuals" and resulting in a "repression of the past."[24]

Produced some ten years after German unification, Wortmann's film attempts to end active engagement with the Nazi past. *The Miracle of Bern* does not deny the Nazi past, but it marginalizes issues of German guilt. Moreover, it follows the ongoing trend of historicizing both the twelve years of Nazi rule and the Bonn Republic.[25] In contrast to recent discourses on issues such as the Allied bombing of civilian centers such as Hamburg and Dresden, the movie refrains from a rather revisionist sole victimization of Germany, as it always connects the German plight with the country's responsibility for causing the war.[26] In the scene where Richard Lubanski arrives at the local train station with other recently released POWs, his wife expresses her hope that the Russians did not treat him too badly. The eldest son, Bruno, simply replies, "The Russians kicked the Germans' ass 'cause the Germans attacked them for no reason."

With regard to Germans' coming to terms with their history, the close-knit parallel structure of *The Miracle of Bern* depicts the process of the democratization of the FRG on two major levels: the national soccer team and the Lubanski family on the micro level and Germany on the macro level. On the micro level both storylines are connected through the character of soccer player Helmut Rahn, a member of head coach Herberger's "family" who serves Matthias Lubanski as a surrogate father while Richard Lubanski—Matthias's father—is in the Soviet Union. Analogously, the two father figures undergo a process of initiation into a democratic lifestyle.

After his return, Richard Lubanski tries to reestablish his authority by using physical and verbal force. In his view, an ideal family adheres to hierarchical orders, discipline, and manners. Not coincidentally, his authoritarian style and his principle that "a German boy doesn't cry" greatly resemble the slogans of the Hitler Youth. After years in the Wehrmacht

and his ensuing POW experience, he has great difficulty adapting to his role as a father. Unable to listen to the needs and desires of his wife and children, he gives orders instead of negotiating with them. In a key scene, after he has punished his son with a belt, his wife Christa has an argument with her husband:

> CHRISTA LUBANSKI: Don't you care what the kids and I feel?
>
> RICHARD LUBANSKI: Are you blaming me? Look what you've done! Our oldest son is a big mouth with Communist ideas, our daughter a soldier's whore, and the kid wants to run away!
>
> CHRISTA: Ask him why! It's because of you!
>
> RICHARD: I'm just trying to teach him discipline to make him fit, so he'll be somebody.
>
> CHRISTA: I see! What do you think I've been doing? I fed the family. I started the bar, took care of the household, and raised the kids. Now you come and run everything down and put things "right" again!
>
> RICHARD: I didn't run everything down . . .
>
> CHRISTA: Let me tell you something. Before you came, we were happy. Since then, the kids feel upset, sad, and wretched.
>
> RICHARD: You want me to go back to prison camp?
>
> CHRISTA: Stop pitying yourself all the time. Can't you ever think of anyone else? Since you arrived, everybody's constantly thinking of your feelings. Have you ever shown any appreciation? Bruno earns a few Marks with his band, Ingrid helps out in the bar. Even the kid helps out by selling cigarettes. That's discipline! And one more thing . . . You are the least disciplined of us all!

Here, Richard Lubanski is confronted with his behavior for the first time. Another important step in his change from frustrated soldier to respected father figure and member of the community is a scene in which he seeks advice from a local Catholic priest, who encourages him to talk to his family. As a consequence, Richard Lubanski fulfills his son's biggest dream by driving him to the World Cup final in Bern. On the family level, their journey to the soccer game marks the reconciliation between father and son. On a more general level, the reconciliation between Richard and Matthias can be interpreted as a harmonious resolution of the conflict between

the so-called perpetrator generation and their children. The movie thus negotiates major developments on a national level.

In the same way that the flawed father-son relationship improves to the point of contributing to a harmonious, peaceful family life, the soccer players serve as ambassadors of a pariah nation and help the FRG regain its place on the international stage. Although team coach Sepp Herberger, who was a member of the Nazi party and head coach during the Third Reich (although this affiliation remains unnamed throughout the film), "reigned" over the team in an authoritarian style for most of the tournament, he also developed into a more democratic leader.[27]

Herberger's development becomes clear in a key scene in which the German coach talks to a hotel employee who is cleaning the lobby. During the conversation, Herberger initially believes in discipline and punishment, whereas the cleaning lady preaches forgiveness and moderation. She urges Herberger toward greater understanding by saying, "You aren't in Germany now. You don't always have to punish 'em." Taking this advice into account, he changes his methods in favor of a more democratic approach. After his authoritarian leadership results in a humiliating defeat in a first-round game, he consults his team captain, Fritz Walter, about whom to pick for the position of striker. As a result of this change in approach, Helmut Rahn plays in the final, scoring and thus propelling the underdog Germany to triumph.

In its portrayal of Herberger, *The Miracle of Bern* affirms the public image of the German coach as one of the FRG's first legends. In 1977 the German postal service even issued a memorial stamp to celebrate his eightieth birthday—an honor previously enjoyed only by the chancellors Konrad Adenauer and Willy Brandt in their own lifetime. Herberger's famous sayings—"The ball is round and a game lasts ninety minutes" and "After the game is before the game"—made him a sort of soccer philosopher.

On the micro level, the examples of Richard Lubanski and Sepp Herberger represent personalized histories; taken to the macro level, they embody Western Germany's postwar society. Their evolution from authoritarian leaders to members of a team symbolizes the change in German society from a totalitarian regime to a democratic society. In this way the film portrays an idealized post-wall view of how Germans would like to perceive their postwar history and the image they would like to convey of their country abroad.[28] On the one hand, the film follows the traditional

concept of the nuclear family as the core of society, expressed also in the movie poster's tag line, "Every boy needs a father." On the other hand, the humble and modest appearance of the German national soccer team, even after the victory in the final, seems to be a newly acquired "German virtue" in contrast with Nazi ideology.

The optimistic outlook of the film stands in sharp contrast to polls conducted by the U.S. military, which indicate that West Germany's population was not composed entirely of people who fully believed in democratic values. In the years 1951 and 1952, for example, 41 percent of the interviewees agreed that Nazi ideas had been, for the most part, more good than bad.[29]

It is of great importance to observe that Wortmann's film does not critically analyze and thus does not attempt to damage the popular myth revolving around Sepp Herberger. Although Bruno reproaches his father, Richard Lubanski, for his Nazi past, no one confronts Herberger with his former Nazi affiliations. At first glance, it appears odd that in 2003 no one seemed to be willing yet to deconstruct a popular postwar legend. Instead, it is the fictional character of Richard Lubanski who is accused of being a fellow traveler. A second look at the production context of the movie, however, reveals that filmic representations of great historic figures were common at the time and can, for instance, be seen in national television shows about great Germans.[30] More than a decade after unification, Germany, in its quest for a new identity, celebrates historic heroes and events.[31]

Forging a German Collective Identity: The Unifying Power of Soccer

The triumph of Bern created both a sense of virtually standing united in front of the few television sets available or collectively listening to Herbert Zimmermann's famous radio broadcast of the match and a feeling of security less than a decade after the end of World War II. The collective perception of the triumph at Bern is perhaps comparable to that of the first moon landing. Just as Americans know exactly where they were when Neil Armstrong performed his "giant leap for mankind," Germans remember where they were during the 1954 World Cup final. As Arthur Heinrich highlights, "Winning the World Cup also gave the West Germans a chance to celebrate themselves against the background of an economic

Representing the nation: like millions of their fellow countrymen, Bruno and Matthias Lubanski listen to radio coverage of the 1954 World Cup. Courtesy of Filmmuseum Berlin—Deutsche Kinemathek.

reconstruction that, although proceeding rapidly, was primarily being experienced individually."[32]

The Miracle of Bern also attributes the successful German nation-building process to the victory of Bern. Drawing on actual accounts of the broadcast of the match, Wortmann's movie juxtaposes scenes of empty streets and train stations with scenes of people thronging in bars and in front of television and radio shop windows. In so doing, the film also follows descriptions that stress the sense of community present during and after the World Cup final, which Nobel laureate Günter Grass vividly captured in Mein Jahrhundert (My Century).[33] This feeling of unity, however, was not limited to audience reception. The triumph itself, which has been called the "rebirth of Germany," is depicted as a team effort in Wortmann's film. The film makes wide use of regional dialects and thereby alludes to the American concept of strength through diversity. Depicting a potpourri of regional dialects, The Miracle of Bern anticipates the success story of the FRG as a federal democracy when the German team wins the World Cup.

Moreover, Wortmann's sports epic depicts the victory as an all-German celebration, despite Germany's political division into two separate states at the time. Bruno Lubanski continues to support the "other Germany" once he has arrived in East Berlin. In a scene charged with political symbolism, the film depicts Bruno and other young people watching the World Cup on television while a larger-than-life portrait of Lenin looms in the background. Although Bruno and all his companions wear the shirts and insignia of the communist youth organization Freie Deutsche Jugend (Free German Youth; FDJ), they compassionately follow the efforts of the West German side. Here, Wortmann's film points to the great difficulty that the East German regime faced in defining the people of the GDR as a country in its own right, particularly because before 1989 East Germans considered themselves German regardless of official efforts to construct an exclusive Socialist East German identity.[34] In fact, by celebrating the West German triumph in soccer, the filmic representations of East German-ness in *The Miracle of Bern* cast some light on how the two states defined themselves. As Andrew Plowman observes, "The GDR never functioned for the FRG as a reference culture as the FRG did for the GDR."[35]

The unifying power of soccer, however, is not restricted to the realms of sports and politics but extends also to social class. Here, it is important to mention Wortmann's classless portrayal of the West German triumph at Bern. While Pierre Bourdieu maintains that sports not only reveal and justify class relations but actually manifest them in a rigid manner, *The Miracle of Bern* represents soccer fans as a community united across social strata.[36] Almost fifty years after Bern, a similar unifying moment in soccer occurred with the German World Cup victory of 1990. Taking place the summer before German unification, once again a West German national team won, and both East and West Germans celebrated the victory. Unlike *The Miracle of Bern*, which affirms the unifying power of soccer, the internationally acclaimed movie *Good Bye Lenin!* makes ironic reference to the all-German event of the 1990 World Cup triumph by juxtaposing the event with a personal tragedy and the downfall of the GDR.

Devoid of irony, *The Miracle of Bern* depicts the events surrounding the German victory rather uncritically as a decisive and unifying moment. In this way, the film represents 1950s views such as those expressed in the newspaper *Rheinische Post*, which stated that Germans were seized by a feeling "which is really the expression of a national solidarity."[37] Wortmann's movie reenacts the events of 1954 as a community-building

force and evokes long-remembered emotions about a new beginning. What the 1954 victory was to the emerging Bonn Republic, the fall of the Berlin Wall and the victory in the 1990 World Cup were to the foundation of the Berlin Republic. Accordingly, Paul Cooke and Christopher Young note that Wortmann's film portrays "a harmonious image of Germany's national identity which clearly has more to do with a post-unification longing for normalisation than it does with the reality of life in the 1950s."[38] The importance of the soccer World Cup in 1954 also prompted German Chancellor Gerhard Schröder, who reportedly cried while watching the film, to declare Bern's Wankdorf stadium a national memorial, alongside sites like the city of Weimar, the Berlin Wall, and the Brandenburg Gate, owing to its historic significance in the past, present, and future.[39] When the stadium was demolished in August 2001, the Swiss Embassy in Berlin presented a piece of the grass from the playing field in Bern to the German chancellor in a carefully staged ceremony. Schröder proposed to place the piece of the historic lawn at a special place in the garden of his newly built grand chancellery right at the center of Berlin.[40]

"Wir sind wieder wer!" The "Economic Miracle" and the German Version of the American Dream

The great popularity of soccer made the 1954 World Cup one of the FRG's first mass media events. What is more, at a time of economic and political uncertainty, the victory of the 1954 World Cup created a collective euphoria in Western Germany. The triumph of the national soccer team has often been seen as one of the positive indicators of West Germany's economic recovery. Arthur Heinrich appropriately notes, "Winning the World Cup crowned [the] economic breakthrough [of the FRG]."[41]

Throughout the 1950s, the West German economy was blossoming. The gross domestic product grew by an annual rate of more than 8 percent.[42] This prosperity became commonly known as the "economic miracle" (*Wirtschaftswunder*). The economic boom was envied by other countries, particularly those that suffered severely from Nazi occupation or fought against the Third Reich. With regard to West Germans and their self-perception, Ries Roowaan has noted, "At the same time it seemed somewhat unfair to the Dutch [and other nations]: the same Germans who had wrought havoc over Europe were not condemned to suffer, but instead were rewarded with larger cars, better consumer durables and more

travel opportunities than most other peoples in Europe. What is more, they were not modest about their new wealth, but praised themselves highly for recovering so soon, considering it proof of the superiority of the German way of doing things, summarized in the formula . . . *wir sind wieder wer* [we are someone again]."[43]

Once again, *The Miracle of Bern* does not make reference to any problematic issues that might blemish the view of the young FRG. Instead, it follows general views of popular culture by forging an intrinsic link between economic and sports success. In this regard, the part that Adi Dassler plays in the movie is very important. Wortmann's film reduces the *Wirtschaftswunder* success story of the sporting goods manufacturer Adidas (named after its founder, *Adi Dass*ler) to his role as the major supplier for Herberger's team. In *The Miracle of Bern* Dassler's newly invented replaceable screw-in studs are a key factor in Germany's win against Hungary in the rainy "Fritz Walter weather." The advantage of the German players is vividly captured by the mise-en-scène of the Bern final: whereas the Hungarian team repeatedly slips on the wet soccer field, the new shoes quite literally give the German squad a better standing. The shoes were not developed overnight, but the legend perfectly fit Hollywood's blockbuster formula. By including the Adidas episode, *The Miracle of Bern* conveys popular views that, in the 1950s, the creativity of individual middle-class inventors was the backbone of economic recovery. Along with their American-style entrepreneurial spirit, these visionaries were characterized by their pragmatic optimism. Just as the soccer players represent the German people, Adi Dassler is the epitome of a new breed of German businessman who embodied the possibility of living the West German version of the American dream: from rags to riches. By 1958 most national soccer teams were equipped by the German sporting goods manufacturer, demonstrating the overwhelming success of Adidas as a major brand.[44]

That Wortmann's movie follows popular legend in regarding the soccer victory as proof of Germany's economic success is clear in the last sequences of the film, which lead to its reconciliatory happy ending. While most of the film is characterized by the stark contrast between the Ruhr Valley, with its coal mining and heavy industry, and the modern and quite extravagant residence of the Ackermanns in Munich, this dichotomy disappears when the victorious German national team returns home. The FRG, which has formerly appeared dull and colorless in some scenes, literally

Street soccer with balls made of old rags—a means of escapism in the industrial heartland of Germany before the World Cup victory and the economic miracle. Courtesy of Filmmuseum Berlin—Deutsche Kinemathek.

blossoms. The bright and lavish Swiss landscape—created through the use of Technicolor-like coloring—is eventually transported into a German scene. The dramatic tensions and oppositions created through contrasting colors and balances are gradually reduced as the film proceeds. Like the immensely popular escapist *Heimatfilm* (homeland film) genre, which was described by some scholars as a holiday from the everyday and a retreat to the harmonious living conditions found in German landscapes, the end of *The Miracle of Bern* suggests an optimistic outlook on the future.[45]

Nevertheless, some artists—in particular, the New German Cinema of the 1970s and 1980s—contested such a positive perspective on the 1950s. In Rainer Werner Fassbinder's film *Die Ehe der Maria Braun* (*The Marriage of Maria Braun*, 1979), for instance, this biased view of the early postwar period received ironic treatment. In a montage style, Fassbinder establishes a link between West German rearmament and German military tradition. While auteurs of the New German Cinema viewed slogans like "wir sind wieder wer" critically, filmmakers of the post-wall era were rather more affirmative in their portrayal of the 1954 victory. *The Miracle of*

Bern celebrates the victory of the German soccer team as a personal and national triumph of a country at the crossroads. In contrast, Fassbinder's version of the 1950s is a bleak picture of a cold and inhumane society. As Paul Cooke and Christopher Young note, the juxtaposition of Herbert Zimmermann's famous radio commentary with "the visual image of Maria's bourgeois home exploding—an event that symbolically points to the emptiness at the heart of Germany's rapid and, in Fassbinder's view, hypocritical reinvention of itself as a Western bourgeois society."[46] The paradigm shift amongst post-unification filmmakers is underlined by Sönke Wortmann himself, who states, "When I was at film school at Munich, the great hero was Tarkovsky. Today it's Spielberg."[47]

Conclusion: 1954–2006

Produced some ten years after the unification of the two German states, *The Miracle of Bern* presents a nostalgic and affirmative view of the 1950s. Many elements of German popular memory such as the "economic miracle" and the notion of "wir sind wieder wer" are portrayed either uncritically or in an extremely simplified way. For post-unification audiences, the film serves as a means of escape and offers a refuge from problems of a stricken Germany, which faces difficulties such as high unemployment, illegal immigration, globalization, and the process of European unification. Perhaps one reason for the movie's great box-office success in the FRG when the country was about to pass a string of reforms known as Agenda 2010 is that the plot revolves around a West German working-class family in the Ruhr Valley. The story of the German national soccer team offers a screen onto which audiences can project their own feelings, expectations, fears, and hopes.

Wortmann's movie illustrates that the victory in Bern has become part of a constructed German past. The legend of Bern, as presented in the film, bears great resemblance to American monomyths such as the frontier myth.[48] In other words, like the pioneers of the American West, the German national soccer players of 1954 are portrayed as "founding fathers" of the newly established FRG, helping West Germany on its way toward becoming a sovereign nation.

By personalizing and emotionalizing history in a Hollywood-like style, Wortmann's film bears the peril of contributing to the creation of a simpli-

fied German "national character"—a concept that has been questioned by historian Richard Slotkin, who argues that "the mythology of a nation is the intelligible mask of that enigma called the 'national character.'"[49] *The Miracle of Bern* uncritically portrays a German version of the American dream. On the micro level, the figures of Adi Dassler, Richard Lubanski, and Helmut Rahn show that the FRG offers many prospects for advancement. On the macro level, the film depicts the triumph of Bern as a major unity-building moment for all Germans, regardless of their social or political origin. The tag line from the movie poster—"every country needs a legend"—reveals *The Miracle of Bern* as an attempt to establish a German postwar foundational myth as popular entertainment.

In many respects the symbolic meaning of Bern as a site where Germany rose Phoenix-like from the ashes of World War II cemented the exceptional role of soccer within German culture and society. Only by understanding the cultural, social, and political authority of soccer in the FRG can we explain why Germany was able to win the bid to host the 2006 World Cup over favored South Africa. When the doyen of German soccer, Franz Beckenbauer, addressed FIFA at the end of the selection procedure in Zurich, he was accompanied by some of Germany's foremost representatives in the realms of politics, sports, and public life: Chancellor Gerhard Schröder, Secretary of the Interior Otto Schily, former tennis idol Boris Becker, and star model Claudia Schiffer.[50]

What appears mostly as a forced and constructed new feeling of being German, often coupled with a good amount of uneasiness in Wortmann's film, was freely lived and celebrated by Germans as a "normal" patriotism has emerged in the host country of the 2006 World Cup.[51] Although the German national team finished third, coach Jürgen Klinsmann, who had previously won the World Cup as a player in 1990, and his team were celebrated as "the world champions of hearts."[52]

With *The Miracle of Bern* Wortmann certainly helped set the tone for the collective euphoria that made the slogan of the 2006 World Cup, "Die Welt zu Gast bei Freunden" (Time to Make Friends), become true. Given the film's success at the box office and the fact that it received the support of the organizing committee of the 2006 World Cup and the DFB, it comes as no surprise that the German director was granted permission to accompany and film the national team.[53] For his documentary film, *Deutschland: Ein Sommermärchen* (Germany: A Summer Tale, 2006),

which might be seen as a sequel to *The Miracle of Bern*, Wortmann gained access to some of the team's most intimate moments before and during the World Cup in Germany. A German newspaper even suspected Wortmann of having "directed" and "orchestrated" the World Cup. If this was indeed the case, the journalist cheekily suggested, he should be awarded each and every prize as best director because never before has one witnessed such *Edelkitsch* ("pompous kitsch") that was so entertaining.[54]

Notes

We would like to express our deep gratitude to Andrew Plowman for his help and support in our research and to James Leggott for helpful comments on the manuscript.

1. Koen Stroeken, "Why 'the World' Loves Watching Football (and 'the Americans' Don't)," *Anthropology Today* 18, no. 3 (June 2002): 9–13.

2. Bill Murray, *The World's Game: A History of Soccer* (Urbana and Chicago: University of Illinois Press, 1998), xiii. On the significance of soccer worldwide, see, for example, Christiane Eisenberg, "Fußball als globales Phänomen: Historische Persepektiven," *Aus Politik und Zeitgeschichte*, June 21, 2004, 7–15.

3. On the relationship between games and culture, see Johan Huizinga, *Homo Ludens: A Study of the Play Element in Culture* (London: Routledge and Kegan Paul, 1980).

4. Ramanchandra Guha, "Cricket and Politics in Colonial India," *Past and Present* 161 (1998): 157.

5. On the importance of soccer in German culture and literature, see, for example, Alan Tomlinson and Christopher Young, eds., *German Football: History, Culture, Society* (London and New York: Routledge, 2006); R. Adelmann, R. Parr, and T. Schwarz, eds., *Querpässe: Beiträge zur Literatur-, Kultur- und Mediengeschichte des Fußballs* (Heidelberg: Synchron, 2003); Rainer Moritz, "Das unfähige Leder: Fußball in der deutschsprachigen Literatur," *Jahrbuch für finnisch-deutsche Literaturbeziehungen* 31 (1999): 30–35; Hermann Bausinger, "Kleine feste im Alltag: Zur Bedeutung des Fußballs," *Jahrbuch für finnisch-deutsche Literaturbeziehungen* 31 (1999): 36–44; Michael Gamper, "Literatur, Sport, Medium. Diskurstheoretische Überlegungen zu einem vertrackten Verhältnis," Special Issue of *SportZeiten* 3, no. 1 (2003): *Sport in Geschichte, Kultur und Gesellschaft*: 41–52. For a comprehensive bibliography of soccer on film, see Jan Tilmann Schwab, "Fußball, Fußballfilm und Medienfußball. Eine Auswahl-Bibliographie," *Medienwissenschaft Kiel: Berichte und Papiere* 51 (2002), available online at http://www.uni-kiel.de/medien/sport.html. On the more general relationship between sports and the media, see the bibliography by Hans J. Wulff, "Sport als Medienthema: Eine erste Bibliograpfie,"

Special issue of *Medienwissenschaft/Hamburg: Berichte und Papiere* 22 (2003): *Sportfilm/Sport und Medien*, available online at http://www1.uni-hamburg .de/Medien/berichte/arbeiten/0022_03.html [October 30, 2007].

6. Axel Schildt, *Ankunft im Westen. Ein Essay zur Erfolgsgeschichte der Bundesrepublik* (Frankfurt: Fischer, 1999), 17.

7. Andrew Plowman, "*Westalgie?* Nostalgia for the 'Old' Federal Republic in Recent German Prose," *Seminar* 40, no. 3 (September 2004): 249–61.

8. Stuart Taberner, *German Literature of the 1990s and Beyond: Normalization and the Berlin Republic* (Rochester, NY: Camden House, 2004); especially chapter 1, "Literary Debates Since Unification: 'European' Modernism—or 'American Pop.'"

9. Sabine Hake, *German National Cinema* (London and New York: Routledge, 2002), 182.

10. Randall Halle, "German Film, *Aufgehoben*: Ensembles of Transnational Cinema," *New German Critique* 87 (Fall 2002): 13, 19.

11. Hake, *German National Cinema*, 186.

12. Wolfgang Benz, *Die Gründung der Bundesrepublik Deutschland: Von der Bizone zum souveränen Staat* (Munich: DTV, 1999), 145.

13. Christoph Kleßmann, "Abschied vom 'Sonderweg' und doppelte Bündnisintegration: Folgen des Krieges für die Außenpolitik beider deutscher Staaten gegenüber den europäischen Nachbarn," in *1945: Der Krieg und seine Folgen: Kriegsende und Erinnerungspolitik in Deutschland*, eds. Burkhard Asmuss, Kay Kufeke, and Philipp Springer (Berlin: Deutsches Historisches Museum, 2005), 30.

14. Peter Kasza, *1954—Fußball spielt Geschichte: Das Wunder von Bern*, Bundeszentrale für politische Bildung Schriftenreihe, vol. 435 (Bonn: BPB, 2004), 196. On soccer as part of the two German states' national identity, see Markus Hesselmann and Robert Ide, "A Tale of Two Germanys: Football Culture and National Identity in the German Democratic Repubic," *German Football: History Culture, Society*, eds. Alan Tomlinson and Christopher Young (London and New York: Routledge, 2006), 36–51.

15. Kasza, *1954—Fußball spielt Geschichte*, 174–75.

16. Ibid., 172–74.

17. On the use of military metaphors in soccer media coverage, see Rainer Küster, "Kriegsspiele—Militärische Metaphern in Fußballsport," *Zeitschrift für Literaturwissenschaft und Linguistik* 112 (1998): 53–70. On nationalism and soccer, see, for instance, Jeremy MacClancy, "Nationalism at Play: The Basques of Vizcaya and Athletic Club de Bilbao," *Sport, Identity and Ethnicity*, ed. Jeremy MacClancy (Oxford: Berg, 1996), 181–99; Peter Stankovi , "Sport, Nationalism and the Shifting Meanings of Soccer in Slovenia," *European Journal of Cultural Studies* 7, no. 2 (May 2004): 237–53.

18. Cited in Hugh Ridley, "'Blitz the Fritz': Vom Nutzen und Nachteil des Fußballs für die Nation," *Der Deutschunterricht* 50, H, 2 (1998): 59. See

also Joseph Maguire, Emma Poulton, and Catherine Possani, "Weltkrieg III: Media Coverage of England versus Germany in Euro 96," *Journal of Sport and Social Issues* 23, no. 4 (1999): 439–54.

19. Benz, *Die Gründung*, 145–58.

20. Ibid., 149–50.

21. Ibid., 159; also Kasza, *1954—Fußball spielt Geschichte*, 181.

22. Ulrich Herbert, "Academic and Public Discourses on the Holocaust: The Goldhagen Debate in Germany," *German Politics and Society* 17, no. 3 (Fall 1999): 37.

23. Hermann Lübbe, "Der Nationalsozialismus im deutschen Nachkriegsbewußtsein," *Historische Zeitschrift* 236 (1983): 579–99.

24. Herbert, "Academic and Public Discourses," 37–38.

25. Schildt, *Ankunft im Westen*, 17.

26. Jörg Friedrich's monograph, *Der Brand: Deutschland im Bombenkrieg 1940–1945* (Berlin: Propyläen, 2002), initiated a public debate over the morality of the Allied bombing campaign against Germany during World War II. The book was published in English in 2006 under the title *The Fire: The Bombing of Germany, 1940–1945*, trans. Allison Brown (New York: Columbia University Press).

27. On the history of the DFB during the Nazi era, see also Nils Havelmann, *Fußball unterm Hakenkreuz: Der DFB zwischen Sport, Politik und Kommerz* (Frankfurt: Campus, 2005).

28. On the influence of soccer on national stereotypes and national identity, see Sanna Inthorn, "A Game of Nations? Football and National Identities," *German Football: History, Culture, Society*, eds. Alan Tomlinson and Christopher Young (London and New York: Routledge, 2006), 155–67.

29. Anna J. Merritt and Richard L. Merritt, eds., *Public Opinion in Germany: The HICOG Surveys, 1949–1955* (Chicago: University of Chicago Press, 1980), 7.

30. Norbert Seitz, "Was symbolisiert 'Das Wunder von Bern'?" *Aus Politik und Zeitgeschichte*, June 21, 2004, 3.

31. Paul Cooke and Christopher Young, "Selling Sex or Dealing with History? German Football in Literature and Film and the Quest to Normalize the Nation." In *German Football: History, Culture, Society*, eds. Alan Tomlinson and Christopher Young (London and New York: Routledge, 2006), 193.

32. Arthur Heinrich, "The 1954 Soccer World Cup and the Federal Republic of Germany's Self-Discovery," *American Behavioral Scientist* 46, no. 11 (July 2003): 1493.

33. Günter Grass, *Mein Jahrhundert* (Göttingen: Steidl, 1999), 218–21.

34. Paul Cooke, "Performing 'Ostalgie': Leander Haußmann's *Sonnenallee* (1990)," *German Life and Letters* 56 (2003): 156–67.

35. Plowman, "*Westalgie?*," 251.

36. Pierre Bourdieu, "How Can One Be a Sports Fan?" In *The Cultural Studies Reader*, ed. Simon During (London: Routledge, 1995), 339–56.

37. "Fußball und Politik," *Rheinische Post*, July 6, 1954, 3.

38. Cooke and Young, "Selling Sex or Dealing with History?" 191.

39. Seitz, "Was symbolisiert," 3. On the meaning of soccer stadiums and cultural memory, see Christopher Young, "Kaiser Franz and the Communist Bowl: Cultural Memory and Munich's Olympic Stadium," *American Behavioral Scientist* 46, no. 11 (July 2003): 1476–90. On the relationship between soccer and national identity, see, for example, Jeremy MacClancy, "Sport, Identity and Ethnicity," *Sport, Identity and Ethnicity*, ed. Jeremy MacClancy (Oxford: Berg, 1996), 1–20; Philippe Carrard, "'L'Equipe de France du Monde': Sport and National Identity," *French Cultural Studies* 13 (February 2002): 65–82; and Eduardo P. Archetti, "The Spectacle of Identities: Football in Latin America," *Contemporary Latin American Cultural Studies*, eds. Stephen Hart and Richard Young (London: Arnold, 2003), 116–26.

40. Wolfram Pyta, "German Football: A Cultural History," in *German Football: History, Culture, Society*, eds. Alan Tomlinson and Christopher Young (London and New York: Routledge, 2006), 18.

41. Heinrich, "The 1954 Soccer World Cup," 1493.

42. Anthony J. Nicholls, *The Bonn Republic: West German Democracy 1945–1990* (London: Longman, 1997), 95–98; Dennis L. Bark and David R. Gress, *A History of West Germany*. Vol. 1, *From Shadow to Substance: 1945–1963* (Oxford: Blackwell, 1989), 392–98.

43. Ries Roowaan, "Two Neighbouring Countries and a Football Pitch: The Federal Republic of Germany and The Netherlands after the Second World War," *Dutch Crossing* 24, no. 1 (2000): 140.

44. Kasza, *1954—Fußball spielt Geschichte*, 183–84.

45. Johannes von Moltke, "Evergreens: The *Heimat* Genre," in *The German Cinema Book*, eds. Tim Bergfelder, Erica Carter, and Deniz Göktürk (London: BFI, 2002), 18–28.

46. Cooke and Young, "Selling Sex or Dealing with History?" 189.

47. Wortmann, quoted in Ute Lischke-McNab and Kathryn S. Hanson, "Introduction: Recent German Film," *Seminar* 33, no. 4 (1997): 284.

48. Robert Jewett and John Shelton Lawrence, *The American Monomyth* (Garden City, NY: Anchor Press; Doubleday, 1977).

49. Richard Slotkin, *Regeneration through Violence: The Mythology of the American Frontier, 1600–1860* (Middleton, CT: Wesleyan University Press, 1973), 3.

50. Erik Eggers, "All Around the Globus: A Foretaste of the German Football Imagination, c. 2006," in *German Football: History, Culture, Society*, eds. Alan Tomlinson and Christopher Young (London and New York: Routledge, 2006), 226.

51. "Hunderttausende umjubeln die Fußball-Nationalmannschaft," *Frankfurter Allgemeine Zeitung*, July 10, 2006, 1; Marina Hyde, "League of Nations Allows Germany to Fly Flag with Pride," *The Guardian*, international edition, July 10, 2006: 34; Dirk Kurbjuweit et al., "Deutschland, ein Sommer-

märchen," *Der Spiegel*, June 19, 2006: 68–74, 76–77, 80–81; Andrew Purvis, "Party People: Germany Has Finally Stopped Worrying and Learned to Love Its Flag, Its Team and Its Role as Host," *Time*, June 26, 2006: 54–55.

52. Andreas Hunzinger, "Aus einem Guss," *Frankfurter Rundschau*, July 10, 2006, 17.

53. Cooke and Young, "Selling Sex or Dealing with History?" 194.

54. Christof Kneer, "Gestrüpp aus Liebeserklärungen," *Süddeutsche Zeitung*, July 10, 2006, 25.

Contributors

RON BRILEY is assistant headmaster and a history teacher at Sandia Preparatory School in Albuquerque, New Mexico, where he has taught for thirty years. He is also adjunct professor of history at the University of New Mexico–Valencia Campus. His work on sports and film has appeared in such journals as the *History Teacher*, *Film & History*, *Social Education*, the *Journal of Sport History*, *Literature/Film Quarterly*, *OAH Magazine of History*, *AHA Perspectives*, *Nine*, and *Popular Culture Review*, and in numerous anthologies. He is also the author of *Class at Bat*, *Gender on Deck*, and *Race in the Hole: A Line Up of Essays on Twentieth-Century Culture and America's Game*.

DEBORAH A. CARMICHAEL, who teaches at Michigan State University, is a former editor-in-chief of *Film & History*, and she serves on the editorial advisory board of the *Journal of Popular Culture*. She has published on film exhibition history, Depression-era movies, and documentaries. Her most recent publication, *The Landscape of Hollywood Westerns: Ecocriticism in an American Film Genre* (2006), focuses on the role of nature and the environment in film. Her many conference presentations include one on outlaws in film, given for the National Museum of Australia.

HARPER COSSAR teaches moving image studies at Georgia State University. His research interests range from sports and media to genre, narrative, and technology. His publications have appeared in the *Quarterly Review of Film and Video*, the *Journal of New Media and Communication*, *Film & History*, and *Flow TV*.

DAYNA B. DANIELS is a professor at the University of Lethbridge, Alberta, Canada. She is currently the coordinator of women's studies and a member of the department of kinesiology and physical education. Her research

focuses on the intersections of femininity, sexuality, and women's involvement in sports and physical activity.

DAVID SCOTT DIFFRIENT is a lecturer in the film and media studies program at Washington University in St. Louis. His work has appeared in several journals and anthologies, including *Cinema Journal*, *Film & History*, *Horror Film: Creating and Marketing Fear*, *Beyond Life Is Beautiful: Comedy and Tragedy in the Cinema of Roberto Benigni*, *New Korean Cinema*, and *Reading Deadwood: A Western to Swear By*.

VICTORIA A. ELMWOOD is a postdoctoral teaching fellow at Tulane University. She is currently writing a book on autobiography, masculinity, and countercultural identity during the Cold War. Her work has appeared in *Biography*, *Film & History*, and *Western American Literature*, and she has an article forthcoming in *Soundings* on *The Autobiography of Malcolm X* and Iceberg Slim's *Pimp: The Story of My Life*.

TOBIAS HOCHSCHERF is a lecturer in film and television studies at Northumbria University. His research interests include exilic and diasporic filmmaking, the cultural significance of sports in film and television, British reality television, and contemporary German television and cinema. He has published articles and book chapters on the role of German-speaking émigrés in the British film industry, the cultural significance of cricket in colonial and postcolonial fiction, and British wartime propaganda films. He is an area chair for a number of international conferences.

JOHN HUGHSON is professor of sport and cultural studies at the University of Central Lancashire. He is the principal coauthor of *The Uses of Sport: A Critical Study* (2005), coauthor of *Confronting Culture: Sociological Vistas* (2003), and coeditor of *The Sociology of Art: Ways of Seeing* (2005). He is series editor of the journal *Ethnography* and a member of the international advisory board for the journal *Cultural Sociology*. Hughson has published several academic papers on the cultural aspects of sports in a variety of refereed journals and is currently working on volumes concerning the cultural history of sport and sport and media theory.

LATHAM HUNTER's doctoral project dealt with representations of masculinity in 1990s Hollywood "office movies." Her writing on gender

representations and cultural studies has been published in the *MCRI Globalization & Autonomy Compendium, Film & History, Mosaic, the Journal of American Culture,* the *Toronto Globe and Mail,* and other publications. She teaches postsecondary courses in cultural studies, film, and literature in Ontario, Canada.

CHRISTOPH LAUCHT holds a graduate degree in history and American Studies from Kiel University in Germany and a master's degree in German studies from the University of New Mexico, Albuquerque. He is currently a doctoral candidate at the University of Liverpool, where he is completing his dissertation on German-speaking émigré atomic scientists and British nuclear culture during World War II and the early Cold War. He has published articles and book chapters on the cultural fallout of the atom bomb, *007* films, and the Royal Austro-Hungarian Navy. His research interests also include American and British World War II propaganda films and contemporary German historical event films. He has served as area chair at several international conferences.

DAVID J. LEONARD is assistant professor in the Department of Comparative Ethnic Studies at Washington State University. His work focuses on sports, video games, and popular culture, and it has appeared in both popular and academic mediums. He recently published, with C. Richard King, *Visual Economies of/in Motion: Sport and Film* (2006), an edited volume on sports films, and a monograph, *Screens Fade to Black: Contemporary African American Cinema* (2006). He is working on two other monographs: one about race and the culture wars of the National Basketball Association and another (with C. Richard King) that analyzes the production and consumption of media culture within white nationalist communities.

PELLOM MCDANIELS III is assistant professor of history and American studies at the University of Missouri–Kansas City. He specializes in African American masculinity; sports; and Negro Leagues Baseball. Dr. McDaniels teaches courses in sports history, gender studies, film, and African American history. He has written on Carter G. Woodson, black baseball, and contemporary African American art. He has published in the *International Review of African American Art,* the *Journal of Sports History,* and the *Missouri Historical Review.* His forthcoming article, "A Time Called Too Early: African American Men, Baseball and the Pursuit

of the American Dream," will appear in the inaugural issue of *Black Ball: A Negro Leagues Journal* in 2008. He is currently researching the life of contemporary African American artist and activist Benny Andrews and the nineteenth-century African American jockey Isaac Murphy.

CLAY MOTLEY is associate professor of English and director of the honors program at Charleston Southern University in Charleston, South Carolina. He received a doctorate in English from the University of South Carolina, and he conducts research on nineteenth-century American literature, Southern literature, and popular culture, particularly in relation to religious faith and gender.

DANIEL A. NATHAN is associate professor of American studies at Skidmore College. The author of the award-winning *Saying It's So: A Cultural History of the Black Sox Scandal* (2003), Nathan is a former member of the North American Society for Sport History Executive Council and has served as the Film, Media, and Museum Reviews editor for the *Journal of Sport History*.

JOAN ORMROD is senior lecturer on film and media in the Department of the History of Art and Design at Manchester Metropolitan University. She is an active member of the Images, Narratives and Cultures research group affiliated with the Manchester Institute for Research and Innovation in Art and Design. Her research interests are in surfing history, representations, and culture, and she organized a conference, "On the Edge: Leisure, Consumption and the Representation of Adventure Sports," held at Manchester Metropolitan University in March 2008. Her future research will be in the area of fantasy narratives and their audiences.

MICHAEL K. SCHOENECKE teaches film studies at Texas Tech University and has published on film, sports, music, Jack London, and architecture. He served as executive director for the Popular Culture Association and the American Culture Association for five years.

Index

Page numbers in italics refer to illustrations.